World Design for 2D Action-Adventures

Award-winning action-adventure designers Christopher Totten and Adrian Sandoval guide you on a quest to create levels for different styles of 2D action-adventure games, from top-down dungeon-crawler adventures to side-scrolling non-linear "Metroidvania" titles. Blending theory and practical analysis, this book shows how principles of game and level design are applied in some of your favorite 2D action-adventure games. It uses examples from popular games such as *The Legend of Zelda* and *Hollow Knight*, while also providing insights from the authors' own experiences creating independent games in the genre.

This book also intersperses these examples with practical exercises in 2D action-adventure world design using the free and easy-to-use GB Studio engine, allowing readers to practice their skills and see how lessons from the theory chapters apply in real game development environments. These practical chapters cover the basics of using GB Studio and related software, such as Aseprite and Tiled, to help readers create their own action-adventure characters, monsters, quest systems, switches, keys, and other mechanics – all the way up to designing their own dungeon!

World Design for 2D Action-Adventures will be of great interest to all those looking to improve their level design skills within this genre.

Level Design Practices Series

Level Design Practices are short books that break down level design principles for individual game genres. Level design was once thought of as impossible to write about because the differences between genres made it difficult to have a unifying theory of design. Recent works have solved this by focusing on general principles that span genres, but the genre specificity once envisioned by commenters has been lost. This series addresses this need by focusing on best practices for each genre, helping designers in those genres create better games through specific case studies.

Series Editor

Christopher W. Totten is an award-winning game designer and an Associate Professor and Program Coordinator of the Animation Game Design program at Kent State University.

World Design for 2D Action-Adventures
Christopher W. Totten and Adrian Sandoval

For more information about this series, please visit: http://www.routledge.com/European-Animation/book-series/LDP

World Design for 2D
Action-Adventures

Christopher W. Totten
Adrian Sandoval

CRC Press
Taylor & Francis Group
Boca Raton London New York

CRC Press is an imprint of the
Taylor & Francis Group, an **informa** business

Designed cover image: Christopher W. Totten and Adrian Sandoval

First edition published 2025
by CRC Press
2385 NW Executive Center Drive, Suite 320, Boca Raton FL 33431

and by CRC Press
4 Park Square, Milton Park, Abingdon, Oxon, OX14 4RN

CRC Press is an imprint of Taylor & Francis Group, LLC

ISBN: 9781032579979 (hbk)
ISBN: 9781032579986 (pbk)
ISBN: 9781003441984 (ebk)

DOI: 10.1201/9781003441984

Typeset in Times
by KnowledgeWorks Global Ltd.

Chris: In memory of Mike
Adrian: To Daniel

Contents

Acknowledgments

From Chris:

I am sometimes asked whether books or games are harder to make, and I think that games are absolutely more difficult, but books can also be lonelier and more isolating work. For this reason, I have to first thank my friend, game design collaborator, and co-author Adrian Sandoval for embarking on this adventure together through one of our favorite game genres to play and build. I would also like to thank our friend and collaborator Ben Cole for his support, experience, and collaboration in the games we have made together, as well as our other *Little Nemo* collaborators, including Max Kunze, Wayne Strange, Heidi McDonald, and all our awesome student interns. I want to thank my wife Clara for her love, encouragement, and patient support through both my game and book-making endeavors, as well as my kids Adeline, Margaret, and William for being awesome cheerleaders and playtesters. I especially want to thank Adeline for building out the premise of the game that readers will build throughout the book, *Molly the Plant Princess*. Thanks also to my awesome parents Bill and Cindy Totten for their many years of love and support, as well as my cousins for all those years of playing Game Boy together!

We cite Jeremy Parish's foundational work dissecting action-adventures and Metroidvanias so much that it would be a crime to not also give him mention here – thank you so much for sharing your knowledge with gamers and game designers throughout the years! Same with Mark Brown – your work was instrumental in a book like this. Thanks also for the encouragement of the GB Studio community and our games' fans throughout the development of the games that led us to write this book. We obviously could not have done this without folks at CRC Press, especially our editor Will Bateman, and the other editors, marketers, reviewers, and staff who help us sound like we know what we re talking about! We want to thank our early reviewers Dr. Jeff Howard, Chris Barney, and Kurt Kulata for their expertise and feedback in helping us shape this book. I also want to thank our friends in the industry who have supported us. You are too many to adequately list all of you here, but thanks especially on this project to Geoff Long, Tracey Fullerton, Ian Schreiber, Tanya DePass, Travis Faas, Devin Monnens, Bernard Schmalzried, Scott Rogers, and Daniel Greenberg. Thank you lastly to Ian McKenzie, who tirelessly organizes the GDC Conference Associate program, where all of us formed such awesome connections that make projects like this possible.

From Adrian:

First, I have to thank former Bridgeton High School English teacher David Price who taught the necessity of creative outlets, without which I would not have ever had the gumption to put a single word to a page. Of course, this book would not exist without co-author Chris Totten's lifelong dedication and experience to the craft of level design. I will be forever grateful and flattered that he asked me to collaborate with him on this project. Like Chris, I also thank our wonderful collaborators on *Little Nemo*, including Ben, Max, Wayne, and Heidi for all the reasons cited above and more. I am so thankful to my partner Karen for her love and support through this project and the many others throughout the years that led up to it. Thank you to my dear friend and fellow designer Jason Corbett, whose additional perspective has been an invaluable resource. Thank you to my mother Christina Plummer and my aunt Cynthia Belshaw for their unconditional love and support, despite never really understanding this whole video game thing.

All of our early reviewers deserve immense praise for lending their time and incredible font of knowledge to the book, and I am grateful for their contributions. I must give special acknowledgment to my friend Kurt Kalata, without whom I would not be writing professionally at all. A big thank you to everyone from CRC Press, including our editor Will Bateman and all others who believed in this book

and helped make it a reality. The work of Jeremy Parish, Mark Brown, Tracy Fullerton, Tim Rogers, Chris Barney, Richard Lemarchand, and all others cited throughout not only helped to shape this book but myself and my work as well and for that I thank them. We stand on the shoulders of giants, as it were. Lastly, I must acknowledge all of the communities whose knowledge and passion for games inspired my words in this book in some small way including the Philly Game Mechanics, Talking Time, Island Officials, and the GDC CA program. I had fill every page with all of your names if I could.

About the Authors

Christopher Totten

Christopher Totten is an award-winning game designer and an Associate Professor and Program Coordinator of the Animation Game Design program at Kent State University. He is also the founder of the studios Pie For Breakfast, LLC and Team Nemo, Inc., which has created games for mobile, PC, tabletop, Game Boy, and the Nintendo Switch. He holds a Master's Degree in Architecture with a concentration in digital media from the Catholic University of America in Washington, DC and is a lifetime member of the International Game Developers Association (IGDA).

Chris's games and community work explore the intersections between games and the arts. He is a founder of the Smithsonian American Art Museum (SAAM) Arcade and has created games based on art, literature, and works of animation, including the award-winning games *La Mancha* and *Little Nemo and the Nightmare Fiends*. For this work, he won the Faculty of Excellence Award for Innovation at IndieCade Horizons 2022. He is the author of *An Architectural Approach to Level Design*, and *Game Character Creation in Blender and Unity*. He is also the editor of the collected volume, *Level Design: Processes and Experiences*.

Adrian Sandoval

Adrian Sandoval is a video game designer, writer, and professor of game production and history. His work spans nearly fifteen years, with titles published across platforms such as the Nintendo DS, PC, and mobile. Currently, he is the lead designer on the upcoming *Little Nemo and the Nightmare Fiends* game for PC and Nintendo Switch, and the current chair for the Philadelphia chapter of the International Game Developers Association (IGDA).

Introduction

0.1

For both game players and designers, few genres fire the imagination like the action-adventure. This may seem like a generic statement: lots of games involve doing things (action) and having adventures, but the genre known as "action-adventure" has, over time, come to embody design pillars that both excite on their own and inform other game styles. Games like those in *The Legend of Zelda* series and the more non-linear *Castlevania* games delight with large explorable environments and expansive sets of tools and abilities for players to find. Likewise, the work of independent creators continually refines the genre or adds experimental new ideas to it, such as Team Cherry's seminal game *Hollow Knight* (2017) or Greg Lobanov's *Chicory: A Colorful Tale* (2021) and its coloring book-based mechanics.

For designers, action-adventures can feel intimidating: they include two-dimensional (2D) and three-dimensional (3D) games, top-down and side-scrolling viewpoints, open worlds, procedurally generated levels, bespoke human-authored gameplay sequences, and lots of other things. There are also debates over whether these games should or should not have specific features, like "RPG elements" where players gain experience points to increase their characters' stats and capabilities. At the same time, the elements that are more consistently identifiable, such as exploration and non-linear progression – where players can tackle challenges in an order they wish – thematically rich quests, and narratively rich settings, are consistently valuable. In a world where game design trends and technologies are constantly in flux, this genre holds steadfast, like a magic sword in its forest resting place for a hero to wield it once again.

Action-adventures are also consistently appealing to audiences, allowing a rewarding balance of gameplay mechanics and narrative detail, and appearing on many top-selling lists. For 2D entries in the genre, they can be friendly to small teams or teams with few resources to develop. If scoped properly, action-adventure games hold the potential for a lot of content to be packed into a concise set of systems and environments. The very best level design in this genre can feel like whole miniature worlds with histories beyond the events of the games that take place in them: actual places rather than just spaces for games to happen. The flexible and evolving nature of the genre allows it to take on a variety of elements, evidenced by the multiple subgenres that exist under its umbrella, like survival horror, Soulslikes, and the venerable Metroidvania (if this is your first time hearing these terms, we will explain them all throughout the book). Mastering the design of this genre requires a lot of practice, knowledge, and skill: the worlds that make up games in the genre can include tangled webs of plotlines, characters, quests, and activities.

Organizing the progression of players through these games can be a challenge for even experienced designers, which is why we wanted to write this book. We are designers with collective decades of experience in game development, including on award-winning 2D top-down and side-scrolling action-adventure games. We have chosen to focus this book on 2D-style action-adventures both to keep the book concise (introducing a Z-axis that adds all sorts of other spatial considerations) and to emphasize core level design aspects that carry into both 2D and 3D action-adventure games. As designers (and game players), we have found that 3D action-adventures like *TUNIC* (2022), *Dark Souls* (2011), and *The Legend of Zelda: Tears of the Kingdom* (2023) share many elements in their designs and structures with 2D games in the genre. Likewise, as educators, we believe that practicing in 2D forms a strong basis for building 3D action-adventures[1] such that readers can take many of the design concepts in this book into their potential 3D work.

So, dear reader, let us embark on our own adventure to discover the design secrets of the action-adventure genre; specifically, how to create interactive environments (levels) for this challenging but gratifying game style. In this introductory chapter, we will begin by more clearly defining the genre and

DOI: 10.1201/9781003441984-1

its variations, then exploring its history to make sense of these variations. We will then identify some level design considerations specific to the genre, and how they will form the content of the book. Lastly, we will discuss the structure and approach of this book, including how this book will handle its blend of design theory and practical information.

DEFINING ACTION-ADVENTURES

Game genres are on the one hand useful tools for quickly describing games and a historically fraught topic. Critics argue that they inadequately describe what players do in specific games, limit the creativity of game makers (Clarke, Ha and and Clark 2015), or are so in-flux as to be nearly useless as a critical tool as game trends evolve (Juul 2014). This can be doubly true for genres like action or action-adventure, which seem to encompass so many different styles of gameplay and sub-genres. For this reason, we need to break down some common attributes to frame the rest of the book's explorations of level design for the genre.

Rollings and Adams describe the action-adventure genre as having both "physical" navigation and combat skills as those found in the action genre – which itself encompasses combat or traversal-based subgenres like the platformer – while also having detailed storylines, characters, inventory systems, dialogue, and other features of adventure games (Rollings and Adams 2006). Other elements that game development writers highlight include puzzles (Luban 2002), how the narrative aspects of the games are triggered by the player's movement through the environment, and mastery of in-game skills, rather than through narrative or dialog choices (Aya 2005). Typical examples include games in the *Legend of Zelda*, *God of War*, or *Tomb Raider* series.

Complicating these definitions, but perhaps creating the flexibility that allows designers to make lots of diverse works within the genre, are the many sub-genres under the "action-adventure" umbrella. The example series above each has varying degrees of action, narrative, and puzzle solving: *Zelda* games have action but are known more for their intricate puzzles, while *God of War* games place more emphasis on combat mechanics and encounters. Sub-genres can also be defined by subject matter: many "survival horror" games – horror-themed games where players must use limited resources to fight monsters – are also action-adventures based on their gameplay design, as in the *Resident Evil* series. The games may likewise be highly linear, where the gameplay progression and narrative follow a highly set path, as in the *God of War* games, or allow for more open-ended exploration, as in the *Grand Theft Auto* series or *Hollow Knight*.

A BRIEF HISTORY OF 2D ACTION-ADVENTURES

With all of this nuance, we begin to see how difficult it is to put so many games under an umbrella-like "action-adventure." While it is outside the scope of this book to offer a complete history of the genre, a quick history of action-adventures may help us make sense of the genre such that we can effectively level design within it. As a combination of the action and adventure genres, the history of action-adventures goes back to the foundations of commercial video games themselves.

Early Action Games

Many early video games would fall squarely into the action genre, where the focus is on "physical" challenges requiring the player's skill, timing, and hand-eye coordination for success (Rollings and Adams 2006). More accurately, most of these challenges involve objects (game sprites, balls, bullets, etc.)

colliding with one another and producing a discernible outcome such as one of the objects exploding, bouncing off the other, or rewarding points. Early electronic games like *Tennis for Two* (1958)*, Spacewar!* (1962), and many of the games for the Magnavox Odyssey game console (1972) included players moving around a screen (or in the case of *Tennis for Two*, oscilloscope) and engaging in some competitive action: shooting lasers at opposing spaceships, hitting a bouncing tennis ball, chasing other players, and so on. Such games formed the basis of early popular arcade games, which these ideas were iterated on in games like *Pong* (1972), *Combat* (1977), *Space Invaders* (1978), and others.

Early Adventure Games

In 1976, programmer Will Crowther created *Colossal Cave Adventure* for the PDP-10 mainframe computer. Crowther, who had previously enjoyed spelunking with his ex-wife and notable cave explorer Patricia Crowther (later Wilcox), wanted to create a game based on his experiences in Kentucky's Mammoth Cave as a means of connecting with his two daughters. He added elements of the popular tabletop role-playing game *Dungeons & Dragons* (1974), such as magic, dragons, and treasure that players could find. This game spawned a number of similar "text adventure" games such as *Zork* (1977) and later graphical adventures like *Mystery House* (1980). These games utilized text parsers, or computer programs that could respond to and interpret typed inputs, to deliver feedback to players on their chosen actions. Utilizing no collision-based gameplay, only narrative, and text, players could reach fail states by choosing the incorrect story path, but interactions were controlled entirely by the player's typed commands rather than exertions of skill.

The Action-Adventure Is Born

In 1978, Atari programmer Warren Robinett was creating an engine with which he could create a graphical adaptation of *Colossal Cave Adventure* for the Atari VCS (later called the 2600). During the development of his game, Robinett was tasked with creating a Superman game from Atari's owners at Warner Communications but passed on it, leaving the job to another programmer, John Dunn. Robinett gave Dunn some of his *Adventure* code to help in the development of the Superman game, which included the ability to move around multiple screens and carry items (Bunch, Superman: Atari Archive Episode 29 2019). Dunn's finished *Superman* (1979) Atari VCS game would see the caped superhero fly around the city of Metropolis after the villainous Lex Luthor and his henchmen blew up a bridge, trying to fix the damage and put the criminals in prison. Robinett's fantasy-themed game, *Adventure*, would eventually be released in 1980 and have players use various keys, weapons, and tools to progress through a 30-screen world and retrieve a magical chalice, all while dodging three dragons – Yorgle, Grundle, and Rhindle (Bunch, Adventure: Atari Archive Episode 33 2020). These two games, both spawning from Robinett's code kernel, balanced the action that had dominated games until that point with the story-driven mindset of *Dungeons & Dragons* and *Colossal Cave Adventure* such that the action-adventure was born.

These games were not only influential from a design standpoint but also from a technical one: both were among the first games to see worlds that stretch across multiple screens and have players interacting with limited inventory systems. They also established the "top-down" viewpoint as a major element of action-adventures: both games utilized a perspective that allowed players to move in eight directions on screen, but which showed characters from a front or side view to keep them recognizable. This formula would prove influential not only within Atari, as seen through later releases such as *Raiders of the Lost Ark* (1982) and the *Swordquest* series (1982–2022), but also among other studios throughout the worldwide industry. Even at this early stage, the elements of the action-adventure proved to be malleable enough to fit into different game modalities beyond computers and home consoles. Exidy's 1981 arcade game *Venture* would take the exploratory concepts of *Adventure* and adapt them into an arcade format, with players moving between a zoomed-out overworld view and into zoomed-in "trap rooms," where they could fight monsters for treasure (Parish, Metroidvania Works #04: Venture [Exidy, 1981] 2015).

Parallel Developments

Venture's shifting perspectives mirrored spatial archetypes that were hinted at in the likes of *Adventure*, and which was a core of the at-the-time ongoing evolution of the computer role-playing game (CRPG), *overworlds,* and *dungeons.* These archetypes are a hallmark in traditional heroic epics, where heroes descended into caves, dungeons, and even the underground lands of the dead on literarily thematic quests (Howard 2008). This device has origins in *The Epic of Gilgamesh* (where Gilgamesh sends his friend Enkidu to retrieve objects from the Underworld) and *The Odyssey* (where Odysseus likewise visits the Underworld) and appears in later works such as *Beowulf* (where Beowulf pursues various monsters to their lairs) and *The Inferno* (where Dante and Virgil explore the nine levels of Hell[2]), up through the works of Tolkien and into modern fantasy literature. These narratives, including those of Tolkien, had "plenty" of influence on Gary Gygax (TheOneRing.net 2013) in his designs for *Dungeons & Dragons (D&D)*. *D&D*, in turn, influenced the creators of early CRPG games, many of whom wrote their games as a way to have the computer do all of the math one does during roleplaying campaigns.

Befitting the action-adventure genre's origins as a melting pot of other game types, the ongoing development of CRPGs (a full history of which is outside the scope of this book; Barton 2008), and other nascent game styles of this era further impacted the action-adventure. Also emerging at this time was the *platformer* game, a genre generally viewed in a *side-scrolling* manner, where the gameplay is viewed from the side of the characters as though looking into a dollhouse. In platformer games, players navigate a character between various floating ledges (platforms) via climbing or jumping. Early examples of this genre include *Space Panic* (1980), in which players climbed ladders to avoid aliens, and *Donkey Kong* (1981), where players guided a certain moustachioed character – first called Jumpman and later, Mario – up girders via jumping and climbing.

Elements of both platformers and CRPGs wound be quickly integrated into the action-adventure genre. David Crane's *Pitfall* (1982) featured a side-scrolling quest for treasure across 256 screens arranged in a line but included caves that would both tease players with treasure – the side view gave a "cut-through" perspective where the caves were visible – and provide shortcuts (Parish, Metroidvania Works #05: Pitfall [Activision, 1982] 2016). In the "bedroom coder" and homebrew-fueled British microcomputer market, designers such as Matthew Smith would imbue their platformers with themes of treasure hunting and open-ended exploration. Smith's game *Jet Set Willy* sets platforming action in a continuous mansion featuring 60 rooms that players can freely explore (Donovan 2010). Mikro-Gen's 1984 game *Pyjamarama* and its sequels *Everyone's a Wally* (1985) and *Three Weeks in Paradise* (1986) would expand this formula with more detailed environments, collectable keys and items, and multiple playable characters (Aya 2005). These gameplay ideas were soon blended with adventure settings inspired by the popular *Indiana Jones* films, leading to a greater focus on contiguous environments such as temples and caves. *Montezuma's Revenge* (1984) sees players searching for treasure by descending in a large pyramid, requiring backtracking and the collection of color-coded keys to progress, imbuing the platformer genre with the inventory management of the RPG. Crane's *Pitfall II: The Lost Caverns* (1984) similarly tasks players with searching an intricate maze-like 256-room cavern that entices exploration via hidden treasures.

The Genre Crystalizes

Distinct elements would emerge from these early efforts: flexibility between using the top-down or side-scrolling perspectives, the inclusion of "action" via combat or jumping, non-linear design where players could explore within their limitations, large worlds that have persistent elements such as unlockable doors or collectable treasures, distinct items – like color-coded keys – required to progress, using the perspective to show the player treasures that they did not know how to reach yet, etc. The *Indiana Jones*-inspired settings of caves, temples, pyramids, etc. were further buttressed by the dungeon-delving fantasy settings of CRPGs like *Wizardry* (1981) or *Ultima* (1981). In Japan, *Wizardry* and *Ultima* were quite popular and

inspired a number of games that included action but featured many more RPG elements than the typical action-adventure. These *action RPGs* included games like Nihon Falcom's *Dragon Slayer* (1984), which saw players powering a character with items with the ultimate goal of defeating a dragon, and T&E Soft's *Hydlide* (1984), which emphasized top-down combat among its questing systems (Parish, Pitfall II retrospective: Get Lost | Metroidvania Works #007 2019). Also looming over this genre is Namco's "role playing game for the arcades" *The Tower of Druaga* (1984), in which an armor-clad knight explores the maze-like floors of a tower. *Druaga*'s popularity and influence grew from the arcane manner in which players had to find hidden upgrades in the game – finding specific and inconspicuous spots in maps that would reveal items. The game forced players to compare their notes from playing the game with one another, building a strong communal element as play communities worked together to solve *Druaga*'s riddles (Parish, Game Boy Works #115: The Tower of Druaga retrospective 2019).

Many of these systems and influences could be found in the first true masterpiece of the genre, Nintendo's *The Legend of Zelda* (1986). Structurally, *Zelda* features an expansive top-down overworld full of interesting characters, items, secrets, upgrades to the hero – Link, and hints to the location of eight hidden dungeons. Link must descend into these dungeons (technically completable in any order) to retrieve the eight pieces of the Triforce of Wisdom, which was broken by Princess Zelda to hide it from the evil Ganon. After retrieving the Triforce pieces, Link must enter a ninth dungeon to defeat Ganon and rescue Zelda herself. The game included a more varied and dynamic overworld/underworld layout than games that came before, as well as more diverse possibilities for combat and item-based progression. Link can attack with not only a sword but also bows, bombs, boomerangs, and magic. He also does not only progress with keys but must use ladders, rafts, and other items, giving the world a puzzle-like quality. Upgrades and items could be found in arcanely hidden caves, which required players to search every nook and cranny with their various tools. This game also features a variety of distinct boss monsters in each of the dungeons which must be defeated in unique ways, which would be a hallmark of action-adventures moving forward, and in-game maps to help players navigate dungeons. Later games in the series would push many of the original's elements further, adding more non-player characters and narrative. Likewise, the focus of the series would shift from purely open exploration and combat to more intricate puzzle-solving in sequels like *A Link to the Past* (1991) and *Link's Awakening* (1993). Later *Zelda*-inspired games (*Zelda*-likes) would fall somewhere on a spectrum of being exploration and combat-based as in *Hyper Light Drifter* (2016), or more puzzle-based, as in *Ittle Dew 2* (2016). Games like Hideo Kojima's *Metal Gear* (1987) would also iterate on *Zelda*'s gameplay by refining the item-based progression and putting a greater focus on narrative.

The Nintendo Entertainment System (abbreviated as the "NES" and called the Famicom in Japan) would become a haven for the action-adventure genre and the place where many of its early seminal works would be found. In addition to *Zelda*, Nintendo would release *Metroid* in 1986, which feels like a synthesis of *Mario*'s platform jumping with *Zelda*'s exploration and progression. The game's heroine, Samus Aran, must upgrade her combat and traversal capabilities both to withstand the alien creatures in a deep underground maze, and to progress to new areas in the maze. Samus's upgrades notably become part of Samus's movement and physical appearance rather than items added to an inventory. These upgrades include items like missiles, bombs to open new passages, boots that let Samus jump higher, and notably a "morph ball," which lets Samus roll into a tiny ball. Beyond these required items, players could also search for optional energy tanks and missile upgrades that increase Samus' strength and resilience. *Metroid*'s cavern went beyond the singularly themed world designs of previous games and instead featured varied *biomes,* or areas with differently themed environmental artwork, to aid player navigation. This included caverns, ruins, lava, and laboratory-themed areas. *Metroid* would also popularize the idea of *speedrunning* action-adventure games, or trying to play them as fast as possible, thanks to alternate endings that would occur if players beat the game more efficiently. This practice would grow in other games in the genre and indeed become pervasive in game playing more widely.

Other notable games for the evolution of the action-adventure were Konami's *Castlevania II: Simon's Quest* and *Zelda II: The Adventure of Link,* both released in 1987. *Castlevania II is* a sequel to the original NES *Castlevania* (1986) and follow-up to *Vampire Killer* (1986) for the MSX computer. Where the original *Castlevania* was a straightforward action-platformer, *Simon's Quest* creates a wholly open non-linear

action experience set in an explorable world that even features a day/night cycle (Parish, Castlevania II / Golvellius retrospective: 'Vania mania | Metroidvania Works #013 2020). Players must navigate a side-scrolling overworld to retrieve artifacts from five mansions, which will break a curse placed on Simon by Count Dracula after the events of the original *Castlevania* game. Reaching these mansions requires item collection and solving (some famously obtuse) puzzles in the game's expansive world map, as well as upgrading Simon's abilities with items bought in towns, as in an RPG. In the similar but more influential *Zelda II*, Link must venture through the land of Hyrule as in its predecessor but now in a blend of top-down overworld exploration and side-scrolling combat and dungeon exploring modalities (Parish, Zelda II / Rygar / The Goonies II retrospective: NES is more | Metroidvania Works #11 2020). As in *Castlevania II,* the game shifts between an open overworld and self-contained side-scrolling dungeons, which in *Zelda II* must be explored via locks, keys, and item acquisition. Link can also be upgraded via items found in towns and dungeons, with many of these items also required for progression. While controversial among fans of both series, these entries would prove influential on the action-adventure formula: they provide a mid-point between the overworld/underworld style of exploration found in *Zelda*-style top-down games and the side-scrolling openness of what would later be identified as Metroidvania-style gameplay.

Rise of the Metroidvania

As this is a book about the design of 2D action-adventures, it is outside of the scope of this text to delve into later advancements in 3D action-adventure games. It is, however, important to address the previously mentioned and vitally important Metroidvania subgenre. These games are typically 2D side-scrolling platform jumping games where a player character is charged with navigating a large maze-like environment. Movement through the environment is facilitated by the player's access to items and abilities that give their player character permanent upgrades or new abilities which make more of the maze explorable. These games also sometimes include role-playing-game elements such as expandable stats, armor, and power levels that allow characters to defeat more difficult enemies. At this point in our historical overview, these elements are yet to converge, but we are seeing the foundations appear. The 2D action-adventure genre oscillates frequently between top-down and side-scrolling perspectives (truly, it also touches the semi-3D "isometric" perspective too, but building such games adds additional technical hurdles). While we have covered both the evolution of top-down and side-scrolling games in the genre, we will soon see the designs of *Metroid, Castlevania II,* and *Zelda II* converge into this important subgenre that blends elements of all of these efforts.

The story of Metroidvanias is not only the story of action-adventure or action-RPG games but also of *exploratory platformers,* games within the platforming genre where players explore large, continuous levels rather than those limited to a few screens. Metroidvania games also employ tools or character abilities as a means to constrain exploration, as we've already seen in other action-adventure games. Enix's 1985 Sharp X1 game, *Brain Breaker,* is considered by many to be the first *Metroidvania* game, starring an explorer on an alien planet who must collect lasers and jetpacks to escape. Konami, developers of *Simon's Quest* and the company who would eventually develop one of the Metroidvania subgenre's seminal works, also experimented with this genre early on with *The Goonies II* (1987) (Parish, Zelda II / Rygar / The Goonies II retrospective: NES is more | Metroidvania Works #11 2020) which sees protagonist Mikey exploring the cavernous hideout of the Fratelli family to rescue his friends. What makes this game good enough for inclusion in a history of the subgenre is its iterations of *Metroid*'s exploration via platforming stages in multiple biomes (ice, underwater, caves, etc.), item-based progression, and its addition of an in-game map to aid navigation.[3]

Several games by Nihon Falcom in the late 1980s further developed the side-scrolling action-adventure game format and included RPG mechanics such as inventories, stat-building, and experience levels in different ways. Games journalist and historian Jeremy Parish specifically cites several games as the center of this activity, including the side-scrollers *Legacy of the Wizard* (1987), and *Faxanadu* (1987) (Parish, Romancia / Ys / Legacy of the Wizard / Faxanadu retrospective: Falcom Works | Metroidvania Works #12 2020). In *Legacy of the Wizard*, players control a family of adventurers as they explore a labyrinth trying

to find the magic sword that will defeat a dragon. Each family member has unique abilities and can wield specific weapons: progression is therefore based on which family member you have at a given time and which items you have equipped. The different regions of the labyrinth are designed to highlight the skills of each of the characters, giving the labyrinth a varied feeling. Additionally, each characters' unique items are gained during another character's section, so it is normal for players to gain an item then *backtrack* – or revisiting previously explored areas – to where they can swap to a different character that can use it. *Faxanadu* is noticeably more linear than previous games but still gates its progression behind the need for items and tools that grant new abilities. It was also a leap forward in usability and refinement of the genre: where other games of this era drop you into their maps with little prompting of where to go, *Faxanadu* uses *short-term goals* to direct the player.

Other games would further refine the blend of side-scrolling, item or ability-based progression, narrative, maze-like level design, and uniquely themed regions that mark the Metroidvania genre. *Wonder Boy III: The Dragon's Trap* (1989) marks an influential evolution of the *Zelda II*-style and *Metroid* styles. Players are Wonder Boy, who has been cursed by a dragon into a lizard form, losing much of his strength. Wonder Boy must travel outward from a central town into differently themed areas of Monster Land to acquire new forms that will enable him to reach the Salamander Cross, which will lift his curse. This game's world is structured in a way commonly referred to today as *hub-and-spoke,* where progression to different regions is facilitated through the player's progression in a central "hub" area. Each new form (lizard man, fish man, hawk man, etc.) gives Wonder Boy the ability to reach new areas of the central town, which lets him venture out into new areas of the outside world ("the spokes"). These aspects would be carried further in *Wonder Boy's* sequel series, *Monster World.*[4] Another refinement comes from Konami in their 1993 Game Boy game *Teenage Mutant Ninja Turtles III: Radical Rescue*, which is a *Metroid*-style action game in which the titular Ninja Turtles must navigate a maze-like cavern to defeat the evil Shredder (Sorlie 2011). *Radical Rescue* has players begin the game with only one of the four turtles, Michaelangelo, and gives them the task of rescuing the other three. Each turtle has a unique ability that helps the player progress farther into the mine and toward the Shredder himself, and using some of their abilities in combination can open new areas. *Radical Rescue* is an important step in the evolution of the Metroidvania due to its refined game loop (use ability to explore available environment, locate and defeat boss, rescue turtle with key, repeat) (Lockwood 2023) and the reappearance of an in-game map a la *Goonies II*, further codifying this feature.

The games that cemented the form of the Metroidvania are, not surprisingly, entries in the *Metroid* and *Castlevania* series of games: *Super Metroid* (1994) and *Castlevania: Symphony of the Night* (1997). *Super Metroid* greatly built on the legacy of the original *Metroid*, along with the games that came between it and this later series entry. It features a larger and more varied map, expanded abilities, but also quality of life features such as level design that gives players hints at which powers may help them move forward.[5] One noteworthy example is early in the game, when players reach the high-jump boots: players enter the room with this item from a high point and fall into the area where they get the boots themselves. Without the boots, they cannot jump back out, but collecting the boots gives them an easy means of escape. This kind of *skill gate* design was something present in older games but was used to great effect here such that it would become a standard in the genre and indeed in much of level design moving forward. *Super Metroid* also makes great use of *environmental storytelling,* where environment art is arranged such a way that it hints at events which happened in the space before the player arrived. Indeed, much of the game's narrative plays out through in-game actions without dialog: early on, the stakes of the game are spelled out by an enemy appearing on screen to steal a dangerous alien specimen, initiating a boss fight.

Symphony of the Night features many of the same structural elements as *Super Metroid* such as a continuous and persistent map, ability-based progression, distinct regions, and rich storytelling, but incorporates stats, an inventory, shopping, and other RPG elements. In fact, this is where controversies about the definition of the term "Metroidvania" arise: it has come to colloquially refer to any game with non-linear 2D platforming and item/ability-based progression. Indeed, some authors[6] include 3D games with similar structures like *Metroid Prime* (2001) and *Batman Arkham Asylum* (2009) in this genre as well. Others insist that the term should only refer to games in the *Castlevania* series with *Metroid*-like elements

or games with both *Metroid*-style level and progression structures as well as RPG mechanics (Retronauts 2017). As the term has both come to popularly encompass all of these design styles and since this book focuses mainly on level design and world structures, we will be using "Metroidvania" in the more general and expansive way throughout our discussions.

Symphony of the Night's assistant director, Koji Igarashi, describes how the team looked to *The Legend of Zelda* series for inspiration for its open castle design (ironically, not *Metroid*) (Matulef 2014). Like *Zelda*, *Symphony of the Night* (*SotN*) features non-player characters that players may interact with and which initiate narrative sequences. Likewise, there are distinct areas around the fully explorable Dracula's Castle for shopping and other activities associated with RPG and adventure-style gameplay. *SotN* also features a number of hidden secrets, big and small, which add flavor to the game's world. Around the castle are chairs in which the player character, Alucard, can sit and rest (if he sits long enough, he falls asleep) and confession booths where a priest may help or hurt Alucard. Most notably, the game features a hidden mirror image of Dracula's Castle (the famous "Upside Down Castle"), which is the entire game map flipped on its head so that the dungeons under the castle are at the top of the map. This second castle includes extra challenging bosses, as well as items that allow players to reach the final "good" ending of the game where they fight Dracula. Player-friendly design patterns that would be found in Igarashi's other *Castlevania* games, like placing save rooms adjacent to boss encounters, were likewise codified in this game.

Modern 2D Action-Adventures

Both 2D action-adventures and Metroidvania games would continue to be a part of the commercial game landscape into the early 2000s before they fell out of fashion with large game studios in favor of 3D games. The genre would be carried forward by independent game makers – game makers who work in small community settings and without help from large publishers – in games like *Cave Story* (2004), *Anodyne* (2013), or *Guacamelee!* (2013). These games feature varying amounts of non-linearity, RPG elements, and other aspects of the genre's foundational games such that they contribute to the notion of action-adventures as a malleable genre. In the case of the Metroidvania subgenre, this flexibility manifests in industry writers referring to variations more geared toward the "*Metroid*-like" side (fewer RPG systems and more of a focus on skill-based progression), and "*-Vania*" games with more of the RPG systems intact. Still others, like the *Shantae* series, would adopt a more *Monster World*-style hub and spoke model. These indie creators would also smooth out some of the genre's more annoying aspects, such as the need for excessive backtracking, through various mechanisms and clever level design layouts which will be explored throughout the book.

A newer subgenre that has appeared in recent years, and indeed been mashed up with the Metroidvania and other action-adventure styles, is the "Soulslike." These games feature mechanics derived from the games *Dark Souls, Bloodborne* (2015), and other games by FromSoftware and directed by Hidetaka Miyazaki. These games include high levels of difficulty where player death is incorporated as part of the gameplay, usually by allowing players to retrieve resources from their dead selves if they can reach their last point of death. Death in these games is used as a device for iteration, pushing players to constantly improve their skills, rather than punishment: there are no permanent game-overs or loss of progress as in old arcades or early console games. Indeed, these games also feature frequent checkpoints that players return to upon death, which can be "fast-traveled," or teleported between. These games are themselves action-adventures, and Metroidvanias with these elements include *Blasphemous* (2019) and the seminal *Hollow Knight*. These games are known for their dark fantasy or gothic settings and imagery, as well as deep worldbuilding. Though, increasingly more games use Soulslikes' gameplay and narrative techniques without the "grimdark" aesthetics.

This brings us to the modern state of 2D action-adventures. Through this exploration, we have distilled core gameplay and narrative aspects of 2D action-adventure games and several of their most important subgenres. In the following section, we will give a brief overview of how these elements impact the level design of top-down and side-scrolling action-adventures such that we can dive further into their design.

GAMEPLAY AND LEVEL DESIGN CONSIDERATIONS

In our previous section, we saw how the evolution of the genre was inclusive of both top-down and side-scrolling game styles. In this section, we will identify common level design considerations found in the above historical examples. These considerations will drive the content in the rest of the book, as they are elements, we must master to make effective 2D action-adventure worlds. These are complex topics that will be explored in greater detail throughout the book's design concept chapters and put into practice in the tutorial chapters. As such, this section will provide brief overviews of these design themes and set the stage for how we will approach them moving forward.

Top-down Design and Side-Scrolling Design

First of all are top-down style 2D action-adventures. We described how games in the *Zelda* series and other series inspired by it are viewed as though the player is looking down on the action from above (often with some visual stylization so characters and objects read clearly – Figure 0.1). These games are great for creating sprawling, exploratory adventures, but in 2D, special consideration must be taken to create worlds that feel like they have any sort of vertical depth – different floors to environments, etc. – or they risk feeling geometrically flat.

The genre also includes "side-scrolling" games with examples including games in the *Metroid, Castlevania,* and *Shantae* series. Due to this, side-scrollers often require special consideration to not make the screen busy with repetitive texture work as players see the "inside" of level geometry (Figure 0.2). In 2D, these games excel at vertically based gameplay mechanics such as jumping to different platforms,

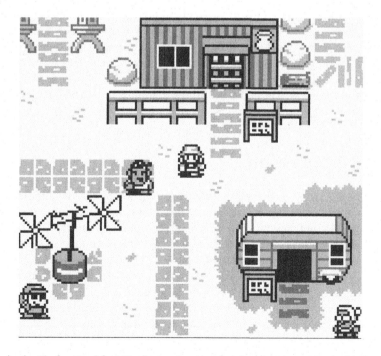

FIGURE 0.1 *Kudzu* by Pie for Breakfast Studios uses a visual style often associated with "top-down" adventure games. Characters and objects in this style are usually drawn as though viewed from the front to make them more easily identifiable, rather than actually top-down, where the player would only see the circular top of their head and shoulders.

FIGURE 0.2 Screenshot from *Little Nemo and the Nightmare Fiends*, an action-adventure game viewed from a side-scrolling perspective.

flying enemies and objects, and other vertically based challenges. On the flip side, games of this genre require more work to create the sort of freely explorable worlds that top-down games excel at. Rather than just being able to walk from room to room, for example, characters in side-scrolling exploratory games must jump, climb, or fall into rooms above and below the one they are currently in, requiring some extra programming effort. Characters may jump up into a new room then fall back down, so a solution with "passthrough" ledges may be needed; or they may need a climb ability to be scripted so they can use ladders. These are all things that must be planned as designers chose their gameplay style.

Ability-based Progression

A mechanic which began in top-down action-adventures, but which became a hallmark of some side-scrolling action-adventures, is *ability-based progression*. In this model, a player may explore the game world in any way they wish, but their movement through the game environment is at least partially facilitated through the tools or abilities available to their character at a given time as in Metroidvania games. In these games the player avatar can only partially explore the game map until an item is collected that grants an ability (such as a higher jump), allowing access to more of the map and additional ability expansions (Figure 0.3).

Ability-based progression requires significant planning and organization on the part of the designer. When making these games, you must carefully plan and keep track of the items within the game, as well as how they facilitate exploration through the game world. Likewise, games with this feature require a lot of clarity in level design so that players can identify what new places they can explore once they receive the items. Overall, these types of games can be among the most challenging to plan for level designers, so many of the lessons in this book involve methods for organizing your design process.

FIGURE 0.3 A diagram of a map from a typical game in the "Metroidvania" subgenre. The game features a large map that can be explored freely within the limitations of their avatar's abilities. Finding new abilities such that they can explore the full map and reach the end point is often the goal of the game.

Non-linear Design

Another level design consideration comes in creating non-linear opportunities for play, where players are able to wander as they please through your world rather than being on one rigid path. While this may seem to be an inherent part of exploratory games with ability-based progression, designers can easily fall into the trap of creating linear progressions if they are not careful. This is not to say that linearity is necessarily a bad thing – lots of excellent games are linear. Action-adventure games, however, are known for creating lots of opportunities to explore the game world. With this in mind, much of the book will center on creating opportunities for players to meander back and forth between landmarks in your world via primary (story-required) and secondary (optional) quests, puzzle design, and the design of specific challenges. These elements, which will be covered throughout the book, help you add richness, a sense of place, and a sense of narrative purpose to your game world.

Encounter Design

While the previous considerations were very "macro" in scale, that is, "big picture" elements that designers consider when creating whole worlds, things like puzzle design or specific challenges are much more "micro" in nature: the size of a screen's view or a room. In this regard, it is important for designers to practice shifting their perspectives as they design from their larger world structures, and down into specific encounters. In the industry, this is called "encounter design" and can be things from planning varied ways that a room full of enemies can be dealt with, to designing puzzles. This is an important aspect of action-adventure games, as it is where the "action" comes into play; usually through gameplay mechanics described at the beginning of this chapter that use *collisions* between various game objects.

We highlight this aspect of using the physics/collision system for several reasons. On one hand, a designer can make a perfectly reasonable adventure-style game without having skill-based challenges or combat. Games from text adventures (*Zork!*), to point-and-click adventures (*The Secret of Monkey Island*), to modern indie games like *Deadeus* (which uses the engine that will be used for exercises in this book, GB Studio) have gameplay primarily focused on moving through environments and talking to characters in branching stories. Adding elements of what is normally described as *action* mechanics – avoiding collision with hazards, jumping, climbing, fighting, making puzzle elements collide, etc. – adds additional dimensions to your gameplay. It can also add more potential upgrade paths for ability-based

progression (jump higher, break down walls, dig, etc.) in addition to story and quest mechanics. As such, designing how encounters with these mechanics in your game spaces is highly important to give action a space in which to occur. This will be another theme of future chapters: using these challenges to add depth to the adventure without feeling unfair or poorly planned.

Persistent Environments

Along with individual elements such as puzzle or encounter design comes *persistence*: the ability for the changes you make to your game world to be meaningful. One example may be a standard lock and key structure – you use one of your limited key items to unlock a door (thereby spending the key) and the door opens. Theoretically, the door should remain open for the rest of the game unless you clearly communicate to the player that the door shuts behind them again. By default, though, the door would likely not remain open for reasons of programming: if rooms are reloaded every time you enter them, then the door may reload in the "locked" state you set it to load in by default. This is bad for multiple gameplay reasons: players would have to spend keys every time they wander through the room, the game becomes harder in an uninteresting way, and the player feels that their actions do not matter.

To avoid this, designers of action-adventure games build persistence into their game levels: in addition to having doors open, puzzles being solved, enemies being killed, etc., the game records these actions. This way, when players leave the room and come back, pause, or do any action that may require reloading the game environment, progress is recorded. Throughout the book, we will discuss where to plan in persistence and where making scenes reset may be helpful for creating a great experience for players.

Enticing Exploration

Making exploration interesting and meaningful is great, but first the player has to want to explore at all. There are concepts in level design that we will explore in future chapters to do just this, such as using the placement of items and obscuring pathways to create a sense of *denial*. Making players aware of upcoming goals or passageways, but denying them immediate access is a powerful way to encourage further exploration of the world. One example is making an object visible, but only showing a small part of the path to it (Figure 0.4).

This is just one way to make players curious when playing through your game. This sort of enticement is a great tool for action-adventure design, as these games typically have rich economies of items, upgrades, collectables, and other rewards.

Controlled Backtracking

Inevitably, and perhaps most infamously, action-adventure games, particularly games in the metroidvania sub-genre, require players to backtrack as part of their exploration. This means that the player must travel through previously visited areas to reach items that they passed by, or to reach new passageways (often after they have obtained some new ability). On the one hand, carefully designed backtracking is a great way for designers to coax extra play time from a game: even somewhat small maps can provide hours of gameplay via rewarding traversal. On the other hand, too much or poorly implemented backtracking can cause gameplay to feel repetitive and players to get bored.

Working with many of the level design concepts already listed in this section will create some amount of backtracking in your world designs and, in fact, many of the games listed in the history portion of this chapter had significant backtracking. However, the long history of action-adventures has seen the

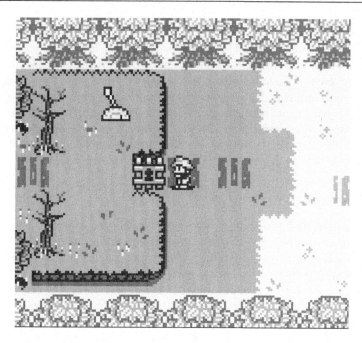

FIGURE 0.4 Another screenshot from *Kudzu*, showing a typical example of a room in which a switch for a door is shown onscreen, but denied to the player by level geometry. To find it, the player must explore more of the level to reveal the path to the switch, which opens the pictured door and streamlines travel through the game world.

development of solutions to the problem of excessive backtracking. As we plan our worlds throughout the book, we will keep them in mind so that players can more fully enjoy traveling through the game worlds we create.

Again, these level design considerations are just brief descriptions of much bigger concepts that we will need to chip away at throughout the rest of the book and indeed. They are, in a way, like a list of learning goals: concepts that are among the most important to master when creating your own 2D action-adventure games. In the next section, we will see how the book's structure will facilitate these further experiences with these concepts.

BOOK OVERVIEW

Now that we have explored the history of the genre and distilled core level design concepts from some of its formative games, we can talk about the approach that this book uses to help you on your own action-packed level design adventures.

Who Is This Book for?

First of all, many readers want to know what level of expertise they should reach before approaching a book like this. Presumably, by picking up or previewing this book, you are interested in 2D action-adventure games and how they are designed. Likewise, you are probably a person who plays and/or a person who makes or wants to make games. With these more general assumptions aside, here are some groups we think can benefit from this book and how.

Students and game design learners

First of all are new game design learners. This may include students, hobbyists, or even just curious folks that want to try their hand at making a game. For this reason, we have included not only chapters on level design theory for this genre of game but also practical chapters that guide you through tutorials on an easy-to-learn game engine well-suited to action-adventure games, GB Studio (more on the specifics of this shortly). We have also elected to use non-jargony, explanatory language in the book: rather than assuming a reader understands when we say something like "metroidvania," we try to provide easy-to-follow definitions and accessible game examples. In this way, we hope that this can provide first-time designers with a pathway toward creating exciting games while maintaining an achievable scope.

Veteran level designers

On the complete opposite end of the spectrum, we want this to be a book suited for working level designers in the industry. Level design is, at the time of this writing, still a young field in terms of building a common language that designers can use to talk about or even evaluate their work. There are some works that do this for level design more broadly, but our goal with this book, and for the series that it is part of, is to dive into a specific genre; in this book's case 2D action-adventures; and start to build a language for talking about it. Beyond a sort of "indie designer" approach of hammering out levels by oneself, this book includes tips for not only building but planning exploratory worlds for games such that they can be manageable for teams of designers and artists working together. Likewise, folks in the industry may be used to working in one genre but not have as much experience in others. The exercises in this book teach software that has been adopted by industry vets for creating hobby homebrew or game jam projects in genres they may not be as experienced with.

Game design teachers and scholars

Last is game design teachers and scholars. As educators and academics ourselves, we are always on the hunt for informative new resources for engines or game design theory. Likewise, when we cannot find ones we like, we sometimes make them ourselves! Our hope in this regard is twofold: on the one hand, as stated above, we're hoping to assist in providing a common language for 2D action-adventure games and their various subgenres. In this way, scholars can talk about them in understandable ways throughout their own analytical work and teach their students using a commonly understood language. Likewise, we want to provide a resource for some newer tools, specifically the GB Studio engine, for which there are not currently comprehensive textbook-style resources. While we love using YouTube tutorials and written materials, we have found that they rarely walk a learner through the process of building a whole game or are difficult to discover among the many resources (of varying quality) out there. In this way, we hope to provide an education-ready resource that can still be of use, via the level design concept chapters, long after the tools for building these sorts of games have evolved.

General Approach and Book Structure

If you have read through the previous section and decided that you should continue reading, we are ready to embark on this epic-level design adventure! In this final section, we want to lay out how this book is structured and how to approach it.

First of all, this book has two styles of chapters: *Design* (numbered with a ".1" in the chapter number, sometimes referred to as "D" chapters) chapters that explore the level design concepts detailed previously in greater detail. We are specifically avoiding the term "theory" here, as that tends to have bad connotations within the game industry as being non-useful, but one could call these chapters

"applied theory" if they so wished. The other style of chapters is shown in the *Practical* (numbered with a ".2" in the chapter number, sometimes referred to as "P" chapters) chapters, which are practical tutorials for level building that put the concepts from the D chapters into use. In this way, we want to show how design concepts are expressed through real gameplay examples that you build yourself. We will also be pulling heavily from our own experience as game players and game designers, including citing examples of designs we have done for the indie games *Kudzu* and *Little Nemo and the Nightmare Fiends*. While we will also include lots of examples from other games (many of which were mentioned earlier in this chapter), we will be able to closely discuss why design decisions were made in games that we worked on.

For these exercises, we will use GB Studio, a free and open-source game engine that requires no coding and is well-suited to the action-adventure genre. The "GB" stands for "Game Boy," Nintendo's 1989 black-and-white (or black-and-green depending on which model you have) handheld gaming console, which the engine can be used to develop new games for. GB Studio is the work of developer Chris Maltby and a team of volunteers who have built the engine as an interface for another open-source toolset, GBDK, or the Game Boy Development Kit. Every GB Studio game can be released either as a game that can be played within a browser or as a ROM file that can be played on Game Boy, or Game Boy Color emulators.

While individual readers' interest in developing Game Boy or Game Boy Color may vary, the engine's focus on development for these consoles provides a useful set of constraints for designers that can result in small-scale but impactful design projects. Building in this engine means building artwork around 16 × 16-pixel sprites, four colors, and simple animations. Likewise, gameplay mechanics must be relatively simple, so learning to design lots of variations of your level and puzzle concepts is a must. This will help designers practice the skills of turning their ideas into full games. In this way, learners can develop what feels like finished games much more quickly, producing 2D adventures just like the classics.

CONCLUSION

This chapter was about setting the table. We briefly explored the origins and evolutions of 2D action-adventures, then distilled common design features from our list of important examples from the genre. We then discussed how the rest of the book will proceed and what individual readers may gain from it. In the next chapter, our first practical chapter, we will set up the GB Studio workflow by downloading the necessary software tools and prepare to set foot into the wider world of action-adventure design.

NOTES

1. Many 3D action-adventure games utilize 2D game making in their prototyping processes. One famous example is how the developers of *The Legend of Zelda: Breath of the Wild*, a 3D open-world style action-adventure, created a top-down 2D game in the style of the original *Legend of Zelda* as a means of prototyping *Breath of the Wild*'s core gameplay.
2. Game Designer Scott Rogers contends that this association with the *Inferno* and the nine levels of Hell, along with the similar concept of descending into "levels" of a dungeon in many RPG games, are where the term "level" comes from when referring to game environments.

3. *Goonies II* would also include "adventure scenes," which were first-person-styled and menu-based graphical adventure sequences not unlike early adventure games. Parish notes that this makes the game a link between contemporary action-adventures of the late 80's and their "primordial" origins in the likes of *Colossal Cave Adventure* and *Zork*.
4. It is further outside the scope of this book to untangle the complicated lineage of the *Wonder Boy* and *Monster World* games and these authors, in fact, don't wish to touch that.
5. Though this book's focus is on how the creative aspects of these games' designs evolved over time as developers continued to learn from previous works, the authors acknowledge the role that increased hardware power and storage space also contributed to these evolutions.
6. Co-author of this book Chris Totten included.

REFERENCES

Aya (2005). *A brief – But comprehensive – History of the action/adventure genre.* 8 February. Accessed May 22, 2023. https://web.archive.org/web/20090129103800/http://justadventure.com/articles/ActionAdventures/AA.shtm

Barton, M. (2008). *Dungeons and desktops.* AK Peters.

Bunch, K. (2019). *Superman: Atari Archive Episode 29.* 15 December. Accessed May 22, 2023. https://www.youtube.com/watch?v=XyM8Qf4Bls4

Bunch, K. (2020). *Adventure: Atari Archive Episode 33.* 29 March. Accessed May 22, 2023. https://www.youtube.com/watch?v=IKq2_060Hk4&list=PLPb8P1_Kn–aDXU7QKIpZh_aCQ0NiBksm&index=2

Clarke, R. I., Jee, J. H., & Clark, N. (2015). Why video game genres fail: A classificatory analysis. *School of Information Studies – Faculty Scholarship, 167,* 445–465.

Donovan, T. (2010). *Replay: The history of video games.* Yellow Ant.

Howard, J. (2008). *Quests: Design, theory, and history in games and narratives.* AK Peters/CRC Press.

Juul, J. (2014). *Genre in video games (and why we don't talk [more] about it).* 22 December. Accessed May 22, 2023. https://www.jesperjuul.net/ludologist/2014/12/22/genre-in-video-games-and-why-we-dont-talk-about-it/

Lockwood, T. (2023). *GB Studio Central: TMNT III radical rescue and map design.* 11 April. Accessed May 23, 2023. https://gbstudiocentral.com/spotlight/tmnt-3/

Luban, P. (2002). *Designing and integrating puzzles in action-adventure games.* 6 December. Accessed May 22, 2023. https://www.gamedeveloper.com/design/designing-and-integrating-puzzles-in-action-adventure-games#close-modal

Matulef, J. (2014). *Eurogamer: Koji Igarashi says Castlevania: SotN was inspired by Zelda, not Metroid.* 21 March. Accessed May 23, 2023. https://www.eurogamer.net/koji-igarashi-says-castlevania-sotn-was-inspired-by-zelda-not-metroid

Parish, J. (2015). *Metroidvania Works #04: Venture [Exidy, 1981].* 29 December. Accessed May 22, 2023. https://www.youtube.com/watch?v=48R-usJ_XKU&list=PLd3vJYdenHKGrWrvCGsIbOOl_h_6tzERM&index=5

Parish, J. (2016). *Metroidvania Works #05: Pitfall [Activision, 1982].* 19 April. Accessed May 23, 2023. https://www.youtube.com/watch?v=YgzDMPNKUvE&list=PLd3vJYdenHKGrWrvCGsIbOOl_h_6tzERM&index=6

Parish, J. (2019a). *Pitfall II retrospective: Get Lost | Metroidvania Works #007.* 6 November. Accessed May 23, 2023. https://www.youtube.com/watch?v=jZ2rP6r-KOU&list=PLd3vJYdenHKGrWrvCGsIbOOl_h_6tzERM&index=8

Parish, J. (2019b). *Game Boy Works #115: The Tower of Druaga retrospective.* 18 December. Accessed July 14, 2023. https://youtu.be/3pyfx2jcotg

Parish, J. (2020a). *Castlevania II/Golvellius retrospective: 'Vania mania | Metroidvania Works #013.* 28 October. Accessed May 23, 2023. https://www.youtube.com/watch?v=HTD0cDHd5Wk&list=PLd3vJYdenHKGrWrvCGsIbOOl_h_6tzERM&index=14

Parish, J. (2020b). *Romancia/Ys/Legacy of the Wizard/Faxanadu retrospective: Falcom Works | Metroidvania Works #12.* 5 August. Accessed May 23, 2023. https://www.youtube.com/watch?v=Ktp1FNt6DGo&list=PLd3vJYdenHKGrWrvCGsIbOOl_h_6tzERM&index=14

Parish, J. (2020c). *Zelda II/Rygar/The Goonies II retrospective: NES is more | Metroidvania Works #11.* 29 July. Accessed May 23, 2023. https://www.youtube.com/watch?v=_wcefuuDoBU&list=PLd3vJYdenHKGrWrvCGsIbOOl_h_6tzERM&index=13

Retronauts. (2017). *Episode 104: Chronicling metroidvania.* 19 June. Accessed October 3, 2024. https://retronauts. com/article/405/retronauts-episode-104-chronicling-metroidvania.

Rollings, A., & Adams, E. (2006). *Fundamentals of game design.* Prentice Hall.

Sorlie, A. (2011). *HG101: Teenage mutant ninja turtles III: Radical rescue.* 14 February. Accessed May 23, 2023. http://www.hardcoregaming101.net/teenage-mutant-ninja-turtles-iii-radical-rescue/

TheOneRing.net. (2013). *Interview with Gary Gygax, Creator of Dungeons & Dragons.* 6 December. Accessed May 23, 2023. http://archives.theonering.net/features/interviews/gary_gygax.html

Downloading and Installing GB Studio and Related Software

0.2

As covered in the book's first introduction, we will not only be describing conceptual elements of action-adventure design but we will also utilize game-making software to put these conceptual elements into action. While there are lots of great tools that game developers can work with to build these sorts of games, we have chosen to utilize GB Studio for this book's exercises, as opposed to bigger tools like Unity or Unreal. While bigger tools allow you to do some really awesome and graphically impressive things (we are using them in our own commercial development projects), we want the exercises in this book to be as approachable as possible for new and experienced developers alike.

Whenever we begin a game project, we like to take some time to look at our creative goals for the project before diving into any engine and let these goals help us choose the right software to make the game a reality. We will begin this chapter in the same way, by giving a brief overview of GB Studio, including how it will help us explore the concepts throughout the book.

OVERVIEW OF GB STUDIO

GB Studio was created by programmer Chris Maltby (https://www.chrismaltby.com/) a London-based game and application developer. He participated in a game jam – an event where creators make a game in a short period of time, usually only a few days – which had the theme of "Game Boy." He wanted to make the game compatible with the actual Game Boy (Figure 0.5), and so developed custom tools for building his entry, *Untitled GB Game* (which can be downloaded at: chrismaltby.itch.io/untitled-gb-game). After building the game itself, he continued working on the tools so they could be used by others with the ambition of making them simple enough to use for people who had never made a game (Maltby, 2022). Thus, GB Studio was born. It has since, in these writers' opinions, become one of the most important game-making tools in the indie scene, not only expanding Game Boy homebrew development but also introducing entirely new communities of people – including visual artists, journalists, marginalized people, and plenty of wide-eyed dreamers – to game making. It even has a dedicated news and information site, GB Studio Central (gbstudiocentral.com), which provides resources for GB Studio game makers, as well as game analyses and developer interviews.

From a technical standpoint, GB Studio is a front-end for a virtual machine called GBVM Game Engine. GB Studio provides a way for game creators to build games through the use of visual scripting – or high-end game programming through manipulating program elements graphically rather than typing them in text. It is released free and open-source on Windows, Mac, and Linux systems through the MIT license, which allows developers to use the engine for commercial use, modify it, and distribute it as long as the original copyright notice is provided. In addition to the visual scripting interface, newer versions of the engine also include ways for advanced users to modify the underlying GBVM's C and Z80 assembly code from within GB Studio itself, adding even more powerful features.

DOI: 10.1201/9781003441984-2

FIGURE 0.5 A screenshot from Chris Maltby's *Untitled GB Game*, the development tools for which became GB Studio.

Because it is based on a Game Boy-compatible engine, GB Studio can output. gb ROM files, and in later versions,. gbc files are compatable with Game Boy Color. These ROMs are playable through Game Boy emulators or on original Game Boy hardware (up to the Game Boy Advance series) if loaded onto a cartridge (Figure 0.6). GB Studio can also generate ROMs that include features compatible with Nintendo's Super Game Boy peripheral for the Super Nintendo, such as custom frames. For users lacking an original Game Boy or those who do not wish to use emulators, GB Studio games can also embedded in web-pages and played in browser with either keyboard controls or touch-screen Game Boy buttons in mobile browsers.

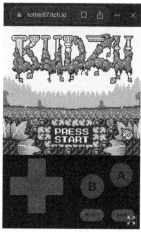

FIGURE 0.6 Kudzu, a game created in GB Studio, being played from a cartridge on a Super Famicom (the Japanese iteration of the Super Nintendo), via a Super Game Boy 2 and in a mobile browser.

WHY GB STUDIO?

One reason that GB Studio was chosen for this book is that it for the many features of newer versions, its earliest versions focused on adventure games such that later versions had this style of gameplay in their digital DNA. The 1.0 series releases of GB Studio did not contain many tools for creating action games, but users could easily create top-down games in which a character walked around the world, talked to others, collected items, and went on quests. Two early GB Studio games, *Deadeus* (2019) by -IZMA- and *Dragonborne* (2021) by Spacebot Interactive, were built on these features and given full commercial releases by their creators. The later 2.0 series introduced a number of new features, notably collision-based gameplay elements like weapons and projectiles, as well as multiple modes for side-scrolling platformers, shoot-em-ups, and point-and-click adventure games, making it a robust tool for creating action-adventures. The 3.x series and 4.x series added even more features, such as an expanded sprite-editing system that enabled large sprites for bigger characters and bosses, as well as an internal music editor. As adventure-style gameplay was among the earliest features rolled out for GB Studio, they are among the most flexible in the engine. As such, GB Studio allows designers to easily create cutscenes and narrative-driven elements which can be difficult to produce in other engines.

GB Studio is an open-source project, which means that it is always in development by a team of awesome and dedicated folks, but it also means that new versions and features are always coming quickly. This book and its screenshots were created while the engine was still in the 3.x series versions, 4.x came out during editing, and new versions are ever on the way. We have tested and confirmed that screenshots are as accurate as possible and tested the tutorial files to make sure that the files and procedures written in this book are consistent with the newest versions at the time of this publication (especially with the new file system after version 4.1!) That said, future readers: please pardon any inconsistencies you may find.

The other reason GB Studio was chosen was convenience and ease of use in a book like this one. Like many other engines, GB Studio is offered for free on its website, but unlike other engines, does not have licensing terms for using the engine to make your games. Likewise, the visual scripting interface and focus on not only retro pixel art games, but those for Game Boy – a famously limited console – keep both project scope and the "lift" of building things in its light. Had we written this book for more modern-style engines like Unreal, Unity, or even the open-source Godot engine, it would have needed to be a lot longer and the training portions much more of an effort for learners. Instead, our focus can be squarely on the conceptual elements of level design for 2D action-adventures, which readers can utilize in games that they make for any engine. As developers and teachers, our mantra is for learners to be able to think about the design concepts more and the software less.

Of course, if you find yourself unenthused by GB Studio, we absolutely invite you to create the tutorial projects in whichever software you wish. Though obviously, you will not be able to follow the GB Studio-specific technical details and prompts, you can build the game elements in your tool of choice and arrange them as we discuss. Our goal is ultimately to help readers understand how these action-adventure design concepts are put into practice in real-world game development situations.

DOWNLOADING AND INSTALLING GB STUDIO

With that out of the way, let us get set up with all the proper software. This will, of course, include GB Studio itself, but also include software that will build out our game development *pipeline*: the collection of tools that enables us to create different digital assets and implement them in our game.

1. Navigate to the GB Studio website, www.gbstudio.dev
2. At the top of the page, you will find a large button that says "Download on Itch.io," click that with your left mouse button (LMB).
3. Under the GB Studio banner image and a tagline that says "A downloadable tool for Windows, macOS, and Linux, is another button that says 'Download', LMB click that" (Figure 0.7).
4. This will lead you to a download screen with multiple red buttons that say "Download." Choose the one that represents your operating system, Windows, Mac, or Linux, and LMB click that. This will initiate your download of the latest version of GB Studio. You may also see a pop-up on the page thanking you for downloading – you can choose to ignore that.
5. The installers will be packaged as .zip files, which will require you to extract them. On Windows computers, you can right mouse button (RMB) click the file to bring up a menu with the option

A downloadable tool for Windows, macOS, and Linux

Download Now Name your own price

[Update] GB Studio 3.2.0 now available!

I can't believe how long it's been since the last update! GB Studio 3.2.0 is finally here, including some of the features that have been teased for a long now including slopes in platform scenes, tile priority for GBC (allowing background tiles to show in front of actors!) and support for UGE v6 in the music editor!! Plenty of bug fixes too.

Full changelog is available at https://github.com/chrismaltby/gb-studio/blob/develop/CHANGELOG.md

If you spot any problems, please make sure to report an issue at https://github.com/chrismaltby/gb-studio/issues

[Update] GB Studio 3.0 now available!

Wow, has it been that long? Over a year since the last GB Studio 2 beta, we've skipped right over to GB Studio 3.0 to mark the big changes that our new game engine will allow both now and in the future.

FIGURE 0.7 The GB Studio itch.Io page, with download button visible near the top of the page.

FIGURE 0.8 The startup window for GB Studio version 3.2, the most current version of GB Studio at the time of this writing.

for "Extract" – LMB click on this option and follow the onscreen prompts to extract the file. On a Mac, double-click the .zip file and you will bring up the Archive Utility tool that will likewise assist in unzipping the file. Linux builds will download as install files native to your specific distribution of Linux, so open them as you would other programs.

6. LMB click on the installer and a magenta square will appear on the screen with a progress bar. You will then see a startup window for GB Studio – if you have previous GB Studio projects, it will default to the "Recent" tab, while new users will see the "New" tab (Figure 0.8).

Congratulations! You have GB Studio! Before we move on to the next chapter; however, we need to get a few more pieces of software to complete our GB Studio action-adventure game pipeline, including a level editor, a pixel art program, and a GB-compatible color palette.

DOWNLOADING AND INSTALLING TILED

The Game Boy hardware processes images according to 8 pixel by 8 pixel *tiles*. When using GB Studio, this is important for a number of reasons: if an image has more than 192 unique 8×8 tiles, it will not be able to process the image due to memory limits. On the other hand, creators who use GB Studio's Game Boy Color mode can colorize their images by applying different palettes to 8×8 areas of screen space. As such, backgrounds in your GB Studio action-adventures should be drawn with these tile specifications in mind. While it is possible to utilize freehand pieces of art, building environments out of carefully drawn 8×8 and 16×16 square tiles are generally recommended for best results.

It is possible to draw your own backgrounds in a pixel art program, but there are also tools that will help you build tiled environments quickly and easily. Tiled is another free and open-source tool, this time for creating game levels from grid-based art assets called *tilesets*. Tiled works in concert with your pixel

FIGURE 0.9 The Tiled interface, showing a GB Studio-compatible background in production.

art program: you create a set of tiles in your pixel art program of choice, then import them into Tiled, where you can build backgrounds. In this way, you can draw a concise visual language of tiles for your game once, then use them to build many level backgrounds (Figure 0.9).

Downloading and installing Tiled is very similar to the process we used for getting GB Studio. As such, some of these steps can be written more concisely than in the tutorial for getting GB Studio:

1. Navigate to the Tiled website: www.mapeditor.org
2. Under the page's banner, you will see a green button that says "Download on itch.io." LMB click on it.
3. At the top of the page, click the light blue button that says "Download Now" and follow the same procedure as you did with GB Studio to download Tiled. Unlike GB Studio, Tiled is set up as "pay what you want," so you may see a pay screen that will give you the option of donating money to the development of the tool. You can also choose the "no thanks, just take me to the downloads" link.
4. Click the download button associated with your computer and follow the same steps you did before to install Tiled.

Now that you have the game engine and the software that you will use to make level backgrounds, all you need is the pixel art program, and we will be ready to make our 2D action-adventure games!

GETTING A PIXEL ART PROGRAM AND THE GB STUDIO COLOR PALETTE

The last part of our pipeline that we need is a pixel art program. As this book is not a pixel art tutorial book, we will be less specific on the software you use and indeed, less detailed on the actual operation of these programs' interfaces when compared to GB Studio and Tiled.

GB Studio processes pixel art imported into it via a specific color palette, specifics of which can be found in the GB Studio documentation at www.gbstudio.dev/docs/assets/sprites and www.gbstudio.dev/docs/assets/backgrounds/. These pages provide the hexadecimal codes for each color that you can put into the color picker in your program of choice. These pages also have specific palette swatch files for Adobe Photoshop and for Aseprite that you can download and install in those programs if you are using them.

There are many options out there for readers, and we welcome you to use one that you are comfortable with. For those not knowing where to start, we do offer these recommendations.

Aseprite

For those wanting a more robust pixel art making experience, we cannot recommend Aseprite enough. This is the software we use ourselves and will be the software that we will be taking screenshots of for the sections of this book where you are making sprites and tilesets.

Aseprite has a number of tools that make it feel almost like an alternate universe version of Adobe Photoshop that was created specifically for pixel art. It includes features like layers, *onion skinning* – an option where frames before and after the frame you are working on are shown in a transparent view for reference, "pixel perfect" strokes that avoid messy lines, and much more. What makes Aseprite and pixel art programs like it different from a tool like Photoshop is *palette management*, where colors for artwork are stored in a palette rather than in each individual pixel. What this means is that if you decide to make a character with a red shirt have a blue shirt instead, you can change this by changing the color on the palette – applying the color change to all frames with a few clicks – rather than repainting each frame. Aseprite is also one of the programs for which GB Studio provides a palette swatch, so color management for GB Studio is quick and easy in it (Figure 0.10).

Aseprite can be purchased and downloaded at www.aseprite.org. It is also available on Steam at store.steampowered.com/app/431730/Aseprite/. The downside for some readers may be the price tag – Aseprite costs $20 at the time of this writing – which may be an unwanted expense if you are not looking to continue making pixel art beyond the exercises in this book. It does periodically go on sale through Steam and other marketplaces, so it is worth keeping an eye on if you are interested in pixel art.

FIGURE 0.10 The Aseprite interface, showing a GB Studio-compatible character in production.

FIGURE 0.11 The Piskel interface, showing a GB Studio-compatible sprite in production.

Piskel

Another powerful alternative is Piskel, which is a free online pixel art editor that can be found at www.piskelapp.com. While not as fully featured as a tool like Photoshop or Aseprite, it includes all the tools we need to create the kinds of artwork that you will use in a GB Studio project. These features include layers, custom color palettes, palette management options, and many similar drawing and editing tools to those found in other programs. GB Studio does not provide a palette swatch for Piskel, so readers using it will have to enter the hex codes into the color picker (Figure 0.11).

While it is an online editor, Piskel still allows you to save your artwork locally as both native project files and as exported sprites that can be used in your games. Overall, this tool offers another powerful option for artists making the sort of 2D games we will make in this book.

CONCLUSION

While individual readers' interest in making Game Boy and Game Boy Color games may vary, GB Studio nonetheless represents a powerful tool for practicing 2D action-adventure level design. By finding a tool that offers little resistance to implementing elements like character sprites, puzzle mechanisms, cutscenes, and other common features of these games, we can focus more on experimenting with design than with fighting our software. In this chapter, we set up our project pipeline, the collection of software that allows us to fully develop our ideas and implement them, including a game engine, a level editor, and an art program that we will use to make the tiles that our levels will be built from.

The next pair of chapters focus on the high-level design of our game world, including conceptual world design structures for building exploratory gameplay and tools with which we can visualize these structures.

REFERENCE

Maltby, C. (2022). *GB Studio – About*. Accessed July 20, 2023. https://www.gbstudio.dev/about

Structures for Exploratory Gameplay **1.1**

INTRODUCTION

Now that we have laid some historical, conceptual, and technical groundwork for our own explorations of 2D action-adventure level design, we will sally forth in this chapter with an exploration of high-level world design structures found in these games. As we previously discussed, these games present a challenge to designers from a purely organizational standpoint: they can be complex to both plan and implement. This is due to several factors particular to the genre, three of which we will tackle specifically in this chapter: whether such games should or should not be linear, the open design of many action-adventure game worlds, and how progression is managed. Understanding the impact these factors have on your design will help us understand these types of worlds more easily and have a more organized outlook when we plan our own.

To Be [Linear] or Not To Be

The first is most action-adventures' question of linearity – whether progression through them occurs in a straightforward fashion where players are led through a series of ordered tasks (linear design), or whether players are free to choose tasks in any order they wish. Examples from the 2D action-platformer genre are games like *Super Mario Bros.*, which leads players through a pre-determined set of levels in a specific order, or *Mega Man*, which allows players to choose which levels they want to visit in any order. Despite its openness, *Mega Man* provides some guidance to players: a core mechanic of the games in this series is that players obtain a level boss's weapon after defeating them, and each level boss is themselves weak to one of the other boss's weapons. This added complexity creates interesting choices for players: do they approach the levels in random order to show their skills, or do they follow one of several dominant pathways through the levels based on weapon acquisition order?

Action-adventures are yet more complex than action-platformers but offer similar options to both players and designers for linear gameplay. In a game like the original *Legend of Zelda*, players can visit the game's nine dungeons in any order they wish, but there are dungeons whose selections of enemies are best tackled when the player has powered up Link. Other games, like *Link's Awakening*, alternatively have players progress in a very specific order, but offer time between major story events for the player to explore more freely. The structures in this chapter will offer means of analyzing and planning the amount of linearity in this genre.

Open Design

Second is the open design of these game worlds. Most action-adventure games do not take place in segmented levels (level one, level two, etc.) but have players explore large contiguous worlds. Apart from linear progression or non-linear progression through the world and its story, the amount of

DOI: 10.1201/9781003441984-3

openness refers to how much of the world may be visited by the player at any given time. Just as these games can offer different levels of linearity, they can also each offer various degrees of openness. Indeed, the amount of openness that players perceive they have is a factor many use to judge games in the genre.

In the previous example of *Link's Awakening*, the main story of the game progresses more or less in a linear order, but the game offers numerous side-quests that players can take on at any time. These side-quests usually have players revisit previously explored areas with new abilities and break up the game's otherwise linear progression. More modern examples like *Hollow Knight* implement this openness as soon as they can, basing many in-game goals on choices between several equally accessible options. One major goal in the game is to locate the three Dreamers, characters who entered an eternal slumber to lock away the game's supposed final boss. Players are told where these Dreamers are at the same time and can choose to visit them in any order. By making one goal – reaching the game's end goal – dependent on three equally weighted and accessible goals – reaching the Dreamers, the game feels overall more open than others in the genre. The structures in this chapter will offer ways to understand the amount of openness offered by existing games and tune the openness and linearity of your own.

Progression

Finally, this chapter will cover different models of having players progress through action-adventure worlds. The concepts we will cover straddle the line between game design and level design, and can be one of the more difficult elements for designers to manage when planning their own worlds. Where the other two factors are challenges related to the "physical" structure of the game world, this one deals with how and when players encounter different parts of the game world. Progression can be structured in different ways: a purely linear game only allows you to reach levels in a certain order – once you pass level one, you can play level two, and so on. In many 2D action-adventures, methods for progression can vary – some control progression by requiring players to earn specific abilities before they can move forward. Others use systems of locks, keys, switches, or other puzzles. By far, this is the factor that will require the most planning on the part of the designer to address, which will be a major element of this and other chapters.

With these factors in mind, let us now explore different structures common in action-adventure games. While not exhaustive, these common models will offer launching points for you to develop an approach to your own action-adventure worlds.

HIGH-LEVEL STRUCTURES

To address the factors of non-linearity, openness, and progression in action-adventure worlds, we must first look at different common high-level world structures. These are, simply put, common spatial shapes and types that a player might see if they were to look at a map or diagram of your game world.

It is important to note that this list is not exhaustive, meaning that other structures may exist not covered here. These structures should be seen as broadly generalized starting points for design, rather than inflexible types: many game worlds (and indeed many of the examples offered here) may have aspects of two or more of these game world structures. When you design, you may likewise find yourself using features of several of these common structures, and that is perfectly reasonable. The goal in sharing them is to establish a common language with which you and your design team can plan your work or through which you can describe the design of these worlds in game analysis.

Hub and Spoke

The design of theme parks was revolutionized when art director for Disney parks Marvin Davis first unveiled his concept for Disneyland. The original concept proposed that park guests would enter through the south, moving through a brief introductory zone toward the castle in the center. In their blog Imagineerland, architect Tim Furest notes the functional advantages of this type of space (2016). This central area, or hub, then split off into distinctly themed regions, or "lands" with their own unique rides and attractions. The original design had each region bespoke from one another, usually designed in a circular or similar roundabout fashion for guests to circle the region before coming back to the central hub and choosing another path. Over time, this has been refined into the design that is still in use today has paths that also connect the different regions to each other, allowing guests to easily move between them without needing to return to the center (Figure 1.1).

Like theme parks, action-adventure games will utilize hubs as a way of providing easy access to different regions on the map. However, most pathways will be locked at the start of the game, with access to new regions opening as the player makes progress. Unlocking new spokes or pathways requires first choosing a path and following it until a key, item, or new ability is accessed which allows for a new path to be explored from the central hub. This structure has a lot of benefits for pacing and balance we will explore in a bit; however, we must look at their historical precedent first in order to see how it has been refined.

The first *Metroid* features several distinct map regions, all connected via the game's starting region of Brinstar. These other areas feature original enemies and hazards as well as a distinct color palette to give each of them their own unique feeling and aesthetic. However, there are no shortcuts from these regions to return to Brinstar easily nor are there any paths that connect parallel regions to each other. Instead, the player must tread back to Brinstar to find new pathways to other regions.

Another classic example, *Wonder Boy and the Dragon's Trap* from 1989 combined the concept of a hometown (see Chapter 4.1) with the hub. The central area of the game not only splintered off into different regions like *Metroid*'s Brinstar, but it was also devoid of any combat, providing a store for players to purchase upgrades and a "health center" to heal up before moving on with the adventure. *Wonder Boy* would also reward players with a door back to the starting town after defeating the boss at the end of a spoke, reducing unnecessary backtracking. All of these elements combine to create a natural core loop where players find a new area to explore from the central town, find a new ability, defeat a boss, and then return to the town to do it again.

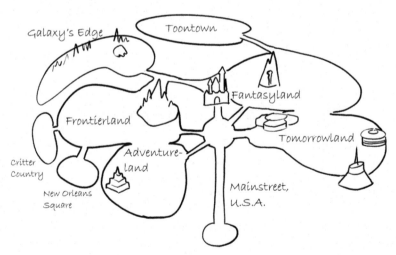

FIGURE 1.1 A simplified map of Disneyland emphasizing the hub-and-spoke design. Visitors enter via Mainstreet, USA then arrive at Sleeping Beauty's Castle and the statue of Walt Disney, then can branch out from this central hub point to the various themed "lands."

These earlier patterns continue to be refined in modern games. Much like *Wonder Boy*, 2019's *F.I.S.T.: Forged in Shadowtorch* main town also serves as a central hub for the map but is a more central part of the game's core narrative and progression loop. By the end of each region in *FIST*, players will have gained a new ability, fought a boss monster, and given a clue to their next objective that they must bring back to the town. Once there, the player can shop for items and character upgrades, talk with NPCs for expository dialogue, or to receive side-quests. Once the player feels ready to continue, the game, they can go to the next main quest marker in the town to unlock access to the next area.

The 2016 *Zelda*-like action-adventure game *Hyper Light Drifter* also contains a central town where the player can purchase character upgrades. However, unlike *FIST*, *Hyper Light Drifter* utilizes a fast travel system; As players explore the four major regions that branch out from the central town, they will discover checkpoints dotted throughout which can be warped to from nearly any location. This allows *Hyper Light Drifter*'s designers to focus on the design of the region itself without needing to consider the design of the overall world map. By way of contrast, *FIST* instead uses new character abilities and carefully planned macro-loops to make returning to the central hub easy with minimal backtracking regardless of the player's current location within a region (Figure 1.2).

A similar approach is used in 2010's *Cave Story* by developer Daisuke "pixel" Amaya. It, too, features a central hub within the town of Mimiga village and lacks fast travel in favor of shorter regions that loop back to their starting point upon completion. However, rather than having a contiguous map, the village instead contains a teleporter room which acts as a level select for new and previously accessed areas. This allows for each region to be a distinct biome without any narrative or logical framework such as natural geography, as well be a bespoke piece of design that doesn't need to consider the global map like *Hyper Light Drifter*.

All the examples we've explored thus far use their hub as a way of accessing bespoke, unconnected regions. By contrast, *Metroid Fusion* for the Game Boy Advance features a main space station that has six specific sectors. The beginning of the game has structural similarity to other hub-and-spoke games we've looked at before: explore a path, gain a new ability or key item, and then return to the hub. However, the latter half of the game allows the player to open routes between the sectors, breaking from this structure that more resembles the open nature of earlier *Metroid* games.

By examining these patterns, we see that the inclusion of a central hub has clear advantages for level and map designers. It naturally lends itself to a pattern of tension and release, with spokes providing platforming, combat or navigational challenges, and hubs providing moments of calm for NPC conversation, shopping, or inventory and ability management. It also allows designers to focus more on designing each

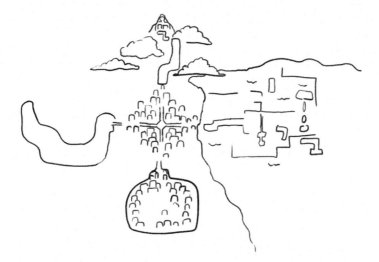

FIGURE 1.2 A simplified map of the world of *Hyper Light Drifter*, showing the central town area and how it branches off into the four different regions of the game.

region, catering their difficulty independently of the global world map. Additionally, fast travel mechanics or selection menus can keep the hub completely bespoke, provided designers remember to properly teach and reinforce the use of fast travel.

There are drawbacks to this structure as well. All the games we have examined have a well-defined structure; they exist in the center of the map, provide easy access to all other areas, and involve secondary mechanics such as story exposition and shopping rather than core action of platforming and combat. It is also generally required that you return to them prior to gaining access to a new area of the world rather than the player discovering them on their own. While this helps create a sense of pacing and helps provide direction, it can come at the cost of freedom and exploration that are core to the action-adventure experience. In an assessment of *Metroid Fusion*, Hardcore Gaming 101 editor Kurt Kalata noted that the more restrictive game loop compared to the series earlier entries was a bit of a disappointment where the appeal of the earlier games was the sense of exploration and discovery (Kalata, 2017).

It's worth noting that games with large, contiguous maps can utilize the properties of hub-and-spoke as part of their overall map design to help aid in navigation and backtracking. The first act of *Super Metroid* begins as a linear tour through most of the games major regions, beginning in Crateria, slowly unlocking new abilities to continue to the next accessible area. By the time the player returns to Crateria, having looped around from exploring Norfair, they will have access to enough abilities that all of the major regions are now quickly accessible via Crateria. This allows for the game to feel much more expansive in the second act while also transforming Crateria from simply the start of the adventure into the central hub from which most of the other spokes can be quickly accessed with minimal backtracking.

Many of *Castlevania: Symphony of the Night* regions are connected through the starting, central area, the Marble Hall, which begins on the westmost end of the castle and extends all the way horizontally to the eastmost end. This allows the Marble Hall to connect to many of the regions of the castle and contains many one-way and ability gates that will later act as shortcuts around the castle. This also allows the hall to act as a linear introduction to the game and its central game loop, a technique we explore in more detail in the next chapter.

One last example worth considering is *Hollow Knight*, which has a rather expansive map. All of *Hollow Knight*'s center-most regions connect with each other as well as two or more other regions along the outer edges of the map. For example, the starting area of the game the Forgotten Crossroads connects to Greenpath in the west, the Fungal Wastes in the south, and the City of Tears in the southeast. Each of these areas is also connected to each other, either directly or indirectly through one small region, and then branch off into surrounding, smaller regions. Essentially, these three areas can be seen as the three major hubs of *Hollow Knight*'s kingdom of Hallownest, ensuring the player never has to travel more than four regions to reach another. Additionally, while fast travel points don't allow access to every region, they are always situated near one of the three major hub regions allowing players to get where they need to be easily.

One core difference that contiguous world maps have from our earlier, more linear examples is that the hub areas are not clearly conveyed to the player. They contain the same game mechanics and challenges as any other part of the world rather than shops and NPCs. This allows the designers to keep their functional purpose effectively invisible to players and maintain a sense of organic exploration and discovery. Consequently, their hubs do not function as a natural resting point for players and only serve to ease the burden of backtracking.

The Highway

A typical and versatile exploratory game world feature is one we will call *the Highway*. This is simply a central passage through a large game map that players will travel through multiple times in order to reach different sections of the game. We are referring to it as a "highway" specifically because once revealed in a game world, it functions like a commuter route between different regions or areas of interest. This concept has roots in several early action-adventure and Metroidvania games, but it truly came into its own in *Castlevania: Symphony of the Night* (SoTN), in which there was a multi-room passage cutting through the center of Dracula's Castle, off of which the access points to several other areas of the castle branched (Figure 1.3).

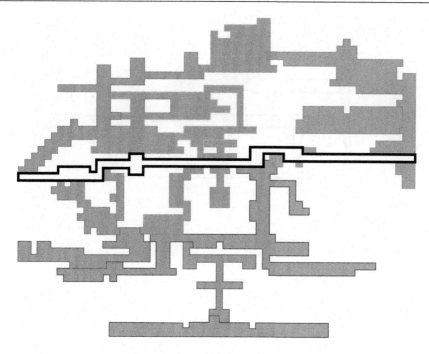

FIGURE 1.3 A diagram of the map of *Castlevania: Symphony of the Night*, emphasizing the central "highway" passage with a thicker black outline.

What made *SoTN*'s implementation unique is that this central passageway offered only light resistance to the player in terms of platforming challenges and enemies. It was designed to be traveled through quickly and without incident, since players would be revisiting it often. This became a common feature in many following "Igavania" (that is, *Castlevania* games directed by Koji Igarashi) games and games inspired by them. This design element was innovative in how it minimized the strain of backtracking in action-adventure-level design. Earlier games like those in the *Metroid* series made players navigate a series of twisty passages to traverse the game world, making the process of backtracking an unpleasant one for many players. Providing a central commuting route between major areas of the game world eased this somewhat.

Later indie Metroidvania games would iterate on the Highway structure by integrating quick travel passages more seamlessly into how challenges were built. In *Hollow Knight*, players visiting the Forgotten Crossroads area for the first time visit a vertical shaft that is largely hidden behind a locked gate, though the switch to open the gate is visible nearby. Players must traverse a series of windy and challenging side-passages that will allow them to reach the larger part of the shaft, as well as the switch to open the gates at the top (Figure 1.4). From then on, the player has few reasons to visit the twisty side passages and can instead utilize the more quickly traversed vertical passage to travel through the Crossroads. This structure is used throughout *Hollow Knight*, tying challenge to the creation of openness in the world's many sections.

In the indie Game Boy game *Kudzu*, the concept of a Highway becomes the spine of the entire game world. The game is a top-down action-adventure like *The Legend of Zelda: Link's Awakening*, but with a Metroidvania-style structure: themed zones and item-based progression in a contiguous space instead of an overworld with self-contained dungeons. As it is a Game Boy game, meaning that the world within it had to be somewhat small compared to the expansive worlds of games like *Hollow Knight*, backtracking between zones became an important part of extending potential playtime. A key challenge was balancing the need to add time for movement between zones in the game world without annoying players with poorly designed backtracking. In this case, "the highway" showed its value as a design pattern.

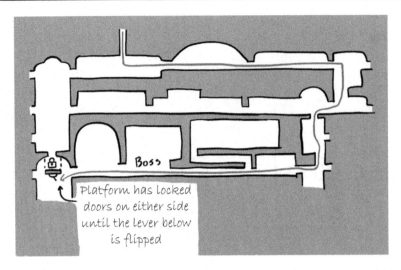

FIGURE 1.4 A diagram of a portion of the Forgotten Crossroads in *Hollow Knight*, where the player must first travel through challenging winding side-passages on their first visit, before being able to skip them via a central quickly-traversable passage in later visits.

The first zone of the game, the Kudzu Field, demonstrates how the highways were integrated into the design of the world overall (Figure 1.5). The area includes a central axis of about six rooms heading "north" from the zone's entrance to the boss room. On the player's first trip to the Kudzu Field area, there are three locked doors throughout this axis that must be unlocked by searching side passages for switches. These switches are, of course, guarded by enemies and puzzles, providing challenge for progressing through the area.

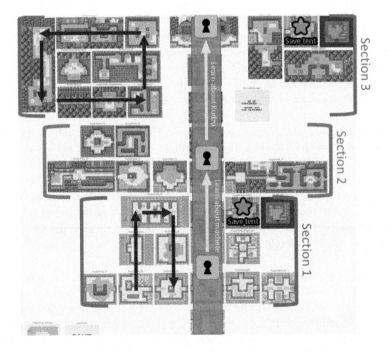

FIGURE 1.5 A diagram of the Kudzu Field area in the indie Game Boy title, *Kudzu*, by Pie for Breakfast, LLC. The central axis is closed off by several locked doors during the player's first visit to the area, but once unlocked, creates a route that players can quickly travel through while traversing the game world.

Since the world, like many in action-adventures, is persistent, the doors stay unlocked once the player solves their corresponding puzzles. The now-open spine of rooms can be easily passed through as players travel between the game's different zones, and the side passages can now be mostly disregarded, unless the player wants to search for any missed treasure. In this way, the highway becomes a reward for traversing the world: each zone of the game starts as closed off and focused on challenges in side-passages but is transformed as locks are opened into an easily traversed space where the most important space is the highway route. The highway allows worlds to adapt to emphasize different factors of action-adventure world design discussed at the beginning of this chapter: these spaces at first feel like linear "dungeon"-style levels, but adapt to become an important part of the world's overall openness as the highway is revealed. By building spatial transformations in this way, the world feels more usable and dynamic.

Overworld/Underworld

While many side-scrolling action-adventure games such as Metroidvanias take place on one contiguous map, top-down games will often have a distinct segregation between their main map and individual interiors such as dungeons or buildings that are explored separately. This segregation is often marked with a screen transition that cuts or fades to black to indicate that the player is moving into a different space.

This is one of the most ancient concepts in games, coming not from games themselves, but from literary and mythological sources. Game designer Scott Rogers traces the entire origins of "levels" to sources such as the levels of Hell in the *Inferno* (Rogers, 2016), while the concept of an underworld specifically may be as old as humanity itself, appearing in the belief systems of many ancient peoples (Wallace & Hirsh, 2011). Adventures into the underworld feature heavily in Greek myth, in stories such as Orpheus and Eurydice or *The Odyssey*. *Dungeons & Dragons* popularized the use of underworlds and dungeons as separate, interior spaces in games, and regularly used a hierarchical separation between "underworlds" and exterior spaces. Over the years, players have designated abstract exterior land maps that contain access points to interior gamespaces as the "overworld." The use of the term "overworld" to classify this type of gamespace can most likely be traced back to the instruction manual for the original *Legend of Zelda*. In the manual, the term is used to separate the main game world from dungeon levels, which were unsurprisingly called the "underworld."

This distinction is not dissimilar to the hub-and-spoke structure we explored earlier, with the overworld acting as an explorable hub that players need to traverse to find smaller maps and stages. Yet they are distinct enough from other game structures and contain enough variety of game design patterns that they warrant their own dissection.

Hierarchal overworlds

We mentioned that the distinction between the exterior world map and interior spaces such as dungeons has its roots in tabletop roleplaying games. It should be no surprise then that overworld maps and traversal are a large component of computer and console roleplaying games that are meant as a computer interpretation of tabletop games and mechanics. Early games such as *Ultima: The First Age of Darkness* and *Dragon Quest* utilize a type of overworld that would be used for many years in traditional RPGs before branching into other genres, a format which we will refer to as hierarchal overworlds.

Hierarchal overworlds treat the main map as the topmost level, a birds-eye view of the world with each graphical tile acting both as aesthetic decoration as well as functional iconography. For example, many top-down RPGs will use a special graphical tile featuring a row of houses that represent a town. Stepping on this icon then transitions the screen from the overworld map into a separate town map that is more zoomed in and to scale with the player's onscreen avatar. Similarly, the hierarchal overworld contains icons for other sub-map types such as dungeons or caves, and these sub-maps can contain further icons for stairs for going up or down different floors of the dungeon.

In games with hierarchal overworlds, available game mechanics for the player can depend on which type of gamespace the player is actively within. Overworld maps are primarily for traversal, moving on the map to find the next town or dungeon that moves the game forward. As such, interaction on world maps is generally limited to movement or accessing a submenu. Towns can also be traversed but also include social mechanics such as talking with NPCs or shopping for gear and equipment (for more information on the function of towns in nonlinear games, see Chapter 4.1). Finally, dungeon spaces such as caves or temples are similar to the overworld except they may also contain unique game elements such as puzzles, items, or special combat encounters, which are required for game progress.

While the breadth of this book doesn't include all nonlinear exploratory games such as RPGs, a small number of action-adventures games have utilized this format, though it's uncommon. *Zelda II: The Adventures of Link* from 1987 is a notable example, where its top-down overworld features icons for caves, towns, and dungeons that upon touch transition the screen into side-scrolling segments and features very limited interaction beyond movement on the map.

Contiguous overworlds

While the first *Legend of Zelda* may have made a clear distinction between its overworld and underworld, movement and combat mechanics did not change as the overworld featured many of the same enemies and hazards as dungeons. This is distinct from the hierarchal approach to the overworld from other RPGs. Another important distinction between *Zelda*'s map and other RPGs is that the visual perspective does not change between the overworld and underworld sections of the game. This conveys the impression that the world is smaller and more contiguous than the hierarchal world maps, though they too divide their interior and exterior spaces through screen transitions. As game mechanics and player inputs do not need to change between the overworld and other spaces, contiguous overworlds are much more common for action-adventure games.

This lack of difference in overworld map gameplay also affords them many different opportunities for player exploration and how much or how little linearity there is. The original *Legend of Zelda* has very few obstacles preventing the player from exploring the entire map at the outset of the game. This would be refined slightly in its Super Nintendo sequel *A Link to the Past* where certain dungeons and other interior spaces would require a linear progression of abilities and key items to access later interior levels; however, the overworld itself is largely explorable from the beginning with few exceptions.

This contrasts with *Link's Awakening*'s world map in several key ways. At the start of the game, the player must retrieve Link's sword. Before the sword is obtained, they are blocked by impassable bushes, holes, and rocks that prevent Link from being able to explore beyond the first ten screens or so of the overworld. Once the sword is obtained, the bushes could be cut down and slightly more of the map would become accessible, and so on and so forth as new equipment is gained. This approach makes *Link's Awakening*'s world map more akin to how Metroidvania games structure their map, with the amount of explorable space on the overworld expanding along with the player's abilities.

Overworlds in side-scrolling action-adventures

We already mentioned that nonlinear side-scrolling action games generally have one large, contiguous map. That is not to say these games don't contain interior spaces, rather than those interiors are merely a change in backdrop scenery on individual game screens. There are some side-scrolling games that make a clearer divide between their main map and other spaces and interiors, however. This generally requires the player to hit a button to enter a door in the background, transitioning the screen from the game's overworld map to an interior space.

This format is associated more with action RPGs from Japan such as *Dragon Slayer II: Xanadu*, though more action-oriented games have borrowed this approach as well. *Castlevania II: Simon's Quest* for NES is a side-scrolling game that contains structural similarities to the top-down *Zelda* games. Each screen continuously links to the next as you might expect; however, certain buildings will have open doors, signaling to the player that they can be entered. While this is mostly used for various NPC houses

and shops, there are also several dungeon spaces that can be located as well. And much like *Zelda*, the final battle can only be unlocked once each of these places has been completed and their individual key items have been obtained.

Also like in the first *Zelda*, most of the map is explorable from the outset with only the difficulty of each screen preventing the player from progressing. This is different from *Wonder Boy: The Dragon's Trap* which contains a similar overworld structure to *Simon's Quest*, in which there is an explicit difference between "overworld"-style areas and more dangerous dungeon-like areas. However, much more of the map is blocked off to the player until they obtain different abilities throughout the adventure, such as being able to climb onto walls. In this way, *Dragon's Trap* structures its overworld similar to Metroidvania or *Link's Awakening*.

Micro-overworlds

Some games also have more than one contiguous overworld. We say more than one as these overworlds tend to not be connected to each other. The player must instead confirm and select which map they want to explore via a level-select menu. This type of overworld tends to be smaller in size and features minimal exploration or backtracking, and requires the player to find a dungeon which, once completed, will reward the player with access to the next level.

Shantae and the Pirate's Curse is a nonlinear platformer that features eight micro-overworlds, designated as islands, each of which that must be unlocked one at a time. Each game loop starts with the player going to a new island, having their progress blocked, and needing to fulfill a quest, usually one that requires them to backtrack to a previously completed island, before unlocking a new dungeon. Once the dungeon has been completed, a new island will unlock.

Open/Non-hierarchical

There are some games that do not neatly fit into any of these models, often in the *Metroid*-like or *Metroidvania* genre or games that follow their often item or character ability-based progression structures. These worlds tend to have a selection of zones or region that may function as "dungeons" upon your first visit, usually through the need to solve puzzles or clear major enemies, but which can be easily passed through on subsequent visits. Many of these worlds begin as linear spaces where challenges are tackled in a particular order but open up such that players may return to explore areas for hidden secrets at their own pace. We are calling them *open/non-hierarchical* here because once players begin to see the overall shape of the whole game world, the region or zones of the world give little indication of any sort of hierarchical importance. Unlike overworld/underworld structures or hub/spoke structures, there is not a main path of travel and smaller zones that branch off from a bigger one, but rather a series of zones that may be traversed at will (Figure 1.6).

These elements give open/non-hierarchical worlds a lot of cross-over with the Highway structure described previously. In fact, the Highway is often a feature of these game worlds, rather than a separate structure of its own. For this text, we decided to keep this structure separate from the highway for one simple reason: not all games with worlds like these take the care to ease player exploration through a mechanism like The Highway. These commuter routes rather become an indicator of a well-designed open/non-hierarchical world by easing problematic backtracking than acting as a structure of their own. We will briefly look at two ways that these worlds are frequently implemented, as initially linear experiences and as initially more open experiences.

Linear

As hinted at above, a common way that open/non-hierarchical worlds like these are implemented is as initially linear experiences that later allow players to explore them freely. In the previous example of

FIGURE 1.6 A diagram of the map of *Metroid Dread*, showing a number of similarly-sized region without clear hierarchical relationships. This game is primarily a trip from the bottom of a cave (the lowest part of the lowest region, Artaria), to the planet's surface at the top of the map, but the player's actual path is not so linear and, in fact, requires players to criss-cross through many regions multiple times.

Metroid Dread, each region of the game functions as a dungeon would in a *Legend of Zelda*-style adventure, where players must solve puzzles using some region-specific gimmick. One example early in the game is in the Cataris region, where players must use machines to redirect the flow of lava through pipes, changing which rooms are accessible and which are unbearably hot. In older examples of games in the same genre, such as *Axiom Verge* or other games in the *Metroid* series itself, this progression is mediated less by puzzles, but by whether players have collected specific abilities or upgrades. By *gating* – restricting access to parts of the largely open game world – in these ways, the game initially functions in a linear fashion before "opening up" (we have even used the term "blooming" in internal game planning discussions) and letting the player wander freely.

This linear structure is maintained by the number of goals offered to players. In the case of these examples, the number of goals offered at one time is typically just one. In *Metroid* games following the 2002 release of *Metroid Fusion* and *Metroid Prime*, games in that series marked spots on the in-game map for players to seek out as their next "objective." While it is often possible for players to break from this prescriptive path, dubbed *sequence breaking* in fan speedrun communities, these paths largely control how worlds are revealed. Older games or games in other series alternatively communicate their singular goals by showing players an obstacle that must be overcome with weapons or abilities that the player does not have yet. This lets the player say to themselves "my next goal is to overcome this obstacle," which motivates them to explore the areas they can access more fully. Along the way, side-passages with smaller-scale rewards, such as health upgrades or other points of interest, can break up the feeling of absolute linearity.

Non-linear

It is this number of goals that also provides the opportunity for producing non-linear iterations of these open/non-hierarchical worlds. In *Hollow Knight*, the previous example of The Dreamers – characters that The Knight must seek out in order to reach the end of the game – is a multi-choice goal that breaks the game's linearity. In his *Boss Keys* videos, game developer and critic Mark Brown describes *explorable space* as a component of satisfying open world and action-adventure level design. Explorable space is, quite simply, how much level space the player can access and wander around in at a given time. By offering three goals that may be approached in any order rather than one goal at a time, the game greatly opens its explorable space.

This is something we have worked to achieve in both *Kudzu* (itself built in GB Studio) and in *Little Nemo and the Nightmare Fiends*. In *Kudzu*, creating opportunities for explorable space was important in maximizing the small cartridge space available on the Game Boy with opportunities to wander in levels and create non-intrusive backtracking moments. The game progresses mostly linearly through its early areas, but steps are taken within each of those areas to provide non-linear goals. Taking a cue from *Hollow Knight*'s split-up goals, *Kudzu* uses switches for doors instead of keys and ties several of the game's doors to multiple switches so that the player must seek out all the switches in an area. Levels are even laid out to communicate this sequence (Figure 1.7): the player arrives in one of these explorable areas via the room with the door to telegraph that their next goal is to open it. The player then sees a few pathways that they can take to begin their search. These moments of explorable space, though mostly self-contained, break up linearity and invite backtracking (and extending playtime) as players mill around the level.

In *Little Nemo,* we likewise wanted to allow players to approach challenges in the order they wish. We give players access to their major traversal abilities as they recruit the cast of playable characters that can be switched between at any time. Once the titular Nightmare Fiends reveal themselves in the game's second act, the players are tasked with hunting them down in the game's previously explored regions but are given the freedom to do so in any order. To unlock the doors to the Fiends' hideouts, players must gain enough "Figments" – dream energy gained by doing side-quests for non-player characters – to unlock the doorway. Instead of creating non-linearity by breaking goals into multiple smaller goals, we made the resource for unlocking challenges more generic such that they could be used anywhere – there are no keys or switches tied to specific doors or challenges.

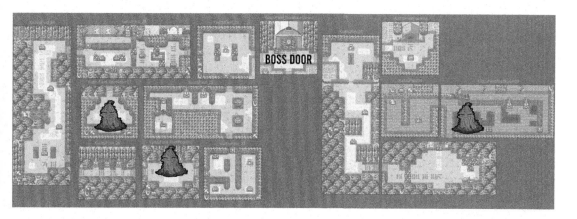

FIGURE 1.7 A diagram of the area near a boss room in *Kudzu*. To pass the door, players must chop down roots that are littered through a portion of the level, but can do so in any order they wish. Splitting one goal into several is an effective way to introduce a greater feeling of exploration into your level by allowing wandering and non-intrusive backtracking. This can even help extend gameplay time of your game, which is helpful if you are working with limited memory or resources.

As we have said previously, this is just a small list of potential structures you might put into your own games. Indeed, these can be mixed and matched (and are even in some of the examples we gave!). The structure of the levels gives only half the story of managing progression in action-adventure games though. In the next section, we will briefly look at how progression models also help us manage player pathways in these worlds.

PROGRESSION MODELS

Progression models, or the mechanisms through which players are granted access to new areas of a game world, stand at a strange border between game design and level design. On the one hand, they are not spatial at all: they deal with the order in which the character expands their capabilities or stats such that they can overcome more challenges. On the other hand, action-adventure games and their subgenres (Soulslikes, Metroidvanias, etc.) typically embody this progression spatially: the more the character grows in strength and abilities, the more of the world they can access. As with world structures, there are several common models with which you can use to describe progression in these games, or use as starting points for the design of your own action-adventure progressions.

Item and Skill-based Progression

The first, and possibly the most common model seen in action-adventure games, is basing progression on item or skill acquisition. It is so common that we even included it as one of our major design considerations of the genre back in this book's introduction. To recap: it is a pattern in which players may explore freely within a contained area, but their progress beyond this area is blocked until they have found a specific item or ability for their avatar. Lots of games feature this style of progression in the action-adventure genre and its subgenres – notably the Metroidvania subgenre, for which this is a core mechanic – so we think that it is less useful to identify noteworthy examples as it is to talk about designing these systems.

Gameplay Research and Pattern Languages

Throughout the book, we have so far alluded to the idea that planning these worlds requires a lot of planning on the part of the designer. In his book *A Playful Production Process*, game designer Richard Lemarchand describes the various phases of the game development process from idea to release. In the first phase, *Ideation*, designers brainstorm, create first prototypes, set project goals, and conduct research to strengthen their design ideas (Lemarchand, 2021). The research aspect of this phase is among the most important for the success of many types of game projects but is often overlooked by new designers who may try to jump right into their favorite game engine. For action-adventure game worlds, part of a game or level designer's research might include playing noteworthy games in the genre and identifying design *patterns* that create the type of gameplay experiences that they wish to create in their own games.

Pattern theory is derived from the work of architect Christopher Alexander, who defines a pattern as a "core solution" to a specific design problem (Alexander et al., 1977). By themselves, patterns are effective but do not ensure good design, and as game designer Chris Barney points out, even a group of non-related patterns may not accomplish this (Barney, 2020). Alexander further describes the idea of a *pattern language*, which is a series of closely interconnected patterns that

share common attributes or address different design problems within the same or similar projects (Alexander et al., 1977). By focusing on building a "language" of patterns that support, or in some case derive from, one another, designers can create a comprehensive system of solutions to design problems in their projects. Multiple efforts to adapt Alexander's work even exist within the fields of game and level design, including the book *Patterns in Game Design* by teachers and designers Staffan Bjork and Jussi Holopainen (Bjork & Holopainen, 2004) and Barney's own *Pattern Language for Game Design* (Barney, 2020). Barney's efforts are notable, as they are not just a pre-made pattern language (though a community-generated one deriving from his method may be found at PatternLanguageForGameDesign.com), but also exercises for making different types of game design patterns.

While it is outside the scope of this book to provide a detailed breakdown of Barney's method, we can offer an example of something that might be identified as a design pattern that could be integrated into a pattern language for action-adventure games: the highway. The previous section covering the highway – a set of passages that provide efficient access to different regions of a game world – is a pattern derived from interacting with Barney's method for creating game design patterns. When starting to conceptualize our games' worlds, we wanted to curb problematic backtracking, so looked for solutions from existing games for best practices to this issue. We identified it in games like *Hollow Knight* and various Metroidvania games and gave it the name "the highway" so that it could be easily described and utilized later in design meetings.

In terms of item or ability-based progression, identifying meaningful patterns during your own ideation research phases can be vital for getting control of this often-daunting design task. Some games use patterns of *gating*, or blocking off areas behind challenges that require a new skill or item to overcome, to control progression. A pattern for designing gating might be called something like "goal setting skill gates," in which a challenge requiring a yet-unearned skill is located near the entrance to a new area in a game (maybe even right off of a highway-style area). This pattern shows the player their next goal: overcome this challenge, but leaves it to the player to press on ahead through the region to find the tool that will help them (Figure 1.8).

Pre-production planning tools

Another tool in designing item or ability progression in these games comes from the next phase of production described by Lemarchand, *preproduction*. This is the phase of early game development, where the goal is to build and establish your game systems and create high-level design documentation, including the *game design macro*. We will cover game design macros in more detail in the Practical chapter immediately following this one, but they are generally high-level spreadsheet documents breaking down the content and mechanics of each phase of a game (Figure 1.9).

Macros are useful for several reasons. The first is that they are structured such that game designers can get an overview of how their game will progress, albeit still in an abstract way: any prototyping happening in this early phase is still likely for core game mechanics. By documenting how they think progression may happen, game designers can start to get a sense for when players may encounter specific mechanics and when to start featuring them more heavily in their designs. The second reason is that by carefully documenting these progressions, all members of the design team will be able to refer to this document and stay in sync on the design goals of each part of the game, even if their exact approaches vary.

Another tool that designers may find useful as they begin planning the actual layouts of their levels, and which folks studying level design may find useful as an analytical tool, are the *Boss Keys Diagrams* originally created by Mark Brown. Once again, we will cover these diagrams in greater detail in the Practical chapter immediately following this one, but the general idea is to use a simple graphic language to show the relationships between points of interest in a level and any gates or locked doors (Figure 1.10).

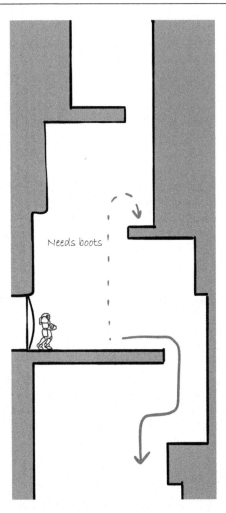

Needs boots

FIGURE 1.8 *Super Metroid* uses goal-setting skill gates, such as in the red area of the Brinstar region, to telegraph the player's next steps and make them think about solutions to navigational puzzles. When players enter this region, the find a high jump that they will be unable to make going upward, so their only choice is to proceed downward. This leads then through passages that will eventually allow them to find the High Jump Boots upgrade, encouraging the player to backtrack and attempt the Jump with their new ability.

Brown originally created these diagrams as part of his video series *Boss Keys*, in which he explored the design and layout of dungeons from each game in the *Legend of Zelda* series, and later used them to analyze Metroidvania worlds. Mapping out levels in this way allows the designers to see whether they are offering enough explorable space in each area and plan when to confer new abilities to the player. These high-level views offer a quick sense of how levels will progress, allowing the designers to set their goals for what the level experience should be like, before they have to worry about designing actual level geometry.

Again, this seems like a lot of planning without a lot of building, but the planning allows the designer to set and observe their goals for the design. In this way, the "hard parts" of the design – planning how players progress – can be answered quickly, and the level construction itself becomes just a means of making that experience longer or shorter. In our experience, you will still need to playtest carefully and often change these plans by giving players abilities at different times or adjusting the size of your levels to account for time/budget/memory limitations. Regardless, establishing a plan helps you keep your design goals in mind even if the details change.

	A Location Sequence	B Description	C Player Mechanics	D Player Goals	E Design Goals	F Emotional Beats	G Characters Encountered	H Enemies Encountered	I Objects Encountered
2	Opening Animatic	• Peony is given assignment				• Very cloak and dagger • Dark undertones - something's rotten in Slumberland	• Morpheus • Princess • Peony • Nightmares • Popcorn? • Bon Bon? • Mephisto?		
3	Nemo's Bedroom	• Peony awakens Nemo • The bed gets up and walks out the window!				• Happy, quaint, reunion with our old friends	• Peony • Nemo		
4	City Rooftops	• The bed romps down the street • Nemo is tossed off and lands on a roof. • The bed is getting away! Initial gameplay begins. • At the end of the stage, Nemo slides off a roof and tumbles through the air. • Peony, riding on the bed, catches Nemo. Gotcha! • They fly off into the sky.	• Run • Jump • Attack	• Chase Nemo's bed • Reunite with Peony	• Learn the game's basic movement mechanics	• Initially happy and exciting • Oh no! The beds out of control • What WAS that thing that scared the bed?	• Peony • Nemo	• Pig chickens	
5	Night Sky	• Peony lets Nemo off the bed. Stay here, I need to investigate something! • Nemo doesn't listen and makes his way to the first boss; the moon • Fight the moon • Peony and Nemo talk to the moon. Peony goes in it's mouth. A key falls from the sky.	• Map use • Nemo glide • Locked doors • Timed platforms • Boss encounters	• Reach Slumberland	• Exciting intro level ("Mega Man X") • Introduce and explore Nemo's glide mechanic • Introduce level exploration (looking for locks and keys) • Introduce the map via it being active in the level	• Joyous return to Slumberland • Something's wrong - what's up with the Moon? • What WAS that thing that infected the Moon?	• Peony • Nemo • Night sky citizens • Moon	• Pig chickens • Tick Tock birds • Sandman • Cloud version of jub jub bird	• Keys • Candy • Health pickups • House key
6	Nemo's House - Return Trip 1	• Nemo awakens. The key is floating in his bedroom? It floats off, leaving a trail behind. • Following the trail, the key unlocks a room in the house (library?) • Going back to bed, the Mushroom Forest is unlocked	Game flow - beating levels and unlocking the next area of the house	• Explore the house • Unlock the Mushroom Forest • Learn about the kitchen	• Introduce game flow via exploring the house • Introduce the kitchen				• House key • Mushrooms
7	Mushroom Forest	• Nemo is in the forest alone. Where's Peony? • Nemo happens about Dr. Pill. He hasn't seen Peony, but he's got stuff to sell. • Nemo also meets a farmer who needs fertilizer to help revive the forest. • Nemo happens upon a big wooden house owned by the Mosquito Farmer. • After exploring the entrance to the house, the Mosquito Farmer traps Nemo! He falls in a pit. • Further into the cave, Nemo finds Peony! She joins the party. • They get out of the cave. • With Peony's help, they find fertilizer • They deliver it to the farmer, and new bouncy mushrooms unlock! • At some point they happen upon both Pigmi's Progress guy, whose very happy he doesn't have his cate. • Peony and Nemo get cornered by the Pie Eaters! • Upon defeating the pie eaters, a key appears. Nemo awakes!	• Peony Climb • Character Swapping • Non-linear level design quests • "Hope" collection • Bouncy mushrooms • Floats (moving climbable vats) • Moving platforms (Love Birds)	• Pass through the forest • Find Peony • Escape the Mosquito Farm • Find fertilizer for the mushroom farmer • Defeat the Pie Eaters	• Introduce Peony and climbing • Introduce metroidvania style level layouts • Introduce "hope" collection • Introduce Quests	• The forest is wondrous but spooky - what happened to Peony? • Nemo's gotten himself into BIG trouble with this mosquito guy • Ta da! Peony to the rescue! • Let's get outta this forest! • Oh no! Not the Pie Eaters again! • Ahhh! The nightmare energy made them even worse!	• Peony • Nemo • Pill • Farmer • Mosq. Farmer • Bunion • Pie Eaters • Mushroom town people	• Slithy Tove • Jub Jub Bird • Wild Man • Mosquitos • Potato Bug	• Keys • Candy • Health pickups • House key • Hope • Records • Comics • Bunion Case • Fertilizer
8	Pill's Shop	• The store for various items and collectibles. Requires candy.	• Candy (money) • Shopping	• Power up	• Introduce game economy	• Snake oil salesman	• Pill?		

FIGURE 1.9 A game design macro document from our game *Little Nemo and the Nightmare Fiends*. Formatting and content for these documents will vary by game, but ours has the different levels taking up rows in the spreadsheet, while the columns allow us to describe different aspects of the levels, such as what mechanics players use in them, what the design goals of each level are, enemies encountered, etc.

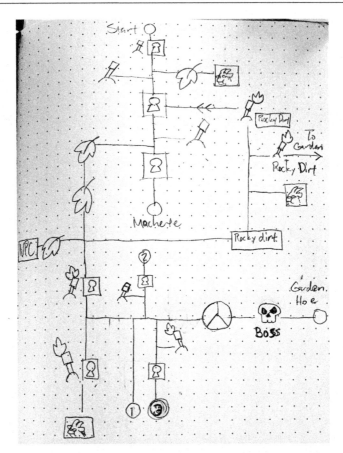

FIGURE 1.10 An example of a *Boss Keys*-style diagram created to plan levels in the game *Kudzu*. The regions in this game are structured much like *Zelda* dungeons during the player's first visit to them. Each region is split into phases separated by locked doors for which the player must find a certain number of levers to open. The paths to these levers are blocked by puzzles and combat challenges, which are marked with symbols corresponding to the abilities required to overcome them.

The "Rod of Many Parts"

Taking a step back from the more intensive planning of item and ability-based progression, we will talk about some other progression models that may be useful in design and analysis, and which can be part of your broad concept of how your game world works. The first of these is the *"Rod of Many Parts"* model, described by game and narrative designer Jeff Howard (Howard, 2008). According to Howard, this model derives from the history of tabletop RPG design, appearing as early as 1982's *"Dwarven" Quest for the Rod of Seven Parts* module for *Dungeons & Dragons*. Game designers Ken Rolston, quest designer on the computer RPGs *The Elder Scrolls III: Morrowind* and *The Elder Scrolls IV: Oblivion*, and Hal Barwood, former designer at LucasArts, likewise refer to this model as a means of conceiving a story, then breaking it into manageable portions (Howard, 2008).

In the action-adventure genre, this manifests in games like the original *Legend of Zelda*, where the player must find the eight broken pieces of the Triforce of Wisdom so that it can be returned to Princess Zelda. Later games in the *Zelda* series and games inspired by it frequently use this model, swapping out the Triforce pieces with instruments, spiritual medallions, pendants, and other *MacGuffins* – objects used to move a plot forward but irrelevant in themselves. While this chapter does not cover narrative or expressive aspects of these worlds, mainly structural ones, Howard notes that the *Dwarven* sourcebook offers suggestions on how such a structure might be incorporated into a game's plot. It suggests that the

quest begins when the player sets out to find the first piece or happens upon it accidentally. Supporting Barwood's point about breaking the story into parts, the plot begins with a basic premise of finding one objcct but then deepens as the existence of the other parts is revealed. Finding each part may also involve individual side stories, where each object's location features a small episode of its own. Plots revealed in this way can feel very satisfying and dynamic.

"Choose Your Own Quest"

The last progression model that we will cover is a variation of the rod of many parts, and one that we have covered already in the chapter, but which we will call here, *"choose your own quest."* This is the same concept as the structural idea of creating non-linearity by breaking one goal into several and allowing the player to choose which order they wish to pursue the different goals. Earlier in this chapter, we used the example of the Dreamers from *Hollow Knight* as one example of this, where players can choose which of three non-players characters to kill to reach the game's end point. This structure is also used in the game *Hyper Light Drifter*, where the world offers four different regions, each branching from the central town in a cardinal direction, that players can approach in any order. This openness makes the world feel full of potential, but subtle hints coming from non-player characters and in-game prompts imply recommended first steps for players seeking more guidance. Indeed, even newer games like *The Legend of Zelda: Tears of the Kingdom* use this model at a high level, allowing players to approach its dungeons in any order, while still using character dialog and quest design to imply a recommended direction to go first. In these cases, the game balances complete openness and guidance in a way that players can make informed choices about the path to take.

Choose your own quest does not only have to be a high-level progression model for world-scale spaces. As stated previously, this model can be used at the level of individual regions or dungeons to increase the explorable space during each step of progression. The multi-lock doors in *Kudzu* are the example we cited in the version of this concept described in the section on level structures. This implementation structures the game's dungeon-like regions as smaller zones of space where players must find multiple switches to unlock a door and move on to the next area. By having more space and multiple goals, these areas feel more open than in levels where players are trying to find just one key or upgrade. *Cave Story* includes a quest in the Sand Zone region where the player must recover five puppies belonging to Jenka, an important non-player character, before the story can progress. This area breaks the linear patterns of the game's previous regions and gives players a goal-oriented reason to explore the more expansive Sand Zone, which has other hidden items.

Straddling game and level design, the progression models of action-adventure games are where the game's presentation – art, music, narrative, etc. – and its gameplay structures blend. The progression of a character may be the story of them remembering their old powers, recovering lost abilities, or growing from a child to an adult. Different models for progression represent this growth in different ways, and while intimidating to implement, careful planning and documentation can help designers and critics sort through these ideas.

CONCLUSION

Action-adventure worlds can be complex and intimidating for many designers, but top-down models exist as a means of approaching their design. Among these top-down ideas are general structures and shapes of the world. When architects work, they typically begin with basic high-level formal elements before planning things like the layout of a bathroom. So too can level designers begin with a basic concept of their game worlds before stressing over details of how each chamber will look. In this chapter, we also begin to

see how action-adventure levels provide holistic game design experiences: where some game levels follow a very "form follows function" approach and turn the game's mechanics into space, these worlds do all of that and more as they integrate narrative and metaphor as level progression.

In the next chapter, the Practical chapter companion to this one, we will turn some of these concepts into planning methods by exploring tools for plotting out 2D action-adventure world designs.

REFERENCES

Alexander, C., Ishikawa, S., & Silverstein, M. (1977). *A pattern language*. Oxford University Press.

Barney, C. (2020). *Pattern language for game design*. CRC Press.

Bjork, S., & Holopainen, J. (2004). *Patterns in game design*. Charles River Media.

Furest, T. (2016). *Imagineerland*. 10 February. Accessed February 21, 2024. https://imagineerland.blogspot.com/2016/02/theme-park-environmentals-urban-plan.html

Howard, J. (2008). *Quests: Design, theory, and history in games and narratives*. AK Peters/CRC Press.

Kalata, K. (2017). *Hardcore Gaming 101*. 27th December. Accessed February 21, 2024. http://www.hardcoregaming101.net/metroid-fusion/

Lemarchand, R. (2021). *A playful production process for game designers (and everyone)*. MIT Press.

Rogers, S. (2016). Hell, hyboria, and Disney land: The origins of themed video game level design. In C. W. Totten (Ed.), *Level design: Processes and experiences*. CRC Press.

Wallace, I. L., & Hirsh, J. (2011). *Contemporary art and classical myth*. Routledge.

Planning "Tools" for 2D Action-Adventures

1.2

INTRODUCTION

The previous chapter examined common structures found in 2D action-adventure games and their sub-genres. While not completely exhaustive, the discussion of each structure's elements shows how even the most top-down choices greatly affect the nuances of action-adventure games' designs. To better sort through how these high-level structures and decisions affect more minute aspects of gameplay, designers should be prepared to carefully *document* aspects of their level and world design.

To many new designers, this seems unintuitive: isn't "level design" what happens when you build things in level editors? Haven't we been taught that you should make playable prototypes as quickly as possible? The answer to both of these questions is "yes," but in the case of action-adventure design, these "yeses" come with some nuance. Prototyping for game design does not only need to include "prototyping content to put in front of playtesters," it can also mean prototyping basic gameplay systems – like having your action-adventure character be able to run around a simple environment and perform basic actions. It also means testing individual systems like the camera, how you will display animations, testing your interface, most anything that will come together to make the game experience. Gameplay, more broadly, can and should also be prototyped in forms other than their literal application within software, including translating even 3D digital gameplay into paper prototypes (Fullerton, 2018). For levels, paper maps – playable and non-playable – are important visualizations of levels that regardless of their digital interactivity and our ability to see from within them, allow us to see potential issues in our level implementations as early as possible.

Regarding the role of the level designer, working within editors is only part of a level designer's job, which includes a lot of other planning and collaborative tasks (many of which are outside the scope of this book. In the context of action-adventure level design, the levels not only exist as individual spaces as they may in something like a retro action game, but they also fit into a larger and continuous world structure. As such, the way that the world is revealed through narrative and ability acquisition requires extra visualization beyond graybox prototypes of level space. With this in mind, this chapter explores various digital and non-digital, as well as spatial and non-spatial, tools for level planning, up to and including taking our first forays into the GB Studio and Tiled editors to make a simple gameplay prototype.

THE LEVEL DESIGN MACRO

In his book *The Art of Game Design*, game designer, Jesse Schelle, introduced the concept of interest curves, a technique for understanding the interest of an audience and charting how it rises and falls from moment to moment (2019). If the audience's interest remains in a high or low state for too long, they may get bored

DOI: 10.1201/9781003441984-4

FIGURE 1.11 Diagrams of Freytag's Pyramid and the three-act dramatic structures.

or restless and thus lose interest. He argues that the most engaging entertainment, regardless of the format, follows a clear pattern: The hook at the beginning creates initial excitement or interest, followed by smaller periods of excitement and relaxation over the course of the experience. At the end, there is a big finish, or climax, at which point the experience can resolve loose ends and come to a close with a satisfied audience.

People familiar with structural theory in storytelling might see parallels in the falling and rising action of interest curves to something like Gustav Freytag's Pyramid or three-act structure (Figure 1.11), a similarity that Schell mentions in the book. And like dramatic structure, interest curves are a great way of looking at and analyzing any work of entertainment, including games, and trying to understand why some part of it isn't working. In the same way, it can be a great planning tool for organizing and structuring a game's moment-to-moment gameplay, allowing designers to consider how to pace exciting and/or difficult action segments with calmer periods of exploration or narrative.

Before we talk about planning gameplay moments and charting interests, it's important to note that interest curves are a subjective theory, not an objective rule. This is something Schell touches on as well, noting that "imagination" and "empathy" are required to put yourself in place of the audience as they are engaged in the experience to be able to properly imagine how interest may rise and wane throughout. Interest is ephemeral, something we can imagine and use to help generate and organize ideas. Therefore, plotting interest curves is not a surefire way to craft an exciting experience for every player one hundred percent of the time.

In order to understand how to plot interest, Schell argues the first thing to understand is how entertainment is made up as "a series of moments." In the context of a game, what constitutes a moment can vary depending on genre. For nonlinear action-adventure games, we can think of them as a series of quests, encounters, and/or narrative sequences. But this is a very high-level view; a single quest for example can be further broken down into a series of challenges, and then again into individual game elements. For example, the first quest of *Link's Awakening* requires the player to find out where the sword is, discover that location, and avoid several obstacles such as enemies and holes in the ground. This is again like story structure; a story can be divided into acts but many plot beats and moments of character growth can happen within the act. To go a step further to understand and layout our moment-to-moment gameplay, we can use a game design macro chart.

The game design macro chart was an idea posited by designer and engineer Mark Cerny during a talk at the 2002 D.I.C.E. conference and further elaborated by designer Richard Lemarchand in his book *A Playful Production Process for Game Designers (And Everyone)*. He describes the chart as a map, specifically one that contains design information and decisions that are needed for a project to enter

full production (Lemarchand, 2021). This includes summarized bullet points for specific features during specific moments rather than the exhaustive descriptions seen in game design documents. In the context of the book, Lemarchand is talking about large-scale productions and how the chart was used during his time at Naughty Dog on games such as *Uncharted 2*. Indeed, this method has a lot of advantages such as helping create the production schedule and affirming the scope of the project early on. In this book, we will be specifically focusing on how small teams or solo developers can use a game design macro chart to help to organize and structure the moment-to-moment gameplay.

The macro chart is laid out like a spreadsheet. The number of columns and rows will vary depending on the needs of a specific game, with each column horizontally listing out the important information needed for each moment. The vertical rows leading down are then listed in sequence chronologically, with the earliest moment of the game on the top down, followed by the next moment, and so forth downward (Figure 1.12).

There are a lot of criteria by which we can define a "moment" in a game. Some of these will be obvious, such as the name of the location the sequence takes place in. We may also want to include information such as the mechanics players will use during this sequence, a summarized description of what happens during that sequence, and any other objective information that is relevant. Similarly, notes about audio, the objects or characters that are encountered, or additional assets needed for that sequence can also be noted.

Lemarchand also includes the subjective qualities of the sequence as a potential column in a game design macro chart such as the player goal, the design goal, and the emotional beat. The player's goal is what the player wants to do during this sequence. At the beginning of many modern *Zelda* games, the first goal is to acquire a sword. Therefore, the first player goal of a *Zelda* title would be to find a sword. This is in contrast to the design goal, which is what the game designer is trying to teach or accomplish with the sequence. The player's goal might be to find the sword, but for the designer, it could be to teach the core gameplay loop, master the basic control inputs, and/or to introduce the game's back story. The emotional beat defines how we want the player to feel during a particular sequence. For an action sequence, we may want our players to feel excited or anxious whereas for a sequence meant to drive narrative, we may want them to feel hopeful, somber, or contemplative. By taking each moment in the game and listing out their objective and subjective qualities with the game macro chart, we can better outline the entire experience.

One thing to note is that we mentioned the macro chart looks at structure linearly. However, especially action-adventure games, not all games are linear. Additionally, this chart doesn't consider side quests and optional content that are also typically part of the action-adventure genre. Lemarchand notes that for branching or "holistic" games, micro-design and preproduction are extremely important and may take more time before a proper macro chart that charts the entire game can be properly made. This is because how levels are traversed and what quests are accessible will be determined by the player's abilities, how they work, and where the player needs to go to obtain them. Compare this to a linear action game such as *Uncharted 2*, the game Lemarchand uses to demonstrate the macro chart; each sequence happens one by one as the player moves forward. For a nonlinear game such as *Super Metroid*, the player will move back and forth between different rooms within one region early on, and then between multiple regions toward the back half of the game. This deliberate structure needs to be considered and planned, what Lemarchand refers to as micro-design, before the macro chart can be properly organized for the full production of the game. We will look at strategies for micro-design, such as controlling the flow and pacing of different regions or dungeons, in later sections of the chapter.

For *Little Nemo and the Nightmare Fiends*, we considered this by breaking the game into separate acts. These acts were then organized in Google's spreadsheet application, Google Sheets, as separate macro charts. We also created a separate chart specifically for optional content such as side quests that also had categories for their assets and goals, as well as what region and act they would be accessible in.

The first act of *Little Nemo* is mostly linear, with players following a path, gaining a new character, completing a quest, and then facing a boss before the next region opens up. While the player can select a previously completed region, it isn't necessary to continue forward progress in the game and primarily is for completing side quests or receiving optional character upgrades, meaning our macro chart could be organized easily.

	A	B	C	D	E	F	G	H	I
	Location/Sequence	Description	Player Mechanics	Player Goals	Design Goals	Emotional Beats	Characters Encountered	Enemies Encountered	Objects Encountered
2	Opening Animatic	• Peony is given assignment				• Very cloak and dagger • Dark undertones - something's rotten in Slumberland	• Morpheus • Princess • Peony • Nightmares • Popcorn? • Bon Bon? • Mephisto?		
3	Nemo's Bedroom	• Peony awakens Nemo • The bed gets up and walks out the window!				• Happy, quaint, reunion with our old friends • Initially happy and exciting	• Peony • Nemo		
4	City Rooftops	• Nemo is tossed off and lands on a roof. • The bed romps down the street • The bed is getting away! Initial gameplay begins. • At the end of the stage, Nemo slides off a roof and tumbles through the air. • Peony, riding on the bed, catches Nemo. Gotcha! • They fly off into the sky.	• Run • Jump • Attack	• Chase Nemo's bed • Reunite with Peony	• Learn the game's basic movement mechanics	• Oh no! The bed's out of control • What WAS that thing that scared the bed?	• Peony • Nemo	• Pig chickens	
5	Night Sky	• Peony let's Nemo off the bed. Stay here. I need to investigate something! • Nemo doesn't listen and makes his way to the first boss; the moon • Fight the moon • Peony and Nemo talk to the moon. A key falls from the sky.	• Map use • Nemo glide • Locked doors • Timed platforms • Boss encounters	• Reach Slumberland	• Exciting intro level ("Mega Man X") • Introduce and explore Nemo's glide mechanic • Introduce level exploration (looking for locks and keys) • Introduce the map via it being active in the level	• Joyous return to Slumberland • Something's wrong what's up with the Moon? • What WAS that thing that infected the Moon?	• Peony • Nemo • Night sky citizens • Moon	• Pig chickens • Tick Tock birds • Sandman • Cloud version of jub jub bird	• Keys • Candy • Health pickups • House key
6	Nemo's House - Return Trip 1	• Nemo awakens. The key is floating in his bedroom? It flies off, leaving a trail behind. • Following the trail, the key unlocks a room in the house (library?) • Going back to bed, the Mushroom Forest is unlocked	Game flow - beating levels and unlocking the next area of the house	• Explore the house • Unlock the Mushroom Forest • Learn about the kitchen	• Introduce game flow via exploring the house • Introduce the kitchen	• The forest is wonderous but spooky - what happened to Peony?			• House key • Mushrooms
7	Mushroom Forest	• Nemo is in the forest alone. Where's Peony? • Nemo happens about Dr. Pill. He hasn't seen Peony, but he's got stuff to sell. • Nemo also meets a farmer who needs fertilizer to help revive the forest. • Nemo happens upon a big wooden house owned by the Mosquito Farmer • After exploring the entrance to the house, the Mosquito Farmer traps Nemo! He falls in a pit. • Further into the cave, Nemo finds Peony! She joins the party. • They get out of the cave. • With Peony's help, they find fertilizer! • They deliver it to the farmer, and new bouncy mushrooms unlock • At some point they happen upon both Pilgrim's Progress guy, whose very happy he doesn't have his case. • Peony and Nemo get cornered by the Pie Eaters! • Upon defeating the pie eaters, a key appears. Nemo awakes!	• Peony Climb • Character Swapping • Non-linear level design • quests • "Hope" collection • Bouncy mushrooms • Floofs (moving climbable walls) • Moving platforms (Love Birds)	• Pass through the forest • Find Peony • Escape the Mosquito Farm • Find fertilizer for the mushroom farmer • Defeat the Pie Eaters	• Introduce Peony and climbing • Introduce metroidvania style level layouts • Introduce "hope" collection • Introduce Quests	• Nemo's gotten himself into BIG trouble with this mosquito guy • Ta da! Peony to the rescue! • Let's get outta this forest! • Oh no! Not the Pie Eaters again! • Ahhh! The nightmare energy made them even worse!	• Peony • Nemo • Pill • Farmer • Mosq. Farmer • Bunion • Pie Eaters • Mushroom town people	• Slithy Tove • Jub Jub Bird • Wild Man • Mosquitos • Potato Bug	• Keys • Candy • Health pickups • House key • Hope • Records • Comics • Bunion Case • Fertilizer
8	Pill's Shop	• The store for various items and collectibles. Requires candy.	• Candy (money) • Shopping	• Power up	• Introduce game economy	• Snake oil salesman	• Pill?		

FIGURE 1.12 A game design macro as created for *Little Nemo and the Nightmare Fiends*.

The second act is where the game opens up a fair bit. Players can explore levels freely with all four characters, with the goal of defeating the three Fiends of the game. Each Fiends' dungeon can only be unlocked by doing side quests which earns the player a currency we call "hope figments" that can be used to unlock access to the Fiends' layer. For the macro chart, this was also fairly straightforward despite the more open nature of the game; most of the emotional beats and player goals are regulated to the side quest tab, while special events such as cutscenes with the Fiends or events that happen in Nemo's House (our game's hub area where levels can be accessed) happen at bottleneck points which we can note in the chart. These bottlenecks include conditions such as a defeated fiend or when a certain number of figments are collected. Finally, the third act is comprised of one level, which follows a normal macro chart structure like the first act.

Note that this approach worked for us and our game's unique structure. By thinking of our game in terms of acts that contain moment-to-moment gameplay, we can better understand how to maintain a player's interest throughout the game. We can then organize these moments within our macro chart, which helped us to define what the game's structure more easily was and how it worked. The form a chart takes and how it is organized will vary from game to game depending on the goals of the designer and the experience they would like for the player to have.

As it says in the name, "macro" charts are excellent at helping developers envision macro-scaled information, such as multi-act story structures, how items or abilities are doled out across multiple levels, and other big ideas. As the designer starts to hone in on more micro-level information, they will need other tools to visualize smaller-scaled design elements. In the next few sections, we will look at some of these tools, and how they can help designers flesh out their action-adventure worlds.

SKETCHING TOOLS AND GRAPH PAPER

To begin talking about tools and procedures for micro-scaled design, we have to first look at how we will be conveying this information. Spreadsheets and other text-based documentation are great for macro-scaled ideas, but smaller moments of gameplay require some visualization. This is where sketching comes in. Sketching is, quite simply, the act of recording thoughts and analyses on design in a visual form into some easily accessible and portable archival object – a napkin, a phone app, or – most preferred by these authors – a physical sketchbook. Using a sketchbook should not be an exact science – designers can and should use any method that suits them such as freehand drawings, text, diagrams – anything that allows you to record your thoughts in the moment (Figure 1.13).

While the methods for sketching are loose, the purpose and rationale for the inclusion of sketching in the design process are quite specific. Fine arts professor and author Seymour Simmons III points to the modern prevalence of visual information as a testament to the relevance of physical sketching as a skill. He argues that it is, "the most direct means of processing and producing visual information" and that sketching best teaches the foundational skills needed to operate digital 2D and 3D art programs (Simmons, 2021). In his book, *Drawn to Design,* architect and design educator Eric Jenkins describes his own professor, William Bechhoefer, asking his students to use their sketchbooks in three ways: 1) to study specific conditions in existing designs that might inform their own design process, 2) to scrutinize the designed and natural environment by using specific drawing types, and 3) to document those things that "strike you" (Jenkins, 2012). The idea of looking to existing works and recording or analyzing their "striking" conditions to inform your own ideas is called *precedent study* – where what works (and what does not work) in existing designs is used to influence current in-progress projects. Developing a rich library of precedents, aided by the archival nature of a sketchbook, prevents designers from reinventing the wheel whenever they go to create something new.

Within the design process itself, sketching can also be your first opportunity to put your ideas down into some viewable form that you and your colleagues can evaluate. The goal here is not skillful rendering (aka, "drawing well"), the goal is *communication* – so sketches, especially by designers without artistic skills – may be simple, but still help the team visualize the idea (Ching & Juroszek, 2019) (Figure 1.14).

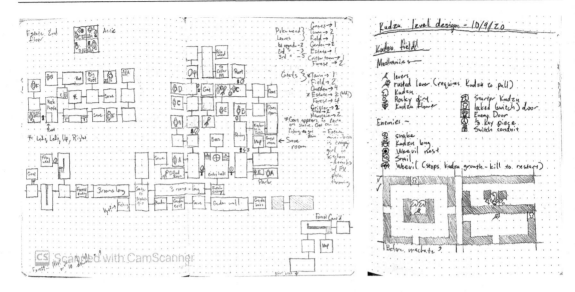

FIGURE 1.13 Excerpts from our own design sketchbooks.

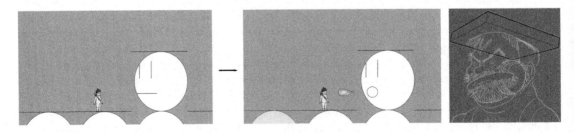

FIGURE 1.14 Early sketches of an enemy idea in *Little Nemo and the Nightmare Fiends*, which wears part of a bridge as a hat and spits at the player. When players knock this character out, the enemy lowers his head, allowing the player to walk in the bridge piece. This early sketch was sufficient for communicating the design idea to the team and was then iterated on by an animator for final implementation.

Graph Paper

The first question most designers have when taking up sketching is, "what kind of book should I get?" While this choice is ultimately up to you based on your individual preferences, we especially like using graph (the one with the lines) or dot grid (the one with dots but not lines) paper books for 2D-level design.

In design, graph paper is traditionally frowned upon in favor of blank paper so that designers are not beholden to the grid-based measurement systems implied by the markings on graph paper. While we likewise want to focus on the design, the tile and grid-based nature of game-making software, especially in 2D games, makes grid-lined papers ideal. With a graph paper notebook, designers can indicate how many in-engine "units" each square on the page represents, then use that basis as a means to plan sketches of their levels. This mindset is far from unique to digital games and has been a mainstay in game environment planning since the advent of Dungeon Masters creating maps for their *Dungeons & Dragons* sessions.

In our 2D digital games, the squares help us plan things like how far jumps will be based on our characters' *metrics* or unit-based movement capabilities. As many 2D engines, such as GB Studio – which we are using for this book's tutorials, base how levels are constructed on *tiles*, or repeatable 2D art assets, the gridded paper also helps us visualize based on these units (Figure 1.15).

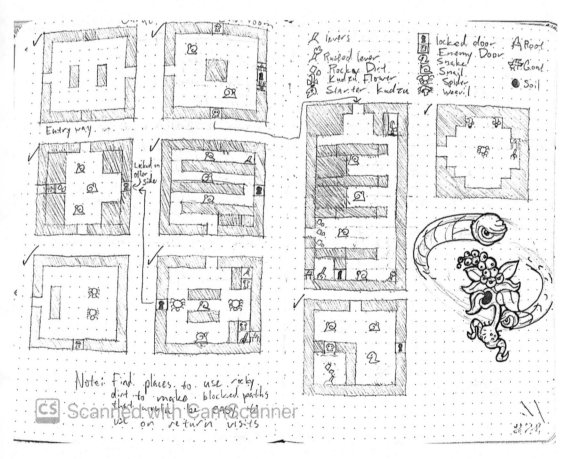

FIGURE 1.15 Planning sketches for *Kudzu* show how graph paper may be used to plan 2D room layouts. Each square on the graph paper represents a 16 × 16 pixel square on the Game Boy screen (the size of an individual Game sprite) to help plan on how game objects could be spaced out on screen.

Regarding other drawing tools – this is largely based on personal preference, but we tend to use pencils to do our sketches so that we may draw softly and erase while designs are still in-process. Especially when working with tile-based screen layouts, drawing how a room or space will appear on screen often reveals areas where your gameplay idea will literally not fit into your screen limitations. As you work through refining your idea, impermanent media is helpful in keeping your ideas clear. You can further clarify the drawing by inking it with a pen when a more finalized sketch emerges. Though you are not playing the space within the game, sketching is its own type of iteration and play as you work out how to make visually communicative level, room, and screen layouts.

Drawing Types

While it is outside the scope of this book to provide a full exploration of drawing techniques that level designers might use (though readers should look through this chapter's citations for recommended texts on the topic), we can offer some tips here. The first would be to familiarize yourself with some basic drawing types and techniques (Ching, 2015), such as these architectural drawing styles (Figure 1.16):

- *Plan* – A "top down" drawing of a space as viewed from above. Technically, most architectural plans are drawn as though cut through walls from a height of about four feet (about 1.2 meters) off the ground. This allows you to see how spaces flow into one another. Most useful for designing or analyzing top-down games.
- *Section* – A "cross-section" drawing, viewing the interior of a space from the side as though you cut through the space from top to bottom. This lets you see the vertical relationships between spaces or architectural details like balconies or ledges. Most useful for designing or analyzing side-scrolling games.

FIGURE 1.16 Different types of architectural drawings relevant to the design of action-adventure games – plan, section, elevation, and axonometric.

- *Elevation* – A visualization of a building or space from the exterior, drawn flat without any perspective. This is not a particularly useful drawing style for planning game levels but is useful for diagramming existing designs in your sketchbook.
- *Axonometric* – A three-dimensional drawing style created by tilting a plan drawing 30 or 45 degrees, then projecting details upward from it to create a 3D visualization of a design. Useful for visualizing the spatial relationships between spaces both horizontally and vertically at once, especially in 3D games or spaces.

Designers will also want to be familiar with the concepts of *contour, perspective,* and *parti.* Contours are the outer-most lines of an object in a drawing. When many of us learn to draw, it is by doing *contour drawing,* which is drawing that focuses mainly on the outer lines of an object. Outer contour lines are distinct from the lines used to draw details within an object because they form the *silhouette,* or identifiable overall shape, of an object. When drawing for spatial design, these outer contour lines can be drawn with a different *line weight,* or thickness, than the lines defining interior details. The rule of thumb for line weight thickness is that the farther a surface is away from another surface, the thicker its line should be – so the lines used to define the outer edge of a building would be much thicker than the line used to draw a window frame (Figure 1.17).

Line weights are useful in plans, sections, and axonometrics alike for distinguishing where specific objects are in space. Any solid masses can likewise be colored in with a solid color – a technique known in architectural drawing as *poché.*

Line weights are especially useful when using another style of drawing, *perspective* drawing, where the artist simulates the way that our eyes perceive objects as bigger or smaller based on their distance from us. For design, perspective sketches are most useful for concept art and planning 3D levels, but can still be useful to the 2D-level designer when analyzing 3D levels as design precedents. To create a perspective drawing, the artist draws a horizontal *horizon line,* or the line that represents the distance in space where objects disappear, then marks *vanishing points* on that horizon line to mark where lines in the drawing will converge. The number of vanishing points used creates different types of perspective drawings: *one-point perspective* only uses one vanishing point, with the side facing the viewer drawn flat, as though viewing the object from one of its sides. *Two-point perspective* is drawn with two

FIGURE 1.17 An architectural sketch showing different line weights, with the outer contour lines of buildings having the thickest line weights.

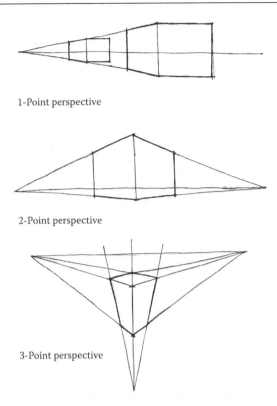

1-Point perspective

2-Point perspective

3-Point perspective

FIGURE 1.18 Different types of perspective drawings.

vanishing points and shows two sides of an object disappearing toward the horizon as though viewing it from a corner – giving it a more dynamic look than one-point perspective. *Three-point perspective* is typically used to show tall objects from above or below, as though viewing a skyscraper from a helicopter (Figure 1.18).

While all of these drawing techniques and styles are used to render reality in different ways, the last drawing concept this section will cover, *parti*, is an approach to drawing emphasizing simplicity and concept over detail. Parti is a term encompassing abstract drawings and models that architects might create when in the initial phases of a design. These drawings and models might be simple shapes and masses, showing how different major shapes might be juxtaposed with one another. They may also include arrows or other diagrammatic elements to show different experiential ideas like how occupants may move through a space or intended sight lines. The idea is that these drawings are quick, loose, but rich in concept (Figure 1.19).

While their abstract nature makes them harder to understand from a conceptual standpoint, parti is useful to game designers who can master it for the reason that they allow you to show in visual form what a level is "about" as an experience. If envision players going from a dark narrow space into a rewarding sunlit vista in a level, you can sketch out that *idea* quickly to share with your team without having to be as exact as you do in other drawing types.

Before jumping into GB Studio for some level prototyping, we will explore a few more abstract diagramming methods that are common for planning levels in the games industry. As the level design macro gives us a very "zoomed out" image of our game world, and sketching offers visualization at the scale of individual tiles, these help us plan how gameplay flows between rooms and spaces. Especially in action-adventure games, the quality of levels is not just determined by how good individual encounters are, but also by the pacing of these encounters and how effectively they transition into one another.

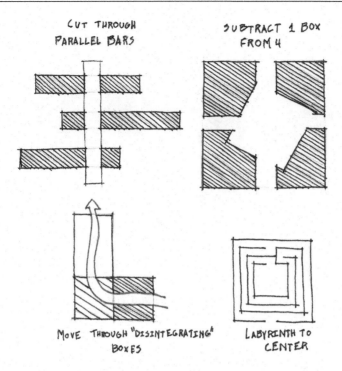

CUT THROUGH PARALLEL BARS

SUBTRACT 1 BOX FROM 4

MOVE THROUGH "DISINTEGRATING" BOXES

LABYRINTH TO CENTER

FIGURE 1.19 Examples of architectural parti sketches, emphasizing different conceptual ideas.

MOLECULE DESIGN

When building exploratory games like action-adventures or those in related sub-genres, the connections between noteworthy level spaces become as important as the spaces themselves. For this, we turn to a GameDeveloper.com article by game designer Luke McMillan and architect Nassib Azar titled, "The Metrics of Space: Molecule Design" (McMillan & Azar, 2013). McMillan and Azar describe *molecule design* as a method focused on the relationships between play spaces, with the spaces themselves being used as *nodes* and the relationships visualized as *edges*. The goal of these diagrams is not to create a literal map of the space, but to give a sense of how spaces that a designer knows might be in their level (spawn points, important areas of combat, treasure rooms, etc.) interact with one another. These graphs are similar to the architect's *proximity diagrams*, which architects use to map out the different rooms needed within a building, then mark important connections between these spaces (such as having the kitchen and dining rooms in a house near one another) (Figure 1.20).

Our method for molecule design integrates both McMillan and Azar's method and ideas learned from architects' proximity diagrams. To draw a molecule diagram of a level, you should begin by listing each important space that the level will contain on your page. These should not be random hallways or rooms with simple gameplay (combat, platforming, etc.), they should be significant areas such as spaces with goals, boss fights, treasure rooms, and crossroads between pathways, gates, etc. Once you have this list, you should draw circles (nodes) with the names of those spaces inside. You should vary the size of these nodes by how important they are to the *program* of your level, or the list of moments your players should experience in the level. For example, an initial spawn point would probably be very important, as would the room where you find an important upgrade for the player character. Less important would be areas like where a character might send you on a side quest or where you might find optional items.

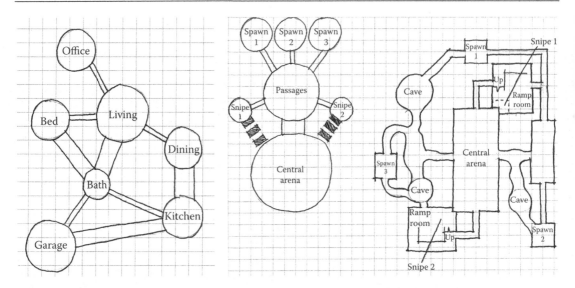

FIGURE 1.20 A molecule diagram used by level designers and a proximity diagram used by architects – both treat spaces in similar ways, as nodes of activity that should or should not have functional connections with other spaces.

When drawing the nodes, you should also try to group them by what you anticipate their physical proximity on your level map would be. Again, this is not the map itself, but by laying out all of your nodes in this way, you can start to visualize where important adjacencies might be, such as placing a save room near a boss. Once these general adjacencies are established, you should next draw lines between nodes describing their connections. For normal situations where there is a pathway between two spaces, you will want to create a solid line, with the thickness of the line determined by how important it is for the spaces to be connected. In our previous example of a save room located near a boss, modern design trends would have a connection between those spaces be very important, so you would draw a thick line between them. A direct link between the player's initial spawn point in the level and the boss room may, on the other hand, not be very important, so it would not feature a line, but a level's central highway corridor might have a thin line (Figure 1.21).

Alternatively, you may decide that the spawn point or some other point in the level should feature a preview of later points, such as boss rooms or places where treasures are hidden. This is common in both top-down and side-scrolling action-adventures, as the camera allows the player to see things that the player character would not, such as rooms on the other sides of walls. In these cases, you can use a dotted line edge between two nodes as shown in Figure 1.21. This allows you to start thinking about ways to entice the players as they play your map.

The last element of McMillan and Azar's molecule graphing method that we will cover here is the *Steiner point*. Molecule graphs are ultimately based on mathematical graphing theory. "Steiner points" are themselves borrowed from a potential solution to computational geometry problems where mathematicians use an added central point (the Steiner point) as a means of finding the shortest distances between endpoints of shapes. For our purposes, Steiner points are platforms, surfaces, or advanced gameplay abilities that a player may use to create shortcuts between level areas that may otherwise take a while to travel between. In action-adventure games, this may be done via hidden passages or ledges, expert-level moves like the Shinespark ability in *Metroid* games, or even non-game-breaking glitches. To draw a Steiner point into your molecule diagram, create a small node connecting to the other nodes where the player will access the Steiner point from, and give the connections between these spaces thin lines (because the passage is secret!) (Figure 1.22).

Graphing in this very abstract way will allow you to brainstorm fun secrets that will engage audiences, especially if your hope is to share the game with speedrun communities who like to play through action-adventures quickly. In the next section, we will explore another graphing method that allows designers to more thoroughly plan lock, key, and progression structures.

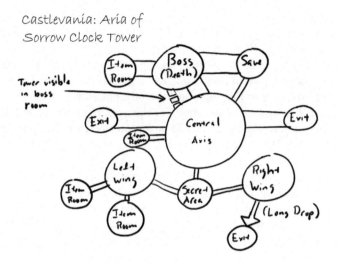

FIGURE 1.21 A molecule diagram used to analyze a Metroidvania game map, showing the different node and edge types one might use to draw them.

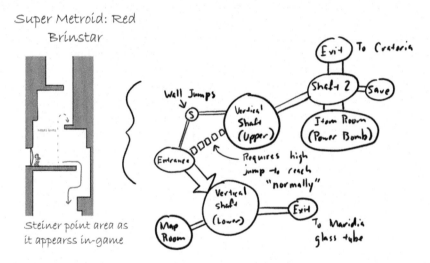

FIGURE 1.22 A molecule diagram of a Metroidvania map with a Steiner point incorporated. You may use text notes to give context to what the player should do to access the shortcut. This one from *Super Metroid* describes how a high-skill ability (wall jumps) may be used to bypass the normal progression path ("sequence breaking").

BOSS KEYS DIAGRAMS

We have mentioned the YouTube series Boss Keys multiple times at this point, a video series that game designer Mark Brown created as a means of analyzing dungeons from the *Legend of Zelda* series, and later the world design of Metroidvania-style games. One of the tools that Brown created to help him break down and understand these spaces was a symbolic graphing system to illustrate the different locks and keys in a given dungeon and how the available explorable options open with each key that is gained. Brown has shared the information on these graphs in detail publicly, but we will briefly describe it here.

Rather than using shapes to draw rooms as in molecule diagrams, Brown's method focuses on keys/items and gates. There are three shapes utilized in all graphs: circles which denote the entrance and the boss room of a dungeon, diamonds which represent a type of key, and squares that represent gates. Inside the diamonds and squares are symbols representing the type of obstacle; key shapes for literal keys, a bow and arrow representing an ability gate of some kind, and a special key icon specifically for *Zelda* games that use boss keys to open the door to the boss room. Finally, placeholder letters are used for locks connected to specific level mechanics such as switches. For example, if a dungeon has a switch that needs to be pressed in order to open a gate, the switch would be represented by a diamond labeled with the letter "A," and the gate as a square with the letter "A" as well. A second switch would be labeled with "B," and so on forth.

For the Boss Key series, Brown would lay out a map for a particular dungeon, placing squares wherever there was a lock on the map and diamonds wherever the key was located. This information made it easier to see the available pathways at a glance as well as the required order of acquiring keys and surpassing gates until the boss room could be reached. Following this order allows for the diagram to begin to form, starting with the entrance circle at the top-left of the graph. A line can then be drawn from the entrance, connecting the first series of encounterable locks and available keys on the top row. The graph can then continue to take shape, adding new rows where players are able to pass through the keys given to them, continuing downward until they are able to reach the boss door with the boss key. For easier readability, lock squares are placed one row below the 'key' diamond needed to surpass that lock. This makes the graph much longer on the vertical axis but allows the sequence the player takes through the dungeon to be much clearer.

While these graphs don't show the layout of the dungeon or specific pathways, they still reveal key information that makes it a useful analytical tool. In his blog, Brown mentions that we can get a sense of just how linear or nonlinear a dungeon is by abstracting the number of branching paths available at any section of the dungeon. Dungeons with many branching paths will extend the map outward, producing wide maps that continue to cascade downward. Likewise, maps that offer little to no backtracking will remain short as there are few branching paths to illustrate. These maps helped Brown to illustrate the different structures of *Zelda* dungeons between each other and were instrumental to differentiating between the classifications of the freeform lock-and-key dungeons with the more linear gauntlet design (Figure 1.23).

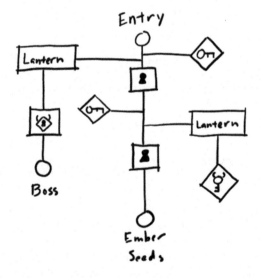

FIGURE 1.23 An image showing a simple, finished Boss Keys diagram.

As stated, this graphing system was created to be an analytical tool for reverse engineering the design of a particular type of gamespace. However, that also makes them a useful tool for designers who are creating similar spaces in their game as they can use this same process to see how linear or complex their own levels are. If the designer intends for a level that they are designing to be easy to navigate and less maze-like, a longer graph full of branching paths may help them spot that they're on the wrong track during the ideation stage. These diagrams were used extensively in the design of both *Kudzu* and *Little Nemo and the Nightmare Fiends* in both digital and non-digital implementations. As with other drawing types in this chapter, they are easy to produce by hand in a sketchbook, but are also well-suited to graph or flow-chart design software, allowing them to be easily shared with team members (Figure 1.24).

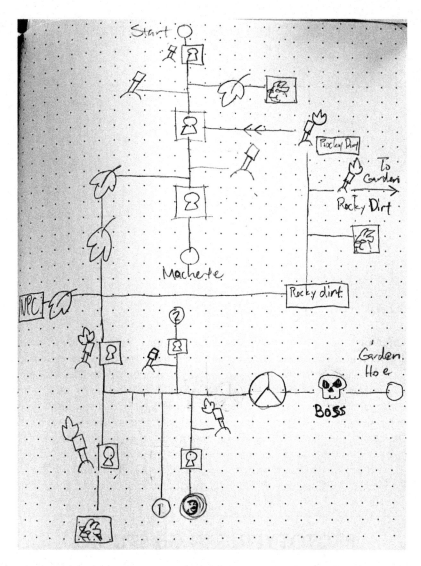

FIGURE 1.24 Boss key diagrams from *Kudzu* and *Little Nemo and the Nightmare Fiends*. Since *Kudzu* features *Zelda*-style item-based progression, it more closely resembles Brown's own Boss Key diagrams. Meanwhile, *Nemo*'s graphs are a bit different, as progression is gated in this game by which characters are in your party at a given time: as players meet more of the cast, they are able to access more areas. *(Continued)*

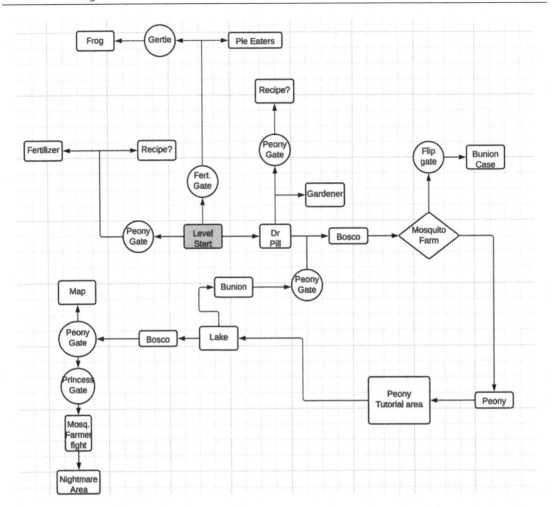

FIGURE 1.24 (Continued)

It's worth noting that there are drawbacks to these diagrams, some of which Brown himself calls out. For one, literal keys in *Zelda* games are a one-time use item, and the player may find multiple keys and have a choice of which door to use. The system does not account for this level of player choice and similarly makes these graphs not work for a game like the NES *The Legend of Zelda* where keys can be found throughout the game and not just in specific dungeons. Relatedly, there is a third type of dungeon in *Zelda* that Brown has designated the "puzzle box." Puzzle box dungeons have several bespoke mechanics that can potentially change the entire form of one or more rooms in a dungeon and can make certain dungeons more complex or even impossible to map with this system. That also makes using these diagrams for Metroidvanias with large, contiguous worlds such as *Hollow Knight* a similarly gargantuan task. As such, they are best used for local regions of a map that function similar to dungeons in *Zelda*-like games.

PROTOTYPING IN GB STUDIO

Now that we have covered a range of planning and sketching tools, we want to cover digital prototyping within the GB Studio engine itself. As mentioned previously, game industry best practices say that prototypes should be done as early as possible in a project. Early sketching and macro-level planning are

one way that we start to organize game design information for our levels. Prototyping of any sort, digital and non-digital, helps you see your gameplay in action. While paper prototyping is certainly a process we have ourselves used in planning action-adventure gameplay, one could devote an entire book, such as award-winning designer Tracy Fullerton's most excellent book *Game Design Workshop* (Fullerton, 2018), to the topic. For our purposes, we are going to focus on digital prototypes built in the GB Studio engine.

Tool Choices for Action-Adventure Prototypes

In previous chapters, we outlined our logic for choosing GB Studio as a tool for this book, so we are going to avoid repeating some of those arguments here. However, we wanted to take some time to lay out how such an engine may fit into the prototyping process for games that do not plan on using GB Studio for the final product. As stated previously, prototyping is not about early work on the final product, but about finding ways to evaluate your gameplay or technical ideas as early as possible. This may include one central prototype, or it may include a series of prototypes testing different systems: proofs of concept for art styles, camera system prototypes, animation system prototypes, etc.

One interesting case study comes from the talk "Change and Constant: Breaking Conventions with *The Legend of Zelda: Breath of the Wild*" given at the Game Developers Conference in 2017 by members of the *Breath of the Wild* development team. The talk showed several prototypes, including an early gameplay prototype that utilized early elements of what would become the game's physics system. One core idea of the game was imagining the world as having interconnected physical forces and elements, or what they called "multiplicative gameplay." This includes having elements of the game such as wind, fire, and various other materials and forces combined to create opportunities for emergent gameplay. One early prototype of this eventual 3D game was rendered in 2D in the style of the original *Legend of Zelda* for the Nintendo Entertainment System. This prototype obviously lacked the full breadth of interactions that one could have in the final 3-D game world but allowed the developers to see how objects, forces, and elements would work together as soon as possible (Dohta et al., 2017).

While Fullerton's book is often cited for its advocacy of paper prototyping, other digital methodologies it mentions are often overlooked, such as working in abstracted forms such as 2D prototypes for 3D games – as in the case of *Breath of the Wild* – or working in engines different from the final tool. Simple engines with no-code interfaces are great prototyping tools for laying down basic gameplay ideas without the need to commit to a more complex interface or more laborious development pipelines such as those found in large engines. As an engine that uses visual scripting, simple sprites, and limited colors, GB Studio and other easy-to-learn engines like it (many of which are covered in Nathalie Lawhead's article "The Generous Space of Alternate Game Engines") make great prototyping tools (Lawhead, 2023).

Setting up the GB Studio Prototyping Environment

With this in mind, we will begin our own digital prototyping process with creating the player character of a theoretical action-adventure game in GB Studio (in both top-down and side-scrolling modes). We will also use GB Studio's templates to give the character an environment to walk around in filled with useful adventure gameplay mechanisms.

1. Open the GB Studio engine and navigate to the "New" project dialog. Select the "Sample Project" template and then click the "Create Project" button at the bottom of the window (Figure 1.25).
2. This will generate a new sample project for you, consisting of several scenes, shown as little windows of levels with title bars at the top. Click on the title bar of one of these scenes, then look on the right side of the interface: the *Editor Sidebar* on the right side of the interface shows all the properties of what you have selected (Figure 1.26).

FIGURE 1.25 Opening a new GB Studio Project with the Sample Project template.

FIGURE 1.26 The GB Studio interface with the Sample Town scene selected. You can see the different scene properties in the Editor Sidebar on the right side of the interface.

3. In the Editor Sidebar for the scene you have selected, its first option will be "Type." This is the type of gameplay that that scene will use. Options for Type include Top Down 2D, Platformer, Adventure, Shoot Em' Up, Point And Click, and Logo. Each describes a game mode that GB Studio supports out of the box. In the Sample Project, you will find examples of Top Down 2D, Platformer, Point And Click, and Shoot Em' Up scenes, along with some menus created from the Top Down 2D scene type. We will mainly be working with Top Down 2D and Platformer scene types ourselves.

4. Take some time to click around at the different objects and characters in the various scenes. These are all *Sprites*. In the Editor Sidebar, you will see their various properties, including the *Event* blocks that define how they move and interact within the game. By starting with the Sample Project template, we already have some common gameplay elements like signs, non-player characters with dialog, simple puzzle elements, and even save points in our project. These will be a basis for our own work.

Setting up the development environment

1. The first thing we want to do is create a character in Top Down 2D mode, and the first step is setting up the game so that it boots into a Top Down 2D scene when you start it up. Right now, it is set to start at the scene titled "Logo," show the title screen after the initial logo screen animation, then load the "Parallax Example" scene when the player selects "New Game" on the title screen. For this step, you can do one of two things. One option, if you want the game to boot immediately to your test scene, is to navigate to the "Logo" Scene, then LMB click and drag the red *Player Start Position* (Figure 1.27) icon into the Starting Town scene. The location where you leave the Player Start Position icon is where the player will start, so make sure you put them in a spot where they will be able to walk around and interact with the town: the parts of the scene marked with a red hue are where there is *collision* in the scene, meaning that they act like solid impassable walls. Put the character where there is no collision.

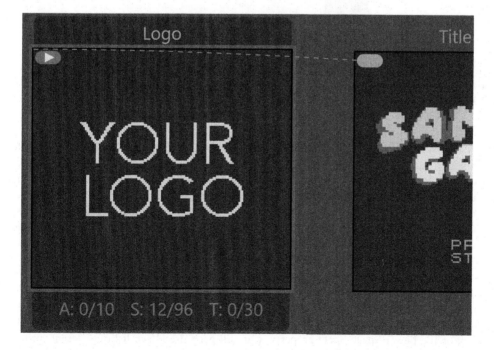

FIGURE 1.27 The Logo scene with the Player Start Position icon visible in the upper right corner. It appears red in the GB Studio interface.

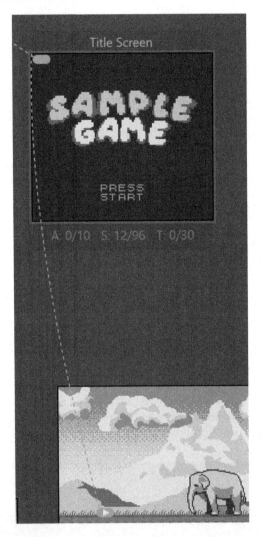

FIGURE 1.28 The title screen and Parallax Example scenes showing the Destination Icon and the dotted "spaghetti" line connecting the scenes. This icon will appear on the screen in blue.

2. Alternatively, if you want to see the Logo and title screens when the game loads, you can leave the Player Start Position where it is, and instead navigate to the title screen scene. In this scene, you will see a blue dotted line going from the upper left of the title screen to the left side of the Parallax Example scene, where there is a blue *Destination Icon* (Figure 1.28). This indicates that the scene is set up to have you travel from the title screen to Parallax Example after some in-game condition has been made (in this case, selecting "New Game"). LMB click and drag the blue Destination Icon to the Sample Town scene, making sure that you put this icon in a spot where the player will be able to walk around and interact without being stuck inside level collision geometry.

3. Click on Sample Town scene and look at the scene properties in the Editor Sidebar. There are options in this scene for gameplay Type, Background, color palettes for backgrounds and sprites, Player Sprite Sheet, and below all that, gameplay scripts in the form of Events. If you click on the Player Sprite Sheet property, you will get a dropdown list of different sprites the player can be. The player sprite is currently set to the "player" sprite sheet. We will leave this as is for now, but we will edit these options later in the book.

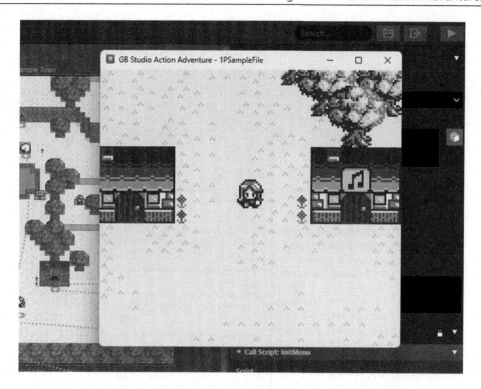

FIGURE 1.29 When you press the run button in the interface, your game will appear in a little gameplay window for testing. This test is running on a Game Boy emulator, so is analogous to testing the game on Game Boy hardware (though for dedicated quality assurance testing, you would still want to use the real thing).

4. In the upper right side of the GB Studio window are a search bar, and buttons named *Open Project Folder, Export As,* and *Run* (which looks like the "play" button on a web video or TV remote). LMB click the Run button and the button icon will become two arrows arranged in a circle, spinning around – this means that the game program is *compiling.* After a little while, a new window will appear (Figure 1.29) and you can play the game.

 To control the game, you use the arrow keys to move and navigate menus (like the Game Boy "+ directional pad"), the Enter key to open the game's pause menu (like the Game Boy "Start" button), and the Z key to talk and interact (like the Game Boy "A" button). Either Shift key functions as the Game Boy's "select" button, and the X key functions as the Game Boy "B" button, but there are no behaviors mapped to those keys yet

Creating a sword in Aseprite

1. In its current state, you can walk around and interact with characters and objects using the Z key/A button. Since this will be an *action*-adventure game, we will add an attack behavior. To do this, we first need a weapon.

 Open Aseprite. You will be greeted by its Home screen, which if you have never used Asprite before, will be mostly empty. In the upper left corner is an icon of Aseprite's mascot, along with options for "New File" or "Open File." LMB click "New File" and create a new 16 × 16 pixel document as seen in Figure 1.30.

FIGURE 1.30 The Aseprite mascot and new file option, along with the new file window. The Aseprite mascot will even react when you hover over or click it!

2. In the upper left corner of the Aseprite interface, and under the window tabs, you will see four buttons, including one with three lines on it. This is the *Options* button. LMB click on it, and you will get a pop-up menu. Navigate down to the "Load Palette" option and LMB click it to open a file browser window. From here, navigate to the location where you downloaded the GB Studio color palette during the tutorials from Chapter 0.2 "Downloading and Installing GB Studio and Related Software" and select it. This will change the color palette on the left side of the interface from a multicolored one to one with four shades of green and a very dark blue. These are the colors compatible with GB Studio. Please note that you should avoid the color picker under the palette window, as you must use the five pre-made GB Studio options.

Make sure you save your new Aseprite project with a descriptive name like "Sword" (Figure 1.31).

3. Select the first color in the palette, the very bright neon green (it should appear as the top left most option on the color palette). This is the color that GB Studio uses to mark transparent pixels (ones that it does not draw). This allows our sprites to not just appear as all squares. On the tool bar on the right-most side of the screen, select the tool that looks like a drop of paint or hit the "G" key. This selects the *Paint Bucket Tool*. Fill in the canvas with the green color (Figure 1.32).

4. On the bottom of the Aseprite interface, you will find the layer window. RMB click on the layer marked "Layer 1" to bring up a pop-up menu. Click on "New Layer" to create the layer where we will draw our sword art. If you RMB click the layers, you can also change their names by clicking the "properties" option in that menu. We like to name the layer where we

FIGURE 1.31 Loading the GB Studio color palette.

FIGURE 1.32 The Aseprite interface. On the left is the color palette. On the right is the tool bar. On the bottom is the layer window.

FIGURE 1.33 Drawing the sword's down frame in Aseprite using the pencil tool. You can make your workload on symmetrical sprites like this sword by activating the "Toggle Symmetry" buttons near the top of the screen (the tool tip is visible in this image above the button for horizontal symmetry) This will reflect your changes on one side of the canvas onto the other.

draw the sprites "Art" and like to name the layer where we put the screaming green transparency color as "background." You can also lock the background layer by LMB clicking the little button with the lock symbol to the left of the layer name so you do not accidentally paint on it.

5. In the tool bar, select the Pencil tool (or press the B key), then draw a sword as shown in Figure 1.33. This will be the "down" frame for when the character is facing downward. Use the black color for any outlines and the white and light green. DO NOT use the dark green or the transparent color to color in your sprites. GB Studio will not use the dark green on sprites and will instead render it as black – that color is only for use in backgrounds. Likewise, the transparent color will not render at all, so you should avoid it in sprites unless you want those pixels to be see-through.

6. Back in the layer window, you will now see dots next to the layer names, and under the number "1." This denotes that there is artwork on the layers in the first *frame* of animation. RMB click on the number 1 and select "New Frame" from the pop-up menu. This creates a new frame identical to the one that comes before it.

7. Open the "Edit" menu at the top of the Aseprite window and select "Flip Vertical," this will flip the art on your current frame and your current layer upside down. If you have the second frame and the layer where you drew your sword selected, you will have created the "up" frame of the sword that will show when you attack facing upward (Figure 1.34).

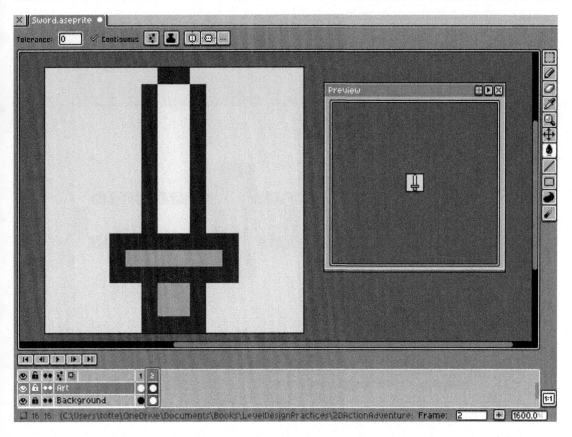

FIGURE 1.34 By flipping the artwork on frame 2 on our sword artwork layer using the "Flip Vertical" command in the Edit menu, we can create the "up" frame of animation.

8. Lastly, you will create the "right" frame by creating yet another new frame (frame 3), then with your sword art layer active, go to the Edit menu, select "Rotate," then "90 CW" for "90 degrees clockwise." This will rotate the sprite 90 degrees clockwise so that it is facing the right. You do not need to create a left frame, as GB Studio will automatically flip horizontal frames when needed (Figure 1.35).

9. Save your Aseprite file again. GB Studio does not take raw Aseprite files, so you will need to export your work onto a *sprite sheet*, or a strip of images that game engines use to create animated sprites.

 To do this, go to the File menu and navigate down to "Export Sprite Sheet." This will bring up a pop-up window with various file options. Click the check box for "Output" and click the button that appears to designate the file location where your new sprite sheet will go. You will want to navigate to the file location of your new GB Studio project and go to the Assets>Sprites directory, maybe even creating a new subdirectory for your own sprites, as it will already be filled with GB Studio's default sprites. Once you have selected an export destination and clicked "OK" in the file window, you can click the "Export" button, and your sprite will be created (Figure 1.36).

With both our GB Studio development environment and a simple sword object created, we can now assemble our initial gameplay prototype in GB Studio.

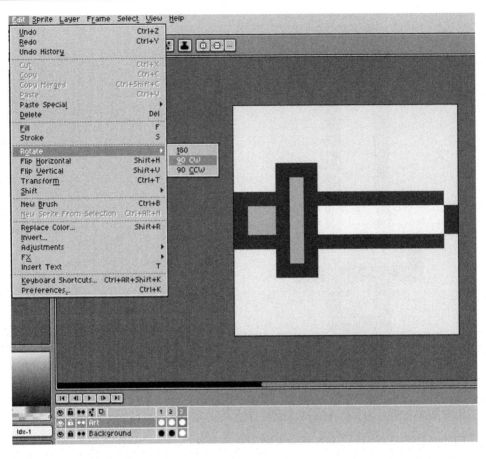

FIGURE 1.35 Rotate the sprite with the commands in the Edit menu. This screenshot shows the command you need to use, along with the result once you use it.

FIGURE 1.36 Exporting a sprite sheet out of Aseprite.

Assembling Character Prototypes

Having "set the table" for our prototype, we are going to assemble two character prototypes using sample elements from GB Studio – one for top-down gameplay and another for side-scrolling gameplay. This will allow us to explore different types of 2D action-adventure level design within our GB Studio project.

Creating the top-down character

1. Return to GB Studio. Since the player character is not an object in scenes, we are unable to add scripts to it directly. Instead, though, we can add behaviors to button input by using various scripting *events*. For the sword, we can add attack script to the scene itself to run when the B button (or X key) is pressed (Figure 1.37).

2. LMB click on the Sample Town scene, if it is not already selected. Below the "Player Sprite Sheet" property in the Editor Sidebar, you will see two tabs: "On Init" and "On Player Hit." These tabs are part of GB Studio's visual scripting system and act as the *functions* within code that some readers may be familiar with. "On Init" runs when the scene is loaded and can be used to set the stage for in-game events or cutscenes in interesting ways once you master using it. Sprite actors have "On Init" functions too, but those run *after* the scene's On Init function, meaning that events run from actors may occur on a delay once the scene is loaded.

 The On Init function already has three events, a "Call Script" event, a "Play Music" event, and a "Fade Screen In" event. Right now, we care about the "Call Script" event: it runs a *custom script*, which is a user-defined script, defined outside of scenes, that can be called easily within scenes. These custom scripts are useful for when you have something you will want to call often, such as the behavior scripts on an enemy, or a scene setup script that defines basic game commands and button mappings.

FIGURE 1.37 The location of the Add Actor command, showing the selected new sprite Actor and its properties in the Editor Sidebar.

The" Call Script" event calls a script called Init Menu, which takes the player to the menu screen when they hit the Start button/Enter key. You can edit this script by going to the "SCRIPTS" list on the left side of the World Editor interface, and finding "Init Menu." LMB click it, and the script will appear in the Editor Sidebar.

3. We are going to make several edits to this script. Since we will do more with it than define the Start button mapping, we will first rename it by double LMB clicking the title "Init Menu" at the top of the Editor Sidebar, and editing the name to be "Top Down Scene Setup."

Next, we will scroll down under the "Script" tab. You will see the "Attach Script to Start Button" script that makes the game switch to the menu scene when you press Start/Enter. At the bottom of this script, you will see two buttons labeled "+ Add Event," one within the "Attach Script to Start Button" event, and one below that and outside of the script. LMB click the one outside of the event to add a new event to this script (if you had pressed the other one, the new event would only run when you hit Start/Enter).

This will bring up a pop-up window with a list of potential script types (Figure 1.38), organized into categories. You will want to click on "Input," which will bring up another set of commands, then click "Attach Script to Button."

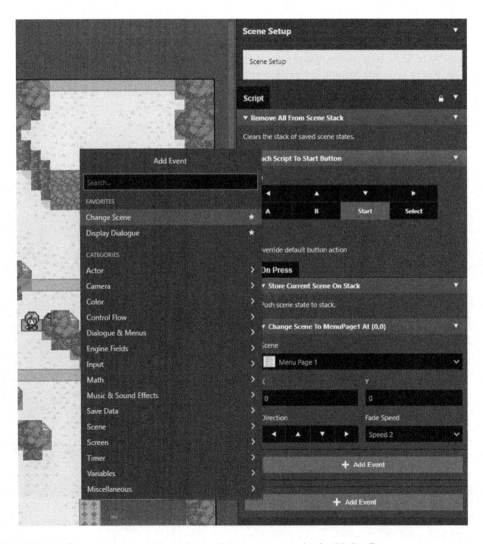

FIGURE 1.38 Adding a new event to our Scene Setup custom script in GB Studio.

4. Within this new script, you will see a "Button" property with different options: four directions, as well as A, B, Start, and Select. We will LMB click on "B" to map this new script to run when the B button or X key is pressed.

 LMB click the "+ Add Event" button within this new event. This will bring up the same window as before. The first event we will add is Variables > Variables Set to 'True'. This command takes a variable, or a piece of code that contains information, and sets it to be the value "True." Within the event is a dropdown list, navigate down the list to $Variable18 and LMB click on it to select it. We will use this variable, set to either True or False, to be able to notify other actors whether the player is attacking or not.

 Since "$Variable18" is not a very descriptive name, we will rename it by navigating to the left side of the World Editor interface again, this time to the "VARIABLES" list, and click on "$Variable18," this will open it up in the Editor Sidebar. Double LMB click the name property at the top of this and edit the name to be "IsAttacking."

5. From the "SCRIPTS" list, select our "Scene Setup" script again and add another event to our "Attach Script to B Button" event. This time, it will be a "Launch Projectile" event. Rather than navigating to it with our mouse, type "Projectile" into the search bar at the top of the event pop-up and you will be guided right to it – this is handy once you become more familiar with the GB Studio events available to you.

 LMB click this event to add it to our B Button event. In GB Studio, all attacks are actually projectiles, even if they are short range (you just set them to die out faster rather than fire across the screen). Make the following changes to this new event (also shown in Figure 1.39):

 - In the "Sprite Sheet" property, select the Sword sprite sheet that you created.
 - "Source" should be set to "Player."
 - In the "Direction" property, LMB click the dot next to the dropdown list, this allows you to select the "Actor Direction" option. Set the actor in the dropdown list to "Player." This will make sure that the sword is always aligned with the direction that the player is facing.
 - Set the "Direction Offset" property to 8.
 - Set "Speed" to 2.
 - Set "Life Time" to 0.1.
 - Un-check the "Destroy On Hit" box.
 - Set "Collision Group" to 1, and set "Collide With" to collision groups 2 and 3. GB Studio organizes collisions by groups, allowing you to set up how you want objects to interact. We will put all enemies on collision group 2 and any environment objects that you can hit with your sword on collision group 3.

6. LMB click the "+ Add Event" within our B button event again, and select a "Wait" event from the "Timer" category. This forces the script to stop running events for a specified period of time, and is useful for things like letting your player character have an invincibility period after being hit, etc. For our purposes, we are having the player stay in the "IsAttacking" state that we created for a short period of time while the attack object does its thing. For this, set the "Duration" property of the Wait event to 0.25.

7. Lastly, we need to bring the player out of the IsAttacking state. LMB the "+ Add Event" button under the B button event and select Variables > Variable Set to "False." In the "Variable" dropdown list within the new event, select our IsAttacking variable. Once we start creating enemies, we will use this variable to do things like making the player invincible while attacking so that the enemies can't get any "cheap shots" in.

8. Use the Run button to run the game. While the game is compiling, you can change GB Studio's project view mode with the dropdown list in the upper left corner of the interface. By default, it is set to "Game World," but if you select "Build & Run" while it is compiling, you can see the compiler do its work. When the game loads, you will now be able to do a simple sword attack by pressing the B button/X key. While there are certainly fancier ways to create an attack animation, this will serve us well as a first pass.

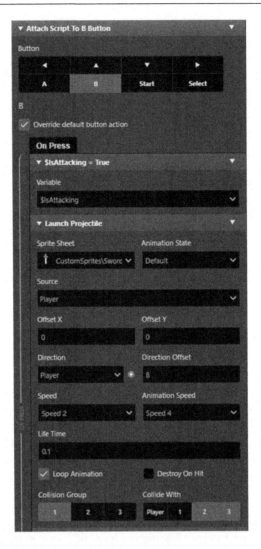

FIGURE 1.39 Making the attack itself with the Launch Projectile event.

Creating the side-scrolling character

1. Since this book covers both top-down and side-scrolling action-adventure level design, we will want to have an option for a side-scrolling character. This can be simply done by using other scenes in our template, along with learning how to copy events from one script to another.
2. If you changed the project view mode to the Build & Run mode in the last exercise, make sure to change it back to "Game World." Navigate to the "SCRIPTS" list on the left side of the World Editor and select our Top Down Scene Setup custom script.
3. In the Editor Sidebar on the right side of the screen, the script will display. To the right of the "Script" tab at the top of the script, there are a lock icon and an arrow pointing downward, LMB click the arrow. You will see options for "Copy Script" and "Delete Script," select "Copy Script" (Figure 1.40).
4. Navigate back to the SCRIPTS list on the left side of the editor and click the "+" icon at the top of the list to the right of "SCRIPTS." This will create a new custom script. Change the name property of this one to "Side Scroll Scene Setup."

FIGURE 1.40 Copying the contents of a script to be pasted elsewhere.

5. Click on the downward arrow next to the Script tab (the same arrow you used to copy the other Scene Setup script), and this time, select "Replace Script." This may be a little confusing, but this command replaces whatever is currently in the script (which is nothing right now), with what you have copied. The events from your Top Down Scene Setup script will now also be in this new one.

6. We will want to test the game again. Move the Player Start Position Icon or Destination Icon (whichever you used previously) as you did earlier in this chapter to the Parallax Example scene in front of the giant elephant. This will allow us to test in a side-scrolling scene. Run the game and make any adjustments you feel are necessary in the attack script

7. When you test, you may also find that you want to adjust the platformer character's physics. To do this, open the view mode dropdown list in the upper left corner of the interface and select "Settings." Click the button on the left side of this screen that says "Platformer" and it will take you down to the Platformer physics settings. Here are the settings we used to get a more tightly responsive-feeling character (as shown in Figure 1.41):

 • Change "Walk Acceleration," "Run Acceleration," and Deceleration to their maximum, 768.
 • Change "Jump Velocity" to 21282.
 • Change "Gravity While Jumping" to 1000

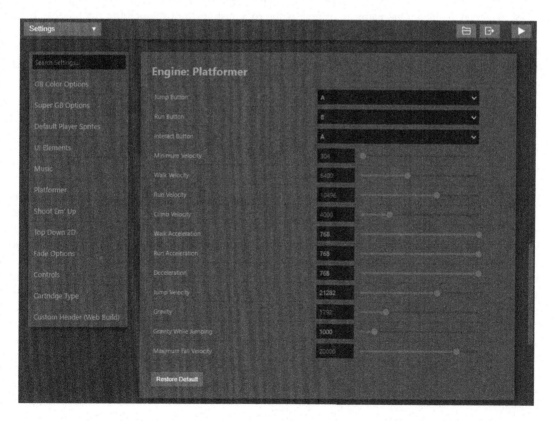

FIGURE 1.41 Making adjustments to the Platformer physics in GB Studio's Settings editor.

Having these two characters functioning is a huge step to exploring 2D action-adventure level design. In the final section of this tutorial, we will put some of this together so that the sample project scenes become a sandbox within which we can experiment with different gameplay mechanisms.

Putting It All Together

1. Return to the Game World editor view. LMB select the side-scrolling scenes within the sample project one by one and have the Call Script event that calls Top Down Scene Setup call Side Scroll Scene Setup instead.
2. Return the Player Start Position or Destination Icon that you moved back to the Sample Town. This is a good starting point that gives us access to different scenes, including side-scrolling ones.
3. You have everything set up now for a *sandbox environment* (sometimes also called a *"toy box"*), a sample environment within which you can test different gameplay mechanisms as you build them. GB Studio's templates come with many sample mechanisms pre-made such as signs, NPCs with different behaviors, pushable rocks, and *triggers* with different scripts attached. Triggers are transparent blocks of passable collision that will execute scripts as the player character moves through them.

Most triggers in GB Studio projects are used to move players from scene to scene using the "Change Scene" event – these are typically found in doorways or on the edges of a scene. Click around to see with the different objects and triggers do, and play the game to see how the different scripts make different types of gameplay happen. One pathway of note is the rock just north of the pond in the Sample Town scene, which takes you to a cave filled with pushable blocks, and finally to a side-scrolling cave with a treasure inside. If you press Start/Enter, you can even see a list of quests to take on. See what other surprises you can find as you explore!

CONCLUSION

Now that you have a prototype project in GB Studio with explorable environments and simple gameplay mechanisms, you can use the other planning, sketching, and diagramming methods from this chapter to start planning your own 2D action-adventure worlds. Having seen how scenes and different types of environments fit together, you can start to visualize how your levels flow into one another and introduce new mechanics. Tools like macro sheets, Boss Keys diagrams, molecule diagrams, and others will help us map these connections out to build satisfying exploratory gameplay. Now that we have explored the basics of the GB Studio and Aseprite interfaces and made a few things within them, we are ready to start editing this existing framework and add our own gameplay.

In the next chapters, we will examine common gameplay mechanisms for games in this genre such as switches, locks, keys, puzzles, and quest design. The design chapter devoted to these concepts will explore how these mechanisms are used in games and best practices for planning environments with them. The following practical chapter will see us building these mechanisms and a simple quest system in GB Studio (apart from the one that is already there) so that we can start fleshing out the moment-to-moment content of our game.

REFERENCES

Ching, F. D. K. (2015). *Architectural graphics*. Wiley.

Ching, F. D. K., & Juroszek, S. P. (2019). *Design drawing*. Wiley.

Dohta, T., Fujibayashi, H., & Takizawa, S. (2017). *Change and constant: Breaking conventions with "The Legend of Zelda: Breath of the Wild"*. March. Accessed October 3, 2023. https://www.gdcvault.com/play/1024562/Change-and-Constant-Breaking-Conventions

Fullerton, T. (2018). *Game design workshop: A playcentric approach to creating innovative games*. CRC Press.

Jenkins, E. (2012). *Drawn to design: Analyzing architecture through freehand drawing*. Birkhäuser.

Lawhead, N. (2023). *The Generous Space of Alternate Game Engines (A Curation)*. 13 September. Accessed October 3, 2023. https://www.nathalielawhead.com/candybox/the-generous-space-of-alternative-game-engines-a-curation

Lemarchand, R. (2021). *A playful production process for game designers (and everyone)*. MIT Press.

McMillan, L., & Azar, N. 2013. *The Metrics of Space: Molecule Design*. 15 January. Accessed September 35, 2023. https://www.gamedeveloper.com/design/the-metrics-of-space-molecule-design

Schell, J. (2019). *The art of game design*. CRC Press

Simmons, S. III (2021). *The value of drawing instruction in the visual arts and across curricula*. Routledge

Common Gameplay Mechanisms

2.1

In his book *The Beauty of Games*, New York University's Frank Lantz tells us that part of playing many games can be learning the *language* of gameplay objects and visual symbols through which they communicate with you (2023). In this particular example, Lantz praises a game that is ever changing the relationship between objects and game mechanics – changing its language. In action-adventure games, though, these languages help players decode the complex worlds that designers put in front of them. The last chapters have taken a "30,000-feet" view of world design in 2D action-adventure games to analyze high-level world and progression structures. These structures help us define, in broad strokes, what we want to accomplish spatially and functionally in our game levels, like envisioning what we want to get out of an essay. In this chapter, we will focus on the letters and words within our level design languages and look at specific gameplay mechanisms commonly found in action-adventure titles.

When looking at structures like hub and spoke, progression models like item and skill-based methods, or even the planning tools such as Boss Keys diagrams, they all function on how and when new explorable areas are revealed to players. Building a Boss Keys diagram to plan your level, for example, involves planning out when players will encounter barriers to progression, what the solution to that barrier is, and when the player finds the solution. Your answers for these quandaries shape the feeling of your game, often being the deciding factor between a quick and straightforward action experience or a slow and ponderous journey through a labyrinth. They can have other subtler impacts as well: two games may both use traditional "lock and key" mechanics, but one like the original *Legend of Zelda* may allow players to use any key on any locked door, whereas another may tie specific keys to specific doors, as in the *Metal Gear* series. The former creates a more open and freewheeling adventure, while the latter more tightly controls progression, but provides a more puzzle-box feel that many players find enticing.

In this following pair of chapters, we will explore some common gameplay and puzzle design mechanisms, as well as how they affect the feel and character of action-adventure worlds. Then, we will dive back into GB Studio to make our own versions of these mechanisms that see how they may be implemented to facilitate the progression structures that define this genre.

GATES

A major theme of our discussions of game world structures and progression thus far has been how parts of the world are made accessible and inaccessible to the player, often until some item or resource has been found. When talking about design mechanisms that block you from parts of a level, we are talking about what the industry calls *gating mechanisms*. For our purposes, we define a gate as any obstacle or hazard that blocks off a path for the player. This can include any critical or non-critical path, with the promise that they will be able to surpass the obstacle at a later point. While the appeal of nonlinear games is the freedom of choice and movement, restricting potential pathways offers several benefits. For example, it can create feelings of curiosity and mystery when players first come across certain gates. It also amplifies the reward of a new ability by creating a sense of satisfaction and anticipation to see new areas of

DOI: 10.1201/9781003441984-5

the game. From a design standpoint, restrictions also help developers to control the pace of the game by limiting the number of available pathways and slowly increasing the complexity of the map over time. In this section, we will explore some classic examples of gates in games, see how they are used, and analyze the feeling they create in players.

Locks and Keys

We will start by looking at one of the longest-running gates in games: literally locked doors and accompanying keys. These have been a part of exploratory games since tabletop games and have a direct parallel to the real world; a locked door with a keyhole which most likely has a matching key somewhere to be found.

An entire book could be written on the design philosophy of keys in video games based on the sheer amount of linear and non-linear games that utilize this mechanic. We will instead limit our scope by looking at the *Legend of Zelda* series exclusively and how it has used keys across different games in the series. Apart from ensuring this section is no longer than it needs to be, it also provides us with two models of lock and keys that each have their own benefits and detriments.

Global keys

The first two games in the series, *The Legend of Zelda* and *Adventures of Link*, took the same approach to keys that would establish fundamental patterns for the series, but would also create unique quirks in each individual game. The fundamentals of this system are the following: first, keys are only used for locked doors found inside of dungeons. Second, keys are a consumable item, meaning that when a key is used to unlock a door it is removed from the player's key counter. What makes the early *Zelda* games unique is that keys are global, meaning that they can unlock any locked door regardless of where the player found it. Later games in the series would move to keys being localized to whichever dungeon the player found the key in, creating a new dynamic that we will explore in the next section.

Global keys are one way in which the original *The Legend of Zelda* is much more open than future *Zelda* titles, with far fewer gates preventing the player from exploring the world. The game does not have story sequences outside of the ending, and the overall goal is to clear eight dungeons before being able to access the final dungeon. In addition, nearly all of those dungeons can be accessed without entering a previous dungeon.

Keys can typically be found either by defeating a certain enemy that is carrying a visible key, or by defeating all enemies in certain rooms. In this way, keys act as a reward for clearing a combat encounter, something future *Zelda* games would embrace. While most dungeons have just enough keys in them to complete a level, this isn't always the case. Dungeon Three has five keys for four locked doors, meaning a player can potentially finish the dungeon with one extra key on hand. This could work out well for them, as Dungeon Four has three keys for four locked doors, two of which are inessential to completing the dungeon. This may leave less thorough players stuck unless they go back to a previous dungeon or purchase a key from a shop. That keys are available in shops, and not exclusively in dungeons, in and of itself lends even more to the world's openness.

This approach will not work for every player. In his *Boss Key* level design series, Mark Brown notes that often players will find themselves holding more keys than they need and make the dungeon feel too easy or linear. Conversely, they can become frustrated by having to backtrack or needing to grind for money if they don't have enough keys. While this criticism is valid, it is also worth considering that most dungeons either only have one extra key or just enough keys to complete a dungeon. This makes the lack or abundance of keys while exploring a dungeon a feasible, though ultimately rare occurrence. Furthermore, *The Legend of Zelda* is a relatively short game compared to its contemporaries and relies on its open-ended nature to increase the length of the game for new players. Veteran players who enjoy replaying and finding optimal ways to play through the game such as speedrunners will find a lot to like

about this approach. Ultimately global keys pair well with a more holistic design approach such as *The Legend of Zelda* where the overworld and all of the individual dungeons are designed as one large space rather than individual challenges.

Local keys

Zelda games would abandon global keys along with the 8-bit NES console for future titles. While keys still largely act as a reward to be found in a dungeon for either combat challenges or exploration and puzzle solving, they cannot be taken outside of their respective dungeons. Furthermore, keys are no longer an item to be purchased in a shop as they are no longer necessary.

In the previous chapter, we mentioned that Brown had classified *Zelda* dungeons into distinct types (which can therefore extend to other *Zelda*-like games), including lock-and-key and gauntlet dungeons. Both types of dungeons use the local key system in distinct ways. Dungeons, where the player receives multiple keys and is given multiple locked doors that they have the choice to unlock, are the lock-and-key dungeons. This offers freedom of exploration and choice at the risk of players becoming lost, confused, or frustrated depending on the complexity of the level and other gate methods such as puzzles. Gauntlet dungeons are more linear and focus on individual combat or puzzle rooms. These dungeons tend to only give the player one key at a time which they can bring back to a previous room and continue forward exploration of a dungeon. This is akin to the design utilized by the shrines in the latest *Zelda* games, *Breath of the Wild* and *Tears of the Kingdom*, just on a larger scale.

The advantage to the local key system is that as the name implies, the designer can concentrate on the dungeon itself as an individual space. This allows for a more intricate, considered design that expects the player to completely explore and finish the dungeon rather than requiring them to leave and then come back. Similarly, the player only needs to think about the space they are currently in, reducing the cognitive load when deciding when and where to use the key, and making the key a more satisfying reward when they know exactly where they can use it.

Inventory Object Gates

Another popular method of gating player progress is through retrieval of an item. Depending on the game and genre, this can take many forms. In its most basic implementation, a non-playable character wants something the player needs to retrieve. The player must find said item, and once they bring it back to the person, they are able to make forward progress on the game. At a base level, this is the same as a lock and key; a door is blocking progress, once a key has been returned, the door is unlocked, and the player may continue forward. While inventory objects can function in this way, they offer aesthetic benefits and opportunities for unique design patterns.

The most obvious difference is that the form of the object and the gate creates semiotic or narrative meaning. *The Legend of Zelda*'s seventh dungeon features a room where a hungry, non-combative monster blocks Link's progress. Retrieving meat for the monster from one of the overworld shops causes the monster to disappear and the dungeon can continue. Despite the lack of proper dialogue or animations, the cause and effect of giving the monster food to continue forward is clear. This is a simplistic example, but it still demonstrates the power of inventory objects as a means of conveying narrative and world building.

This is in fact a major part of classic PC interactive fiction and graphic adventure design, which revolves almost entirely on retrieving and using items to clear gates. The first *King's Quest* game from Sierra Entertainment in 1984 tasks protagonist Sir Graham is tasked with retrieving the three lost treasures. Obtaining these treasures requires a combination of world exploration, lateral thinking and of course, collecting other items. By doing so, the player is motivated to engage with the game's fiction and learn more about the world and its secrets.

Like keys, items required to surpass certain gates can themselves be blocked off. This could include needing money to purchase the necessary item, such as the monster meat from the previous *Zelda* example, or by clearing a puzzle or ability gate. They can even be gated off by other item gates; a character has an item you need and will only give you an item in exchange for another. This is a typical pattern seen in many pure and hybrid adventure games, with long strings of inventory item gates which are colloquially known as a "white elephant quest," a reference to a common gift-swapping tradition.

Ability Gates

It is reasonable to say that ability gates help define the action-adventure game. These are paths that require the player character to gain a new ability to proceed. These abilities augment or expand the available actions to the player, such as being able to jump higher or add the ability to run. This gate directly ties character growth to forward progression in a less abstract way than traditional experience point systems and difficulty gates which we will discuss later in this section. Ability gates create many opportunities for designers. A door on a ledge above where a player cannot reach both creates mystery and teases the new ability for players, for example.

A major design consideration for abilities and gates is proper signaling and feedback. A great example is the opening of the first *Metroid*. At the start of the game, if the player goes to the right, they will eventually be met with a wall that has a one-tile high crawlspace along the bottom. As the player cannot crawl or duck to move into this space, they'd be forced to the left and back to the starting point. Continuing left of that point reveals a tall structure with platforms they can jump on, and beyond that a glowing orb perched atop a pillar in near-ritualistic fashion. Grabbing the orb pauses the game and executes a long music cue, signaling something important has happened, but giving no indication as to what. The player is then trapped in this space, with a wall to their left and the structure they just climbed now being unsurpassable on this side. The only notable feature is a similar one-tile high gap between the floor and the structure. It's only by trying every available button that a new player might realize that pressing down now allows Samus to turn into a one-tile high ball, capable of moving underneath the gap. They're now able to go back to the original obstacle and continue forward in the game.

This sequence has two important considerations. First, locking the player's progress until they learn about their new ability defines this area as a tutorial space. In modern games, gaining the ability would typically be accompanied by tutorial text explaining how to use the ability rather than forcing the player to discover the new ability. Lacking the memory to provide tutorial text for each item in the game, the NES *Metroid* instead opts for pausing the game and audial cues as a form of feedback that something important has happened. Regardless, the power of demonstration cannot be understated. This is why modern action-adventures have continued to teach skills using similar gates within tutorial spaces rather than relying on solely text to teach new skills. In fact, the variation of these gates used specifically to teach the player what abilities their avatar has is known as *skill gates*, and can be seen in games ranging from world 1-1 of *Super Mario Bros.* to modern games like *God of War*.

The other consideration is the gap that players fit through. By having the skill gate in the tutorial space be visibly reminiscent of later gates, players can recognize how and where they need to use the ability regardless of whether they have seen it previously or not. This is a simple example, but making skill gates unique combined with other level design techniques can help players to create a mental map of a space. One example of this is in the later *Super Metroid*, where the entrance to Kraid's lair requires the player to gain high-jump ability. Rather than having a standard door visible from the high perch, the lair has a unique door that resembles a creature's agape mouth. This visual combined with being too high to reach helps to remind the player about this area when they receive the high-jump boots.

Something to keep in mind when creating abilities and their gates is the ability's utility. A large part of the appeal of gaining new abilities in action-adventure is the feeling of strength that comes with the players expanded ability set. The bow and arrow in *The Legend of Zelda* series, for example, both give the player a ranged attack as well as a way to hit certain switches they previously weren't able to, for example,

giving it both combat and mobility functions. Giving the player multifunctional abilities helps them to feel meaningful and more than just a different type of key.

Another way to make abilities meaningful is a skill threshold that's required to use them properly. The grappling beam in *Super Metroid* for example requires the player to aim, catch a hook, swing, and let go at the proper time in order to clear obstacles. This creates different challenges for players and adds variety to the game. This technique is used extensively in *Axiom Verge* which gives weapons that need to be aimed and fired with unique shot types to hit switches, or *Cave Story* with its rapid-fire gun that doubles as a jetpack when fired at the ground. Abilities with higher difficulty may make it difficult for certain players to advance through the game, so care and playtesting are important in this case.

Puzzle Gates

As the name implies, puzzle gates task the player with completing a mental exercise of some sort before they can progress. Alternatively, they may receive a key, an inventory item, or skill upon successful completion of a puzzle. They are an alternative form of challenge, usually from combat in an action-adventure context. Much like inventory items, they can also be the only form of challenge such as in the popular *Myst* franchise. We will hold off on doing a deep dive into the various types of puzzles and puzzle design until later in this chapter. For now, we will discuss their implementation as a design framework.

Myst is an example of an adventure game that solely uses puzzle gates as a form of challenge, the only thing differentiating it from a pure puzzle game being its hub-and-spoke world map that opens further with each puzzle solved. Rand and Robyn Miller have said this was intentional, removing the guess work from inventory-object gates for lateral thinking and deduction. Modern adventure games have borrowed this paradigm including *The Witness* and *The Talos Principle*. Puzzle gates are also common in action-adventure games as well. *The Legend of Zelda* series will either require players to solve micro-puzzles within individual rooms or have dungeon-spanning macro-puzzles that require navigational memorization as well as lateral thinking to reach the end.

The indie adventure-exploration game *Sable* – which can be described as *Breath of the Wild* if it had no combat – is another compelling example of puzzle-based challenge and gating. The game is about a young woman on a ritualistic coming-of-age quest – her "gliding" – to discover her purpose in life. Progress in this quest, and options for Sable's future role in her society – is marked by acquiring masks representing different jobs or experiences. As such, the quests to earn masks for each job fall into different puzzle categories, such as using environmental resources to manage different species of beetle or moving batteries around to power the machinery aboard crashed spaceships. Though concise, the language of mechanisms used to create the puzzles is mixed and matched in ways that create a massive world of content.

Difficulty Gates

These are among the simplest type of gating mechanisms. Many classic action-adventure or role-playing games would use nothing more than strong enemies to block player progress in a particular area. This was particularly useful for RPGs where the odds of success were drastically impacted by statistics and mathematical formulas regardless of the player's tactical skills. Without editorializing too much, it is fair to say early PC adventure games wielded difficulty clumsily at best. Formative RPGs such as *Wizardry* or *Ultima* could have drastic difficulty spikes rather early in the game with seemingly little reason or warning. The Japanese RPG *Dragon Quest* is often credited for reducing this pain point by dividing its world map into sections and warning the player through the manual that crossing a bridge to a new area would result in tougher monsters. Yet even in *Dragon Quest*, difficulty spikes were still present before a bridge, just to a lesser degree.

Action-adventure games were not exempt from this either. *The Legend of Zelda* and *Metroid* both have worlds that are largely explorable from their outset with few gates outside of more difficult monsters in specific areas. The key area where early action-adventure games differ is that more difficult monsters generally lay on the periphery of their global map and could be defeated or avoided by careful players.

As they relied more heavily on locks-and-keys and ability gates to keep players from wandering into more difficult areas, action-adventure games quickly moved away from this paradigm. Today however, the popularity of *Dark Souls* and similar games from Japanese developer FromSoft has reintroduced difficulty gates as an acceptable design pattern. While *Souls* games have an experience-based character growth system more akin to a traditional RPG, numerical stat gains are relatively small. Therefore, the emphasis on success in combat is based more around available equipment and the player's twitch-reaction skills, especially in games with "*Souls*-like" elements, such as *Hollow Knight*. Thus, players who become more skilled at the game have more freedom of exploration available to them.

Putting It Together

While few games only employ one type of gate, some may be more common in certain genres than others. Most pure adventure games utilize some combination of puzzle and inventory-object gates. While escape room games that combine *Myst*'s first-person view alongside of inventory-object puzzles have become a popular subgenre, third-person adventure games such as the King's *Quest* or LucasArts titles such as *The Dig* also include puzzles that either are required to obtain an item or must be solved using an item. This is a common paradigm for survival horror where riddles are combined with inventory objects to create interesting puzzles. *Resident Evil* and *Silent Hill* games are well known for having players hunt around a small, dangerous space in search of inventory objects required to solve riddles that help break up the action.

While many genres have recently been taking influence from the *Souls* series, a trend in modern indie games has been to combine traditional Metroidvania tropes with *Souls'* open-ended world design. Games such as *Hollow Knight* and *Ender Lilies: Quietus of the Knights* still utilize lock-and-key and skill gates; however, they also focus on a skill threshold as well. This allows for them to have much larger maps with more explorable spaces for players of a proper skill level, while still having item and skill-based character growth such as *Metroid* or *The Legend of Zelda*.

With these overall gating paradigms in mind, as well as a sense for how they may be mixed and matched, we will look at some more specific elements of these systems to get a sense of how they may be used in our exploratory game worlds.

SWITCHES

Beyond locks and keys, another pervasive level gating mechanism is *switches* – mechanisms that when interacted with, activate other nearby mechanisms, including doors and gates. These can take many forms, including buttons that activate and stay activated if a player stands on them, buttons must be weighed down by a player or object to stay activated, buttons on in-game computer consoles, levers, and other types of simulated input devices. Switches can also be used in theatrical set pieces: in *Metroid Prime*, a solution to a puzzle is to scan a computer which makes the arm of a crane swing around to smash a wall and reveal an item. While this example is ultimately a fancy gate, switches – whether they be levers, computers, buttons, or other devices – can be used to create memorable scenes like this thanks to how they are represented in your game's fiction.

This is also just one example of how switches can be used in gating mechanisms within our games. Like keys, switches can be used to activate doors or remove barriers (either theatrically as with *Metroid Prime's* crane or by simply lowering a shield), but have other affordances that must be considered in design. In this section, we will look at different uses for switches.

Puzzle Switches

The first type of switch we will explore is the more common – switches used to activate other elements or mechanisms within a level. We will call these *puzzle switches*, as they are most often used in the context of other puzzle mechanisms. For this context, we are explicitly excluding switches that activate doors, gates, or exits that lead to a different area – even those used as the solution to a puzzle. Those will be covered specifically in the next section.

In action-adventure games, it is common to split puzzles into several stages, where a player has to solve one puzzle, only to unlock access to another. In the previous example of *Metroid Prime*, the sequence with the crane is part of a multi-stage switch puzzle, where players first discover a computer console with its power shut off. By scanning the console for information (a core mechanic of the game), they learn that a power conduit is likely nearby that will allow them to activate the console. This leads the player to switch to their character, Samus Aran's, x-ray visor, which leads them to the power source, which they can activate by shooting it with the electrically powered Wave Beam. As stated previously, the player then scans the console, which turns the crane and opens a section of wall. After this, the player must use another item, the Spider Ball, to travel along a magnetic track where they can reach a power-up in the area opened by the crane. This several-stage puzzle involves four character upgrade abilities (X-Ray Visor, Wave Beam, Scan Visor, and Spider Ball) and some deduction, but is ultimately facilitated by two switches – the power source and the computer console (Figure 2.1).

Puzzle switches become increasingly interesting when paired with other mechanics. In the *Metroid Prime* example, the switches cannot just be activated, but require separate tools to use (or even to see): the X-Ray Visor, the Wave Beam, and the Scan Visor. Making the second switch initially apparent, but not usable until the first switch is activated, makes for an interesting sequence and increases the time that the

FIGURE 2.1 A diagram of the crane puzzle in *Metroid Prime's* Main Quarry area in the Phazon Mine region. This puzzle requires the player to use several of their character upgrades and some deduction to solve it, but is facilitated by two switches. Only the middle switch in the sequence is initially apparent to the player, but requires a simple deduction puzzle to be solved before it can be interacted with.

player spends playing the game. Puzzle types will be covered in even more detail later in this chapter. For now though, it is important to know that puzzle elements such as pushable blocks, tool requirements for activation, or time limits can add extra intrigue to switches.

Tool-based switches

One such puzzle switch type is *tool-based switches*, which need a specific tool or object to activate. The power source that had to be electrified by the Wave Beam in our *Metroid Prime* example is one version of this. The method for activating these tool-based switches also enriches the game's worldbuilding: the Wave Beam is an offensive weapon, but also has the element of electricity, giving it another role in the game's fiction of powering machines.

Games in the *Legend of Zelda* series use tool switches often, such as fan-like switches that must be activated with wind-producing tools, or sun-shaped switches that players must direct a beam of light toward, typically with Link's Mirror Shield. These sorts of tool puzzle switches provide a more satisfying alternative to the blocks that require specific items to destroy found in Metroidvania games, which require a specific tool to destroy. While functionally similar (use weapon or item on thing to open access to place/other thing), packaging the mechanic can be fleshed out with additional art and animation. While we have certainly used both the destructible blocks and switches, varying your approaches to tool-based mechanisms like these helps create better variety and gives your players the sense that the game has more varied styles of gameplay.

Environment-based switches

Another type is *environment-based switches*. These are like tool-based switches in that they must be activated by some element beyond the capabilities the player has at the beginning of the game, except these explicitly use environmental objects to activate the switch. The most common example of this is the case of switches that must have a heavy object, such as a rock or a box, placed on them to fully activate the switch. In Chris's game, *Kudzu,* rusted switches had to be pulled down by kudzu vines. To make this happen, players had to solve puzzles so that a kudzu seed would reach the rusty switch, requiring either seed-spewing objects to be pushed or clearing pathways between seed sources and the switch (Figure 2.2).

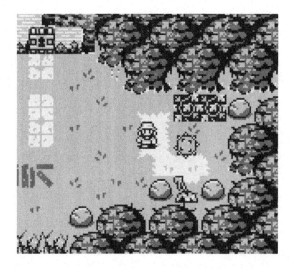

FIGURE 2.2 A screenshot of a kudzu puzzle from the indie Game Boy Game, *Kudzu.* Requiring certain switches to be pulled down by kudzu vines allowed for lots of freedom in puzzle design, based on the idea of helping kudzu seeds reach switches.

Like tool-based switches, environment-based switches also add to the game's worldbuilding. The idea that switches might be rusty or otherwise difficult to depress (maybe blocks in your dungeons have a magic aura, or interface with the ancient technology of the button in a specific way) allows opportunities for enriching both your world's design and fiction.

Key Switches

The other type of switch to discuss is what we will call *key switches*, that is, switches that act like alternatives to traditional lock-and-key puzzles by using a switch to open a door instead of a key. We are making these distinct from switches that open doors at the end of something like a puzzle, since one might see these in an environment without being part of a larger puzzle, as in games like *Hollow Knight*. While this seems like a simple concept, the decision to use switches instead of keys has some advantages and disadvantages worth considering in your design.

The first, and most obvious, aspect of using switches instead of keys is the distinction between the local and global keys that we discussed earlier in the chapter. Using switches all but eliminates the idea of picking which door you want to use a key on – effectively eliminating "global key" style interaction from your game completely. In most applications, this also eliminates even local keys, since switches tend to be tied to specific gates, except in theoretical situations where you might design switches to potentially serve multiple doors. Examples where switches may give the feel of local keys might include the switch-activated colored blocks that rise and fall from floors in *Zelda* dungeons, or a theoretical game where a player can route power from switches to different gates (someone feel free to make this). Overall though, using switches instead of keys locks you into specific doors or gates.

This is not always a bad thing. On one hand, linearity in design can sometimes be an effective tool for creating strong gameplay sequences that you wish to unfold in particular ways. Likewise, switches can be powerful tools for building open and non-hierarchical world structures. The Dreamers in *Hollow Knight*, which must each be killed and absorbed, work as switches in a way, in that each interaction with one furthers the mission of unlocking the gate to the game's final confrontations. As we described in previous chapters, we took this same approach in *Kudzu*, where we created doors and boss gates that could only be opened when the player flipped multiple switches or chopped down a specific number of kudzu roots (Figure 2.3).

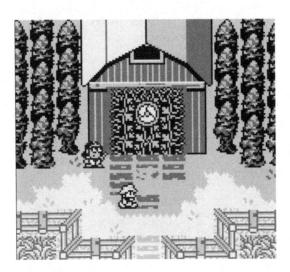

FIGURE 2.3 A boss door in *Kudzu*, showing that the player must kill 3 kudzu roots hidden around the area to open the gate.

With keys, there is a sense that you collect them and use them on a door if you have them, or that if you must find a specific key (like a boss key), that you have to find it, then haul it back to its door. With switches, the moment of mission fulfillment comes as the player flips the switch itself. The distinction between these two experiences is subtle but important. You still have to walk back, but the unlocking being done makes the journey feel slightly less like backtracking.

Indeed, switches' location-based nature is their main advantage. In *Hollow Knight*, the designers regularly use switches to tease the player into exploration. Early in the game, players find themselves at the top of a vertical shaft in the Forgotten Crossroads area, on a platform those sides are shut by giant gates, blocking off the rest of the room. On the bottom of the platform is a switch that can only be hit from below. Players have to instead traverse a series of winding passages to enter the vertical room from the bottom, then climb back up to hit the switch. This vertical room is actually a "highway" for the level – allowing quick traversal without having to pass through the twisty side passages packed with enemies. Seeing this switch from behind a gate creates an effective spatial tease and instills a sense of curiosity in the player on how they can reach the other side to hit the switch. While it is possible to create a similar effect with a floating key in the same location, the switch creates a stronger visual connection between the switch and the gates it activates than a floating key – which could be a random item unrelated to the switch – might.

Like keys, switches are common to the point of cliché, but the decision to use them over other mechanisms has massive implications on the design of your game. Their strongly location-based nature allows players to draw connections between switches and gates they may be stuck behind, giving players a powerful tool for communicating goals to players. In the next section, we will talk about another kind of goal-setting element of games, the quest, and how quests influence the design and structure of action-adventures.

QUESTS AND QUEST DESIGN

In games generally, but in action-adventure and role-playing games specifically, it is easy to casually discuss elements of the game as quests: we have even done this throughout the book, invoking the book's "quest" to better understand action-adventure level design. In reality though, *quests* carry great literary, symbolic, and narrative meaning, in addition to being activities that one does in a game. In his book *Quests: Design, Theory, and History in Games and Narratives,* designer and scholar Jeff Howard defines quests as "a journey across a symbolic, fantastic landscape in which a protagonist or player collects objects and talks to characters in order to overcome challenges and achieve a meaningful goal" (Howard, 2008). For our purposes, this definition hits some important points that speak directly to the design of action-adventure games and worlds, even beyond the landscape element. Much of this book has so far been devoted to the actual structure of our game worlds – specifically the challenges faced within and how they are revealed to the player – but the "symbolic and fantastic," "meaningful goals," etc. speak to traditions older than digital games.

The Purpose of Quests

Before delving into the purpose and symbolic and narrative potential of quests, we should establish a baseline for how quests function in games. Quests, above all else, provide *goals* to players as they move through your world – guidance to points of interest or the next event in a narrative. The structure of these goals is often used to lead players to important areas of the world, such as leading the player from the starting area to a central hub town where they will pick up other quests. In world design, these quests can be marked in a variety of ways, from directing the player via paths or varied tile artwork in 2D games, to landmarks, plumes of smoke, or other "*weenies*" that can be seen from a distance in 3D games. Massively

Multiplayer Online (MMO) games have had a lot of influence in quest design, which are typically presented as a sort of menu or checklist with a list of tasks for players to accomplish. This paradigm is convenient but also comes with a lot of negative baggage.

Much of the distinction between "good" and "bad" quest design, argue the creators of the *Extra Credits* video series, comes from how quests are given to and managed by the player. They advise against systems that treat quests as items on a checklist or otherwise devoid of narrative, such as performing tasks for a guild with little other story or reward involved. Similarly, *Kirby* and *Super Smash Bros.* creator Masahiro Sakurai talks about making engaging quests in his video on "Good Errands and Bad Errands" (2023). He argues that bad quests are those that feature little content beyond having the player traverse world space back and forth between the quest-giving NPC and the object of the quest with little other context or gameplay. Sakurai posits a theoretical game quest where a hero is sent to get herbs for a sick child, only to be sent to fetch other supplies, such as a mortar and pestle to grind the herbs with, as soon as they return – making the player feel like a "gofer." Both videos offer solutions to poorly designed quests such as these, such as providing engaging and meaningful rewards, using quests as a means to move the game's story along, providing "moments of joy" along the way, giving the player meaningful choices of how to complete the quest, and hinting at the world's greater context within quests (Sakurai, 2023). Even a seemingly simple fetch quest, Sakurai argues, can become more exciting if some secret is revealed along the way or varied gameplay is provided along the quest path. This speaks to the concept of *long-term goals* and *short-term goals* in games. The subject of the quest (finding a magic item, killing a monster, etc.) may be its long-term goal, but placing shorter-term challenges or elements along the way that are unique, but integrated, enriches the quest. Alternatively, Extra Credits directly cites the quest design of *Everquest*, and how it avoided rote-feeling quests by foregoing a quest list altogether and letting quests flow naturally from the player's own curiosity: letting them find a mysterious item or planting quest information in optional NPC dialog.

Both *Extra Credits* and Sakurai hint at what Howard would call the deeper purpose of quests: tying games and game levels back to the broader literary and cultural traditions of the *quest narrative*. As with most literature, quest narratives examine themes beyond the surface-level aspect of a person on an adventure. For example, the 14th-century chivalric romance *Sir Gawain and the Green Knight*, which Howard utilizes, is a quest that sees Gawain, the nephew of King Arthur, seeking the mysterious Green Knight in answer to a challenge. The poem explores themes of temptation and the nature of chivalry, among others. Symbolic objects likewise feature heavily in the poem, and further the themes of the narrative. The pentangle (five-pointed star where the interior diagonal lines are drawn) on Gawain's shield is said in the poem to be a symbol of Gawain's faithfulness. Likewise, the girdle that Gawain receives from the Lady of a castle in which he stays may symbolize a sexual trophy (throughout his stay, Gawain refuses the Lady's advances multiple times), or a loss of faith in the divine, as he is assured that the girdle will protect him from the Green Knight's axe.

Some may argue that games rarely feature this level of depth in how objects within them are conceived, but it is not uncommon in popular video games to weave game objects, narrative, and symbolism. The mystical Triforce in the *Legend of Zelda* series, for example, is made up of three triangles that symbolize Power, Wisdom, and Courage, and are represented in the three characters that possess them, Ganondorf, Princess Zelda, and Link, respectively. The interplay between these three characters and their prevailing "virtues" as symbolized in their individual pieces of the Triforce drive much of *Zelda*'s metaphysical narrative. A key feature of Soulslike games is likewise giving deep narrative significance to even simple items, such as the butterflies in *Elden Ring* being symbols of various gods within the game's lore. Through careful design, quests in games can be more than busy work meant to keep the player wandering through the world.

While this may seem like content from a book on broader aspects of game storytelling and narrative design, these manifest in how level designers reveal quests to players. As stated at the beginning of this section, giving players quests via NPC dialog, story sequences, or by putting other mysteries in the player's path entices players to move through our worlds. In *Kudzu*, we began the game with a simple quest: take some tea to your mentor, and quickly let it spiral into subsequent revelations as players move

through the game world. Upon finding the mentor's house, the player discovers he has wandered into a field of kudzu vines and needs rescuing. After the player has conquered the early part of the field, they discover that the field is huge, evil, and has mysterious characters wandering through it, all while discovering other side quests; suddenly the game has a network of quests to engage with. In *Little Nemo*, we closely tied quests and objects to the development of the world: unlocking part of the Mushroom Forest region requires players to find fertilizer so that a farmer can grow bouncy mushrooms. The quest is simple, but both open new areas and develop the visual identity of the world in a meaningful way. Quests in that game additionally garner "figments," which are tied to the hope that the people of Slumberland have for combatting the negative powers of the Nightmare Fiends. Carefully playing different types of quests and rewards off of one another, while also revealing quests – even as players engage in other quests – helps them feel like a rich and organic element of your world.

Quest Types and Presentation

Creating engaging quests requires knowing what types of quests one might encounter in action-adventure games. In their quest design video, *Extra Credits* cites these types of quests as among the most common (Extra, 2014):

- Kill Quests – venture out to kill a monster or group of monsters.
- Fetch Quests – retrieve a specific object.
- "FedEx" Quests – deliver an object to a character.
- Collect Quests – collect a specific number of objects (often in tandem with kill quests).
- Escort Quests – guide a non-player character (NPC) to a specific place and protect them from danger.

On the one hand, this is a useful typology of quest styles that designers (including this book's authors) frequently use in their work. On the other hand, the list is presented by the Extra Credits crew as a list of tropes with negative connotations. To combat this, we will briefly cover how such quests may be structured to create more exciting gameplay.

Kill quests

Kill quests are one of the most pervasive types of quests in games, dating back to some of the earliest computer role-playing games, such as Richard Garriot's *Akalabeth: World of Doom*. Quite simply, they are quests in which you have to kill one large monster or a specific number of smaller monsters. They are derided by many, and often with good reason: kill quests become boring and repetitive when they are too simple, such as when the player has no points of interest, things to do, rewards, or story events along the path between the quest giver and the target. At the same time, they are one of the oldest types of quest in culture, with a classic example being Beowulf's quest to kill Grendel in the epic poem bearing that hero's name. While they are RPGs and not action-adventure games, the *Dragon Quest* series manages these sorts of quests very well: the actual kill quest component is more like the spine of a bigger challenge, such as a dungeon. The player knows they must reach something at the end or eliminate a monster, but along the way are puzzles, other enemies, treasures, and so on, making the kill quest itself a very rewarding one. *Super Metroid* sets the player on a kill quest for specific boss monsters via a giant statue with the monsters' likenesses carved into it. As the player defeats the monsters, the pieces of the statue fade away and reveal the opening to the final area of the game. Between encounters with the monsters, though, the game provides the usual trappings of a Metroidvania: new items and abilities, other bosses, new zones, and other things to entice the player's curiosity. Finally, *Shadow of the Colossus* and *Superbrothers: Sword and Sworcery EP* offer their own spins by negatively changing the player in some way as they complete kill quests, increasing both the narrative intrigue and the symbolic complexity of the quests. The hero of

Shadow of the Colossus, Wander, becomes more corrupted by the game's antagonist, whose fragments were sealed within the Colossi. Likewise, the hero of *Sword and Sworcery* loses health after each boss fights, as her "woeful errand" ultimately requires her to sacrifice herself.

Fetch quests

Fetch quests are the other most used (and maligned) style of quests in games. They are the "errand" style of quests that Sakurai talks about in his "Good Errand, Bad Errand" video – where you are given the task of retrieving an item and bringing it back. As Howard points out though, the fetch quest is also one of the most storied types of quest in literature (just like kill quests). Emblematic ones include King Arthur's pursuit of the Holy Grail or Aladdin's retrieval of the magic oil lamp.

The rich legacy of the fetch quest as an archetypal style of quest hinges on the elements that Sakurai identifies as elements of a "good errand." While the Knights of the Round table frequently had such overarching longer-term goals in their quests – such as proving their worth or finding something – they frequently found other mysteries or challenges. In a literary sense, some of these smaller scenes contribute to the overall quest narrative by providing symbolic context to the overall quest. In *Sir Gawain and the Green Knight*, Gawain's stay in the castle where he is given the girdle is a test of faith and purity that provides further insight into the purpose of the quest itself. Sometimes, fetch quests in games are bolstered by other quests or challenges, such as the quest to retrieve the Master Sword in *Zelda: Link to the Past*. Rather than being a "one and done" errand, players must collect three pendants, each hidden in a dungeon with their own sets of puzzles and challenges, then successfully navigate the maze-like Lost Woods. This layering provides interesting depth that lets players map their progress in the fetch quest ("I have two pendants and need just one more") and keeps players engaged with a variety of quest-relevant challenges. Things like puzzles and battles are therefore not just "in the way," but "part of the quest."

"FedEx" (delivery) quests

Delivery quests (or "FedEx" quests, as they are called by the Extra Credits folks to create a little wordplay with "fetch quest") are quests where rather than retrieving an object, you deliver the object somewhere. This might include transporting an item to an NPC or taking an object to a place in the game world (such as putting a statue on an altar). These are also often paired with other quests, such as a delivery quest being the "other side" of a fetch quest ("find the thing and bring it back") or by having a boss guard the place you put an item.

Delivery quests offer some narrative opportunities that regular fetch quests do not. J.R.R. Tolkien's *The Lord of the Rings* is perhaps the most famous literary delivery quest: Frodo Baggins' quest to destroy the malevolent One Ring by throwing it into the fires of Mt. Doom. A constant danger throughout *The Lord of the Rings* is that the Ring will be stolen by its creator, the dark lord Sauron, or his many followers and its power used to subjugate the people of Middle Earth. This lends additional drama to genre-defining quest featuring dives into orc-filled mines, great battles, encounters with increasingly wondrous creatures, and lots of other spectacles. Though Tolkien famously rejected allegorical interpretations of his stories, scholars have since come to view them as having symbolic meaning, especially as a means for exploring the corrupting nature of power (Shippey, 1992).

While it is odious to think of a human as a resource to be delivered, one may say that *The Last of Us* is also a game about a delivery quest: delivering Ellie to the Fireflies so they can extract the cure for a global infection. The time spent with Ellie throughout the game becomes valuable for adding emotional weight to the ending, in which protagonist Joel realizes that the Fireflies must kill Ellie to extract the cure and massacres everyone in the medical facility to stop the procedure. This has led to interpretations of the ending as varied as a testament to the power of fatherhood, to questions of whether Joel is actually robbing Ellie of her agency in the situation (Kunzelman & Lutz, 2023). The delivery quest is not unknown to 2D games – both *Golden Sun* and the original *Final Fantasy* have their heroes carry artifacts with them

throughout the journey. While it is common to think of such artifacts as *macguffins* – or objects with no other significance except to move the plot forward – you can plan your quest structures to impart much more meaning and significance to them.

Collect quests

Collect quests are a lot like fetch quests, but with more things to fetch – typically items in a series. When applied to the main plot of a game, it is closely tied to the Rod of Many Parts progression model, where multiple parts of one artifact or multiple related objects must be collected to finish the game. As with other quest types, these quests also appear in literary tradition, such as Tang Sanzang's pilgrimage to find seven *sutras* (sacred texts) in *Journey to the West* (a scenario loosely adapted in the manga and anime *Dragon Ball*). *Zelda* games frequently use this model, having the player collect multiple instruments in *Link's Awakening* or the Sages' Medallions in *Ocarina of Time*. At times, they are even offset with a more singular fetch quest, such as collecting the three Pendants in *Zelda: Link to the Past,* which unlocks the way to the Master Sword (a fetch quest leading to the goal of defeating a wizard). They do not have to be the primary quest, though, and how these are implemented in games can add a lot of flavor to how the player explores the world.

In both Extra Credits' and Sakurai's explorations of quest design, we can see that the form of the quests is less in question than how they are presented. Early in *Hollow Knight*, the players receive a quest to retrieve caterpillar children who have gotten lost in the game's sprawling world, a typical example of a "collect quest." Another is the Secret Seashell quest in *Zelda: Link's Awakening*, where Link has found seashells hidden across Koholint Island to appease the spirit of the Seashell Mansion. Both quests are lightweight: in *Hollow Knight,* when players find a caterpillar in their spherical prisons, the caterpillar leaps for joy then burrows underground to return to their father. When the player returns to the father's chamber (easy to do because it is conveniently near the game's main town), they can stop in to receive any rewards they have earned for the task. *Zelda*'s Seashell quest functions much in the same way, with the Seashell house having a warp point near it, inviting lots of return trips. Both quests do not just offer rewards at the end when the player has found all the caterpillars or shells, but at specific intervals such that engaging the quest provides a variety of important upgrades and rewards. By being both convenient to engage with (collectables are found organically as part of regular exploration, returning to the quest giver is convenient) and consistently rewarding (quest encourages further exploration and lots of rewards), these quests are well-regarded.

In both models, how a collect quest is presented, along with how they blend with other types of quests, can be the difference between an interesting adventure and a chore. Games that task you with quests like "collect 10 mushrooms" as a task for a guild with little else to do along the way will quickly bore players. However, if those 10 mushrooms were the key to some other bigger treasure, and each mushroom was hidden behind some other puzzle or challenge, that could be the structure for a whole interesting game.

Escort quests

Perhaps the most hated of all quest types is the escort quest, where the player must travel with another character or unit, often protecting them from danger. While these are more common in 3D games instead of the 2D games that are the topic of this book, they still bear mention as playing with an NPC can offer important variations in gameplay. In combat games such as *Star Wars Rogue Squadron*, players experience escort quests as missions where a medical ship or one carrying an important person is subject to waves of enemy attack. Many players' frustration comes from the fact that the vulnerable, often not combat-ready, unit feels like a point of unfair failure – they may lose the whole level/mission even though they otherwise play well. This is not just an issue for combat games, but also action-adventure games, where even masterpieces like *Metal Gear Solid 3: Snake Eater* have pace-killing escort sections.

At the same time, there are masterpieces for whom escort missions feature heavily, such as *Resident Evil 4*, where much of the game is spent escorting Ashley Graham – the character that player character Leon Kennedy is sent to rescue from a mysterious cult. Ashley is considered a high point in escort quest character design, since she is allowed to be a partner in Leon's mission instead of totally helpless. This is accomplished through carefully scripted moments of interaction – when the player is exploring, Ashley runs along with the player character and assists in specific puzzle-solving moments. During combat, Ashley moves out of the way into a safe area to minimize friendly fire incidents. During large-scale combat encounters, where players fend off a lot of enemies in arena-like spaces, Ashley likewise hides but is occasionally grabbed by an enemy and carried off. In these instances, the player must shift their priorities from fending off enemies, to defeating the specific carrying her. While this seems like a nuisance, it does not happen often, is well-telegraphed, allows lots of time for the player to react, and is highly scripted as part of gameplay flow. These highly isolated moments provide the drama that is intended by the escort mission format, without the randomness or unfairness that comes from poorly designed examples.

Again, these are not only in 3D games. In *Zelda: Link's Awakening,* players must escort Marin, the villager who rescues Link in the beginning of the game, to sing for a walrus who is blocking the road to the game's desert area. This escort quest is not a traditional escort quest, in that Marin does not take damage and is, therefore, never in danger, even though there are enemies along the pathway. It is still a memorable part of the game, as the text that shows when the player interacts with an object or character becomes Marin's dialog instead of Link's, so there are opportunities for humor with the new perspective.

Kudzu does not have escort quests, but there are three boss fights where the player character, Max, fights alongside the game's deuteragonist, Grace (Figure 2.4). These fights are an important part of the story, as Grace's journey is the emotional core of *Kudzu*: Max observes as a "silent protagonist," which allows Grace to experience a fuller range of emotions.

We mention these fights because, as with Ashley from *Resident Evil 4*, Grace's behaviors are highly scripted in such a way that moves her from specific location to specific location at specific times. While we cannot speak to the specific implementation of Ashley in *Resident Evil*, Grace's behaviors are set up to feel spontaneous such that she does things like attack a snake's head after the player draws it out by hitting its tail. In reality, events like the snake boss's head popping out of its hole, Grace walking to the head's location, then "attacking" it are a scripted series of events that play after the player's attack

FIGURE 2.4 One of the partner boss fights in *Kudzu*, in which the player character fights alongside the most important NPC, Grace.

on the tail. They cannot "miss," and the boss still takes damage regardless, but the artifice of scripting Grace's behavior makes the fight feel like a team effort. As we see with other successful partner or escort characters, scripting their movement to be in the proximity of danger, but actually keeping them out of it (or making it impossible for them to take damage altogether) makes the *set piece* much more effective. Moments of the characters being in danger in a controlled way, such as Ashley being carried off and the generous time window one has to prevent it, make even escort missions not only tolerable but interesting. Likewise, treating the escorted character as a full partner instead of a weaker character helps build the narrative significance of these moments in the game.

As we have seen, these common quest types work best when mixed and matched with one another, or when they integrate elements like puzzles or enemy encounters into their design. In the following sections, we will also explore these challenges to see how they may be best integrated into our action-adventure worlds.

PUZZLES

Puzzles in adventure games have a very long history. The seminal text adventure game *Colossal Cave Adventure* by William Crowther in 1976 and later expanded upon by Don Woods in 1977, tasked players with escaping a cave by understanding its layout, experimenting with inventory items gained throughout the adventure, and solving various puzzles. While many of these puzzles were obtuse with little-to-no hints to their solution, the game was praised at the time for its sense of exploration and discovery. It is little wonder then that this tradition of mixing spatial navigation and brain teasers has been a staple of the adventure game genre over the years since *Colossal Cave Adventure*, though it has become much more refined with different approaches that can cater to wider audiences.

For context, we are defining a puzzle in this context as any obstacle with a non-obvious solution that must be solved using the player character's abilities, items, and/or equipment. It is differentiated from a skill gate or a key in that the player must utilize logical deduction or lateral thinking to discover the solution, rather than just using a tool or mechanic to bypass an obstacle. In this section, we will be exploring the use of puzzles in video games, both in general practice and in terms of nonlinear action-adventure games, as well as looking at several different classifications of puzzles and how they are utilized.

There are many reasons designers may want to consider adding puzzles to their adventure game. For one, they are a different type of challenge from the twitch action that tends to be the primary focus, allowing the gameplay to have some variety. While they can cause momentary frustration, they also provide a great sense of relief upon completion, often allowing players to feel smart for having solved the puzzle. They also can add a lot of texture to the world itself; many adventure games take place in fantastical locations such as fairytale kingdoms, haunted mansions, and hidden temples to name a few. Proper theming around puzzles can help make the world feel like a real place that doesn't want the player to figure out its secrets despite that it has been carefully designed for the player to navigate and solve.

Yet puzzles are also a contentious addition to action-adventure games precisely because they are on the opposite spectrum to the "action" part of the genre. This makes puzzles feel alienating to those players who do not play games to have their mental ability tested. And even among puzzle fans, different types of players have different tolerances for certain types of puzzles; some players may excel at logical deduction, but struggle with sliding image tiles, and any interruption to progress, no matter how brief, runs the risk of frustrating players. There is also the contradiction of puzzle difficulty as well; by their nature as obstacles with non-obvious solutions, it is very easy for even seasoned designers to create a puzzle that is too complex or too obtuse for many players. On the other hand, very simple puzzles may lead to the player feeling as if they are just doing busy work and wasting their time. So many different puzzle types out there and the complexity of puzzle design, they are often considered to be the hardest types of challenge for game designers to implement.

It is worth noting that different games will have different design goals. Traditional puzzle games such as *Sokoban*, *Adventures of Lolo* or *Baba is You* are composed of nothing but interesting puzzles that escalate in difficulty with each level. As such, the difficulty of these puzzles is expected to be more taxing as they are specifically catered to puzzle-loving demographics. New designers in the action-adventure genre may especially feel pressure to create a "perfect puzzle" that is obtuse and keeps the player stumped. However, these games use puzzles for narrative texture and variety, not for brain-bending difficulty, which means they can afford to be less difficult than these more traditional puzzle games.

Puzzle Structure

Before we look at specific types of puzzles, we need to discuss the general structure of all puzzles, and how they are used in the context of adventure games. This will allow us to understand and appreciate the different types of puzzles and what contexts in which they are most appropriate to use more easily. Specifically, we will look at two common forms of puzzles, how they can be recognized as puzzles, how they lead the player to discover the rules of the puzzle, and how they reward the player for their effort.

While puzzles are commonly used in adventure games of many stripes, the form they take can differ depending on the game. Some will entirely use the same inputs and mechanics as other elements in the game. Moving block puzzles such as *Sokoban*-types, which we will cover in the next section, are one example of this: the player pushes against a block with their on-screen avatar so they may move it where the block needs to go. Another example would be pressing a switch by having the avatar stand near it and pressing the interact button, or striking it with the character's melee attack, to make the switch move between different states.

Not all puzzles utilize the same game mechanics or interfaces as normal gameplay, however. Certain games will have puzzles that take place on different screens, such as shifting over to a first-person perspective. This is useful for puzzle variety such as moving pieces around a chess board. It also can help immerse the player into the world, such as getting to interact with complex machinery or arcane structures that exist within the world in a more direct way. Sometimes these puzzles require inventory-objects that players find in the game space before they're able to proceed with the puzzle, such as a missing battery that must be found before a machine can be interacted with.

Regardless of which format a puzzle follows, the player must be able to recognize a puzzle from other elements in the game, and they need to interact with the puzzle in order to understand how it works. For puzzles where interaction takes place on a separate interface from the rest of the game world, the shifting perspective helps indicate that new interactions are required to proceed. These shifts of perspective can be followed by dialogue text to hint at what the player needs to do or how they can interact on this new screen.

Puzzles that take place within the same gameplay context have unique challenges to consider. While they may utilize familiar movements and interactions, the resulting function may not always be immediately obvious. An extreme example of this is the doors in the original *The Legend of Zelda* that cannot open with a key. The solution to opening these doors requires guesswork from the player; either they must defeat every enemy in a room or push one of the blocks in the room to open the door, neither of which is signaled to the player in the game itself. Future *Zelda* games have refined this approach, such as by locking the player in completely until all enemies are dealt with or creating unfinished patterns of blocks on the floor that the player must complete to open a door. Regardless, the resulting pattern is the same in both these instances; the game's primary mechanics are used in such a way to create non-obvious scenarios, and the player must deduce how they work before they can solve the puzzle.

In his video titled *What Makes a Good Puzzle* for game analysis video series Game Maker's Toolkit, game design analyst Mark Brown refers to this process of the player discovering non-obvious systemic interactions and the resulting actions as learning the "rules" of the puzzle. This distinction between game mechanics and how the world responds is important; it is not enough that a player can move against a block, but how that block reacts to being pushed. If the block moves over one tile and a door opens, the

player learns that certain blocks may open doors. If the block moves one tile at a time with each push, the player learns that the block can move and may deduce that the block needs to go somewhere else in the room and can start looking around the room for clues. Once the rules have been established and the player can solve the puzzle, they are rewarded for their efforts.

Earlier, we defined puzzles as an obstacle with a non-obvious solution that results in a reward. The reward or goal can be any number of game elements, with making progress toward finishing the game or an optional reward of some variety. In some cases, the goal can be obvious such as a treasure chest that is in view but seemingly inaccessible until a solution to the puzzle is found. Seeing a goal that is out of reach helps signal to the player that a puzzle needs to be solved and is a great motivator to keep them engaged with a puzzle.

But this need not always be the case as depending on the context of the game's world, the existence of a puzzle can be rewarding enough. Puzzle-heavy games such as graphic adventures or survival horror games will often present textual riddles and interactable game objects such as switches or movable blocks but don't reveal the reward until the puzzle is solved. In nonlinear adventure games where player engagement is derived from exploration and discovery, the element of surprise can create memorable moments for the player.

In either case, the resulting reward for solving a puzzle should be clear to the player. This is similar to what was discussed in a previous chapter on how designers can use their level design to help guide the player and keep them from feeling lost or confused. If an ability allows the player to jump higher, then areas where this new skill allows them to progress should be marked by unique landmarks or easier to return to, for example. Likewise, if the resulting reward for a puzzle is a key required to open a new path, it is helpful that the item they received is clearly recognizable as the item they have been looking for. The same is true of optional upgrades or items that unlock bonus material; the benefit of the reward should be immediately obvious. Aside from the clarity of purpose, this also allows the player to feel satisfaction and relief at having solved the puzzle as they know what the payoff is immediately once they have received the reward.

Puzzle Types

Now that the form and structure of puzzles have been established, we can look at the specific types of puzzles that are employed in action-adventure games. We will also look at why these types are used, how they can be mixed and matched together, and how individual puzzles can be used on their own or as part of a larger macro-puzzle.

Sokoban

Sokoban, an early puzzle game originally released in 1982 for the NEC PC-8801 computer, has long been the basis for many puzzles within popular action-adventure games over the years, most likely because of the simplicity of its mechanics. In the original game, players control a warehouse worker who must move boxes around tight corridors to several marked areas on the ground below. All movement is tile-based; the worker can only move vertically or horizontally one tile at a time, and boxes can only be pushed one tile ahead of him. The puzzle comes in the form of immovable walls that block box movement, meaning the boxes must be moved in a specific order that the player must figure out, lest they or any of the boxes are no longer able to move, requiring the player to restart from the beginning.

While computers and game consoles became much more powerful very quickly throughout the 80s and 90s, games remained restricted to tile- and grid-based movement, making the act of pushing boxes or box-like obstacles around a map a fit for games with a similar top-down perspective to *Sokoban*. This meant that many puzzles in older action-adventure games often resembled *Sokoban*. For example, Figure 2.5 shows a scenario from *The Legend of Zelda: A Link to the Past* that acts as a simple *Sokoban*-style puzzle.

FIGURE 2.5 A diagram of a Sokoban-style puzzle from *A Link to the Past.*

Three blocks, two on the left and right and one in the center, are placed two rows in front of a treasure chest with walls blocking each side. Each can be moved one space either horizontal or vertical, but only one at a time and they can only be moved over once. The solution is simple; push the left and right blocks up once along the side of the chest, and then push the center block either to the left or right and claim your prize. Despite this simplicity, it is worth noting that nothing in the game tells the player how block pushing works or that there is a puzzle to solve; it's something the player must deduce on their own, including what blocks they are able to push. It's also more rewarding than if the player had entered the room and the treasure chest was sitting in the middle of the room with no obstacle blocking its path.

We see another slightly more involved example in the 3D horror game *Resident Evil 2* for the Sony PlayStation in Figure 2.6. Here, the goal is closer to the original Sokoban; two statues must be moved to a marked area on the floor. Once both statues are in place, the character can retrieve an item required to open a new part of the map. The only difference in the solution compared to a traditional *Sokoban* puzzle is that the facing matters; the statue facing to the left must be placed on the area marked on the right wall, and vice versa.

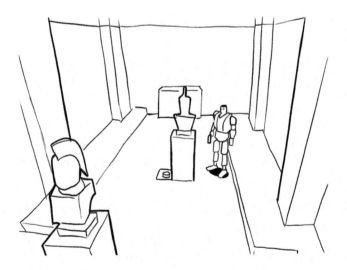

FIGURE 2.6 A sketch of a block-pushing puzzle in *Resident Evil.*

Moving the statues into place is trivial; there are few walls blocking the players' movement or the statues from being moved. Just like in the *Zelda* example above, the puzzle is more about tasking players with looking for context clues about what they need to do rather than the complexity of the puzzle itself. *Resident Evil 2* also provides more in the way of hints; however, the areas marked on the ground where the statues are meant to go are colored differently from the rest of the floor with visually distinct protrusions on the wall. Inspecting this area prompts the dialogue "Something seems to have been placed here...." The reward for solving the puzzle is also in plain sight; a red jewel that shimmers to catch the player's eye as it is held tightly by a big, immovable, marble statue with a plaque beneath it. The plaque reads "The god of the sun and the god of the moon. Their gaze upon me is the only thing that can release red soul." The two movable statues flank the sides of the larger, immobile statue. The graphical styling of Resident Evil 2 here is used functionally, whereas the interactable statues have much less detail and stand out from the pre-rendered center statue, signaling to the player that they can be pushed.

Notably, *Kudzu* features five different types of block-pushing puzzles, each dressed up in different ways. In addition to *Sokoban*-style puzzles where you move blocks to spots on the floor and others where you move blocks out of the way, there are also puzzles where pushable statues fire seeds can activate switches, pushable piles of leaves, and others. Block-pushing puzzles are indeed a versatile puzzle type that can be extended in lots of different ways, which is why engines like GB Studio feature pre-made tools for making them. As such, they will feature in the next chapter – the practical chapter in which we build some of the mechanisms we discuss here.

Inventory-object

We mentioned inventory-objects as keys required to unlock forward progression earlier in the chapter. Sometimes the use of inventory-objects needed to progress is specifically spelled out to the player; a non-playable character requires a certain item before they will let the player pass into the next section, for example. Sometimes, however, the key that is necessary is not obvious. This type of puzzle tasks the player to consider the different objects in their possession and deduce which one is needed to surpass a given scenario. This puzzle is typically seen in graphic adventure, survival horror, or escape room games, such as needing a sharp object to cut dense vines that are blocking a path. Additionally, some games will include a mechanic to combine two or more items to solve a puzzle.

Traversal

The *Sokoban* puzzle we looked at in *A Link to the Past* actually has two solutions. Before we looked at how players can receive the chest. But behind the three blocks is also a door. Of course, this puzzle is as simple as receiving the chest, but this reveals another pattern of puzzle design; how to get to a certain location that is blocked off by an environmental hazard. *Sokoban* block pushing is also seen often as a type of traversal puzzle, but it is by no means the only one.

Another example from *A Link to the Past* has a couple dungeons that feature orb-like switches that resemble a fortune teller's crystal ball. When the switches are set to blue, blue blocks around the dungeon are depressed into the floor and can be walked upon, while orange blocks will be raised up and cannot be surpassed. Hitting the switch with a sword or other melee attack causes the opposite. The goal of a traversal puzzle such as this is to make the player think about the space as having different states, how those states affect navigation, and how those impacts getting to their goal (Figure 2.7).

Reflexes

For action-oriented games, the puzzle isn't so much about figuring out how to accomplish a goal; it's reaching the obstacle before time runs out. Sometimes these puzzles are challenges testing the player's capability with a certain ability. In *A Link to the Past*, this is used as a test of the player's ability with the dash boots, an item they receive early in the game allowing them to run. Similarly, *Super Metroid* has several areas with crumbling blocks or gates that begin to lower once the player is on screen.

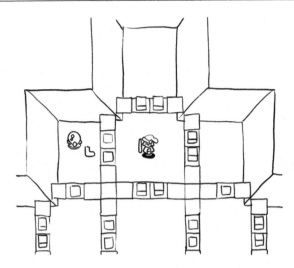

FIGURE 2.7 A sketch of Link hitting a crystal switch with his boomerang in *Link to the Past*.

For platforming adventure games, these puzzles can also test the player's knowledge of the game mechanics and button inputs, as well as being a mental exercise. A sequence from near the end of *Klonoa: Door to Phantomile* requires the player to hit three switches in any order; however, the switches are all on three-second timers. If any of the switches has not been flipped after three seconds, they will revert to their off sequence. They can flip the switches in two ways; either with Klonoa's projectile attack that only can reach a short distance, or by grabbing and throwing an enemy at the switch. The center switch is suspended in the air and requires the player to double jump in order to reach it. The easiest solution to this puzzle then is to hit the center switch first as it would seem faster to hit the other switches at ground level once the highest one has been dealt with. However, because the left and right switches are situated on opposite ends of the room, this can lead to the assumption that these two switches should be dealt with first before hitting the center switch. Furthermore, at least one of the two enemies on screen is required for Klonoa to perform his double jump to gain the height needed to hit the center switch.

In order to hit all three switches, the player must first grab an enemy at the bottom of the room and use it to activate a ground-level switch on either side, while also standing near a switch on the opposite. This will allow them to hit the switch behind them, grab and jump with the enemy that is next to them, and hit the topmost switch. As this puzzle leaves little room for performance error, it requires a deep understanding of how the game mechanics and character abilities work and interact with each other and how the room itself is put together.

Combat

While combat in adventure games is generally a separate activity from puzzle solving, occasionally they are intermingled, such as the previous example from *Klonoa* where capturing an enemy and using them as a projectile was required. Such as being required to discover an enemy's weakness. *Link's Awakening* combines combat with several different puzzle types throughout the game as well. This includes deducing how to use tools to discover enemy weaknesses before being allowed to proceed, or solving a riddle to deduce the order in which to kill different types of must-be-killed enemies before uncovering a treasure chest, to name a few.

Macro and micro puzzles in nonlinear games

Many of the puzzles we have looked at in this section use multiple puzzle types, such as setting switches on a timer for a reflex-based solution. For creating puzzles in nonlinear adventure games, it is important

to understand how they enhance the overall experience the designer is attempting to create. Earlier we discussed the different classifications of *Zelda* dungeons coined by Mark Brown's Boss Keys series, including puzzle dungeons where the appeal is understanding how all of the rooms in the entire dungeon fit together in order to find the items necessary and find their way to the dungeon's boss. These puzzle dungeons can be viewed as one large macro-puzzle, consisting of several micro-puzzles that must be solved as a part of the larger macro-puzzle.

Link's Awakening's Eagle's Tower, with its ball that must be carried to several locations on the map but casts restrictions on the player's navigational options, is one such macro-puzzle: the overall goal is to throw the iron ball into the four pillars, yet achieving this goal requires solving a series of smaller puzzles throughout multiple rooms, such as hitting switches to raise and lower walls or how to navigate back to the ball when it becomes unreachable. Solving these smaller puzzles requires how multiple rooms fit together as a whole. Macro-puzzles that carry through multiple rooms or throughout an overworld can be a very effective tool for non-linear adventure games as exploration and discovery are a part of the joy of those games.

Of course, *Zelda* dungeons also use individual rooms for puzzles, as do many other games. In Chapter 1.1 where we explored linear sequences in nonlinear games, we discussed how linearity can allow for more variety in individual scenarios and can be an appealing option for players who find mentally juggling multiple room configurations or complex navigation a daunting task. As such, micro-puzzle spaces can be a good option for games that utilize large nonlinear hub-spaces with linear spokes. They break up the action and fulfill the sense of discovery and mental challenge that comes with good puzzle design while still providing some sense of exploration.

Additionally, micro-puzzles offer the opportunity for more difficult puzzles that expert players can appreciate. For example, consider how difficult puzzles can be tied to optional rewards such as the difficult *Sokoban*-style block-pushing puzzle rewarded players an optional piece of heart in *Link's Awakening*. Additionally, we see this technique used often in 2021's Metroid Dread; many of the optional extra missile and health expansion upgrades require the player to execute perfectly timed advanced maneuvers in sequence with little room for error. Difficult puzzles such as these are generally not required to allow casual players to be able see the game's ending, and instead incentivize dedicated fans and completionists to continue playing.

Another potential application for difficult micro-puzzles is as a final challenge akin to a boss fight. *Silent Hill 2*, Konami's 3D survival horror sequel for the PlayStation 2, features a *Zelda*-like combination of an overworld and dungeons. Dungeons are nonlinear and composed of a combination of locks as well as inventory-object and logic-type puzzles. In the first dungeon, an apartment complex, the player is tasked with finding three medallions in order to retrieve the key they need to exit the level and see more of the overworld. Once all three medallions are received, each with a different symbol etched on the medallion, the player must solve a riddle to determine what order the three medallions must be placed in a series of five slots. The solution and difficulty of this last puzzle are determined by a separate puzzle difficulty the player chooses, but the result is the same; one last puzzle that culminates at the end of the level.

In the next and final section of this chapter, we will examine an element of level design that many designers overlook as part of the level itself, but which is vital in adding the action element to action-adventures.

ENEMIES AND MONSTERS

Once again, we should state that genre designations in games are, at best, handy but oversimplified and, at worst, a totally unhelpful mess that fails to adequately describe what happens in specific games. The "action" element of action-adventures is no exception: there are many games in which "action" can account

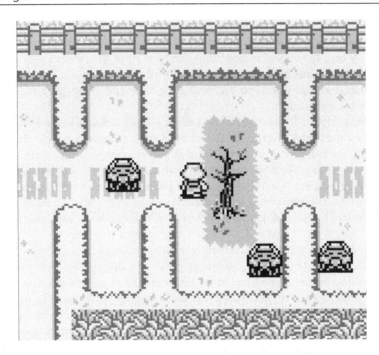

FIGURE 2.8 A screenshot from *Kudzu*, where wandering kudzu bug enemies are encountered in narrow passages in the period before the player acquires a weapon. The narrow space changes this simple enemy into a hazard to be carefully avoided, while in other circumstances, they might be cannon fodder.

for jumping, navigation, driving, or other reflex-based activities. For many, this also includes combat with enemies or monsters, which is why so many games quickly fall under the "action-adventure" umbrella (unless…they have RPG elements which…aaaahhhh!) All kidding aside, enemies are often an overlooked element of level design, not because designers do not use them, but because they are not always thought of as part of a level when compared to things like geometry or mechanisms. In reality though, enemies are important level elements, both because you can create level geometry to enhance how the player experiences their abilities and because they add important challenge to levels. This challenge becomes both points of interest that hold a player's attention as they move through your levels, as well as adding to the time players spend playing (Figure 2.8).

In general, game spaces should be designed around enemies as much as they are designed around the abilities of player characters. Level design can and does make enemy encounters more interesting, such as encounters where players can dodge behind columns or take strategically advantageous positions on high ground in 3D games. In 2D action-adventure games, designers can use even simple enemies to create interesting gameplay scenarios. One example might be having an enemy shoot projectiles from the top of the screen, then forcing the player through a twisty passage that passes through the projectile's path multiple times.

Mixing and matching enemies or mechanisms can also yield interesting results. The Mushroom Forest level of *Little Nemo and the Nightmare Fiends* has two different creatures that we were able to create multiple interesting scenarios with. One was a giant that stood in the background but smashed its club in the player's path on timed intervals, and the other was a walking bird whose head the player could stand on like a floating platform. We introduced each on their own and "*juiced*," or tried to get as many gameplay variations out of them as we could in relation to the level geometry. When we put these characters together, we were able to get even more interesting results, as suddenly players had to time their movements and jump more carefully as they avoided the giants' clubs while on the birds' narrow heads (Figure 2.9).

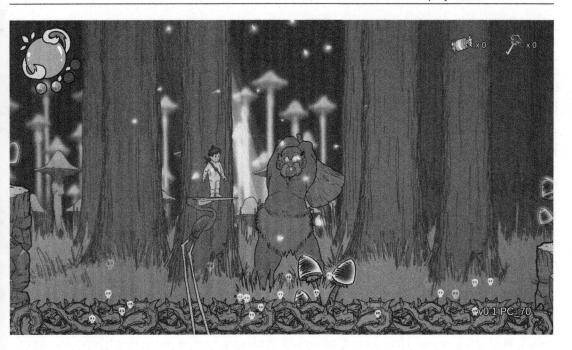

FIGURE 2.9 Screenshots of *Little Nemo and the Nightmare Fiends'* forest level, where the giant and "love bird" creatures each created interesting gameplay scenarios on their own, but created even more challenge possibilities when designers started mixing and matching them.

Ultimately, there will not be a one-size-fits-all solution to enemy placement for all games.. Designers have to carefully consider the enemies they have created for their games and prototypes to find interesting combinations of level construction, mechanisms, and enemy combinations. With that all being said, there are two different types of enemies we want to briefly cover, *battle monsters* and *puzzle monsters*.

Battle Monsters

First of all, we are using "monsters" in a broad sense here to mean all kinds of enemies, including animals, humans, robots, and otherwise. Battle monsters, or enemies that are placed purely for combat, are the much simpler style of enemy that one might put into a game. Their job is to provide challenge and slow the player's progress by making them stop for combat. In many action-adventures, such enemies are also paired with combat puzzle doors that will not open until the enemy is defeated. It should be noted that the number and difficulty of such enemies should depend on the gameplay *tone* of the game you are creating. In more difficult action-adventures such as *Hyper Light Drifter* or *Blasphemous*, having lots of enemies with intricate patterns or which take lots of damage creates a more severe tone those games are going for. On the other hand, many other action-adventures adopt a breezier tone with enemies and puzzles that are easy to beat, pulling players through the space as they dispatch enemy after enemy. It's worth noting that even in games with dark or severe theming, such as those in the gothic-horror-inspired *Castlevania* series, the gameplay tone of the Metroidvania-style entries feels more accessible due to how characters like Alucard can dispatch creatures.

Beyond these points, enemies designed purely for combat encounters fit neatly into some of the examples given above, where you can greatly affect how it feels to encounter them via how the levels around them are designed. A slow *Resident Evil* zombie, for example, would not be a threat in a wide-open arena but becomes more terrifying in the narrow hallways of the Spencer Mansion, where they can easily block

your path. We will cover boss design in greater detail in a later chapter, but boss enemies can be designed within this paradigm as well. Games journalist and Retronauts host Stuart Gipp advocates for more purely combat-based boss designs in games, arguing that even bosses that must be attacked as they go through a sequence of attacks can be interesting (Gipp, 2023). He specifically cites battles with Dr. Robotnik in classic *Sonic the Hedgehog* games, where the boss is vulnerable for most of the time he is onscreen, but the challenge lies in dodging interesting attacks to reach him.

Puzzle Monsters

More complex are puzzle monsters, which are enemies designed to be both combat encounters and puzzles. These are less straightforward in their design but offer important richness and variety in gameplay. The Dodongo Snakes in *Zelda: Link's Awakening* are one such puzzle enemy, which slither around in dungeon rooms and can only be defeated by placing bombs in front of them so that they are swallowed. These enemies are both challenging and require players to solve the puzzle of how to defeat them when first encountered. Even more puzzle-like are the Three-of-a-Kind enemies, also in *Link's Awakening*. These enemies appear in groups of three ("Three-of-a-Kind") and flash different card suit symbols on their stomachs as they move around. When the player attacks them, the suits stop switching and stay on the suit that the enemy was showing when hit. If the player can make all three matches, the enemies are defeated and the puzzle is solved, otherwise, the enemies will reset and continue moving around the room. Both enemies involve a level of deduction and reflexes to defeat: the player must first figure out how they can be defeated, then must perform the action itself (placing bombs in the right place, attacking with the right timing to stop the suit). Later games in the *Zelda* or *Metroid* series ramped up the use of puzzle enemies. In *Metroid Prime*, the Stone Toad enemy requires the player to roll Samus into her Morph Ball form and be swallowed so that a bomb can be placed inside the toad to kill it. Multiple enemies likewise are invulnerable to all but one of Samus's beam weapons, requiring players to deduce which beam to use in which situation. Still others, like several armored or shield-wielding enemies in *Hollow Knight,* require players to find a way around the enemy's defenses to get attacks in. While none of these are particularly complex as puzzles, the juxtaposition of puzzle and enemy within the same mechanism creates interesting gameplay situations. If the puzzles become more complex, or even include multiple stages of puzzle-solving, then they become more like boss designs. Such situations will also be covered in a later chapter when we more fully explore boss design.

CONCLUSION

Many designers do not consider the use of switches, keys, the designs of enemies, or other mechanisms to be particularly earth-shattering, but as we have seen in this chapter, these seemingly innocuous decisions can have huge impacts on your design. A theme of this chapter might be said to be, "take no design decision lightly," as adding more nuance, complexity, and meaning will create richer gameplay experiences. Keys, for example, come with a number of extra considerations beyond whether to include them or not, such as whether keys can be used everywhere in your game world or just in specific areas. Quests, likewise, should not be added haphazardly, as a list of chores on a bulletin board or dictated by an NPC, but work best when layered with other quests, challenges, and narrative details. While these building blocks are common and often simply implemented, how you as a designer integrate them into the internal logic of your world can help it feel like a relatable place.

In the next chapter, once again one of our practical chapters, we will build some of the mechanisms discussed in this chapter in GB Studio, including switches, locked doors, a simple quest system, and others that will hopefully help you to start fleshing out your world.

REFERENCES

Extra, C. (2014). *Quest design I: Why many MMOs rely on repetitive grind quests.* 26 February. Accessed October 30, 2023. https://www.youtube.com/watch?v=otAkP5VjIv8

Gipp, S. (2023). Sonic 3 & knuckles part 1. *Retronauts,* 3 April. Accessed December 29, 2023. https://retronauts.com/article/2043/retronauts-episode-524-sonic-3-knuckles

Howard, J. (2008). *Quests: Design, theory, and history in games and narratives.* AK Peters/CRC Press.

Kunzelman, C., & Lutz, M. (2023). *The last of us roundtabld.* 27 April. Accessed November 3, 2023. https://player.fm/series/game-studies-study-buddies/the-last-of-us-roundtable

Lantz, F. (2023). *The beauty of games.* MIT Press.

Sakurai, M. (2023). *Good errands and bad errands.* 20 January. Accessed October 30, 2023. https://www.youtube.com/watch?v=IM9P9NIKol0&t=78s

Shippey, T. (1992). *The road to middle earth.* Allen & Unwin.

Building Basic Gameplay Mechanisms

2.2

From the previous chapter, covering design concepts related to common action-adventure gameplay mechanisms, we can see that even simple game objects can add a lot of richness to our worlds. The myriad of decisions that go into how a designer uses locks, keys, switches, or other elements greatly affect how a world feels and plays. In addition, using these tools as we build out our game levels helps increase the time that players spend in our games. While this sounds like the "time in app" rhetoric of cynical games-as-service design, in single-player authored games, we are talking more about the game offering a satisfying amount of content. While it's tempting to think of more content (i.e. levels, rooms, etc.) being the best way to add more time, that is not always feasible. On the one hand, there are the time, human, and financial resources that go into creating content – more time is essentially more money, and for devs on small teams (or working alone), potentially more burnout. On the other, you may run into memory issues when working with smaller-scaled engines: memory leaks a real hazard for games as their scope expands, causing game-breaking or crash bugs.

The original *Metal Gear Solid* is a game notable for its very small actual level area – consisting mainly of a few buildings and their basements – that still provides multiple hours of gameplay and a compelling story. While the game does have backtracking that has not aged particularly well, it mediates player movement through the world via clever use of locks, keys, and tools that require the player to take twisty side-paths. As in our design concept chapters, we have seen how many of these games force players through more complicated routes during the first visit to a region of the world. After key challenges have been overcome, switches activated, or keys obtained, the world opens up more direct pathways ("the highway") that then make transit easier.

These spatial tricks of making the world seem very big and then making it very manageable are all done through the magic of the mechanisms we studied in the previous chapter, and which we will build in this chapter. Rather than focusing on just building the tools themselves, we will also address the need for *permanence,* which will allow these mechanisms to stay activated/deactivated even as you travel to other scenes or other parts of the world. Even if you are not interested in developing a whole game in GB Studio, this will hopefully make you think about how you might add permanence to your own game mechanisms in other engines. Our goal here, overall, is to create a toolbox of parts, usable in both top-down and side-scrolling views (all would use essentially the same logic except for enemies) that will help us get the most out of our game worlds.

DOOR SWITCHES

We will start with one of the most basic gameplay mechanisms, a simple door switch. As stated previously, this mechanism is simple in implementation but has a lot of impact when built into an environment in interesting ways, such as when put just out of the player's reach.

DOI: 10.1201/9781003441984-6

Our version of the door switch will not only open a door but will also use GB Studio's *Flag* system to record that the door was opened and should remain so throughout the game.

Making the Switch Sprite

1. First, you will need to create the switch itself. Open Aseprite and create a new 16 × 16 pixel sprite and load the GB Studio color palette as you did in Chapter 1.2.
2. You will need a sprite with two frames, one in a "deactivated" position, and the other in an "activated" position as shown in Figure 2.10.
3. Now you will need to create a door sprite. Create another new Aseprite file with the same setup (16 × 16 pixel sprite, GB Studio palette), and draw just one frame as shown in Figure 2.11.
4. Now that you have your sprites, we can implement them in the engine. Open either the GB Studio project file that you completed in Chapter 1.2 or open the "GB Studio Action Adventure – 2PSampleFile_START" project file in the online resources for this chapter.

 From now on, each chapter will have a "START" and "END" file, the former being the game in the state it should be in as the chapter begins, and the latter being the game after all a chapter's tutorials are done.
5. Export sprite sheets for your new sprites as you did in the previous chapter, and load them into the Assets > Sprites folder within your GB Studio project.

FIGURE 2.10 A simple lever sprite to be our door switch. You will create two frames: one for the "deactivated" position, and the other for the "activated" position.

FIGURE 2.11 A simple door sprite with one frame. Instead of giving it an "open" frame, you will simply hide the sprite.

Implementing the Sprite Sheets and Actors

1. Next, we need to place the sprites themselves. Navigate to the Sample Town scene near where you begin your game. In the upper left-hand corner of the Game World editor view, select the Add Actor command and place a new actor on the door to the music shop in the town. This will be the door sprite, so we will name it "Door."
2. Depending on the sprite sheets you have loaded in the project, the new actor may show up as the new door sprite by default. If it does not, navigate to the Editor Sidebar with the new sprite selected, and click the sprite image under the Sprite Sheet option. This will open a dropdown in which you can select the sprite sheet that the new actor will use from a list of the sprite sheets loaded into the project Asset folder (Figure 2.12).
3. Now, we should add another actor near the door, which will be our door switch. Use the Add Actor command, and place the new actor near the door – putting it in a location where you have to find it as part of a puzzle is not necessary now, we want it very close so we can test it quickly. As with the last actor, make sure to set the Sprite Sheet option in the Editor Sidebar to the correct sprite as in Figure 2.13. Since this is an actor that will open nearby doors, we will name it "LocalSwitch."
4. Select the LocalSwitch actor if it is not already selected, and open the dropdown menu under the "Animation Speed" option in the Editor Sidebar. It is set to "Speed 4" by default, meaning that it will play its animation frames in a loop. We do not want it to change frames until we activate the switch, so set the animation speed to "None."
5. Next, we will start to add the behaviors to our door and switch actors to make them work as a pair. With the LocalSwitch actor still selected, click the "On Interact" tab in the Editor Sidebar – this will make the events we add activate when the sprite is interacted with by walking up to it and pressing the A button/Z key.

FIGURE 2.12 Choosing which sprite sheet the new door sprite will use.

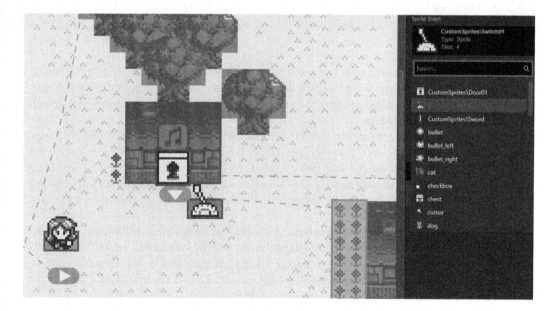

FIGURE 2.13 Choosing which sprite sheet the new switch sprite will use.

Click the "+ Add Event" button and add the following:

- A "Set Actor Animation Frame" (located in the "Actor" event list) event, with the "Actor" option set to our LocalSwitch actor, and the "Animation Frame option set to "1."
- A "Hide Actor" event (Actor > Hide Actor), set to hide the Door actor. This will make the door "open" when we hit the switch.
- A "Set Actor Collisions Disable" event (Actor > Set Actor Collisions Disable), set once again to the door actor. This will make it so you can go through the now-open door (Figure 2.14).

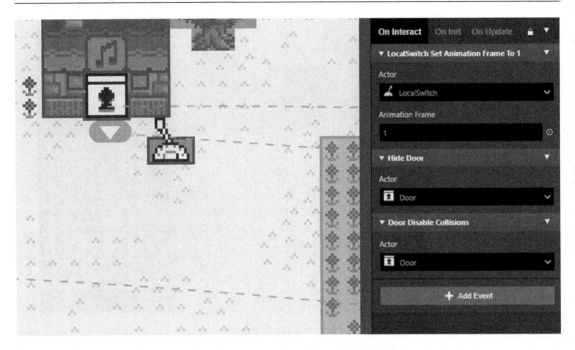

FIGURE 2.14 The script that you will add in the "On Interact" tab of the LocalSwitch object.

6. If you were to play this scene now, you could open the door with the switch and enter the music shop, but when leaving, you would find the door blocking the shop again and the switch deactivated. We want to build some permanence into our level so that puzzles stay solved, so we will use GB Studio's Flags system.

 "Flags" are really a name for the bits of data inside each variable. For our purposes, this turns each variable into potentially sixteen True/False variables. This is useful for adding permanence, as we can add flags whenever we do things like solve puzzles, open treasure chests, and kill enemies. It also saves us from having to use one variable per switch/puzzle/door/enemy, greatly saving on the limited memory inside of Game Boy ROMs.

 Create a Variable Flags Add (Variables > Variable Flags Add) event within the On Interact tab of the LocalSwitch object. In the dropdown menu marked "Variable," select "Variable19" and rename it "PuzzlesSolved01" by clicking the pencil icon next to the dropdown arrow. Select the check box next to "Flag 1," which will make the LocalSwitch actor set Flag 1 of the PuzzleSolved01 variable to "True" on interaction (Figure 2.15).

7. While we have the switch set the Flag, it does not actually do anything yet. To fix this, we need to add some events that run when the scene opens. For this, we will go into the Door object's "On Init" tab. Add an "If Variable Has Flag" event (Control Flow > If Variable Has Flag).

 This event is equivalent to a *conditional* statement in other scripting languages, which checks whether something has happened, and then runs lines of code if the condition is met. In this case, you can set it to run other events if the condition is met. To set up our condition, we need to set the value of the "Variable" dropdown to our PuzzlesSolved01 variable (to make things easier, when you have the pulldown open, you can start typing the name of a variable to search for it). Then, set the value of the "Flag" dropdown to "Flag 1."

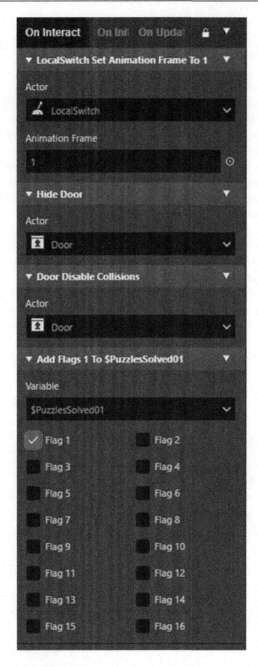

FIGURE 2.15 The updated LocalSwitch script, now with the Flag event.

8. You will also see a new "+ Add Event" button inside of the conditional event, this is for adding events that will run if the condition is met (we will not worry about the ones inside the "Else" part of the conditional yet). Add these following events:

- Set Actor Animation Frame (Actor > Set Actor Animation Frame), with the "Actor" drop-down set to the LocalSwitch actor, and the frame set to "1."
- Set Actor Collisions Disable (Actor > Set Actor Collisions Disable), with the "Actor" drop-down set to the Door.

- Actor Hide (Actor > Actor Hide), with the "Actor" dropdown set to the Door actor (Note: if your scripts include a "Hide" command, it is best to put it last, as some events may not run if the actor they are on is hidden).

This event checks whether Flag 1 of PuzzlesSolved01 has been activated when the scene starts and executes the commands inside it if it has. In this case, we have set it to solve our puzzle for us when the scene is loaded, if we have already solved the puzzle. Otherwise, puzzles will reset when you leave the scene and come back, or when you open an in-game menu (which in GB Studio, is often accomplished by going to a menu scene). Note that sometimes, allowing puzzles to reset before they are solved can be handy, in case there is a situation where the player makes a puzzle unsolvable, such as if they push a block to a place where it cannot be pushed out of.

9. If you play the game now, you will be able to open the door by interacting with the LocalSwitch actor, walk inside the music shop, then exit back to the Sample Town scene to find the puzzle still solved (Figure 2.16). This kind of permanence is important to build into action-adventures, as players will constantly be traveling back and forth, checking menus, and other scene-related activities. You want to make sure that the state of objects stays consistent between scenes for the player to feel as though their actions matter in your world.

10. Before moving on to the next mechanism, you may want to save your new door switch as a *prefab* object, which means that you can easily create new instances of it on the fly without building a new switch from scratch or copying it from another scene. To do this, navigate to the top of the editor sidebar on the right side of the screen, where you see the name of the game object. To the far right of the name, there will be a dropdown arrow, click it and you will see

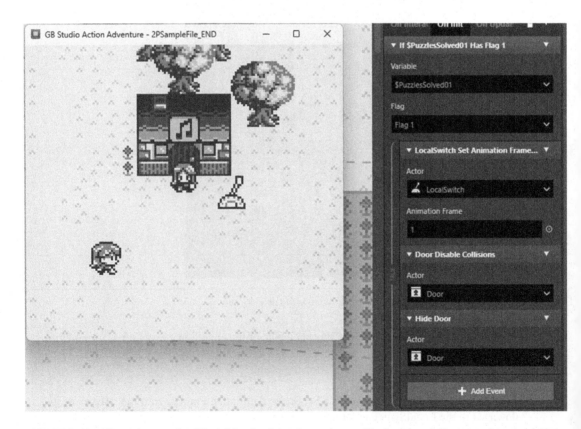

FIGURE 2.16 The scripts on the "On Init" tab of the door, along with the game being tested to check if the permanence works properly.

a pop-up appear with the option, "convert to prefab." When you click this, the switch object will appear in the "prefabs" folder within the navigation panel on the left side of the GB Studio interface. Anytime you need a new copy of the switch, you can click the "+" symbol next to it and place the object wherever you want in the project. Just make sure you modify any flags or variables so that the new instance of the prefab does not interfere with the operation of existing puzzles (like if one door switch puzzle uses "flag 1" of a variable, the new switch instance should use "flag 2", etc.)

With this, our basic door switch is done. Next, we will make a "multi-switch" door that adds some gameplay complexity by adding some multi-goal explorable space to your level. More importantly, however, we will add events that help us manage the game's permanence and reset our puzzles when beginning a new game.

Multi-switch Door

In previous chapters, we discussed how some games create the feeling of more "explorable space" (to use Mark Brown's terminology) by making it necessary to find multiple objects or achieve multiple goals but offering the chance to achieve them in any order. Many games do accomplish this by requiring that doors be opened with multiple keys, but another could be activating a door or machine by activating multiple switches. In this quick extra credit section, we will cover some simple changes you can make to your door and switch actors to add some "choose your own quest" functionality to your world.

1. First, create some sprites similar to the ones in Figure 2.17, and bring them into your GB Studio project by exporting the sprite sheets into the Assets > Sprites folder. You could theoretically use the same sprites for the multi-switch doors and switches, but giving them a unique visual identity will help them stand out to players and be easier to understand as having a different function than the standard doors and switches. Make sure to edit both frames of the switch animation!

2. Select the Door actor in your GB Studio sample town scene. Press CTRL (CMD on a Mac) + C to copy the door sprite. Press CTRL/CMD + V to paste the door sprite. If your mouse is positioned over the Game World Editor view window, you will see a purple rectangle appear around it. LMB click anywhere in your scene (preferably over another open doorway) to place the Door actor copy. This will duplicate the Actor, along with all of its Events. We will name this new Door, "ElectricGate." Do the same for your switch, copying, pasting, and renaming it "ElectricSwitch01." Replace the sprite sheets on both copies with your new sprite sheets created in step 1 (Figure 2.18).

FIGURE 2.17 Potential sprites for a door requiring multiple switches to activate, and the corresponding switch. These are designed with the idea that the door is operated by electricity and you need to activate a few switches to turn it on, but you should use any theming you like in your game – it's your world!

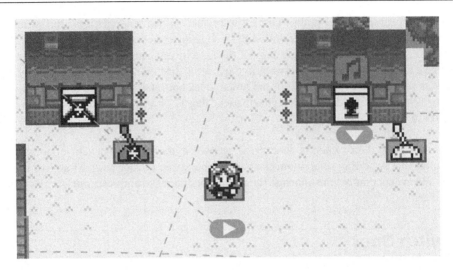

FIGURE 2.18 Copying the door and switch sprites to create new ones.

3. We will use the "Else" portions of our conditionals to set up the behaviors for these slightly more complex mechanisms. These will help us account for the fact that these switches may be hit in any order during gameplay, instead of in a set order as in a more linear level or single-switch setup.

 We will start by modifying ElectricSwitch01. Click the "+ Add Event" button and add an "If Variable Has Flag" event (Control Flow > If Variable Has Flag). Set the "Variable" field to Variable 20, then change the variable's name to "Town_ElecSwitches." Set "Flag" to Flag 1.

4. Next, hover over the headers of the other events above the conditional event that you just added. Your mouse cursor will turn into a "move" arrow with four arrows arranged in a cross. If you LMB click while this is happening, you can move the events around. Move all the old events except for the "hide" and "disable collision" events into the "Else" portion of the conditional event. Delete the events that you did not move, as you will not need them in the switch script.

 Make sure that you also change any references in these events to the LocalSwitch actor to ElectricSwitch01. Change the variable in the older Add Flags event from "PuzzlesSolved01" to your new "Town_ElecSwitches" variable. You can still use Flag 1 though, as this is the flag on the new variable.

5. Last on the Town_ElecSwitch01 actor, add a new event to the top portion of the conditional, under the "If" statement (before the "Else" header, next to the brackets marked "True"), add a "Display Dialogue" event (Dialogue & Menus > Display Dialogue). This will show a text window when you do the action. In the small text window that appears in the event, type "This switch has already been activated." You may need to hit the "enter" key to add a line break (the engine will show you a sample text box as an example of what it will look like). Figure 2.19 shows what your script should look like now.

6. That is all for now for the ElectricSwitch01 actor. Now select the ElectricGate actor and navigate to the "On Update" tab in its event list. Events in this tab run every frame during gameplay (about 60 times per second in ideal conditions), making this tab useful for enemy movement and attack scripts.

 Under "On Update," keep the "Keep Running While Offscreen" option unchecked for now, as we will keep our switches close for testing (if you put the switches farther away, you would want to check it). Add an "If Variable Compare With Value" event (Variables > If Variable Compare With Value) and change the "Variable" field to "Variable 21," changing its name to "LockedGate01" – the other values in this event are fine, as they are looking for whether this number is equal (= =) to 0. Next to the "True" brackets, add a Set Actor Collisions Disable and a Hide Actor event, setting the "Actor" value in both ElectricGate.

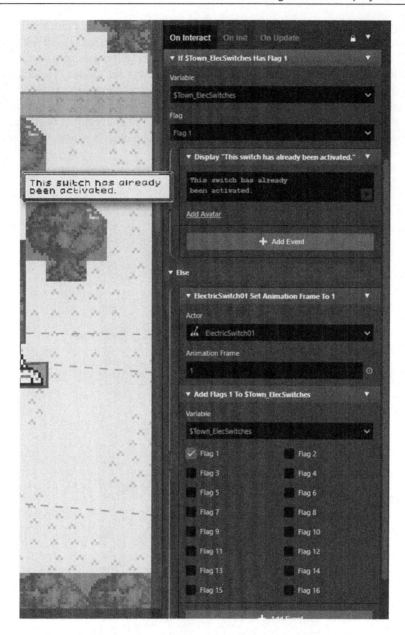

FIGURE 2.19 The events that you should have on the ElectricSwitch01 actor so far.

7. We are going to have two switches work with this door, so we have to do a few things to make it so that the game knows that when the two switches are activated, the door opens. The first is to navigate to the Title Screen scene and select the scene itself. In the Editor Sidebar, scroll down to the "Loop" event. It is set up so that the game presents the player with a choice of "New Game" or "Continue" when they hit a button on the title screen (as you have seen when you play). Selecting "New Game" sets the "Menu Choice" variable to "True," while "Continue" sets it to "False." The first event within the Loop ("If $Local0 Is True") is what we will edit.

Under this conditional (If $Local0 Is True), there is a "Change Scene" event set to send the player to the Sample Town scene. Under that is an "+ Add Event" button – LMB click it and add a "Variable Set To Value" event (Variables > Variable Set To Value). Move this new event above

the Change Scene event (so that it executes before the scene changes, or else it will not actually be executed), then set its "Variable" field to our LockedGate01 variable, and set "Value" to 2. This will make it so that every time the game is reset, the electric gate is locked.

While we are in this script, also add two "Variable Flags Set" events (Variables > Variable Flags Set) before the Change Scene event. Set the "Variable" fields to our "PuzzlesSolved01" and "TownElecSwitches" variables – this will clear the flags we are setting in those variables whenever you start a new game. By adding these events to the event that begins a new game, we are making sure that all puzzles, enemies, or any other elements with permanence are reset when starting a new adventure (Figure 2.20).

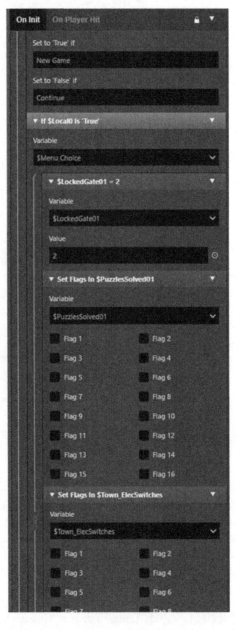

FIGURE 2.20 The events that we added to the event that defines what happens when you begin a new game. This helps us reset our puzzles whenever starting a new adventure.

8. We want to the ElectricSwitch01 actor to work with some of these new variables so that the puzzle works. Navigate back to the Sample Town scene and select ElectricSwitch01. In the "On Interact" tab, add a "Variable Decrement by 1" event (Variables > Variable Decrement by 1) into the Else section of the conditional, above the "Add Flag" event and set "Variable" to "LockedGate01." This will make it so that when you flip the switch, it moves the LockedGate01 variable closer to a value of 0, which is when it will open.

 Next, go into the "On Update" tab and add a "If Variable Has Flag" event (Control Flow > If Variable Has Flag), setting the "Variable" field to "Town_ElectSwitches" and "Flag" field to "Flag 1." Next to the "True" bracket in the conditional, add a "Set Actor Animation Frame" event, setting the "Actor" field to "ElectricSwitch01" and the "Flag" field to "1." This will make it so that when you leave the scene and come back, the electric switch appears as having been flipped if you have already done so, even if the switch is offscreen when the scene loads. If your scene is only one screen (160 × 144 pixels) big, you can put all of the events you put into the "On Update" tab into the "On Init" tab, potentially saving you some framerate issues by not having the script run 60 times per second.

9. Lastly, we need to copy our switch so that the puzzle can be solved (we set it to "2" in the "New Game" event, remember?). Copy the ElectricSwitch01 actor as you did last time and rename the copy "ElectricSwitch02." Change all references to ElectricSwitch01 in the new switch actor's scripts to "ElectricSwitch02" and all references to Flag 1 in the new switch's actor scripts to "Flag 2" (including unchecking the boxes for Flag 1 and checking the boxes for Flag 2). If you play the game now you should have to flip both switches to get the door to open. You can see an example of the events set to the right values in Figure 2.21.

10. Make a prefab out of your new object if you wish and save the project.

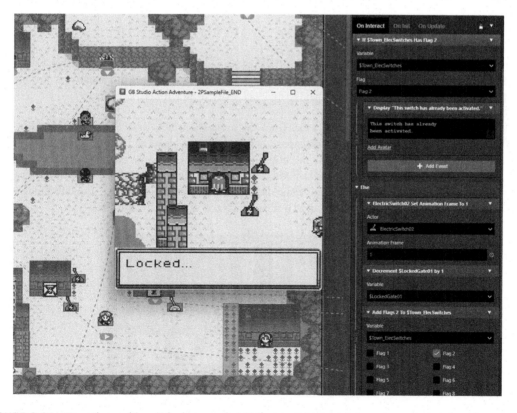

FIGURE 2.21 Now the multi-switch door works! Unfortunately, I set it to open onto another door that is locked by default in the GB Studio template sample town scene. How anticlimactic…

Now you have two different types of switches that can serve different functions in your adventure: one that straightforwardly opens a door (usually used in the same room), and one that can be hidden around a level to create a multi-phase door opening puzzle. These simple elements can be guarded by enemies, puzzle pieces, or even other switches and doors to create some interesting gameplay scenarios. Next, we will explore more of these mechanisms by treasure chests and keys for unlocking doors.

LOCK, TREASURE CHEST, AND KEY

Treasure chests, locks, and keys work with very similar events to the switches we just created, only managed in different ways. Assuming we will use the same door sprites, we will first create the sprites for our keys and treasure chests, then implement them in the project. Since we have covered the basic workflow of adding sprites and events several times, the following sections will assume you have more familiarity with the process, as opposed to earlier sections where more button presses and mouse clicks were spelled out.

Making the Sprites

First, we will need to make a treasure chest and a key sprite. Once again, go to Aseprite or another trusty sprite-making program and create something similar to the following (Figures 2.22 and 2.23).

When you are done preparing the art, import it into the project. For the Treasure Chest sprite sheet, you will add it, as usual, to the Assets > Sprites folder. For the key, add it to the Assets > Avatars folder.

Building the Door and "Key"

Despite building a key sprite, we will not actually be creating a key object. Instead, the "key" will be a variable assigned a numeric value for now many keys we have collected. We will instead use the sprite to decorate the dialogue box that displays when you collect a key from a treasure chest.

1. Copy the Door actor and place it away from the area where you were building switch-based doors – if too many objects are visible onscreen at once, you may run into performance issues (GB Studio will show a warning at the bottom of the scene). Rename the actor, "Door_Key." In the "On Init" tab, delete the event that changes the animation frame of LocalSwitch – you will not need that here. Also, set the "Flag" field of the "If Variable Has Flag" event to "Flag 3" and the "Actor" fields of the Hide and Disable Collisions events to "Door_Key."

FIGURE 2.22 The treasure chest sprite sheet. You will want two frames: one for a closed state, and another for an open state.

FIGURE 2.23 A sprite for the key.

2. Go to the "On Interact" tab of your new Door_Key object and add an "If Variable Compare With Value" event (Variables > If Variable Compare With Value). Set the "Variable" dropdown to Variable 22, and rename the variable to "Keys." Change the value of the "Comparison" dropdown to "Greater Than or Equal To," and the value of the "Value" dropdown to "1." This will check for whether the player has at least one key. Also add a "Set Actor Collisions Disable" event and a "Hide Actor" event, both set to the Door_Key actor. Finally, add a "Variable Add Flags" event, set to activate Flag 3 on the variable "PuzzlesSolved01." This will make the door open, subtract a key from your total collected keys, and mark the locked door "puzzle" solved.
3. Add an event within the "True" brackets of the conditional event you just created. This one should be a "Math Functions" event (Variables > Math Functions). Set the value of the "Variable" dropdown to the Keys variable. Set "Operation" to "Subtract." Then, set "Value" to "Value," which will display a number field below the dropdowns. Set the new numeric field to "1." The "Value" field of the Math Functions event allows you to put in lots of other types of data, including random values, which is handy for creating enemy AI.
4. In the "Else" portion of the conditional event, add a dialogue event, and type "The door is locked. Looks like you need a key..." or something similar, hitting the "Enter" to create line breaks so that the text fits into the box appropriately.

 That should do it for the door itself. You can see the finished Interact script in Figure 2.24.
5. Just to be safe, you may also want to add a new event to the New Game event (recall that it is the "If $Local0 is 'True'" event inside the Loop event) in the Title Screen scene that sets the "Keys" variable to zero when the game starts. This will be a "Set Variable to Value" event, with the "Variable" field set to our Keys variable and the "Value" field set to "0."

Building the Treasure Chest

1. Create a new actor, naming it "TreasureChest," and set the sprite sheet to the new treasure chest sprite sheet you just added to the project. Set its Animation Speed to 0.
2. Add a new conditional event: "If Variable Is False" (Control Flow > If Variable Is "False" We will use this to make the actor act differently if it is open or closed. Keep the "Variable" field set as is (Local 0), but rename the variable to "Opened." Local variables are those that cannot be called by other actors – since we are only having the variable apply to this treasure chest, a local variable will be sufficient.

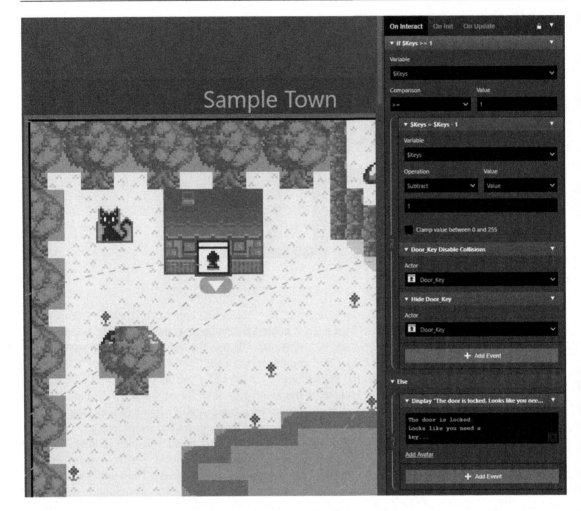

FIGURE 2.24 The Interact script for the door. We have it set to subtract one key from your collection if you have one to unlock the door and advise you to find a key if you do not have a key.

3. Add the following events to the "True" brackets of the new conditional event:
 - An Actor Set Animation Frame event with "Actor" set to our TreasureChest object, and the Animation Frame set to "1." This will visually open the chest.
 - A Display Dialogue event that says something to the effect of, "You got a key! Use it on locked doors!" Under the dialog box, you will see some text that says "Add Avatar." LMB click it to reveal a dropdown menu, from which you can select the key sprite that we added to our Avatars folder. This will show you the item that you received when you opened the chest.
 - A Variable Set To True event (Variables > Variable Set To True), with the "Variable" dropdown set to our "Opened" variable.
 - A Math Functions event, with the "Variable" field set to our "Keys" variable, "Operation" set to "Add," "Value" set to "Value," and the numeric field set to "1."
4. Add a Variable Flags Add event, and set the "Variable" field to "Variable 23," then rename the variable "Town_TreasuresOpened." LMB click the checkbox for Flag 1. Your On Interact tab should now look like what is shown in Figure 2.25.
5. Now we will need to add permanence to the treasure chest. In the chest's "On Init" tab, add an "If Variable Has Flag" conditional event. Set the "Variables" dropdown to our new "Town_TreasuresOpened" variable, and "Flag" to "Flag 1."

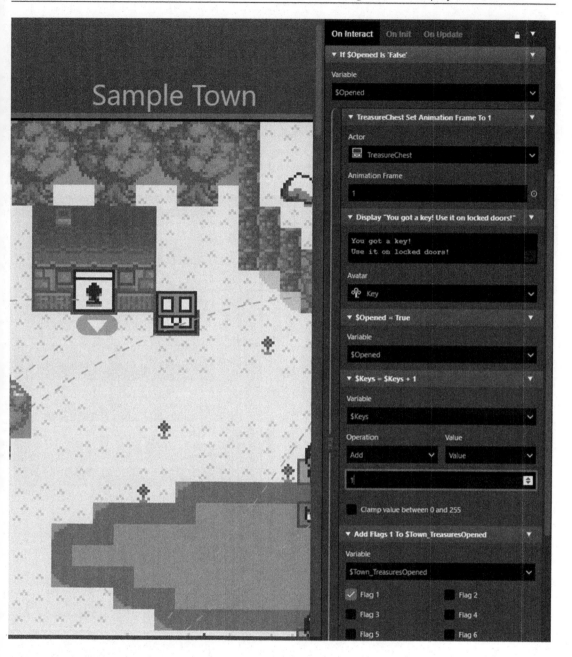

FIGURE 2.25 The On Interact script for the treasure chest actor.

6. In the True brackets of the conditional event, add the following events:
 - A "Set Actor Animation Frame" event, with the "Actor" field set to our Treasure Chest actor, and "Animation Frame" set to "1."
 - A "Variable Set To True" event, with the "Variable" field set to "Opened."
7. Under the "Else" part of the conditional event, add the following
 - A "Set Actor Animation Frame" event, with the "Actor" field set to our Treasure Chest actor, and "Animation Frame" set to "0."
 - A "Variable Set To False" event, with the "Variable" field set to "Opened."

Play the scene to test that the treasure chest works as intended. Once again, if you find that the chest does not remain opened and closed properly when you leave and return from other scenes (if the chest is off-screen when the scene first loads, for example), then you may want to add the contents of the "On Init" tab to the "On Update" tab. In smaller scenes, though, adding these scripts to the "On Init" tab should be sufficient and will make each frame of gameplay more efficient (Figure 2.26).

8. Last, to make absolutely sure that our treasure chests are reset upon starting a new game, add a new "Variable Flags Set" in our New Game event on the Title Screen scene, and set the "Variable" dropdown to "Town_TreasureChestsOpened."

9. Make a prefab out of your new object if you wish and save the project.

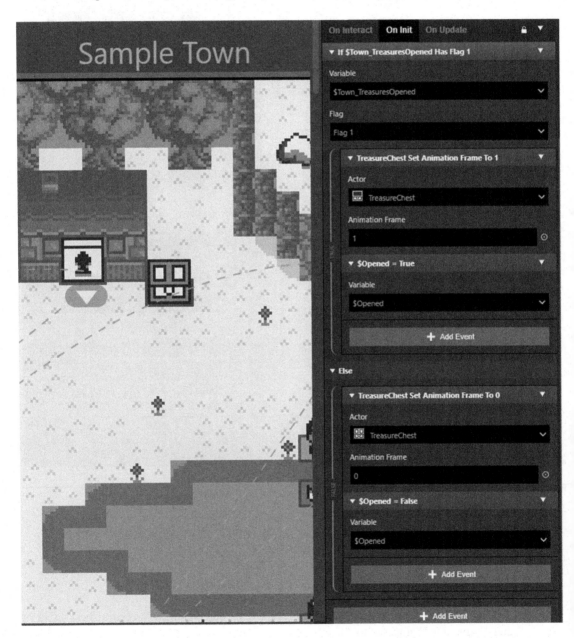

FIGURE 2.26 The On Init script for the treasure chest actor.

Now, you should have a fully functional treasure chest, key-locked door, and "key" variable, so that you can now manage progression via locks and keys. With this solution, you have both permanence built into your game and can use your keys on any door you wish, instead of specific ones. If you wanted to get fancy, you could have multiple key variables for things like color-coded keys (red key doors, blue key doors, etc.), or other special key types, such as boss door keys.

In the next few sections, we will analyze already-existing scripts in the GB Studio Sample Town template scene to understand how to make things like fetch quests and simple sub-screens.

FETCH QUEST

One of the benefits of starting from GB Studio's template scenes is that, while we have had to build lots of mechanisms so far, lots of others are already handled for us in some form. Now that you built scripts in GB Studio and stored gameplay information in variables, we can look to some of these pre-made elements to understand how they are structured, and how we might edit them for our own needs. To begin, we will look at the game's preexisting quests to understand how fetch quests are structured in GB Studio.

Analyzing the Existing Quest

1. Play the game again, and interact with the NPC pacing around in-between the two houses near the south end of the Sample Town scene (in our examples, this is where we have put the starting position for the scene). She will ask you have you have seen her cat (Figure 2.27). Go up to the northwest corner of the town, where you can talk to the cat. Then, speak to the pacing woman again, who will ask if you have seen her cat, then indicate that you told her where it is.

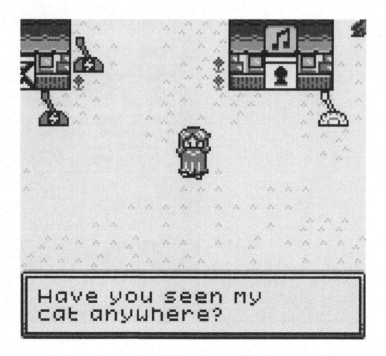

FIGURE 2.27 Finding the "Missing Cat" quest.

2. If you press either the Start button on Game Boy or the Enter key on your keyboard, you will see a check mark next to the "Missing Cat" quest, showing that it has been completed. You can close the game now.

Improving the Quest

1. This is a very simple quest, lacking a lot of the bells and whistles that one might find in a bigger adventure, but as a template to work from, we have all the parts we need right here to build a compelling fetch quest. Before editing it, we should explore how the quest works.

 First, LMB click on the NPC (named "Pet Owner") and look at their On Interact script. They have a dialogue event with the question about not knowing where the cat is. As we have seen, she asks this first, even if you have seen the cat. This is because the script checks whether you have seen the cat (marked by whether the "Seen Cat" variable is true or false) after the first dialogue box. If the variable is true, then it plays the second dialogue box and sets the "Quest1" variable to "true" (Figure 2.28).

2. Navigate up to the Cat actor in the northwest corner of the town. This character is even simpler: it has a dialogue event that says "Meow!" to the player, then sets the "Seen Cat" variable to true. Thus, the order of operations here is: you talk to the Pet Owner to learn about the cat being important, then the cat sets "Seen Cat" to true, and then you return to the Pet Owner, where she will then set "Quest1" to true.

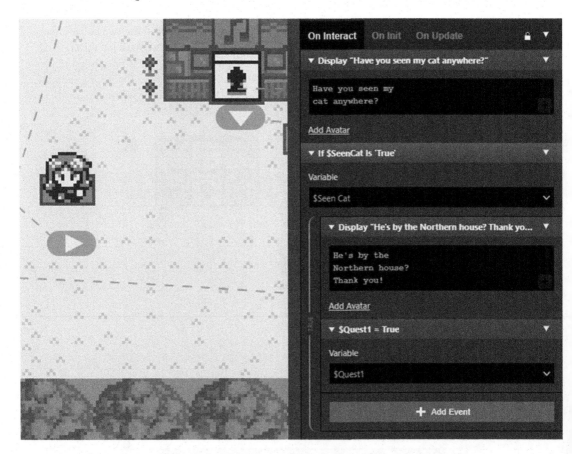

FIGURE 2.28 The events on the Pet Owner actor, showing how the Missing Cat quest is found and accomplished.

3. As we said, this is kind of simple, so we should layer it behind some other puzzle design to make it more exciting. First, LMB click onto the Pet Owner and move the first dialogue box into the conditional event's "Else" section, this will make it so the first dialogue describing the mission only plays if you have not seen the cat.

Then, change the dialogue box you just moved to say something like, "My cat disappeared into that house with the electric door! Please find the 2 switches!" We will layer this quest behind another puzzle so that there's a little more gameplay there. We also outline the task in the quest prompt – the door is locked via electricity and you need to hit two switches to open the lock.

4. If you are following the examples in this book of where to put the electric door, you will recall that the door you open does not actually go anywhere. If this happened to you, you need to make a scene for it to open to. Select the window header on the Cave scene, and press CTRL/CMD + C to copy the scene. Press CTRL/CMD + V to paste it, then LMB click somewhere to place the copied scene. This will create an exact copy of the Cave scene, which we will rename "ElectricHouse."

Delete the Save and Save Point actors in the new scene. The Cave scene's southern exit (created via a trigger with a Change Scene event on it) takes the player to right in front of the cave at the northern end of the Sample Town scene. Since it is a copy, the trigger in the ElectricHouse does too. LMB the trigger in the ElectricHouse scene, then follow the blue dotted line from it to its Destination Icon in front of the cave near the top of the Sample Town scene. Move the Destination Icon to in front of the house where we put the ElectricGate actor.

Move the ElectricGate actor so you can see the trigger under it. Select the trigger and delete its events. Add a Change Scene event and put its Destination Icon inside the ElectricHouse scene at the entrance as shown in Figure 2.29.

5. If you did step 6, return the ElectricGate actor to its position in the door of the house so it can once again block your path. Now, move the Cat actor inside the ElectricHouse, between the

FIGURE 2.29 Connecting the previously unusable door to a new scene.

torches if you want to be all theatric about it (which...we do). Since the Cat actor uses all *global variables*, meaning that the variables can be called from any scene or object, moving it from one scene to another will not affect its functionality as it would if you referenced scene-specific information like actors.

6. Take one of the electric switches and move it to another part of town, leaving one near the house. If we assume that this is the first area of the game, we will want to establish what an electric switch looks like to the player and teach them that it corresponds with electric gates. Putting one switch near the door so the player can mentally establish the connection will do that.

 By putting the other switch at the other end of the scene, the player will have to travel for it past other quests and points of interest. This is called a *tour* and can be useful for engaging your players' curiosity and helping them build a mental check-list of things to investigate in the level.

7. Last, we should make the cat interaction more interesting – if this is a fetch quest, we should "fetch" the cat. Select the Cat actor and add another dialogue event to its On Interact script after the one that says "Meow!" Have it say something like "The cat jumps into your arms."

 Then, add a "Hide Actor" event to the end of the script and hide the cat. This will be functionally the same but use very simple visual changes to make it more dynamic. You will want to also add an "If Variable Is True" conditional event to the cat's On Init script that hides the cat if "Seen Cat" is true – this will make sure the cat will not reappear if you reenter the house.

8. Edit the Pet Owner's dialogue about the cat being by the northern house to something like "You found my cat! Thank you so much!". Now, play the game to see that everything fits together.

Extra Credit: Collect Quest

Already, you have added a lot of dynamism to this quest both by having the cat be more active by jumping into your arms, as well as the big change of layering the fetch quest with a lock puzzle that also served the level design purpose of taking you on a tour of the area. With carefully crafted mechanisms, you can accomplish a lot in your level designs both from a gameplay and a player cognition standpoint.

As an added challenge for yourself, you may even try to enrich this quest further by changing it from a fetch quest to a collect quest – what if the Pet Owner is actually a person who has lots of lost cats? You have already created a lot of the logic that you would use to accomplish something like this, you would just need to make a few tweaks to the Cat and Pet Owner actors. Here are some suggestions:

- Create a new variable called "Cats" that stores the number of cats that you have found, just as you already did with the Keys variable.
- Leave the cat as is, but instead of setting the Seen Cat variable to true, now have it add 1 to the value of the Cats variable (since you would not be using "Seen Cat" anymore, you could even just rename it "Cats" and use it for this).
- Once you made those modifications, create copies of the Cat actor and place them around the world (renaming each copy to something like Cat02, Cat03, etc.) – you could even place them behind other puzzles and locked doors!
- Modify the Pet Owner: instead of checking whether "Seen Cat" is true, have it check how many cats you have, just as the key-locked door checks how many keys you have. When the value of the Cats variable is above a particular value (five or so? How many cats is too many?), then she thanks you for finding all of her cats and sets the Quest1 variable to true.
- The progress in the pre-made quests is tracked with individual variables switched to true/false. As you expand things or include more cats, you may also want to use flags instead to cut down on the number of variables. You could track which cats are collected by having each one add a flag to a custom variable called "FoundCats" and use that to control which cats are hidden when scenes load in, as you did with the states of levers, doors, and chests.

These are just suggestions for how to make this puzzle last within this one town. You could theoretically have the quest for the cats take you to all the other parts of this sample game, collecting cats from the side-scrolling scenes. You could even make it like the Secret Seashells in *Zelda* or the Caterpillars in *Hollow Knight*, where the cat quest spans dozens of cats across a big world, with the Pet Owner giving you rewards at checked-for intervals. Even with these simple mechanisms, the sky is the limit!

In the next section, we will peek into the Quest Sub Screen (Menu Page 1 scene), to see how it works, so that you can use it as an example for your own sub screens in the future.

QUEST SUB-SCREEN

While many action-adventure games have different types of pause, menu, inventory, and other sorts of sub-screens, a common sub-screen style in action-adventures is a quest list screen. In a larger game, you will likely have a combination of several, or all, of the above-listed menu types, we will focus on the quest list in particular for this section. On the one hand, quest lists can be simple, but impactful additions to your game, allowing players to track their progress through the game's different interactive scenes. On the other, the GB Studio template already has one set up, so seeing how it is implemented in its current form can help us conceptualize potential changes or alternate versions. In this brief section, we want to focus on understanding how the screen is connected to the rest of the game, how it displays quests that have been completed, and how multi-screen sub-menus can work.

How the Screen Connects to Scenes

1. Navigate to the Menu Page 1 scene to have it handy. We will not be looking at it first though. Instead, refer to the Scripts list on the left side of the GB Studio interface and select the Top Down Scene Setup custom script that we worked with in previous chapters. In the Editor Sidebar on the right side of the screen, where the custom script is now shown.
2. Navigate down to the "Attach Script To Start Button" event (it should be one of the top ones) and notice that in the "On Press" tab of the script, there are events for "Store Current Scene On Stack" and "Change Scene To MenuPage1." This combination of scripts adds the current scene (whichever scene you were in when you press Start/Enter) to the top of a scene "stack" for reference in other scripts. The second changes the scene to the Menu Page 1 scene.

 If you recall, this Top Down Scene Setup script is called when the Sample Town scene initiates ("On Init"), so this script sets up what happens when Start/Enter is pressed in that scene. If you want a scene to connect to this menu screen, the Top Down Scene Startup script (or another like it) should be included. When you leave the Menu Page scenes, the game refers back to the scene stack and sends you back to the scene at the top of the stack, which is the one where you pressed the Start button/Enter key.
3. If you are looking at the script from the provided sample projects that came with the book, you may see an event at the top of this script called "Remove All From Scene Stack." This clears the scene stack whenever it is called (in this case, when you enter the Sample Town scene). This is a good way to keep the game's memory from getting bogged down with an over-full stack as you explore and use menus. As such, we recommend having it at the beginning of your top-down and side-scroll scene startup scripts (though, do not use it in menus, or you will not return to the proper scene!) It can be found at Scene > Remove All From Scene Stack (or, type the event name into the search bar in the event list) (Figure 2.30).

FIGURE 2.30 The current state of the Top Down Scene Setup script.

The Quest List and Screen Transitions

1. Now that we know how the menu screen attaches to scenes and about the scene stack, we can dive into the Menu Page 1 scene. LMB click on that scene to see it is On Init script. You will notice several interesting events here:
 - At the top of the script is a "Deactivate Player" event – this makes it so that the player character as defined in the scene you were last in is hidden and unable to be controlled in the normal gameplay fashion.
 - The Play Music event – this plays a music track located in your Assets > Music folder. Many of the game's scenes have these to create the soundscape of the game.
 - The Fade Screen In event fades the screen in from white and controls the speed of that fade. Using Fade Screen In and Fade Screen Out can be useful in cutscenes if you need to give the impression of large explosions or have a flash to cover when characters change form or disappear.
 - The Pause Script Until Button Pressed event. This stops the script from executing until a specific button (or any non-directional button in this case) is used by the player. This can be a useful script for doing things like swapping between or leaving menus or other status screens. After this event is a Change Scene script, which goes to Menu Page 2. Without the Pause Script event, the game would automatically go to Menu Page 2 as soon as this scene was loaded.
2. LMB click on one of the check boxes in the scene, surrounded by a purple rectangle. These are the boxes that let you see whether you have completed a quest or not. These have nothing in their "On Interact" tab because they are not interactable. Instead, they have a simple behavior in their On Init tabs: they check whether specific quest-related variables have been set to true, and change to frame 1 of the box sprite sheet if it is. Frame 1 of these sprites is a filled-in box, so this means that the quests show as completed if their corresponding variables have been set to true.

 As noted previously, these quests are each controlled through individual variables. As you make bigger games, you will want to save on variables as much as you can, so instead of whole variables, you could have each of these boxes track whether flags inside of a potential "Quests" variable have been activated.

3. As this is currently set up, you have to navigate through Menu Page 2 before reaching the game scene again. This could be more elegant, so we are going to make some simple modifications to both scenes to make this work better:
 - Remove the "Pause Script Until Button Pressed" event from the Init script in Menu Page 1 and replace it with two "Attach Script To Button" events.
 - Set the "Button" value of the first Attach To Button event to the Right Arrow and nothing else. Under the "On Press" tab, add a "Change Scene" event that goes to the Menu Page 2 scene. Make sure the "Override default menu button" check box is unchecked.
 - In the second Attach To Button event, set the "Button" value to A, B, Start, and Select all at once and likewise uncheck the "Override default button action" box. In the "On Press" tab, add a "Restore Previous Scene From Stack" event. This will make it so that any non-directional button can be used to return to gameplay. Your script will now look something like what is shown in Figure 2.31.
 - Navigate to the top of the On Init script and LMB click on the downward-facing arrow across from the On Init tab and next to the lock icon (make sure you click the one above the events, not the one in the first event in the list). In the little pop-up, select "Copy Script."
 - Navigate to Menu Page 2 and open its On Init script tab. LMB on the same downward-facing arrow above the event list. On this pop-up menu, select "Replace Script," and the script you copied from Menu Page 1 will replace the scene's previous Init script. In the first Attach To Button event, select the Left Arrow instead of the Right Arrow, and set the Change Scene event to go to Menu Page 1 instead of Menu Page 2. This will let you flip back and forth between the two menus.

FIGURE 2.31 The modified menu page script, now with more functionality.

FIGURE 2.32 The Kudzu menu screens.

Play the game, and you will see that the menus work a bit more intuitively. With some clever scripting, you can add even more interactive interface options that can greatly improve the user experience for bigger games. In *Kudzu,* we created a two-scene pause menu with interactable menu options by making the directional pad buttons increase and decrease the value of a CursorLocation variable. Then, we had the cursor move to specific spots on the screen by checking the value of the CursorLocation variable in an Update Function. This let us have an inventory menu where the player could highlight and get info about different items and swap between two inventory screens (Figure 2.32). If we hit the A button/Z key when the CursorLocation value was set to specific values, a text box would then pop up to give us info about the inventory item. In versions of GB Studio after version 3.0, you can also use GBVM scripts via the "GBVM Script" event to swap out background tiles for even more efficiency and flexibility in menus.

In the next section, we will dissect more of the pre-made mechanisms in the sample game to understand some of the opportunities they have for our own designs. In this case, we will look at the pushable blocks to see how many types of gameplay can be built with this pre-made component.

PUZZLE ELEMENTS – PUSHABLE BLOCKS

In the design concept chapter preceding this one, we talked about block-pushing (Sokoban) style puzzles at great length. Beyond the mechanics of the game *Sokoban* itself, where players try to push blocks into specific spots on a floor, pushable blocks have many other potential uses such that a designer can create many other potential puzzles from them.

While the other sections in this chapter required us to make mechanisms from scratch or modify existing ones, the sample project does a good job of showing off the range of options that pushable blocks provide. In this section, we will briefly play through the pushable block puzzles already in the project to discover how they work.

Regular Pushable Blocks

1. Navigate to the Sample Town scene. You will see an actor just north of the duck pond called "Rock." If you click on it, you will see that it has a "Push Actor Away From Player" event in its On Interact tab. This event creates the block-pushing behavior. By keeping the "Slide Until Collision" check box unchecked, it makes the block move in 16 pixels (the width of a default-sized sprite) increments.

2. Play the game and interact with the Rock actor. It will push away from the player and reveal a staircase! This is just one potential use for blocks like this: hiding secret entrances and, with some careful scripting, items (like having an item actor set to hide, but being revealed after the rock is pushed via a "Show Actor" event).

3. Enter the cave, where you will find three rocks in front of you. This is another classic type of 2D game puzzle, where you must open the route ahead of you by clearing the pushable objects from your path by interacting with them in a particular order. If you have not played games with this puzzle before, the solution to this particular one is simple: you push the first and third rock upward, then push the middle rock to the left or right to open the path. This kind of puzzle is very common in games like *Zelda: Link's Awakening,* where different increasingly complex arrangements of rocks are used, showing the puzzle's extensibility. Again, these rocks just have the Push Actor Away From Player event with "Slide Until Collision" unchecked.

Slippery Ice Blocks

1. If you walk north from the three-rock puzzle, you will find a shiny block. This is an actor named Ice Block. If you go to the GB Studio Game World Editor, you can click on the block to see its On Interact script, which is much more complex than the rocks we have seen so far (Figure 2.33).

2. The script is a conditional set to check whether the block is at a specific location (15, 10 – the location of the X-marked tile in the room). If it is interacted with, it does nothing, but if it is not at that location, it is set to be pushable but will slide until it collides with something (the Slide Until Collision box is checked). This will make it act like a block of ice on an icy surface, so it will slip and slide around until stopped.

 Once again, these are very common puzzles in action-adventure games, with an entire dungeon of *Zelda: Link to the Past* featuring this mechanic as a core element, and newer games like *Undertale* using it extensively. The player must find the right pathway of rocks to push the block toward so that it stops in the correct spot. The other events in this script reinforce this – stopping the block when it reaches the proper location, then providing an outcome to the puzzle being solved by opening another hidden staircase and setting "Quest2" to true.

As with the regular pushable rocks, you could do a lot with this sort of puzzle, by having different combinations of pushable blocks, level designs, and even other game mechanics, like a pushable block that fires projectiles at enemies or solve puzzles. Likewise, you can re-theme these objects in different ways so that they take on new roles in a game. In *Kudzu*, we created pushable piles of leaves that you could move only when you collected the rake tool. By attacking the leaves, they would move, and you could push them toward smaller piles of leaves to create ramps and bridges that allowed access to new areas (Figure 2.34). Since they had to be set to be in a *collision group* in order to work this way, they could also block projectiles fired by enemies and hazards, so we also made puzzles where leaves would give you mobile cover from enemy shots!

With some imagination, you can do lots of things with these built-in elements of the GB Studio engine without a lot of effort, so we hope you explore some of the possibilities listed above. In the final section of this chapter, we will create a simple patrolling enemy in both top-down and side-scrolling configurations that can serve as a basis for more complex enemy designs.

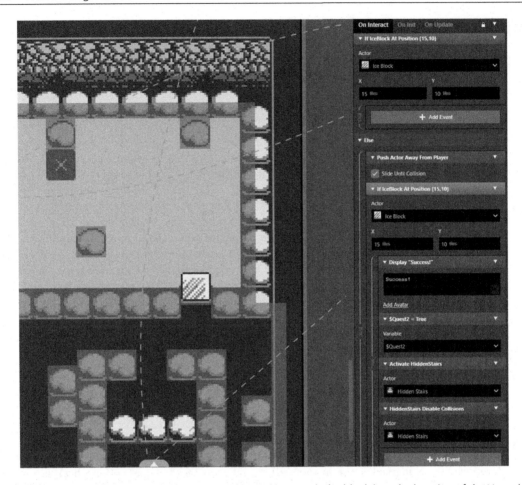

FIGURE 2.33 The Ice Block actor and its script: the goal is to push the block into the location of the X-marked tile on the floor, which will open a secret passage.

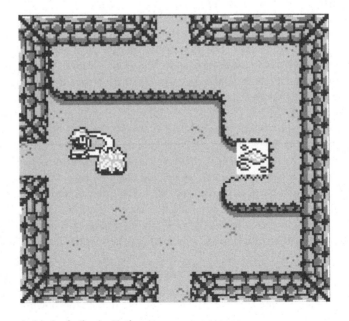

FIGURE 2.34 The pushable leaf piles in *Kudzu*.

SIMPLE PATROLLING ENEMY

As we said in the design concept chapter preceding this one, enemies are an important part of your level design that some newer designers may not consider a "level element." Planning around enemy abilities or movement patterns can allow you to create dynamic *encounters*, even with simple enemies. In this section, we will create a simple top-down enemy using already-made random movement logic and explore the simple existing enemies in in the Path To Sample Town scene to understand how their logic works to both move the enemy around, attack the player, and be attacked by the player.

Top-down

The first enemy we will create is the top-down enemy. As always, we will start with the sprite sheet. While so far, using sprite sheets has been fairly straightforward, here we will need to use GB Studio's sprite editor to create different animation states for our enemy.

Making and implementing the sprite sheet

1. Create and export a sprite sheet like the one shown in Figure 2.35 in Aseprite or your sprite-editor of choice. You may choose a simpler enemy than this spider sprite, but the important part is to have two sprites for when the character is moving downward, two for when it is moving upward, two for when it is moving right (the engine will flip these sprites to also make a moving left animation), and two sprites for a death effect. Import the sprite as usual, by placing it in the Assets > Sprites folder.
2. In GB Studio, navigate to the upper left corner of the screen to the dropdown with the list of different Editor Window modes. Here, you will select "Sprites" from the menu (Figure 2.36).
3. The GB Studio interface will now display the sprite editor. From the "Sprites" list on the left, select your enemy sprite sheet.
 Our goal here is to set up the proper movement type for our sprite so that it is able to walk in four different directions. To accomplish this, we will use the Animation Type dropdown in the Editor Sidebar on the right side of the screen. From this dropdown, select "Four Directions + Movement," then click the "Flip 'Right' To Create 'Left' Facing Frames" checkbox (Figure 2.37).
4. In the "Animations" list on the left side of the screen, you will now see six animations: Idle Right, Idle Up, Idle Down, Moving Right, Moving Up, and Moving Down. We will create each one from the sprite sheet that we imported, starting with "Idle Right."
5. The sprite editor works like a tile-based painting program (much like you will see with Tiled later in the book). The individual parts of your sprite sheet are like the palette from which you will draw each frame of animation on the canvas. Select the "Idle Right" animation from the animation list. In the "Frames" window at the bottom of the interface, you will see eight frames, one for each part of the sprite sheet. Delete all but the first frame of the spider facing right. This will serve as the pose that the spider uses when it is not moving but facing right.

FIGURE 2.35 A spider sprite, featuring two frames each for down, up, and side movement, as well as two frames for a death effect animation.

FIGURE 2.36 Opening the sprite editor.

FIGURE 2.37 Selecting the "Four Directions + Movement" Animation mode in the Animation Type dropdown.

6. Next, select "Idle Up." You will not have any pre-loaded frames here in the Frames window, only a single blank frame. For this one, we will draw our own frame from the sprite sheet. LMB click and drag within that sprite sheet to create a box around the first sprite where the enemy is facing up. This will select the tiles to be the "paint" that you can apply to the canvas. Move your mouse up to the canvas and position the transparent image of your enemy so that it is centered in the frame and click to lay down the "paint." This will add the art to the frame (Figure 2.38).

7. Do the same thing with the "Idle Down" animation, using the first image of the enemy facing down as your tiles.

8. Now, you need to paint the "moving" animations. These will involve two frames each. Select "Moving Right" from the Animation list and press the "+" button in the Frames window. This will add a new frame so that you have two total. In the Tiles window, click and drag to highlight the first frame of the enemy walking right, and "paint" that into the canvas. Click on the second

FIGURE 2.38 Painting the sprite frames into their respective animations. Here is the spider enemy being added to the Idle Up animation.

frame and perform the same operation for the second frame of the enemy walking right. If you want to preview your work, press the "Play" button in the upper left corner of the Sprites Editor Window (the one that looks like a triangle pointing to the right).

9. Do the same thing for the "Moving Up" and "Moving Down" animations.

10. Last, we will need the explosion effect for when we defeat the enemy. Click the "+" symbol in the upper right side of the Animations list (across from the word "Animations"), and this will create a new animation state. You can rename this state in the Editor Sidebar on the right side of the GB Studio interface under "State Name." We should call it "Death Effect" and leave it as a "Fixed Direction" animation type.

11. Select "Idle" in the animation list under the Death Effect state. Add a new frame to this animation, then paint the tiles for the death effect on the sprite sheet onto the two frames.

12. Once you have done all of these, you can go back to the Game World editor by selecting Game World from the dropdown in the top left of the GB Studio interface.

Making the enemy actor in GB Studio

With the sprite properly set up in our sprite editor, we can now make the actual enemy itself. This enemy will wander around, which can seem like very "un-enemy-like" behavior, but can be useful as a basic enemy or as a monster type that takes up space in narrow areas. This behavior is also convenient because it has already been made for us, as the NPC that sends us on the "Missing Cat" quest. To turn it into more of a threat, we just need to make a few small tweaks to the code.

1. Select the Pet Owner actor in the Sample Town scene, then copy and paste it into the same scene, placing it a bit to the north (having too many actors in a small area will affect the game's performance).

2. Rename this new enemy what you like. We called ours "Enemy01," which is both descriptive of its function and numbered so that we can distinguish enemy actors from one another if we create multiple. Change the sprite sheet property of the new enemy actor to your enemy sprite sheet.

3. Set the enemy actor's collision group to "2" in the Editor Sidebar. This will make it hittable by our sword, which can hit objects in collision groups 2 and 3. To stay organized, we find it useful to keep types of objects to the same collision group, so we are using group 2 for enemies and group 3 for hittable environment objects.

4. Instead of a "On Interact" tab, the actor will now have a "On Hit" tab. The contents of the "On Interact" tab will now be found in the "On Hit" tab, under the script for what happens when the enemy hits the player. Delete all of the events in that script, as we will not need them. Leave this area alone for now, but we will return to it when we add the death script to the enemy.

5. Open the "On Update" tab. You will find the enemy's movement script. We will first analyze the script to understand how it works before making some very minor alterations:

 - The script starts with a "Wait" event, which lets you stop a script for a particular amount of time. This is useful for setting the pace of enemy movements (giving more or less time between movement or attack), or creating dramatic pauses when scripting cutscenes.

 - Next is a Math Functions event, this time generating a random number between 0 and 5 and storing it in a Temp variable. Temp variables are useful for storing information that does not need to be remembered elsewhere or referred to by another script, such as this enemy's movement.

 - Finally, is a Switch event. These events are useful when behaviors have a range of possibilities, such as this situation where our Temp variable can be set to a range of values. Once the Temp variable is set to a value, the Switch event then checks what the value is, then executes the events in the "When" field for that value.

6. Within each "When" part of the script is a "Move Relative" event, which moves the actor to a position *relative* to the one they were already in, meaning that if you put in "-2" into the X field, it will move two tiles to the left from where they were before the event executed.

 The script is set to move the character two tiles at a time. This is good for an NPC but is not great for enemies, which should have more aggressive movements. Within each "when" portion of the Switch event, change any "2" values to "4," keeping them positive or negative as they were when you copied the actor (Figure 2.39).

7. Play the game to see if you like the result. If you think that the actor waits a bit too long between moving, you may try modifying or deleting the Wait events at the beginning and end of this script (pro tip: if you do not want to commit to deleting an event, you can Disable it by clicking the downward arrow on the left of its header and choosing "Disable Script.") You can also change the actor's movement and animation speeds. We disabled the first Wait event in the script, then changed the actor's movement speed to "1/2," and animation speed to 3.

Adding collision events

Lastly, we need to add collision events so that we can damage the enemy. Eventually, we will need to set up logic so that the player can take damage, but we will do that when we start creating dungeons. For now, we want to get the enemy damage script working.

1. Go to the "On Hit" tab in the enemy's event list. Since the sword is in collision group 1, we should click "Group 1" under the tab so that the script executes when the enemy is hit by the sword.

2. First, we want to stop the enemy from moving around and executing any commands after it is hit. For this, we will add a "Stop Actor's Update Script" event (Actor > Stop Actor's Update Script). Set the "Actor" field to our enemy actor.

3. Next, add a Set Actor Collisions Disable event, so that the enemy cannot damage the player anymore when killed (the player cannot take damage yet, but we want to build this for full gameplay functionality now rather than having to edit it later). Set the "Actor" field to our enemy actor again.

4. Next, we need to change the enemy's animation to the death effect and set the animation speed so that we get a nice explosion feel. For this, we add a "Set Actor Animation State" event (Actor > Set Actor Animation State), setting the "Actor" field to our enemy, and the "Animation State" to "Death Effect."

 Then, add a "Set Actor Animation Speed" event (Actor > Set Actor Animation Speed), setting the "Actor" field to our enemy and the Animation Speed to "Speed 3."

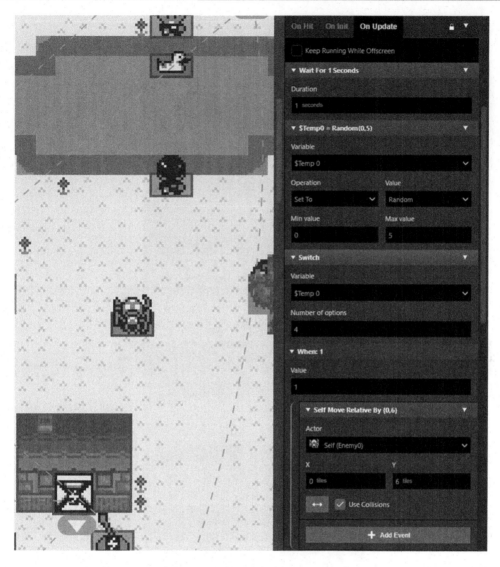

FIGURE 2.39 Editing the enemy's Update script.

5. We want time for this animation to play before the actor disappears, so we will use a "Wait" event (Timer > Wait), set to "0.3" seconds. After this, we will add a Hide Actor event, with "Actor" set to our enemy.

6. Last, but not least, we want to add permanence to this enemy so that it does not come back to life after the scene reloads (unless you are into brutal difficulty). To accomplish this, we will add a Variable Add Flag event as we did with our puzzles. Set "Variable" to "Variable24," then rename the variable to "EnemiesAreDead." Check the box for Flag 1 – since this is "Enemy01," it will use Flag 1 (Figure 2.40).

 Rather than add a script to hide the enemy if Flag 1 is checked to the enemy's On Init tab, we will add it to the scene's On Init tab. The scene's On Init tab always runs first, so if the hide script is in the enemy's On Init tab, it will blink briefly onscreen before hiding, rather than just hiding as the scene loads. At the beginning of the scene's On Init script, before the TopDownSceneSetup script executes, add an "If Variable Has Flag" event set to our "EnemiesAreDead" variable and "Flag 1." Then, in the "true" brackets, add Hide Actor and Actor Collisions Disable events, both set to our enemy actor.

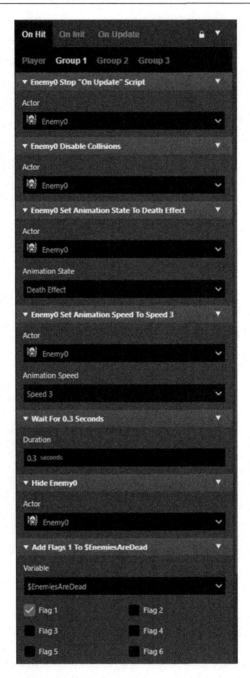

FIGURE 2.40 Making the enemy killable.

7. Play the scene to ensure that everything works, making alterations to your enemy, event timings, or even to your attack script to make sure you get the "game feel" you are going for.
8. Make a prefab out of your new enemy character if you wish and save the project.

With this enemy created, we can now look at the construction of the side-scrolling enemies that come with the sample project to learn how similar enemies can be created in the side-scrolling environment.

Side-scrolling

Once again, the benefit of working from pre-made sample projects allows us to mine existing actors and scripts for our games. In this case, the side-scrolling enemies are more or less ready to go, minus elements of permanence and being killable with the sword. With this in mind, we will walk through how the actor works and make tweaks as appropriate to add the functionality we want.

1. First, drag the Destination Icon from the Sample Town scene to the beginning of the Path To Sample Town scene. Play the game to observe how the Turnip enemies work.
2. Stop the game and select the first enemy in the scene, "Turnip 1." In its On Update script is a Call Script event that calls a custom script called "Turnip Movement." Navigate to the Scripts list on the left side of the GB Studio interface and click on "Turnip Movement." It will now appear in the Editor Sidebar.

 While we did not build our top-down enemy with a custom script in its Update tab, doing so is a great way to cut down on effort if you have to debug characters in your game – GB Studio does not have "prefab" game objects in the way that other engines like Unity or Godot do, so you have to copy and paste individual instances of Actors. As such, using custom scripts allows you to update common actors by changing one script, rather than having to update all instances of that actor in a large project manually.
3. The custom script consists of a conditional that checks whether the player is to the left of the turnip enemy, then has the enemy move to the left toward the player before waiting for one second. In the "else" section (i.e., if the player is to the right of the enemy), the turnip instead moves to the right before waiting (Figure 2.41).
4. This movement works fine for right now. You could theoretically set up something similar to the top-down character, just with two states (right and left on the x-axis) instead of the four needed for top-down.

 Click on the Turnip 1 enemy again and set it to Collision Group 2. Navigate to its On Hit tab. Under "Player" it has another custom script to handle how it collides with the player – dying if jumped on from above, but otherwise damaging the player. We will leave that as-is for now, but will add a death script to the "Group 1" event list so that it can be killed with the player's sword. Copy the script from your Enemy01 enemy in the Sample Town scene, and paste it (if you recall, by using the "Copy Script" and "Replace Script" commands in the script dropdown menu at the top of the event list) into the Group 1 script. Specify "Turnip 1" in all the Actor fields, and uncheck "Flag 1" in the Add Flags event. Check "Flag 2" instead.
5. Copy the If Variable Has Flag event from Sample Town that makes the enemy there hide if killed, and paste it into the Path To Sample Town scene "On Init" tab, before the setup script. Change the Actor references to the Turnip 1 enemy, and change the Flag value to "Flag 2." Technically this will only make the enemy stay dead if the player kills them with the sword. Since Flag-based events like this, where you will use a different flag on each enemy, do not translate well to the custom script system, you may want to copy the contents of the Turnip Collisions script into the Turnip's "On Hit" script directly.
6. Play the scene to see if it provides the game feel you want, and make any tweaks you feel are necessary. Note that the Turnip will appear to glitch when the game calls the "Death Effect" animation state, as we have not set one up for this sprite. That is fine for now, but outside of this tutorial, you may want to add the Death Effect frames to the Turnip sprite and set up that animation state. You can also adjust the other Turnip enemies in the scene, making sure to also set the EnemiesAreDead Flags appropriately. Now you have side-scrolling enemies that react to your sword swings.

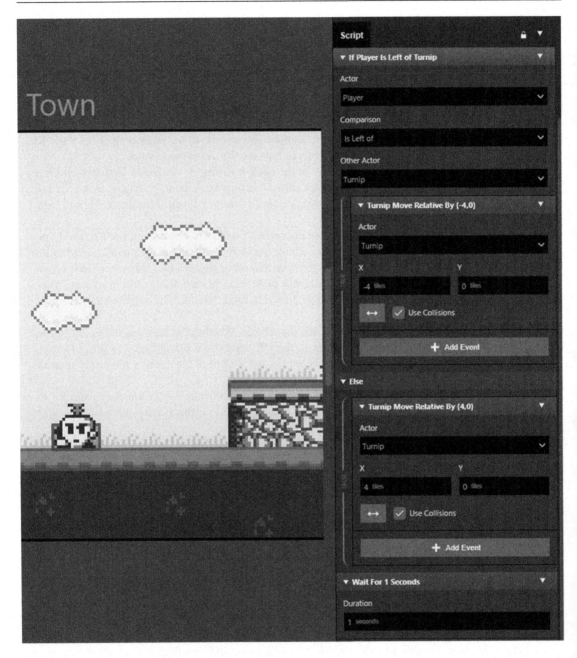

FIGURE 2.41 The side-scrolling enemy's movement.

Extra Credit: Make Them Fire Projectiles

For "extra credit" on this section, we will have our enemies shoot projectiles as they move around our levels. This simple change can make enemies more challenging just by giving the player more to think about during encounters. As we have already used the projectile event to create our player's sword, this will not be a huge lift. Indeed, the implementation for this will be even more straightforward than what we did trying to turn the projectile behavior into a melee weapon.

1. Move the Destination Icon from the title screen back to the Sample Town. Select the Enemy01 actor in the Sample Town scene and navigate to the Enemy's On Update tab.
2. Scroll down to the Switch event. We will add projectile events when the enemy stops after moving. Navigate to the first "When" section and under the Move Relative event, add a new Launch Projectile event (Actor > Launch Projectile).
3. Set the Sprite Sheet to be either the Bullet sprite or a custom sprite of your own creation (in the 2PSampleFile_END, we have a ball of spider web). Set Source to be Enemy01. Set the Direction to be downward (since option 1 is when the enemy walks downward onscreen). Set Speed to be Speed 1, and set the Collision Group to be 2 so that it can hit the player (Figure 2.42).

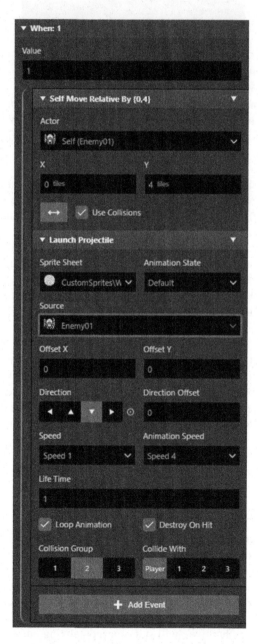

FIGURE 2.42 The projectile event for our enemy, place after the movement event for moving downward.

FIGURE 2.43 Pasting an event after another in the Editor Sidebar.

4. Copy the event and paste it into the following three "When" sections, by clicking the downward arrow in the event header then selecting "copy event," then moving down to the following movement event, clicking the downward arrow on its event header, then selecting "Insert Event After" (Figure 2.43).

Repeat the procedure until you have done all four possibilities in the Switch event. The direction of the projectile event under "When: 2" should be up. The direction under "When: 3" should be left, and the direction under "When: 4" should be right. Test the event to see if it provides the right game feel, and increase or decrease settings as you feel are reasonable (such as increasing or decreasing the projectile's speed).

5. Move the Destination Icon coming from the Title Screen to the Path To Sample Town scene. Select "Turnip Movement" from the "Scripts" list and perform the same operation in this script: adding a Launch Projectile event after each of the two movement events with the same settings (the one in the "true" bracket for the conditional will be going left, the one in the "else" part of the event will be heading right). To get even fancier, we even used the "Bullet Left" and "Bullet Right" sprites in the projectile events serving those directions.

You may or may not want to keep these changes, or only use them on one or the other – cheap projectile hits can be a hazard especially in side-scrolling environments, but you now have a few choices for how to make enemies behave in your games. From this simple base, you can experiment with other ideas such as having these enemies increase speed when the player is near, etc. There are many things you can do with enemies in these games to round out a cast of creepy and weird monsters that will enrich the player's experience of your levels.

CONCLUSION

In this extensive chapter, we created a massive toolbox of gameplay mechanisms that we can use to create lots of different gameplay scenarios. Beyond making the mechanisms themselves, we even saw how some of them can be mixed, matched, and juxtaposed in satisfying ways – such as by using door switch puzzles to obfuscate the path to the end of a fetch quest. In this way, we can use gameplay elements, puzzles, and challenges such as wandering monsters to make quests more satisfying and like what Jeff Howard cites as meaningful quest designs.

With this gameplay toolbox built, we will start conceptualizing our world in the next chapter: settings, characters, and so forth; which will let us give these mechanisms a narrative impact.

Planning Your World 3.1

Once upon a time in academic game studies, there was a far-reaching conflict known as "ludology vs. narratology." In a nutshell, the conflict was one between folks who understood games primarily as systems of mechanics (the ludologists, from the Latin *ludo*, or, "I play") and folks who understood games as a storytelling medium (the narratologists). The goal of this introduction is not to beat this very dead horse any longer – the language with which we talk about games has moved past such a dichotomy into one that can more gracefully account for mechanics and storytelling co-existing meaningfully. Instead, the goal is to acknowledge that this chapter could be read and understood first, depending on your desired design process.

Action-adventures are games in which the structural elements of gameplay and rich traditions of storytelling come together in a meaningful package. Central to action-adventure game construction is the role of *narrative design*, which game designer and Die Gute Fabrik CEO Hannah Nicklin calls "the practice of game design with story at its heart…the advocate for the story in the design of the game" (Nicklin, 2022). Jeff Howard alludes to this in *Quests: Design, Theory, and History in Games and Narrative* (Howard, 2008), in how he blends gameplay objects (weapons, upgrades, pickup items), and narrative or symbolic significance. In this mode, a gameplay object like a shield can be important for both gameplay: boosting a character's defense or opening new types of defensive moves; but also have theming that makes it thematically significant to the game's story.

The ways in which the game levels in our action-adventure games aid this process will be the focus of this chapter. This will not be a chapter devoted to narrative design, as that truly is its own field, deserving of its own entire books. We will, however, do our best to discuss some very important narrative-driven aspects of action-adventure map design such as how world design works hand-in-hand with narrative design and writing, uses of environment art, and others.

ARCHITECTURAL PLACEMAKING IN GAME WORLDS

In some genres, such as many online competitive games, one could make an argument that narrative or art aspects are a "coat of paint" or "window-dressing" to the core gameplay. Action-adventures offer little such ambiguity, with narrative and gameplay working together to draw players through their spaces. The genre has a specifically high ability to *worldbuild* by bringing the disciplines of game design, level design, narrative design, writing, art, and sound together. Worldbuilding is the process of creating a fictional world or reality in a piece or pieces of media. This often includes lore and backstory but can also include elements like the geography of the world, the cultures within it, its ecology, and so on. In his book *Building Imaginary Worlds*, Mark J.P. Wolf acknowledges the interdisciplinary element of worldbuilding, highlighting that the construction of imaginary realities and worlds, such as Tolkien's Middle Earth or the *Star Wars* universe, often occurs across entire series, genres, and media types (Wolf, 2012). Games in genres like action-adventures or role-playing games have the unique ability to include interactivity within their worldbuilding framework, which for our purposes includes the design of the spaces of the world that the players explore: maps and levels. Where levels can simply serve as backdrops to gameplay, action-adventures' exploratory gameplay and narrative-focus have the potential to help game worlds feel more like actual *places*.

DOI: 10.1201/9781003441984-7

In fact, we would go as far as to say that *placemaking*, or the act of giving occupants an emotional attachment or feeling of familiarity in a designed space, is a vital part of action-adventure level design. This idea of place is not one lightly evoked, and actually comes from architectural placemaking theory, in which a goal is to not only create space but create space that invites occupants to form attachments to the space itself (De Matteis, 2020). Architectural theorist Christian Norberg-Shulz coined the term *genius loci,* or "spirit of place," to describe this phenomenon, borrowing a term from the ancient Romans for the guardian spirits they believed watched over inhabited spaces (Norberg-Schulz, 1979). Some of this was based on work by philosopher Martin Heidegger, who proposed a concept of *dwelling* in space, going beyond mere inhabiting, and having what he called an "existential foothold" in the space (Heidegger, 1971).

Why all of this matters for level design in action-adventure games is the desire to create a "placeness" for the worlds that these games take place in. Some of the best action-adventure worlds have a sense that you are in a place with a lived-in history, that your actions in the world matter (permanence), and help you build relationships with the same areas or scenes over time and multiple visits. In this way, we can see how action-adventure game worlds may become fondly remembered places. For our part, replaying favorite action-adventures can feel like returning to places like Zebes, Dracula's Castle, Koholint Island, Hallownest, or *Cave Story*'s Island. Norberg-Shulz argues that people feel that they dwell in a space when they can understand their location, or *orient themselves*, and feel a sense of connection, or *identify themselves*, within the space (Norberg-Schulz, 1979). Beyond elements of the user-interface that help in this orientation, such as a map screen, direct elements of the world's design can also influence these senses of orientation and identification/belonging. To make these concepts accessible to working designers, we are proposing three frameworks for building a sense of place in these worlds (Totten, 2021):

- *Craft* – How the level is built with visual, interactive, and audio assets, and how their arrangement builds atmosphere.
- *Gameplay* – How players change the meaning of game spaces they interact with and how those spaces account for this.
- *Evolution* – How players interpret links between their visits and form relationships with a space over multiple visits.

Having these concepts work in tandem – representational/narrative working with gameplay – is vital to building action-adventure worlds that feel like places. Rather than using environment art as mere eye-candy, we will be focusing on giving regions of action-adventure worlds their own unique character and landmarks to aid orientation. Likewise, thinking of how we use artwork to build a visual language of our world is vital for helping players decode it – what certain repeated switches or mechanisms do, etc. How narrative meets structure is also important: some games include high-level ideas such as "climbing out of a cave" or "descend into forgotten ruins." Both narrative concepts become the shape of a game's map and provide context to the adventure, which further aids a sense of place.

These concepts also account for aspects of action-adventure design such as permanence and backtracking. Making player actions relevant to the ongoing shape of the world (what is locked/unlocked, available NPCs, dialog options, etc.) and giving players incentive to freely explore spaces they have already passed through is vital here. In other chapters, we reference a moment we call "blooming," where a lot of the game's map becomes accessible to players, and there is a sense that they can form their own goals for where to go next. This is a product of the progression system (how or when the unlocked character abilities allow a certain level of access), map design, and amount of potential things to do (quests, hidden objects, etc.). There does not have to be only one moment of blooming in a game, but there could potentially be several as players remember parts of previous areas that a new ability or tool may help them in. These moments of blooming invite the kind of traversal that helps build the gameplay and evolution portions of placemaking, as the map design invites productive backtracking, which in turn builds players' familiarity and feeling of place in the map.

These concepts will form the foundation of our approach to the rest of the chapter, as well as the following practical chapter on building tilesets and art assets for world design. In the next section, we will lay out how high-level narrative ideas become individual concepts for zones and regions.

HIGH-LEVEL STORY AND CHARACTER IDEAS

Professionals rightly get nervous when folks start talking about "ideas" in creative projects. A common "joke-but-not-joke" in the industry – since we have all encountered this person at least once in our careers – is the "idea guy," who thinks that all you need to make a game is a high-level idea, and then the programmers, artists, etc. will "make it happen."

This seems like a "downer" way to start a section on high-level storytelling ideas for building your action-adventure worlds, but it serves a purpose: to begin the worldbuilding and level design process, we will need some ideas, but we also need a careful plan to implement them. One of the biggest hurdles that new designers face as they learn the game development process is how to create ideas that are achievable and can be delivered upon. The other obstacle for this section is one of scope: entire books can be (and have been) written on brainstorming story ideas, game writing, and structuring a narrative. With this in mind, our goal in this section is to provide some advice for ideation (including book references if you want to read further on these topics) and a focus on how to transition those ideas into actionable designs.

Brainstorming and Inspiration

Game designers and authors such as Richard Lemarchand or Tracey Fullerton suggest many processes for *brainstorming* ideas for your games that welcome a *blue sky* approach. It is important in the early stages of a project to allow ideas to flow freely, without naysaying or considering practical hurdles – you want to capture those free moments of inspiration (2018). When it comes to story ideas for your games, especially those in action-adventure-scaled projects, you will want to be open to many different narrative possibilities – you potentially have a lot of content to make! Exercises like shouting out words and writing them on a white board, or writing random words on post-it notes and then mixing and matching them into different combinations are great to get your team's creative juices flowing. Practices like these, or games like *The Exquisite Corpse* – where team members take turns drawing part of a character or writing part of a story, then folding the paper and passing it to the next team member – allow you to come up with ideas you may not have otherwise (Laxton, 2019).

The other half of this equation, which is not often talked about in creative circles, is the inspiration for some of these ideas. On one hand, brainstorming is a wonderful exercise that puts the brain into a more open mode of thinking, helping designers arrive at ideas that they may not otherwise have. On the other, designers with a broader palette of potential ideas will potentially have more "material" to work within these exercises. In our experience as teachers, we regularly see students struggle to find new ideas or settings for games because their inspirations are mainly other games. The most "novel" ideas, though, tend to come from designers with other sources of inspiration. *SimCity* creator Will Wright is known to make games that match topics he reads about or other interests of his: one famous example being how *SimCity* is based on urban planning principles of architects like Christopher Alexander (Radical Reads, 2022). Double Fine Productions founder Tim Schaefer likewise credits his broad range of inspirations, which he has pulled from to create games like *Grim Fandango*, to the world folklore classes he took in college (Dineen, 2020). Many indie games pull from autobiographical or personal sources, such as Nina Freeman's *Cibele*, which explores Internet-based relationships, or the narrative cooking game *Venba*, about immigrant families.

Our own inspirations come from varied sources, such as art history, nature, family, hobbies, and lots of places. Our game *Little Nemo and the Nightmare Fiends* is based on the original *Little Nemo in Slumberland* comic strips from 1905, which are now in the public domain, meaning that they are free for anyone to use. Indeed, the public domain is a great source of inspiration or even source material for games. Chris (one of the authors of this book) has a whole series of public domain-based games such as *Lissitzky's Revenge*, an abstract art arcade game, and others based on works from the Spanish Golden Age such as *Don Quixote* and the play *La Vida es Sueño* (Life is a Dream). *Kudzu* is based on a blend of interest in gardening, family inside jokes (Chris's cats and his in-laws' cats appear in the game) and encounters with various invasive plants. From inspirations like these, one can build ideas like "what if there was a giant labyrinth of kudzu that was actually evil, controlled the creatures that wandered in, and wanted to envelop the world? Could you navigate the maze and defeat the kudzu at the source?" Sounds like an action-adventure to us!

The point is that brainstorming and ideation can be even more effective if you go outside of your comfort zone and learn more about the world around you. Reading, visiting museums, having other hobbies, anything you can do outside of making, and playing games will both inspire you and help you maintain a healthy work–life balance (and remember: not EVERY interest you have outside of games has to be pulled into your game making!)

Narrative Pillars

From brainstorming and your areas of inspiration, you may have the seed of a high-level story idea that needs to be worked into something implementable. Again, storytelling in games is something that we do not have the space to cover here, and which could (and does!) fill up several entire books. For those looking for other sources, we recommend Hannah Nicklin's *Writing for Games: Theory & Practice*; *The Game Narrative Toolbox* by Tobias Heussner, Toiya Kristen Finley, Jennifer Brandes Hepler, and Ann Lemay (2023); and *Advanced Game Narrative Toolbox* by Tobias Heussner (2019). There are some basics though that we can use to focus on both aspects of narrative that will be pulled into our level designs and keep our ideas within a manageable scope.

For game designers, the terms *story, plot,* and *narrative* are sometimes used interchangeably or even confused with one another. Nicklin clarifies these terms by defining *story* as "the *whole* thing that you are then using techniques and conventions to tell" (2022), alluding to it as the complete picture of everything that happens within your story world. The *plot* is what the author chooses to show (Nicklin, 2022). In this way, the backstory or lore of your world might constitute the story, while the events of your game constitute the plot. *Narrative*, then, is the craft of telling the story, such as deciding whose perspective to tell the story from, in what order, whether there is a narrator, whether there are sub-plots, etc. (Nicklin, 2022). Making narrative decisions about the *shape* of the story is incredibly important in action-adventures, as genre's mechanisms lend themselves to worldbuilding and plot delivery through major quests, side quests, NPC dialog, and other interactable elements.

With *Kudzu*, we chose an *in medias res* delivery, where the player starts the game when major story events have already happened – your character's mentor has wandered into the kudzu field and a bunch of bad stuff happened such that he has not returned. Likewise, the major reveals are not about the mentor character, or even your character, but about your character's rival, Grace, and her family's connection to the titular kudzu vines. This is a deliberate *narrative* choice, to make the main character the "most important tertiary character" who learns about the broader *story* of the game as he explores the game world. *Little Nemo and the Nightmare Fiends* likewise uses the original *Little Nemo* comics as the broader story, frequently alluding to Nemo's past adventures and returning characters, but uses the age of the comic to deliver a *plot* about awkward reunions between long-lost friends.

This brings us to *narrative pillars*, a concept taught to us by veteran writer and narrative designer Heidi McDonald. The pillars are major themes or tentpole narrative factors that drive the storytelling

Little Nemo and the Nightmare Fiends narrative ideas

- The Meta – Nemo has been dormant and who owns the dream vis a vis public domain
 - Flip knows he's in a video game
- Slumberland is for everyone – memory and dreams
 - Nightmare Fiends (maybe someone else?) want the dream to themselves
- Friendship
 - Nemo wants to be brave for the sake of his friends
 - Nemo talks like he's in 1905
 - Peony wants to find her own identity among being a Candy Kid
 - Is middle-aged but looks like a child forever because she's made of candy
 - Flip wants to fit in/be welcomed for who he is/is OP
 - Son of the Sun, Nephew of the Dawn. His access to these connections is cut off during the game.
 - Princess is the one to call Nemo to Slumberland
 - Struggles with her upbringing as royalty but her desire to be an adventurer
 - Discovers she can be both
- Nightmare Fiends want to own the dream and make it in their image. They only know nightmares.
- Morpheus is trying to add things to Slumberland to bring people to it. Accidentally invites the nightmares or created them accidentally. (Wants to make the dreams edgy to get the kids excited about dreaming)
 - Makes dreams, wants to make the dreams more exciting
 - Not a bad guy – lost control of his scope
 - DOES NOT get kidnapped

FIGURE 3.1 The narrative pillars of *Little Nemo and the Nightmare Fiends*. Having this outline of narrative themes and tentpole ideas helps align the overall plot, writing, and narrative design for the whole game.

decisions of your game. Since games are a non-linear medium, in that their stories are not always told in a particular order, it is helpful to write out an outline of major narrative points that the many potential subplots, quests, short lines of dialog (barks), etc. can work from (Figure 3.1).

These pillars are not the whole plot or narrative but are part of the major structure ("pillars") of the story. Working from the pillars shown in Figure 3.1, we could define individual scenes in the game's plot. For *Kudzu*, "Max is the most important tertiary character who silently observes the story" was another pillar. This led to narrative decisions that suited the game's retro Game Boy style: learning the plot through found journals, solving puzzles, and meeting NPCs. The pillars also gave our world a shape: in Nemo, we saw the need to have the action rise toward the point where you visited Slumberland itself, so the first few regions of the game world feel more like wilderness on the path toward a big fantasy city. Likewise, *Kudzu's* kudzu labyrinth begins as something more benign, an overgrown farmer's field, in which you eventually discover a haunted estate and a forest of horrors as you plunge deeper.

Though they are still very general, narrative pillars still function as high-level character or story ideas but are given more definition as something that game narrative ideas can be built upon and implemented. Using some of the planning methods discussed in earlier chapters, we can even begin to plot out how the pillars and the ideas that come from them can be implemented in specific gameplay sequences. In the next section, we will look once again at one such tool, game design macro sheets, to see how much of this information can be accounted for in those planning documents.

RETURN TO THE MACRO SHEET

In Chapter 1.2, we described the *macro sheet*, a visual map of design information, laid out in a spreadsheet, that describes level-by-level and moment-by-moment gameplay in great detail, including mood, game mechanics encountered, time of day, enemies encountered, and more (Figure 3.2).

On a typical macro-sheet, as described by Richard Lemarchand in his book *A Playful Production Process,* sequences of gameplay would be tracked in individual rows (Lemarchand, 2021). These sequences may be parts of the story, parts of levels, or entire levels, depending on your game's format and narrative. For a game like *Metroid Dread,* which has players visit regions of the game world several times throughout the game, these rows may be used to represent sequences of the game rather than whole levels. For example, players visit the fiery region of the game, Cataris, several times under different circumstances. During the first visit, they have not yet obtained the heat-resistant Varia Suit that would enable them to explore the area freely, so the player must do a series of puzzles with heat pump machines to cool their path. In this case, the heat pump puzzle sequence through this area would likely be its own row on the macro sheet, listing out the heat pumps, avoiding overheated areas, etc. in the columns related to gameplay mechanics. Likewise, the designer would list related events for that pass through Cataris in the columns for "brief description of events," "player goal," and "emotional beat" (likely related to creating a tense environmental sequence with the heat) (Figure 3.3).

This example shows how thinking about level planning can be different in action-adventure games than in other styles of games. In Lemarchand's examples from *Uncharted,* rows and sequences from that game can be fairly straightforward: the player sees most areas only once, allowing all of the elements of those levels to be contained entirely within one line of the macro. In a game like *Metroid Dread,* the designer can have the player return to areas multiple times for plot-important sequences (not just in regular exploratory backtracking), such that one actual map or region may appear in your macro multiple times.

On the surface, the macro helps us plan out the look and feel of these areas by helping us track the mood, time of day, environmental art and sound assets needed for these areas, and which enemies or characters the player will encounter. This is just the beginning of its usefulness for worldbuilding in level design though. The macro – often done close to the beginning of a project but after initial ideation, testing, and narrative pre-production – is how we can start organizing the non-linear progression of these games early. As we have said multiple times throughout the book, the biggest challenge in creating action-adventure games is planning the ways that players will experience the spaces of the game. Unlike a linear action game, these games include opportunities for backtracking, or periods where players may need to return to already-explored spaces with newly acquired abilities. The macro sheet is one tool for planning out these progressions, by focusing the rows of the macro on story sequences rather than on levels.

According to Lemarchand, beyond basic elements found in most games (like what gameplay mechanics players encounter in each level), the number and content of columns on macro sheets can vary wildly from project to project. In the case of action-adventures, we can use them to track changes to the *game state* – a general game design term that describes the status of the overall game, determined by elements contextual to the game being played (points, position of players, location in a world, etc.). In this genre, one might describe the game state in terms of which areas of the game the player has visited, which upgrades they have found, bosses they have defeated, and so on. In the practical chapters, we have created puzzles and quest events that are tracked with variables and flags. These mechanisms of game engines and scripting are like on/off switches for progressive events in your game, and you can track when they are turned on and off within your macro sheet. When you have a variable (we can call it "PuzzleSolved") switched to "true" in one sequence, we can describe how it is set to true on the macro sheet during the sequence in which it is set to true – possibly in a column describing game state changes. If the sequence that follows is a return to a previously visited area, we can also have a column describing how variable changes to the game state affect the area. When it comes time to build these areas in-engine, you will have a good sense of how a space changes over the course of the game, and construct the room in such a way that allows for these changes.

	Location/Sequence	Description	Player Mechanics	Player Goals	Design Goals	Emotional Beats	Characters Encountered	Enemies Encountered	Objects Encountered	
		A	B	C	D	E	F	G	H	I
2	Opening Animatic	• Peony is given assignment				• Very cloak and dagger • Dark undertones - something's rotten in Stumberland	• Morpheus • Princess • Peony • Nightmares • Popcorn? • Bon Bon? • Mephisto?			
3	Nemo's Bedroom	• Peony awakens Nemo • The bed gets up and walks out the window! • The bed romps down the street • Nemo is tossed off and lands on a roof. • At the end of the stage, Nemo slides off a roof and tumbles through the air. • Peony, riding on the bed, catches Nemo. Gotcha! • They fly off into the sky.	• Run • Jump • Attack		• Learn the game's basic movement mechanics	• Happy, quaint, reunion with our old friends • Initially happy and exciting	• Peony • Nemo			
4	City Rooftops			• Chase Nemo's bed • Reunite with Peony		• Oh no! The bed's out of control! • What WAS that thing that scared the bed?	• Peony • Nemo	• Pig chickens		
5	Night Sky	• Peony let's Nemo off the bed. Stay here, I need to investigate something! • Nemo doesn't listen and makes his way to the first boss; the moon • Fight the moon • Peony and Nemo talk to the moon. Peony goes in it's mouth. A key falls from the sky.	• Map use • Nemo glide • Locked doors • Timed platforms • Boss encounters	• Reach Stumberland	• Exciting intro level ("Mega Man X") • Introduce and explore Nemo's glide mechanic • Introduce level exploration (looking for locks and keys) • Introduce the map via it being active in the level	• Joyous return to Stumberland • Something's wrong - what's up with the Moon? • What WAS that thing that infected the Moon?	• Peony • Nemo • Night sky citizens • Moon	• Pig chickens • Tick Tock birds • Sandman • Cloud version of jub bird	• Keys • Candy • Health pickups • House key	
6	Nemo's House - Return Trip 1	• Nemo awakens. The key is floating in his bedroom? It flies off, leaving a trail behind. • Following the trail, the key unlocks a room in the house (library?) • Going back to bed, the Mushroom Forest is unlocked	• Game flow - beating levels and unlocking the next area of the house	• Explore the house • Unlock the Mushroom Forest • Learn about the kitchen	• Introduce game flow via exploring the house • Introduce the kitchen	• The forest is wonderous but spooky - what happened to Peony?			• House key • Mushrooms	
7	Mushroom Forest	• Nemo is in the forest alone. Where's Peony? • Nemo happens about Dr. Pill. He hasn't seen Peony, but he's got stuff to sell. • Nemo also meets a farmer who needs fertilizer to help revive the forest. • Nemo happens upon a big wooden house owned by the Mosquito Farmer • After exploring the entrance to the house, the Mosquito Farmer traps Nemo! He falls in a pit. • Further into the cave, Nemo finds Peony! She joins the party. • They get out of the cave. • With Peony's help, they find fertilizer • They deliver it to the farmer, and new bouncy mushrooms unlock • At some point they happen upon both Pilgrim's Progress guy, whose very happy he doesn't have his case. • Peony and Nemo get cornered by the Pie Eaters! • Upon defeating the pie eaters, a key appears. Nemo awakes!	• Peony Climb • Character Swapping • Non-linear level design • quests • "Hope" collection • Bouncy mushrooms • Floods (moving climbable walls) • Moving platforms (Love Birds)	• Pass through the forest • Find Peony • Escape the Mosquito Farm • Find fertilizer for the mushroom farmer • Defeat the Pie Eaters	• Introduce Peony and climbing • Introduce metroidvania style level layouts • Introduce "hope" collection • Introduce Quests	• Nemo's gotten himself into BIG trouble with this mosquito guy • Ta da! Peony to the rescue! • Let's get outta this forest! • Oh no! Not the Pie Eaters again! • Ahhh! The nightmare energy made them even worse!	• Peony • Nemo • Pill • Farmer • Moss. Farmer • Bunion • Pie Eaters • Mushroom town people	• Stilthy Tove • Jub Jub Bird • Wild Man • Mosquitos • Potato Bug	• Keys • Candy • House key • Health pickups • Hope • Records • Comics • Bunion Case • Fertilizer	
8	Pill's Shop	• The store for various items and collectibles. Requires candy.	• Candy (money) • Shopping	• Power up	• Introduce game economy	• Snake oil salesman	• Pill?			

FIGURE 3.2 A macro chart from our game *Little Nemo and the Nightmare Fiends*, outlining the gameplay and art elements that players will encounter throughout the various levels.

Location/Sequence	Description	Player Mechanics	Player Goals	Design Goals	Emotional Beats	Characters Encountered	Enemies Encountered
Cataris	• Samus gets more use of Spider Magnet Panels • The area initially needs thermal fuel to be redirected in different ways to pass • Detour to Dairon to get the Wide Beam • Retrieve Varia Suit from Artaria to fully access Cataris • Battle with Kraid	• Spider Magnet Panels • Thermal fuel machines • Morph Ball • Wide Beam • Super heated rooms • Fleeing EMMI	• Get long-awaited Morph Ball • Gain more access via Varia Suit upgrade	• Initially very confining space (environmental mechanisms required for passage) opening up with upgrades	• Frustration - Morph Ball is still withheld • Frustration - Player is limited to only moving where flow of heated fuel will allow • Relief/achievement when Morph Ball and Varia Suit are gained, allowing more movement	• Samus • Adam	Autclast Autool Bigkran-X Caterzilla Central Unit Central Unit Cannon E.M.M.I.-03MB Experiment No. Z-57 (boss) Goobler Infester Insect (non-hostile) Kraid (boss) Kraid Bouncing Creature Light Insect (non-hostile) Magma Crab (non-hostile) Obsydomithon Pty Reptile (non-hostile) Rinka Rock Diver Sclawk Shakernaut Shelmit Vulkran

FIGURE 3.3 A theoretical macro sheet row, filled out for the first visit to the Cataris region in the game *Metroid Dread*, which is more puzzle-heavy than other later visits to this part of the game.

In our homebrew Game Boy game *Kudzu*, the player is meant to return to the starting hometown area several times throughout the game. To have the town feel more dynamic, we made the cast of townspeople move around and change their dialog after different areas of the game were cleared (tracked via a variable counting which bosses the player defeated). In a macro sheet for such a setup, we would have rows for the hometown between each dungeon, describing the changes that would occur after each boss was defeated. Putting these into the macro helps plan the changes that happen from visit to visit, even if the players themselves do not actually return to that area. In *Kudzu,* these changes were tracked by the character sprites themselves via a series of "if" statements that would execute when the scene was loaded (for positioning) or when they were interacted with (for dialog). These sorts of shifts in the game world help it feel more dynamic and as though it has a "life" outside of the player's interactions with it. If you add opportunities for hidden items or quests on return trips, you can further use the evolving state of an area to do additional worldbuilding and reward players for exploring. Again, all of these sorts of things can be written into your macro sheet as a way to start mapping out these more complex aspects of progression.

In the next section, we will get closer to the actual level construction of our narrative-rich spaces by discussing high-level map ideas, and how a general concept for a map can help tie the "shape" of your map to the overall narrative action happening in your game world.

HIGH-LEVEL MAP IDEA

When starting the design of your action-adventure game's overall map, there are a lot of mechanical and progression elements that will inform the form of the map itself. Beyond those concerns, though, are the metaphorical and narrative aspects of the map, which will derive from your game's narrative pillars and your concept for the game's setting. Envisioning a *high-level map idea* – such as "the game takes place on an island," or "descending into a cave" – helps you both envision your map's basic design and make the map design part of your worldbuilding. In this section, we will look at examples from different games to see how these metaphors appear in the map design of action-adventure games and add a sense of place to the game world.

Most entries in the *Castlevania* series share the same goal: climb to the top of the titular castle and defeat Count Dracula in his chambers. It is a tradition with roots in the first linear entry in the series; Simon approaches the gates of the castle during the intro, then makes his way through the halls, dungeons, aqueducts, and more, steadily making his way to the suspended chamber that looms in the background throughout the journey. In fact, as Jeremy Perish points out in his book *The Anatomy of Castlevania*, areas of the castle both past and present are visible throughout the game as environment art in the game's backgrounds. This gives the game world a feeling of logical cohesion and gives the player a sense of their physical and narrative progress throughout the game (Parish, 2012).

We can apply this synergy between narrative and world design to nonlinear games as well. *Metroid Dread* begins with series' protagonist Samus Aran at a metaphorical and literal low point. Defeated in combat and stripped of her powers from the previous game, she must make her way from the underground cave system she's stranded in back to her ship on the surface of the planet ZDR. In typical *Metroid* fashion, Samus finds both old and new abilities alike, she grows in strength and is given more areas to explore, each region being slightly higher as she climbs her way back to the surface. This simple introduction creates a very clean synergy among the narrative, gameplay systems, and map structure of the game. As Samus continues upward toward the exit, her power and capability against enemies increase. Eventually, she can even take down the previously invincible EMMI robots and defeat the final boss character, who initially defeated her at the beginning of the game.

By way of contrast, the ultimate goal of *Hollow Knight* is close to the game's starting point: the Black Egg temple, which the player's character is trying to open so they can face the titular Hollow Knight. Before the player can do so, several goals must be accomplished, all of which will lead the player further

and further downward. As in *Metroid Dread,* the player grows as they explore further, but here the world becomes darker and scarier as the player moves down. While the entire map doesn't need to be explored to finish the game, getting the best ending will eventually lead players to The Abyss, the lowest region on the game's map, where they will find the final items that will unlock the final ending. It is only by the player continuing downward as far as they can go that they can both literally and figuratively dig up all of Hollownest's secrets.

Kudzu's world map and the maps from *Little Nemo and the Nightmare Fiends* each likewise hinge on a larger spatial metaphor. *Kudzu's* map is built around moving further into an overgrown field, so the idea was to always give players something new to discover – such as forgotten statue gardens, an abandoned manor, a forest where all the non-kudzu plants had been choked of life. Since the game was built for the original black and white Game Boy, each area's color scheme focuses on two colors from the Game Boy's limited palette of four shades of green/gray. This way, the game's environments build a continually darkening atmosphere, while also making each area visually distinct (Figure 3.4).

The levels for *Little Nemo and the Nightmare Fiends* do not connect in the typical Metroidvania way, but each still tries to represent a cohesive sense of geographical realism. Jack Frost's Ice Palace, for example, begins with Nemo and friends at the bottom of a cave akin to Samus in *Metroid Dread* but

FIGURE 3.4 The world map of *Kudzu*, showing how different regions use different shades of gray. With the limited Game Boy color palette, we focused each area's color scheme on two colors so that each would give a different mood, becoming progressively darker and more mysterious as the player pushed further into the kudzu maze.

FIGURE 3.5 A portion of the Ice Palace map in *Little Nemo and the Nightmare Fiends*. Each area uses different variations on the same set of environment art to give the sense of geographic diversity and spatial continuity: exploring different parts of a large ice castle from underground caves, to different chambers, and up to high towers.

also parallels the journey Nemo and friends make through the ice caves to the palace in Winsor McCay's original *Little Nemo* comics. As they emerge from the caves, the player is treated to the rewarding vista of the palace's exterior and can then move into the castle itself. As the player explores the different areas of the castle, the environment art shifts from interior masonry, to the machinery of the castle's boiler room, to the castle towers at the top of the map (Figure 3.5). For a large map like this, giving each area a distinct theme helps both narrative worldbuilding and helps players navigate as they get a sense of where each themed area is in relation to one another.

Narrative and mechanical congruence can also be seen throughout individual regions of a game as well. For example, we can examine *The Legend of Zelda: Skyward Sword*'s dungeon the Ancient Cistern. In a series called *Allegories in Architecture,* the website Zelda Dungeon demonstrates how the dungeon's design was inspired by *The Spider's Thread*, a short story written by Akutagawa Ryunosuke. The story, which centers around Lord Buddha lowering a thread of spider silk from a lotus pond in paradise down into Hell to give a condemned thief a chance at redemption, acts as both the aesthetic inspiration for the dungeon and the overall structure and individual puzzles (Robert 2012).

The Zelda Dungeon staff note several visual references to Buddhist concepts within the dungeon, such as the lotus motif throughout the dungeon from the many lotus decorations along the walls and the lotus pond that makes up much of the ground level of the dungeon. Lotuses are traditionally symbols of purity and rebirth, much like *The Spider's Thread* is about a potential rebirth through purification. But this allegory stretches beyond visual allusion. To complete the dungeon, the player must travel to the underworld situated in the dungeon's basement and travel along the spider's silk to obtain the boss key and gain access to the chamber atop the Buddhist's crown, a metaphorical state of enlightenment and an "end" from suffering from the underworld below. Through the inspiration of *The Spider's Thread* and its connection to Buddhist philosophy, *Skyward Sword*'s level designers were able to craft one of the game's most memorable dungeons.

Ultimately, crafting a game world that has narrative and thematic synergy is a creative challenge that will largely be informed by a combination of your game's mechanics, intended biomes and a well-defined story structure. Considering questions such as how your character grows both mechanically and as a

person throughout the game, how the world map expands along with that growth, and how, if possible, it can be tied back to the narrative, are all worth considering. While certainly not necessary for every game, it has the potential to make the game more memorable and meaningful when executed well.

In this chapter's final section, we will explore how environment art – often seen as distinct from level design – is a vital part of creating continuous and persistent action-adventure level designs.

PLANNING BIOMES/ZONES/REGIONS

Depending on the size of your team, the difference between the level design and environment art roles can be blurry. On big teams, they might be distinct departments that collaborate regularly, with environment art adding visual clarity to the level designer's work, usually done in *graybox*, where level spaces are built in blocks of standard game engine geometry. On smaller teams, level design and environment art may be the responsibilities of one or a few people who flip-flop between the two disciplines by creating level geometry and subsequently set-dressing after it has been thoroughly tested. Either way, the work of the two disciplines is generally close, though with distinctly separate functions. In action-adventure games, however, the two disciplines must work more closely than in many other genres. As we will see in this section, the environment art and theming of regions in your world are important in multiple ways related to both gameplay and narrative.

"The Miniature Garden"

We should first start with some overarching design principles to describe environment art's function in our game worlds' designs. Game designer Chaim Gingold describes the aesthetic of certain types of game worlds as the *miniature garden*, based on a cryptic phrase used, but never fully clarified, by Nintendo's Shigeru Miyamoto. Attempting to define this term, Gingold pulls from Japanese garden design principles, particularly David Slawson's *Secret Teachings in the Art of Japanese Gardens* (1987), and analyses of Miyamoto's game worlds. The resulting aesthetic principles describes the miniature garden as compact, self-contained worlds containing "a multiplicity of environments and places" (Gingold, 2003).

Slawson describes how Japanese gardens utilize landscape features like stones, expanses of sand and/or grass, small bushes, and other elements to create miniature recreations of landscapes that viewers can experience as they walk through or observe gardens. If a garden is meant to be walked through to be experienced, it is a *stroll garden*, while a garden meant to be observed from set positions outside of the garden itself is a *viewing garden*. Both orientations symbolize the natural features of much larger landscapes: expanses of sand or grass usually represent bodies of water, stones represent mountains, shrubs represent forests, and so on. Gingold highlights that these miniature, observable worlds invite both macro and micro-level readings: they can be viewed from a distance as someone takes in the whole view, or experienced more closely as individual scenes, much in the way game worlds can.

Games in the *Legend of Zelda* series can be easily read in this way, with many of the games having themed areas matching typical Japanese garden scenes: lakes, rivers, grassy fields, forests, mountains, deserts, etc. This is very apparent in a 2023 fan-made remake of *The Legend of Zelda: Link's Awakening* for personal computers, which allowed players to zoom the game out such that they could see the entire overworld map at one time. While most other *Zelda* games feature a map screen, *Link's Awakening DX HD,* as the remake was called, allowed players to see the whole game in one shot, complete with enemies and NPCs (Figure 3.6)

Miniature gardens are important for our understanding of narrative action-adventure worlds in how they aid both game experience and the player's ability to navigate the world. One element of these worlds is that they contain multiple environment types which would not naturally occur in such close geographic proximity in the real world. This aspect of these worlds adds visual, and often gameplay, variety to the

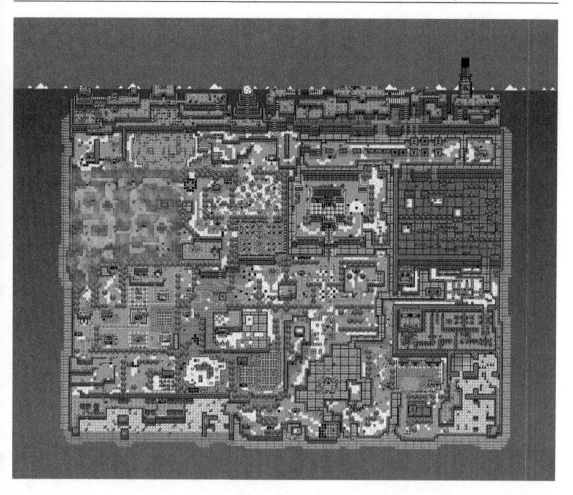

FIGURE 3.6 The fan-made *The Legend of Zelda: Link's Awakening DX HD* remake allows players to see all of Koholint Island at once, emphasizing the feeling of the world as a living miniature garden. While the official Nintendo versions of the game are experienced in single-screen increments, this version allows you to see how each screen and region blend into one another and shares contiguous features, such as the rivers that start in the northern Tal Tal Mountains, through various lakes, and finally out to sea at the island's southern end.

game experience, allowing even small worlds, such as Koholint Island, to feel rich. The variety of visually identifiable areas also aids navigation: players can build a *mental map* of where differently themed areas are in relation to one another, which helps them orient themselves in the world. If you recall, this orientation is a vital element of the *sense of place* described by the architectural theorists at the beginning of this chapter.

In practical terms, these themed regions are implemented via different packs of 2D or 3D environment art representing the various environmental themes. In modern games, these packs would be collections of 3D models. In 2D games, these are often *tilesets*, pieces of art that have all of the square graphics, or *tiles*, used to create the level art. In older games on consoles where there was limited cartridge space, designers would sometimes even reuse tiles in different levels, applying differently colored palettes to give the tileset a new feel. One example of this is *Sonic the Hedgehog 2*'s Emerald Hill and Hill Top zones, which share the same foreground tiles with yellow and blue coloring applied, respectively.

While we have been calling them "regions" or "zones" throughout the book, a common industry term for themed environment types is *biomes*. As with so many terms in the industry, different designers may use it to mean different specific things. For this book, we will refer to a "biome" as the general themed kit of modular environment art parts used to construct levels, as in "the ice biome," "the jungle biome,"

"the haunted house biome," etc. Biomes represent an important piece of action-adventure level design, as they help us create works that players can find a sense of orientation and attachment to. Regions or zones, therefore, become the actual level maps that we construct using our biomes.

The individual rooms or spaces in these areas themselves become distinguishable and memorable thanks to challenges, monsters, or puzzles within. Apart from the fully modular elements of our biomes, we can also use environment art to create other uniquely distinguishable areas to help player navigation. One such spatial design tool is *landmarks* – pieces of environment art meant to be eye catching and memorable such that players know where they are in relation to it ("I am three rooms west of the big waterfall"). Landmarks can be level geometry and/or environment art pieces that are only used once in a while, such that they can stand out when encountered. Another tool are *sub-biomes*, which is where you only use some of the parts available as part of the overall biome kit in an area of your level. In *Little Nemo and the Nightmare Fiends*, we used this method to create levels with visual variety and navigability. In the earlier example of the Ice Palace, everything used one "ice biome," but it was split into the sub-biomes of "ice caves," "ice machinery," "ice towers," "ice palace interiors," "ice hallways," etc.

Depending on your method of rendering your environment, environment art can also itself become a tool for building surprises or discoveries into your game environment and enhancing the impact of landmarks in 2D side-scrolling adventures. In *Little Nemo*, we used a camera, based on Michal Berlinger's perspective/orthographic camera setup published at https://www.gamedeveloper.com/programming/combining-perspective-and-orthographic-camera-for-parallax-effect-in-2d-game, that renders the game's environment in layers using Unity's layering system and multiple cameras arranged in a hierarchy. The main camera object renders the layer that the player is on in an orthographic (flat, without perspective) projection, while the other camera – situated in the scene hierarchy as "child" objects of the main camera – render the various foreground and background layers ("foreground," "near background," and "far background") in perspective. This allows us to layer background art layers in ways that create interesting perspective effects (Figure 3.7).

FIGURE 3.7 An image from the Unity scene window showing the Ice Palace level from *Little Nemo and the Nightmare Fiends*, demonstrating how environment art is layered from foreground, to player layer, to background. The multi-camera perspective/orthographic camera system makes these layers shift around in a way that creates striking perspective effects.

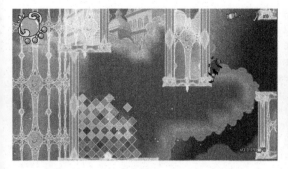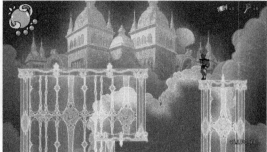

FIGURE 3.8 As players explore in *Little Nemo and the Nightmare Fiends*, shifting background layers (using parallax-like background perspective effects) reveal spectacles that create surprise, serve as landmarks to aid navigation, and act as "rewarding vistas" after difficult action set pieces.

Beyond being simply a cool visual effect, the layered backgrounds – since they shift at different paces based on their distance from the camera rig – can be placed in such a way that they can create dramatic reveals of background art (Figure 3.8). In the book *Chambers for a Memory Palace,* architects Donlyn Lyndon and Charles W. Moore talk about "walls that layer" – a concept where layered walls and columns partially reveal interesting views. Lyndon says, "what we can see through such layers is distinctly affected by how we move and look, by our participation in the place. It places initiative in the hands (or feet) of the observer" (Lyndon and Moore 1996). Lyndon cites buildings like the Great Mosque of Cordoba, whose many rows of columns create the feeling like a shifting orchard as occupants move around it, but the same can be accomplished with carefully arranged layers of art. In this way, the environment art design can "invite the hands" (because we are using keyboards or controllers) of the player to move their characters and discover new things.

As we can see, a "miniature garden" design mindset helps us conceptualize how to make worlds that have both thematic diversity and usability. It can also lead to uses of thematic elements like environment art to build or enhance our level's sense of wonder and discovery. These will create exciting worlds with a sense of place for players to explore. Biomes can be constructed from tilesets, collections of 3D models, or other assets to aid in the creation of these distinguishable regions or zones within the world, with environment art used to add even more variety and clarity.

Scott Rogers on Level Theming

We should say a word on the topic of themes themselves as well, such as outlining some common themes, why they exist, and how they may be best used. In his book *Level Up! The Guide to Great Game Design*, veteran game designer Scott Rogers provides a list of "cliché" video game-level themes. These include outer space, fire/ice, dungeon/cavern/tomb, factory, jungle, spooky/haunted house/graveyard, pirate (ship/town/island), gritty urban, space station, and the most worn-out cliché of all – sewer (Rogers, 2010)

Rather than listing these out as themes to avoid, Rogers takes time to investigate each theme's history and practical uses. Space, for example, is cited as being an efficient theme for early arcade games which had limited visual memory – rendering a mostly black screen was far easier than one full of scenery and sprites. Likewise, fire and ice provide easy-to-program hazards and colors not as commonly found in nature, which adds extra visual interest. Other themes emphasize gameplay, such as dungeons or haunted houses, which can focus on traps and puzzles. Haunted houses are especially great in this regard, as the supernatural element allows designers to go fully surreal, adding environments that shift, or doorways that transport you to a completely different area of the environment. Yet others provide opportunities for action or combat, such as factories, pirate levels, or sewers, which can utilize more timing and traversal-based mechanics.

This is far from an exhaustive list, but befitting the "designer's notebook" style of Rogers' text, it is a good outline of noteworthy design standbys that also provides perspective on how themes can work thematically and mechanically. One could apply the same lens to other common themes like grassland, mountains, forest, desert, underwater, etc. to understand how they become patterns that combine thematic and mechanical interests. Rogers also provides some insight into getting more from these themes by mixing and matching them: variety and novelty can be added by bringing common themes together in new ways. Roger provides examples from his work on *Maximo: Ghosts to Glory*, such as a graveyard being torn apart by volcanic eruptions ("a fire graveyard"), or pirate ships covered in ice. From a narrative perspective, these blends become immediately more interesting than the themes are by themselves: how did the pirate ship come to be covered in ice? How did the haunted house get covered in vines? Explore onward to find out!

Narrative Purpose of Zones

Throughout this chapter, we have alluded to the narrative importance of high-level map concepts, how maps are laid out, environmental art, and other elements, but we also want to address narrative techniques that can be applied in action-adventure levels directly. As a genre where narrative and gameplay intertwine, with story even becoming the driving force that moves players through many games in the genre, levels can themselves be narrative tools. One way to implement narrative into your level is the practice of *environmental storytelling*, or directly embedding narrative details into the level's design and artwork. Environment art is useful for taking the content of the game's story or backstory that exists beyond the game's actual plot, and placing it in front of players in an indirect way.

Narrative designer Clara Fernandez Vara ties environmental storytelling with another practice called *indexical storytelling*, which she defines as the construction of game narrative mainly through indices, or bits of information that players have to piece together through play (Fernandez-Vara, GDC Online – Environmental Storytelling: Indices and the Art of Leaving Traces 2012). These can be very overt, such as the many letters and documents players can find in the worlds of *Skyrim* or *Dishonored*, or be more opaque, such as the lore-packed item descriptions or evocative statuary in *Elden Ring*. In this work, Fernandez-Vara cites Charle's Peirce's philosophy of language and three types of signs he identifies:

- Icons/likenesses: signs that convey ideas by imitating them, such as a photograph or drawing.
- Indices/indications: the idea is physically connected with the sign, such as a sign post that points in the direction a traveler should go, or smoke coming from a fire.
- Symbols/general signs: signs that are associated with meaning through usage, such as a skull and crossbone symbol coming to mean death, pirates, or poison through general social adoption. The actual connection between sign and idea is arbitrary (Fernandez-Vara, 2011).

Many action-adventure worlds are indexical spaces. Referring to some of Rogers' cliché level themes above, they are often set in themed locales like temples, ruins, or other spaces with an explicit or implied history. Environments in the *Metroid* series function in this way, especially in early titles: as players navigate through the caves of Zebes, they happen upon rooms of more advanced technology, which typically lead to item-holding Chozo statues. Since Chozo statues are found in primarily tech-themed rooms and hold upgrades to player character Samus Aran's futuristic armor, one might imply that the Chozo were a technologically advanced civilization. These connections are once again, entirely arbitrary, but working with socially established symbols, and using those meanings to construct new ones, are foundational to how narrative is built in game worlds. When one considers how such symbols and meaning might be partnered with large-scale level ideas, they can see how symbols and meaning-building become quite powerful narrative tools. In our earlier *Hollow Knight* example, the high-level concept of a descent into darkness is aided by indexical factors. The increasingly bleak and muted environment art, darker color

palette, and narrative revelations of the Abyss region stand out as a satisfying payoff to a map that slowly builds the sense of a world gone by: the Abyss is where all its darkest secrets are left behind.

The other types of signs are also great tools for designers in how they help designers move players through the world: a plume of black smoke rising from a distant city is a great way to draw player attention and imply that interesting plot events may be found nearby. Likewise, murals, paintings, and other icons help flesh out the game's story explicitly without the need for cutscenes: such as the murals in *Zelda: Tears of the Kingdom*'s castle catacombs. In this instance, there is mural about the history of Hyrule encountered at the beginning of the game with a portion covered by fallen rock. The player will likely not be able to uncover it until they return to the same place at the very end of the game. The last piece of the mural reveals important parts of the game's story and is teased in such a way that players are excited to return.

Returning to how these work at the scale of regions or zones; portions of maps are themselves an important part of building the narrative "place-ness" of your action-adventure worlds and can themselves contain narrative-rich symbolic elements. How these are revealed to the player therefore becomes an equally important element of the expressive narrative systems of the game world.

Connecting Zones

In writing, the body text – where one delivers facts and information – is an important part of an overall document, but (in these authors' opinions) an equally important element of the work is using transitions between sections or paragraphs to draw connections between points. This is not a book on writing, but on level design, but the same certainly applies – the connections between regions of your action-adventure maps can be an important part of navigation and worldbuilding, though are often a missed opportunity.

In 2D *Zelda* games like *Link's Awakening* and *A Link to the Past*, Hyrule is delivered as a series of "flip screen" spaces, where the player can view one screen or multi-screen space at a time. When the player moves to the edge of their current area, the screen "flips" or provides a scrolling effect to transition to the next area. These games stand out, though, because when one looks at their world maps, they nevertheless represent visually coherent geography. In games, the abstract connections between spaces allow designers to make vague connections between areas, allowing them to fit together in ways that defy logic. *Zelda* maps instead have bodies of water, forests, and mountain ranges that run consistently across the map, once again adding to the game worlds' senses of place and identity beyond their in-game functions.

This is not to say that all game worlds absolutely must have carefully plotted out geographic features, but rather to demonstrate the importance of connections between zones in building both a sense of place and navigation. *Hollow Knight* tackles this from a different perspective: the map takes the opportunity to have labyrinthian and oddly shaped maps consistent with the Metroidvania genre (rather than the neat rectangular worlds of 2D *Zelda*). However, it focuses its connections on the ways that regions' environment art bleed together at their borders. When moving from the Forgotten Crossroads to Greenpath, the Crossroads' muted grays give way to more bright green hues as vegetation creeps into the ruined architecture. *Metroid* games, particularly *Super Metroid,* mark important transitions with monstrous statues that imply danger, yet also a path to one of the pirate leaders that Samus must defeat to reach the end of her journey. Once again, these unique art pieces are landmarks that players can use to orient themselves in the game's world, as well as interesting pieces of worldbuilding.

CONCLUSION

The storytelling and narrative aspects of game worlds are a vital part of the planning of action-adventure worlds. Where some genres can use narrative elements as window-dressing to action or a way to build lore into otherwise mechanic-driven gameplay, these games use narrative-rich environment factors both

for storytelling and for gameplay functionality. It is not a stretch to say that to evaluate the quality or "success" of an action-adventure world design means evaluating how it brings together aspects of storytelling and gameplay.

Similarly, we may also say that part of what makes an action-adventure world successful is how much it can feel like a "place," rather than just as a backdrop for game stuff to happen in. As players move through the world, overcome its challenges, and weave back and forth through it pursuing different quests, they may start to form a sense of belonging in it. We can aid this process by giving players the visual and spatial tools to orient themselves in the world, such that moving through it becomes second nature. Part of this is gameplay design elements covered in other chapters meant to ease travel, such as efficient pathways between zones, but it can also mean visually distinct regions that aid player navigation. The way that environments allow you to identify your position in the world, as well as opportunities to discover elements of the game's story in the environment itself, are important for creating exciting exploratory worlds.

In the next chapter, another of our practical lesson chapters, we will build our own tilesets in Aseprite and create maps with them in the Tiled level editor. We will then import them into GB Studio and see how one creates maps that embody the concepts discussed here.

REFERENCES

De Matteis, F. (2020). *Affective spaces: Architecture and the living body*. Taylor & Francis.

Dineen, D. (2020). *Checkpoints podcast: Tim Schafer*. Accessed December 13, 2023. https://player.fm/series/checkpoints/rebroadcast-episode-100-tim-schafer

Lyndon, D., and Charles W. M. (1996). *Chambers for a Memory Palace*. Cambridge: MIT Press.

Fernandez-Vara, C. (2011). Proceedings of DiGRA 2011 conference: Think design play.

Fernandez-Vara, C. (2012). *GDC online - Environmental storytelling: Indices and the art of leaving traces*. Accessed December 14, 2023. https://www.gdcvault.com/play/1016815/Environmental-Storytelling-Indices-and-the.

Fullerton, T. (2018). *Game design workshop: A playcentric approach to creating innovative games*. CRC Press.

Gingold, C. (2003). *Miniature gardens & magic crayons: Game, spaces, & worlds*. April. Accessed December 14, 2023. http://levitylab.com/cog/writing/thesis/

Heidegger, M. (1971). Building dwelling thinking. In M. Heidegger (Ed.), *Poetry, language, thought* (pp. 143–161). Harper and Row.

Heussner, T. (2019). *The advanced game narrative toolbox*. CRC Press.

Heussner, T., Finley, T. K., Hepler, J. B., & Lemay, A. (2023). *The game narrative toolbox*. CRC Press.

Howard, J. (2008). *Quests: Design, theory, and history in games and narratives*. AK Peters/CRC Press.

Laxton, S. (2019). *Surrealism at play*. Duke University Press.

Lemarchand, R. (2021). *A playful production process for game designers (and everyone)*. MIT Press.

Nicklin, H. (2022). *Writing for games: Theory and practice*. CRC Press.

Norberg-Schulz, C. (1979). *Genius loci: Towards a phenomenology of architecture*. Rizzoli.

Parish, J. (2012). *The anatomy of Castlevania: The NES trilogy*. CreateSpace Independent Publishing Platform.

Radical Reads. 2022. *Will Wright's reading list*. November 16. Accessed December 13, 2023. https://radicalreads.com/will-wright-favorite-books/

Robert. 2012. *Zelda Dungeon: Allegories in Architecture – The Ancient Cistern*. January 11. Accessed December 14, 2023. https://www.zeldadungeon.net/allegories-in-architecture-the-ancient-cistern/

Rogers, S. (2010). *Level up! The guide to great game design*. Wiley.

Slawson, D. (1987). *Secret teachings in the art of Japanese gardens*. Kodansha International.

Totten, C. W. (2021). The spirit of digital place: Architectural dwelling and game space. *Workshop on affecting game space: Theory and practice*. University of Edinburgh.

Wolf, M. J. P. (2012). *Building imaginary worlds: The theory and history of subcreation*. Routledge.

Building Sprites, Tilesets, and Backgrounds

3.2

The previous chapter described design theories related to narrative and storytelling in thematic game spaces, including concepts of architectural placemaking, brainstorming, and planning out your various biomes and zones. In this chapter, we will stick with the idea of biomes and zones by developing artwork that will give our world its own unique character.

First, we need a high-level concept for our game world that we can build from, so we turned to an expert narrative-centric game player for assistance.

HIGH-LEVEL CONCEPT – *MOLLY THE PLANT PRINCESS*

Molly the Plant Princess is an action-adventure game concept created by Chris's daughter, Adeline. It stars Molly, a princess with powers based on elements in the natural world: fire, air, earth, and water. An unknown force (actually an evil cat named Cora) is threatening the world and it is up to Molly to stop it. During a fight with a giant, though, she loses her powers and must travel through the land to get them back. This requires her to go into dungeons to fight and then befriend various boss monsters who can restore her powers (Figure 3.9).

FIGURE 3.9 The high-level game concept document for *Molly the Plant Princess*.

DOI: 10.1201/9781003441984-8

The portions of the game that we will create throughout the rest of the book are the town where you begin the game, the first dungeon – where you will fight the fire-powered lava rock monster, Rocko – and some overworld area between the town and the dungeon. The section of game we will create in the upcoming tutorials will incorporate both top-down and side-scrolling stages, so we will need the appropriate sprite and tile types for those modes. First, we will begin with the sprites for Molly herself, which will incorporate a lot of the lessons we learned from making our patrolling enemy actor in the last practical chapter.

CREATING AN ANIMATED SPRITE

While this is a book on level design, we will need a good hero to occupy our action-adventure game spaces. For this reason, we are going to quickly create a sprite for Molly that will give our game its own identity. Since our game incorporates both top-down and side-scrolling action, we will likewise create top-down and side-scrolling versions of Molly. To save us some time, we will modify the existing sprites from the GB Studio sample project.

Top-down

In our previous practical chapter on game mechanisms, we used the sprite editor to import an enemy into GB Studio, so we will not repeat information on the sprite editor in GB Studio again. Both sprites – the player and the enemy – are both sprites that can face multiple directions, their sheets are very similar: each having two sprites facing down, two facing upwards, and two facing right, which are flipped to create the "left" sprite (Figure 3.10).

FIGURE 3.10 The GB Studio demo player character in the sprite editor. Note that the sprite sheet structure is the same as the enemy we created in Chapter 2.2.

To edit this sprite, we must navigate to it in our file explorer and open it in Aseprite (or other sprite editors of choice).

1. Open the directory for either your own GB Studio project that you have been working on throughout the book or for the sample exercise starter file for this chapter, "GB Studio Action Adventure – 3P_SampleFile_START."
2. Inside, you will see the project files themselves, and a directory called "assets." Open that and open the "sprites" folder within it. Inside you will find a sprite sheet called "player.png" (ignore the one called player_platform.png for now). Open this file with your sprite editor of choice (Figure 3.11).
3. Since we opened the .png version of the sprite, we do not have access to any layers used to make it, so we should add a new layer called "Edits" to draw in, so we do not destroy any of the original sprite's artwork.
4. Since we brought in a .png file, the file may also be in "Indexed" color mode, which can cause problems for editing the art: Aseprite imports the color palette found in the file, which is good, but makes the first color the "transparent" color. The first color in the palette will be the dark color in the GB palette, so that is bad for us. To check the image's color mode, navigate to the "Sprite" menu at the top of the Aseprite interface. Make sure that the color mode is set to RGB by and selecting Color Mode > RGB Color. This will change it to a color mode where you can use the dark color without issue (Figure 3.12).
5. Alternatively, you can also add a useable version of the color by editing the color palette. In the window on the left, above the palette, click the Options button (the one that has three lines on it), and check the "Edit Palette" box (Figure 3.13).
6. Next to the last color on the palette are two small vertical lines. Hover your mouse over them until they become a horizontal resizing handle, then LMB click and drag them to add a new slot to the palette.
7. Click on this new square and navigate to the bottom of that same window to the color picker. At the bottom are two rectangles, one for Foreground and one for Background color. Click the top one for Foreground color and a color editor pop-up window will appear. In the top three boxes

FIGURE 3.11 The top-down player sprite sheet in Aseprite.

FIGURE 3.12 Changing our file's color mode.

on the right side of this window, put the values 7, 24, and 33. These are the color's RGB values. Leave the Alpha value at 255 so that the color is fully opaque (Figure 3.14).

Please note that you should NOT be working in any colors beyond the GB Studio palette at this point. If you wish to add color to your game, that must be done within GB Studio and not within the art itself, based on how GB Studio and the Game Boy itself handle color information.

FIGURE 3.13 Editing our Aseprite palette.

FIGURE 3.14 Editing our new color by setting its RGB values.

FIGURE 3.15 Our edited player sprite, which better matches the concept art for Molly.

8. Since Molly in the concept art has darker hair, we have edited her with dark hair and a lighter dress. You are free to make any edits you want on your version. Ours can be seen in Figure 3.15.
9. We will now save this and import it into GB Studio. Normally, we would export the sprite sheet as we have before into the "assets > sprites" folder, then use GB Studio's Sprite Editor to bring in the sprite animations. However, since there is already a player sprite in the file, we can export this sprite and save it over the existing player sprite. This will replace the existing player sprite in GB Studio without the need to use the sprite editor.
10. If you do decide to name your sprite sheet something other than "player" and import it with the sprite editor, you can change the Player Sprite in the various scenes of your project by going to the Editor Sidebar with a scene selected and changing the "player sprite" option to a sprite of your choosing.

Side-scrolling

We will also use the same set of procedures to edit the side-scrolling player sprite sheet.

1. Find the "player_platform.png" file in the assets > sprites folder and open it in the sprite editor of your choice. As with the previous section, make sure that the color mode is set to "RGB Color" or make sure you add any necessary colors.

2. Edit the sprite sheet by creating a new "Edits" layer and adding new artwork there with the sprite editor's drawing tools. If you are editing it to save over the original artwork, make sure to stay within the boundaries of the original sprite (you can go a bit outside the standard outlines as long as you don't break the 8 × 8 pixel grid boundaries.

 To edit the grid settings in Asprite, navigate up to the "View" menu, and select Grid > Grid settings. Set the "Height" and "Width" settings to "8," leaving the X and Y settings as-is. This will let you see the pixel grid in 8 × 8 pixel increments, helpful for GB Studio sprite drawing (Figure 3.16).

3. We have edited ours to have dark hair, boots, and flowers on her dress, according to the concept art. Once again, as long as you stay within the grid lines surrounding each frame of the animation, you are free to add any detail you want, making sure that they move consistently across frames (Figure 3.17).

4. Export the sprite sheet as before. If saving over the previous sprite sheet, make sure to save it in the Assets > Sprites folder in your GB Studio project (either your own or the one from the chapter exercises folder), with the same filename.

5. If you are utilizing your own custom sprite sheet, import it as in the previous chapter when you imported the enemy artwork and perform the procedures for adding sprite artwork in the GB Studio Sprite Editor.

Now that we have our player sprites edited and imported into GB Studio for use in the game, we need an environment for them to inhabit. In the next section, we will discuss methods for creating environmental tilesets for use in 2D-level editors.

FIGURE 3.16 Changing grid settings in Aseprite.

FIGURE 3.17 Our sprite sheet with the 8 × 8 pixel grid visible, after making our edits.

CREATING A TILESET

While it is outside the scope of the book to be a "how to draw pixel art" guide, this section will give some guidelines for creating *tileset* graphics for top-down and side-scrolling games.

A tileset is a graphic that contains all of the grid-based visual graphics, or *tiles*, used to create environments in a level or game. Rather than coherent pictures or pieces of art, they function more as art palettes that one uses to paint images within tile-based level editor programs – the "paints" just happen to be little tile pictures (Figure 3.18).

Tilesets allow you to create a variety of environments from a smaller number of assets – saving on both labor (you do not have to draw every environment as a fully bespoke picture) and memory. In retro games like those we make in GB Studio, this is especially important, since more environment art tiles eats

FIGURE 3.18 A simple tileset for a GB Studio game. All of the graphics used for a top-down environment are on one image, which makes using the tileset in tile-based level editors an easy process.

up the limited memory on a Game Boy cartridge. Even in modern games, where memory is not as much of an issue, learning to apply a smaller set of tiles in more situations saves labor and keeps your game's download size down (the first games deleted are always the biggest ones) (Figure 3.19).

Though tilesets are a vestige of older computers and retro consoles, they are used even in modern game engines to create environments for 2D games. Working in tiles for modern titles even makes some

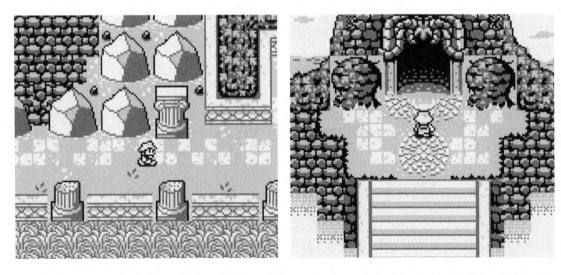

FIGURE 3.19 The same tileset was used to create these two environments in different parts of *Kudzu*. By being creative with how you apply existing tilesets can help you save memory space in large-scale adventures. We applied a similar approach in *Little Nemo and the Nightmare Fiends*, modifying colors of art within the same biome to create new sub-biomes.

interactions, like having a character that can climb walls, easier from a programming perspective. As such, knowing how to properly prepare a tileset remains a relevant and important skill in game art. In this section, we will explain how to lay out and use some common environment tile types in both top-down and side-scrolling tilesets. Following these suggested templates will help you make tilesets that are easy to use once implemented in tile-based level editors.

Top-down Tiles

In terms of functional level geometry with applied collision, top-down tilesets are by far the more complex to produce. This is entirely due to the point-of-view used in these games: viewing the game world from the top-down forced perspective found in games like *Zelda*, there are few opportunities to see passive (non-collision) background art. As such, the "required" or "typical" artwork objects are much more expansive. In this section, we will give some guidelines for drawing common types of environment tiles in 2D action-adventure games.

Land masses

Of course, players most importantly need surfaces to actually walk on and explore. On one hand, this is the most basic tile type to make, since you really just need blank tiles of a color. The complexity, but also opportunity for creating visual interest, comes in whether you produce a variety of surface tiles for different materials or variations on those materials (Figure 3.20), and whether you create edges for the walkable surfaces.

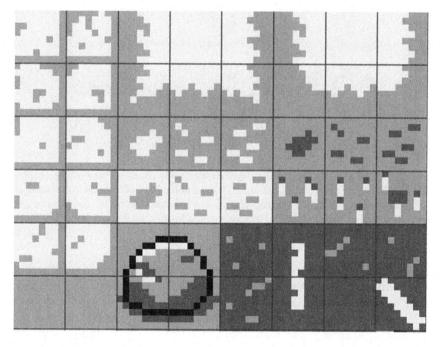

FIGURE 3.20 Different variations of surface tiles. Having a few variations of things like grass (not just a blank color, but tiles with visible blades of grass or flowers), dirt, stone, road surface, or architectural tile goes a long way in creating visual interest.

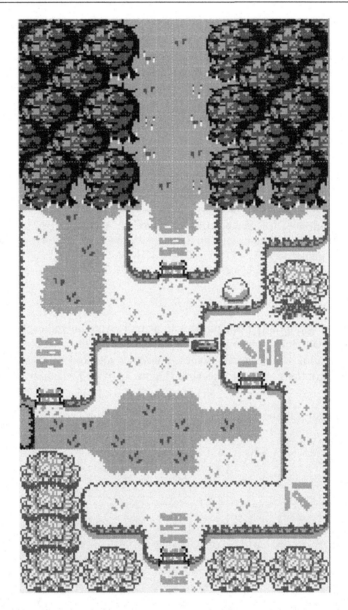

FIGURE 3.21 What could be a straightforward one-screen wide room is made more complex with some short cliffs. These 8-pixel-thick walls create barriers to more interesting pathways without using a lot of screen real estate on thicker wall tiles. Edges combined with wall tiles under them can also be used to make bigger cliffs or canyon walls.

These edges are where more structured art processes are required. Environments in action-adventure games often have cliffs or small elevation changes that allow level designers to make a more interesting room without the need for thick walls to block pathways. Cliffs can also be used as edges for things like canyons, edges over water features, and other more drastic land-based barriers (Figure 3.21).

Making cliff edges requires you to make tiles that match seamlessly and are repeatable. You also want to make enough tiles that will allow you to have *concave* (inward curving) and *convex* (outward curving) corners. To accomplish this, we use the general format seen in Figure 3.22, which produces a result like the grassy short cliffs also shown.

FIGURE 3.22 A suggested template for creating cliff edges. Here also is a set of convex and concave grassy cliffs with cliff sides, shadows, and surface variations shown.

Trees and forests

Trees in top-down environments are VERY useful for filling large areas with collision while keeping the illusion of a vast open space, but saving visual RAM (for consoles where it is at a premium, as on Game Boy) by having repeating tiles. While they are repetitive, but look aesthetically pleasing if drawn well. Also, making room edges in 2D games out of repeating tree tiles can help build the illusion of continuity between rooms in your levels, as though the player is wandering through clearings in a bigger forest.

Tree tiles can be built out of small single-block (16 × 16 pixels in GB Studio) tree graphics (Figure 3.23), which can be nice if you are going for an older-fashioned look like that found in *Dragon Slayer* or *Hydlide*.

Alternatively, a more difficult but visually impactful tree style like that found in games like *Link's Awakening* can be accomplished by following the template in Figure 3.24. These trees require more tiles than the single-square trees but can be arranged either in rows or in alternating patterns. They also produce a clearer sense of scale in your game world by having very big trees next to smaller sprite characters.

Walls

For caves, dungeons, houses, and other interior spaces, you will likely want wall graphics. Depending on your art style, how you draw walls in your game's spaces may change – a more "modern" style is to have side walls represented with only thin tiles – but for this tutorial, we will use *Zelda* style walls that show each wall with an equal thickness.

FIGURE 3.23 A simple 16 × 16 pixel tree tile. Simpler repeating tiles like these can be both memory-saving and create a look akin to early 1980s-style computer action-adventure games.

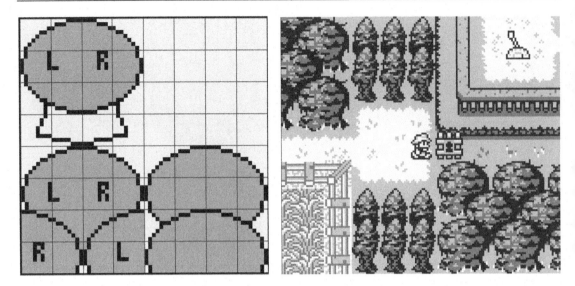

FIGURE 3.24 A template for *Zelda*-style large trees with lettering showing which side is right and which is left on the trees. These can be arranged in straight columns of trees or alternating rows, using the tiles where right and left are reversed. To cap forests of these trees off, you use the edges of the single tree version of the graphic as needed and shown in the screenshot from *Kudzu*. The screenshot also includes a skinnier variation of multi-tile trees that can create further visual detail.

A basic version of a wall template looks something like what is found in Figure 3.25. Here, you have four corners each for concave and convex wall corners, along with regular wall tiles that make the rest of the wall surface. You generally want to draw your wall tiles so they can easily repeat (or "tile") seamlessly if repeated along big areas of screen.

You can also add more repeating wall surface tiles than what is shown in the template, creating something like what is shown in Figure 3.26. Things like columns, pictures in frames, creeping vines, wall damage, or variations on a basic theme (regular stone dungeon walls, and stone dungeon walls with torches, for example) can add further visual interest.

FIGURE 3.25 A very basic wall tile template, built around 16 × 16 pixel blocks, showing artwork for creating concave and convex corners. Gradients are added here to show the flow and direction of walls (added toward the edges that would be the "floor").

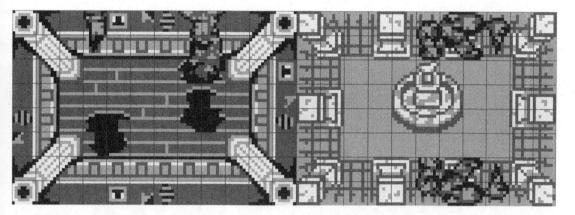

FIGURE 3.26 Tilesets for the walls in the Estate (haunted house) and Garden regions in *Kudzu*, showing corner graphics along with several wall variations between them. The extra space in the middle, usually used for floor graphics, also contains several floor tile variations for creating obstacles and pits.

Buildings

Though they may appear complex, drawing building exteriors can be very simple, depending on the art style you use. In older games or games with a zoomed out "overworld" like those found in 2D RPG games, you will often see a building graphic take up the same amount of space as the player sprite or any other single-tile landscape graphics (such as our tree from earlier). For games with closer points of view, you will want bigger multi-tile buildings that look like a player can walk into them. For those sorts of buildings, a template is shown in Figure 3.27.

Generally, you want a door opening that the player sprite looks like they can fit into (often the same size as the player sprite), along with some tiles for windows or other architectural details on the side of the building. Our template has three-tile-high building walls so that the building looks bigger than the player sprite. This also allows for there to be a lintel above the door, an environmental art detail that helps the building feel more "real." The walls in the template also have right and left end cap tiles so the building can have sides. For the roof, you generally only need the side caps for right and left, and the middle set of tiles, each accommodating the bottom and top of the roof structure as shown. Even a simple tile set like this can be used to create a variety of building types.

FIGURE 3.27 A very basic building template made from 8 × 8 pixel tiles, along with examples of a town made with simple building parts that follow this model.

FIGURE 3.28 More diverse building styles were created by ignoring a modular building method and creating more straightforward pixel drawings. This is great for creating visual diversity, especially in smaller scenes where tile memory is not an issue or for more modern action-adventure games in modern engines.

Since buildings in most top-down games are purely decoration, they can also be created by straightforwardly drawing your building facades and just making sure to include a door somewhere in the graphic. Approaching buildings in this way in your games potentially allows for lots of diverse building shapes and styles within the tile limits of the game or scene that you are making (again – when GB Studio, you will want to stay within tile limits) (Figure 3.28).

While there are lots of other types of visual elements found in action-adventure games, and indeed themes beyond the standard outdoor woodland-fantasy-style biome favored in these examples, this should be enough to get you started on creating your own top-down tilesets.

Next, we will create a tileset for side-scrolling platforming environments that will help us create lots of environments from a simple set of tools.

Side-scrolling

As side-scrolling levels typically have a clear foreground and background, creating the basic functional geometry for your level can involve many fewer visual elements than top-down environments.

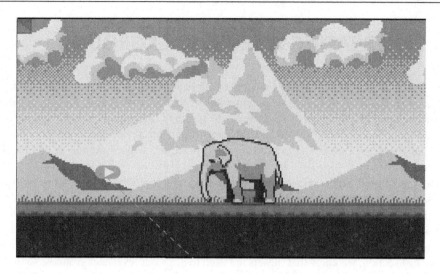

FIGURE 3.29 A simple side-scrolling room in the GB Studio sample project with a large elephant sprite character visible. The foreground (ground) plane appears at the bottom of the room and has a line of collision drawn on it with the engine's collision drawing tools. The mountain and sky graphics in the background are purely cosmetic and do not affect the player's route through the level.

Foreground elements tend to be fairly straightforward – just the level geometry drawn in whichever biome theme you are using at a given time – with background graphics being primarily cosmetic (Figure 3.29).

Since platforming tiles are more straightforward, we only need to focus on basic geometry in this example. As with the ground terrain and cliffs in the top-down examples, you will want a tileset that allows you to create concave and convex corners. Once you have created this, any theming or background graphic tiles can be drawn to add visual interest (Figure 3.30).

Tilesets for both top-down and side-scrolling environments are great for creating lots of level geometry with a smaller visual language of pieces. For smaller teams, this can save labor, money, and memory while producing great results. Though many of the examples here are from pixel-art retro games, the logic behind these templates scale up for use in more modern tile-based game engines and level editors. In the next section, we will take our tilesets and load them into a tile-based level editor, Tiled, to create a simple town level.

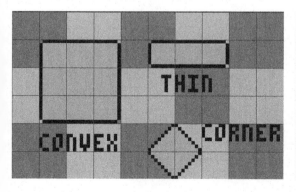

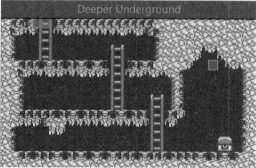

FIGURE 3.30 A template for basic side-scrolling level tiles, including content for normal tiles, thin ledges, and sloped tiles for creating organically shaped walls and ceilings. The example image was created with a tileset following this template.

CREATING A LEVEL BACKGROUND

Now that we have a tileset (either the ones that come with the sample projects associated with this chapter or one you have created yourself based on the templates from the previous section), we are ready to make a simple level background. The term "background" as used by GB Studio is a confusing one, as we have ourselves been using "background" to describe the backdrop of purely decorative graphics that give levels a distinct visual character. In GB Studio's terminology, however, a "background" is any picture used to decorate a room.

To make levels in GB Studio, a *scene* is created, then a *background* for that scene is loaded, which dictates the size and shape of the scene. Using the *Collisions* tool from the tool bar in the upper left corner of the World Editor window, the designer then paints collision information onto the scene, matching how it appears on the background graphic (i.e., if you have what looks like an empty field in your background art, you should not have arbitrary pockets of collision that do not correspond to anything in the background).

From our last section, we know that tilesets are used to draw our level backgrounds, so in this section, we will be doing that background creation. To do so, we will utilize a program called Tiled, which you downloaded in Chapter 0.2.

1. Open Tiled on your computer. You will see a mostly empty interface with some buttons in the upper-left corner. One of these buttons is marked "New Map," LMB click it.
2. A New Map window will appear. Make sure that "Orientation" is set to "Orthogonal," that "Tile Size" is set to a width and height of 8 pixels each, and that the "Map Size" is set to Width: 20 tiles and Height: 18 tiles. At those dimensions, this will create a map the size of a Game Boy screen (160 × 144 pixels) (Figure 3.31).
3. You will see an interface like that shown in Figure 3.32. The center is where you will create your level artwork. The Tool Bar is along the top of the interface, with icons that represent different tools that you will use to create the background art. Along the left of the screen are the project Properties, where you can change settings such as map or tile size.

FIGURE 3.31 The New Map pop-up in Tiled, with the settings that we outlined in step 2.

FIGURE 3.32 The Tiled interface.

4. On the right of the screen, you will find the Layers window and the Tileset window. We will focus on the Tileset window for this step. Click the "New Tileset" button in the Tileset window and a new pop-up will appear (Figure 3.33).

 Make sure that "Tile Width" and "Tile Height" are each set to 8 px. Then, hit the "Browse" button next to the "Source" field – this will let you import a tileset to use for building your level background. Navigate either to the tileset you created in Aseprite or to the image "AdventureTileset01.png" in the TutorialFiles > TiledFiles folder found in this chapter's tutorial project files. When you have selected your source file, LMB the "Ok" button.

5. You will see your tileset appear in the Tileset window on the right side of the screen with a grid overlay. The grid shows tiles that you can paint onto the Map.

FIGURE 3.33 Loading your tileset into Tiled.

FIGURE 3.34 Painting some wall tiles into our map with the Stamp Brush tool.

6. In the Tool Bar above the painting area, make sure that the "Stamp Brush" tool is selected (it looks like a golden stamp icon). Go to your Tileset window and select a wall corner tile. If you LMB click and drag in the Tileset palette, you can select multiple tiles at once. Place the tile in the appropriate corner as shown in Figure 3.34. Then, paint the other corners with the appropriate corner tiles.

7. In the Tool Bar, select the Shape Fill Tool, which looks like a light blue rectangle. This lets us click and drag to paint repeating instances of our selected tiles into our map. Select some wall tiles from the Tileset palette on the right side of the screen, then click and drag to paint them into the walls between our corners, leaving a 2 tile × 2 tile space in the middle of the wall – that will be our doorway. Paint walls around the room in this way with the appropriate tiles.

8. In the Tool Bar, select the Bucket Fill Tool, which looks like a paint bucket spilling paint. Select a floor tile (preferably one without a pattern on it for now) and click anywhere in the blank spaces on our map. It will fill any space of the same kind (in this case, blank ones) with the selected tile (Figure 3.35). If you have any tiles for adding texture or small patterns (like dirt specs in our cave room example), you can use the Stamp Brush tool to add them to your floor for visual interest.

 Please note that if you have any tiles on your map that are not within the intended room bounds, like if you are creating a small room that does not take up the whole screen, you must still paint tiles so that the image displays correctly in GB Studio. Our preference in these cases is to bucket paint with tiles of the darkest color in the GB Studio palette, which can be done with the tileset provided in the project files by using the tiles in the 2 × 2 tile doorway on the tileset. It is also recommended that tilesets you create yourself have a dark-colored tile set aside for this reason.

9. Now that we have a simple room map, we need to export it for use in GB Studio. To do this, you first need to set the zoom of the map to 100%, as Tiled will export your map at whatever level of zoom it is displaying at. To do this, go to the pulldown menu with the zoom level displayed at the bottom right of the Tiled interface. It will be at the VERY bottom of the interface next to the

FIGURE 3.35 Painting a floor with the Bucket Fill Tool.

alert area for Tiled news and updates, NOT the one at the bottom of the Tileset window – that is just for the zoom level of the tileset. Once you set the proper zoom to 100%, the map itself will get very small in the Tiled interface.

10. Navigate up to the File menu and select "Export as Image" from the list. A pop-up like that in Figure 3.36 will appear. The default settings as shown in the image should be fine. Make sure that you select where you want the exported file to go using the "Browse" button – we recommend putting it either directly into your GB Studio project in the "Backgrounds" folder or in another file directory where you store your map background images.

FIGURE 3.36 The Export as Image pop-up.

Now that we have created a simple background map graphic, we can close this chapter out by importing it into GB Studio for use in the engine.

IMPORTING ASSETS TO GB STUDIO

Like many modern engines, GB Studio allows you to import assets by putting them into the project's "Assets" directory in a specific folder, as we have seen with the sprites we created in other chapters. In this last section of the chapter, we will add our newly created background artwork to the "Backgrounds" directory within the "Assets" directory, and implement the background within a scene in GB Studio.

1. If you did not in the last section, save a copy of your new room background or copy it into the Assets > Backgrounds directory within your GB Studio project. Alternatively, you can use the "Tiled_DemoRoom.png" file provided in the sample project files for this chapter.
2. Open your GB Studio project or the "GB Studio Action Adventure – 3PSampleFile_START" project included with the chapter's sample project files. In the Tool Bar at the top left of the World Editor, select the Add tool (the one that looks like a +) and select "Scene." A giant gray box will appear around your mouse cursor. Click anywhere in the world editor and it will create a new scene.
3. Whenever you import new background art into GB Studio, any new scenes will start by default with the most recently added background already in place. If this did not occur for you, select your new scene, then in the Editor Sidebar on the right side of the screen, select your new background in the "Background" dropdown near the top of the editor toolbar (it should be the second option down) (Figure 3.37).
4. This new scene will need collision. To add collisions, select the Collisions tool in the Tool Bar, which looks like stacked bricks. This will bring up the collision tool options at the top of the World Editor. Each of the colored options in this options bar is a different type of level collision,

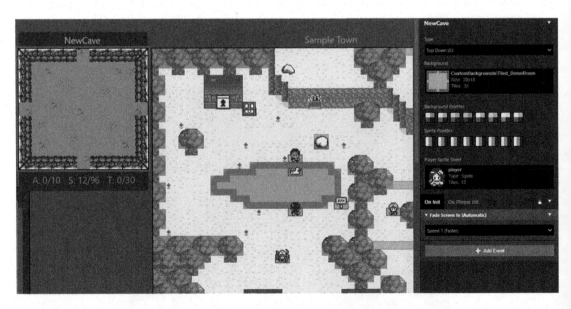

FIGURE 3.37 Adding a new scene that uses our newly created background image. This one is called "NewCave."

FIGURE 3.38 Painting collisions into our new scene. Here, we are only tracing the collision around the outside of the wall, but you can choose to fill in the walls if you wish. The collision tool options also allow you to use a bigger brush or a paint bucket tool for painting collisions.

including solid blocks (the red one), and one-way collisions for top, bottom, right, and left side configurations (like if you have ledges that you want to jump up through and land on top of. It also has a collision type for ladders.

Select the solid collision type and paint it over the walls in the scene as shown. Make sure that there are no openings so that the players can wander into wall geometry (Figure 3.38).

5. That is all there is to adding new scenes. To make it accessible, we need to add triggers with a "Change Scene" event attached, going to another scene. In lieu of this (since we are not adding a lot of new scenes in this section), simply LMB click and drag the objects from the Cave scene into your new scene, making sure to bring over not only the triggers and objects but also the Destination Icon coming from the Sample Town scene. You may also want to paint some collision over your doorways in the new scene that is not being used, though without triggers for exits, the player will stop at the edge of the scene by default (Figure 3.39).

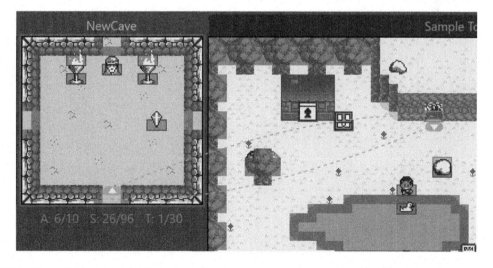

FIGURE 3.39 Adding existing objects from the Cave scene into our new scene. This makes the scene usable within our game.

CONCLUSION

In this chapter, we learned how to use Aseprite's sprite painting tools to customize our player sprites, as well as creating our own tilesets in Aseprite, map backgrounds in Tiled, and new scenes in GB Studio. How visual assets like these go from one program to another, finally arriving in the engine where they will be used, is known as the *art pipeline*. Establishing and mastering your pipeline, as well as how assets are exported and imported between programs, is an important part of game development.

Now that we have built a variety of mechanisms using GB Studio's Event scripting system, as well as learned the art pipeline for making and bringing assets into our GB Studio game, we are ready to start assembling our actual levels. In the next design concepts section, we will explore how introduction and tutorial levels are structured to *onboard* players or introduce them to our game. Afterward, we will use some of what we have learned in this and other practical chapters to create a new hometown-level scene that will serve as the intro to our game, *Molly the Plant Princess*.

Tutorials and Openings in Action-Adventure Games

4.1

For junior designers, crafting the first level for a video game can be a daunting task. The introduction needs to be engaging enough that the player will continue to play the game after the first hour, while also being easy enough to not frustrate new players, all the while teaching core concepts and mechanics to ensure the player does not get frustrated and quit the game before the credits roll. This is in addition to establishing our narrative in the same way as a novel or film; who is our central character? What world do they inhabit? What is the central conflict at the heart of the story? What is the overall tone of the game?

Furthermore, the increasing complexity of game systems and controller inputs over the years has necessitated tutorials; a segment at the beginning dedicated to overtly teaching players how to play the game. After all, we cannot assume our players have the same experience with action-adventure games, or any video games at all. Yet if the beginning of your game needs to be both exciting and engaging, how do we properly teach the player and manage to keep their interest at the same time?

Over the years, many effective design patterns have been utilized in order to address this conundrum. Crafting an effective introduction for a game requires many facets of game development: general game design, user experience, as well as cinematics and more that is well beyond the scope of this book. We will instead include a detailed focus on one of the most important parts of the introduction, however: the opening level or area of the game. In this chapter, we will explore level design patterns that teach the player both through explicit tutorials as well as implicit visual communication, and how we can continue to keep players interested and engaged with the experience throughout the introduction.

TUTORIALS

As mentioned in the introduction, tutorials are considered a necessary part of modern games. They offer a direct way of teaching the player obtuse interactions and game systems. While this book is focused on game spaces and navigation, it is worth briefly mentioning tutorials themselves as they relate to new players starting the game for the first time. By looking at the ways designers have instructed players through the early parts of games, we learn about how visual communication via level design is used to instruct the player. Furthermore, we can also discuss the inherent weaknesses of implicit direction and how explicit direction through dialogue and other direct expressions can properly supplement visual communication.

In the past, video games did not have a lot of memory space to allow for elaborate tutorials (things like extra text take up ROM space), so they often relied on physical instruction manuals to teach complex concepts such as the control inputs and more complex rules. This solution was both costly and environmentally unfriendly from a production standpoint. It was also an inelegant solution for game designers,

DOI: 10.1201/9781003441984-9

as it relied on the player reading the instructions before beginning to play a game. Many older games accounted for this by designing their opening levels deliberately to ease players into playing the game with a lower difficulty and steadily introducing new concepts to the player over a period of time, such as forcing players to perform certain actions in a low-pressure environment. Jumping over the first set of pipes in *Super Mario Bros.* stage 1-1 is one such example, which is followed by escalating jumping challenges as the game progresses. This approach, herein referred to as *implicit tutorial design*, is still widely adopted by modern games as it allows the game to teach the player while keeping them in control of the action.

There are drawbacks to this technique, however. While implicit tutorials excel at teaching spatial navigation and obstacles, they have a harder time conveying more complex topics such as how to operate the controller. To a certain extent, the simplicity of older hardware solved this issue; it allowed designers to trust players to test and memorize the controller inputs for themselves. However, as modern game controllers now have anywhere from 14 to 16 buttons as opposed to older controllers' 4 to 6, this is a much bigger ask for the casual player. Additionally, complex game systems such as character parameters of role-playing games or skill trees cannot be taught implicitly. For this reason, explicit tutorials that utilize dialogue boxes and voiced narration have become much more standard.

Explicit tutorials provide specific instructions within the game itself and are much less ambiguous. Many games would begin to include the tutorial as an optional screen with instructions within the game itself or as an optional level the player could run through, such as the optional training ground for first-person shooter *Half-Life* or Lara Croft's mansion in *Tomb Raider 2*. However, like instruction manuals, this also relies on the player's willing participation to engage with the information.

Tutorials would then sometimes become woven into the opening of the game itself. Some explicit tutorials pause the game momentarily and require the player to press a button to confirm and move on. They also tend to provide illustrations and in some cases video of the mechanic being demonstrated for both clarity and to keep player interest. However, a potential drawback is that pausing the action takes control away from the player, interfering with narrative pacing and causing potential frustration and boredom. Another method often seen in modern games is to put dialogue boxes on the edge of the screen and allow the player to keep playing. Additionally, they may limit progression until the action being illustrated is performed, such as an attack combo or moving the camera. This allows the player to continue controlling the game without asking them to stop and read, but there is some risk that players may ignore messages and miss out on crucial information in the text. In either case, some games allow the player the option to opt out of these tutorials in options menus, or a method to skip past tutorial messages, which is useful both for respecting players' time and for those who want to replay the game.

Another option for explicit tutorials is to make them diegetic, either as a game mechanic or within the narrative itself that the player can opt-in to. In many RPGs, helpful townsfolk and other non-playable characters will tell the player hints about where they should go next or crucial gameplay mechanics such as battle mechanics, leveling systems, and more. Some games would feature what has colloquially become known as "Beginner's Hall," named after an area in the opening town of PlayStation RPG *Final Fantasy VII*. The Beginner's Hall is traditionally an interior space that features NPCs, books, or other thematic game objects that explicitly teach crucial game mechanics for starting players. Later in the chapter, we will explore towns in adventure games in more depth, with a focus on the first town in a game and how they can utilize both implicit and explicit tutorials.

Other examples of explicit, diegetic tutorials include *Super Mario World's* distinct-looking speaker boxes that players can hit from above to open a tutorial dialogue onscreen. After the first box, the player can then recognize them in the future and choose whether they want to hit the box to learn more or continue playing the game. Other examples include special NPCs which follow the player character and they can ask for advice or give additional information for new game mechanics and elements at the press of a button, as exemplified by Navi the Fairy in *The Legend of Zelda: Ocarina of Time*. Less explicitly, designers may also consider writing dialogue for NPCs in early areas of a game that gives the player information about the game's operation and world, then locating those NPCs along the main path (Figure 4.1).

Beyond implicit and explicit tutorials, designers also need to think about specific considerations that need to be made for nonlinear games. Part of the appeal of a nonlinear adventure is the player's freedom

FIGURE 4.1 An image from our introductory level for *Little Nemo and the Nightmare Fiends*, which includes both implicit design elements – players must jump and use Nemo's glide ability to get to the door on the right – and explicit design elements, such as the NPC who tells Nemo (and the player) how to use the glide.

of movement and discovering where they can go and where they will return to in the future. This demands a lot of their spatial reasoning and navigational abilities, particularly since game worlds do not always correspond neatly with real-world navigation and architecture. As such, being able to teach players how to navigate the space of your game world can be crucial at the beginning.

When discussing implicit tutorials earlier, we mentioned that games deliberately ease players into the mechanics of the game; the same can be true for nonlinear navigation. By limiting the number of places that the player can go to at the beginning of the game, they can begin to get a feel for how navigation works slowly as more options and directions can open for them over time. This can be done using lock and key mechanics discussed earlier in the book, such as literal keys or by obtaining early skills in the game that unlock more areas for them to explore.

But the player's ability to move forward is only one aspect to consider; they also need to be able to keep track of where they have been. While explicit, in-game maps are an important tool in the designer's toolbox, we also want to reduce the amount of menu fiddling the player needs to do by allowing them to create a mental map of the space. Limiting the amount of navigational freedom, the player has at the beginning can also be helpful here, as it limits the amount of cognitive load expected of them. Another is by carefully crafting each screen of the game in order to make them memorable and distinct for players to create a mental map of the space. Breakable objects like pots, torches, or candlesticks, or even enemies that you script to not respawn immediately when players leave and return to a room can also help, as players will see a lack of things to interact with, reinforcing that they have already visited. We will look at all these techniques in more detail in the later sections.

Ultimately, much like most of the design patterns we will be exploring in this book, there's no hard or set rule on what kind of explicit tutorial needs to be used. It will largely depend on the needs of your own game and discoveries made during the playtesting process. The most useful thing to remember is that regardless of how the player is taught, it is that the game must also continue to keep their interest throughout. In the book *Art of Game Design* by game designer Jesse Schell, he describes the rise and fall of player interest over the course of a game as an "interest curve"; a series of peaks and valleys that denote the rise

and fall of player interest over time. He writes "if the experience is well-crafted, the guest's interest will continually rise, temporarily peaking at points ... only in anticipation of rising again"[1] (Schell, 2008). Using interest curves as a lens, we can have an idea of how engaged players continue to be throughout our intro, and the game itself. We will continue to explore interest curves as we continue to explore crafting an effective opening level.

So far in this chapter, we have looked at general advice for starting the adventure, the importance of keeping players engaged early in the game, how designers can make use of explicit tutorials to convey complex information to players, and implicit tutorials for teaching basic game navigation and movement. In the following sections, we will look at specific examples of both types of tutorials in linear and non-linear games alike and how we can apply this knowledge to our own games' opening level. First, we will look in-depth at a crucial starting element for a game; the very first screen of the game.

RUNWAYS

When players are given control over their onscreen avatar for the first time, they will usually want to take a moment to orient themselves by moving around the gamespace and testing the button inputs so they can get a feel for their character's movements and abilities. Some games take this into consideration by offering a first screen that is devoid of enemies, hazards and other obstacles in order to give players a safe space to experiment with character movement. One way to think of this is as a *runway* before they take off on their adventure.

Nintendo's *Super Mario Bros.* for the Nintendo Entertainment System is often credited as one of the first games to account for gamers playing a console game over long periods of time. Prior to *Super Mario Bros.*, many developers were still designing games as they had done for arcade cabinets: short gameplay loops with a high difficulty that curves up sharply with each repetition to end games quickly and ensure more coins were dropped into the machine. By contrast, *Super Mario Bros.* opens much more calmly with the first screen acting as its runway. In fact, the game does not truly begin for about a full screen and a half before the first blinking question mark blocks appear and the first enemy, a Goomba, lazily wanders toward the player from the right side of the screen. *Super Mario Bros.* designer and producer Shigeru Miyamoto has said about its first level, "We wanted players to gradually and naturally understand what they're doing. The first course was designed with that purpose. So that they can learn what the game is all about (Eurogamer, 2015)."[2] This philosophy was crucial; *Super Mario Bros.'* Mario controls very differently in this game compared to his previous adventures, such as 1981's *Donkey Kong*, and to other contemporary side-scrolling platformer controls of the time. In an era where few games had used complex physics-based character controls, Mario's variable jump height and movement being centered around speed and inertia were a new concept to most players. This meant that including a short bit of time for players to get comfortable with how Mario runs and jumps was tantamount.

Future games would feature runways similar to *Super Mario Bros.'*s empty screen, and there are some unique examples we can learn from. One is the *Mega Man* series of games; in most cases, all *Mega Man* levels begin with an empty screen and no danger to Mega Man. In some instances, certain enemies or hazards will be visible but out of harm's way to allow the player to observe their behavior. While functionally like *Super Mario Bros.*, it is particularly important for the *Mega Man* series which, uniquely for its time, allowed the player to select which level they want to play first. As any level could potentially be someone's first level, including this safe space for each level was important.

One of the longer, more intricate, and impressive runways, however, is also a formative platformer for the NES: 1986's *Castlevania* from Konami. Unlike the previous examples, which remained obstacle-free for only one to one and a half screens, the initial outdoor path remains clear for three full screens, culminating with a door that leads into Count Dracula's castle. Not only is this significant for teaching gameplay elements, but it also helps to set the tone and setting of the game world as well. *Castlevania* is

not a particularly scary game; however, it uses the backdrop of popular horror fiction for its world design and aesthetic. This is referenced by both the title screen and its film strip borders that appear when the system is turned on, and its opening cinematic of protagonist Simon Belmont walking up to the gates of the manor before turning over control of the game to the player. This walkway, combined with Belmont's comparatively slow movement speed to his contemporary platforming heroes reinforces the horror theme of the game along with its more methodical playstyle.

At the start, Simon stands on the left half of the screen, just shy of about one-quarter away from the leftmost edge. The far background is a pale-blue night sky just barely visible beyond the tall, green trees and their old, gnarled trunks that appear at the edge of the metal fence that leads off screen to the right. Presuming the first press is not to move Simon, two things can happen at this moment. Either the player tests the jump button and watches Simon leap into the air, or the beginning of his attack animation will play. Either results in a teaching moment for the player; jumping without moving shows Simon jumping straight up into the air, two and a half tiles (or 40 pixels) high, hanging at his peak for only a couple of frames before descending back down to earth. Attacking begins a three-frame animation; first Simon reels his hand back, his whip first touching the ground before arching back a frame, and then a single animation frame of it striking, which is held a bit longer than the other frames to make it noticeable. The whip's length is distinct as well, covering two tiles horizontally in front of Simon's hitbox.

Both actions feel deliberate in their timing; the whip strike takes several frames before it comes out in front of Simon, covering a specific distance, and a specific jump height that cannot be adjusted through the length of timing pressing the button. Moving and jumping simultaneously reveal similar results; Simon moves at only one speed which could be described as "plodding," and jumping while moving in a direction will always travel along one arc. Much like *Super Mario Bros.*, *Castlevania*'s hero has a specificity to his physics, albeit with a very different feeling, and reaction time. Here the player must learn to gauge the length and height of actions and use that knowledge accordingly.

Movement is not the only gameplay element introduced in the opening runway, however. In front of Simon at the start is a striking game object; a stone brazier, with a flame atop which grows and shrinks with a short animation. From the starting position, this brazier is two tiles away from Simon's hitbox; in other words, a mere one-pixel shy of Simon's attack range. Thus, any movement in the right direction on the player's part at the same time as experimenting with the attack button will reveal a surprising result for new players; the brazier explodes, and a heart-shaped icon drops from the brazier. Players who have not read the manual will not know what this heart does immediately, but otherwise they have learned an important lesson; that certain objects can be broken to receive items. On the opposite side of the screen, visible from the start, is a second flaming brazier, driving the player's curiosity forward.

This brazier does not drop a heart item, however. Instead, it drops what looks like a wooden handle attached to a chain. Picking this item up causes the game to pause momentarily as Simon's character sprite flashes several colors for about half a second alongside a noticeable sound effect. All of this feedback would indicate that Simon has changed in some way, though it is not immediately obvious how in the same way as *Super Mario's* famous mushroom. Experimenting with buttons once again will reveal the change; the animation for Simon's whip has changed. It now resembles the icon that we have picked up. While some players may intuit that this whip is stronger than our starting whip, this is not immediately obvious from the outset. Nonetheless, the player has learned about the whip upgrade pick up and its use.

There are three more braziers along the path. The next drops another heart, and the next another whip upgrade. Testing this upgrade reveals another change to the whip, this time in length as it now can strike three tiles forward. If the power change in the first whip was not immediately obvious, the increase in length will help to clue in the player that the first change was more than a visual upgrade. It's worth noting here that *Castlevania* normally uses a somewhat random system for determining what items will be dropped from a broken container. At the outset, however, the items will always be dropped in this order in order to ensure the player comes across these vital upgrades. Similarly, the last brazier offers one final, new gift for the player, a dagger. Upon picking it up, the icon is moved from the ground below into a box at the top of the screen where the player's score and health are situated. Although the game offers no way to teach the use of what the game calls "sub-weapons," the item is nonetheless received. In addition to

player movement, by earning item pickups, attack upgrades, and a sub-weapon from the opening runway, *Castlevania* allows the player to experience all of the game's primary verbs before the adventure begins properly.

The above examples are from linear side-scrolling action games; however, we can apply these to non-linear adventures as well. Many side-scrolling action-adventure games will wait to introduce enemies and hazards in their opening minutes to give players a handle on the controls and introduce branching paths along with obstacles the player will encounter throughout the game. For some games, it can also be helpful to set the aesthetic tone and atmosphere, such as the opening to classic games like *Super Metroid* to modern indie darlings such as *Hollow Knight*. Many top-down adventure games include similar training spaces at the outset, such as the first *The Legend of Zelda*'s empty starting screen.

Certain games give the player a bit more downtime beyond just the opening screen. For some games with a large variety of complex systems and mechanics such as role-playing games, the need for more explicit tutorials and guidance is required. As such, many games use towns – a fictional community within the game world – as a space to ease new players into the adventure. In the next section, we will explore towns in more detail.

THE HOMETOWN

At the beginning of the chapter, we mentioned towns as a staple of the role-playing game genre, referred to hereafter as RPGs. In this section, we will look at towns in RPGs briefly, and then focus on how the first town can effectively act as a tutorial and opening for a game.

Towns in tabletop RPGs have been a common part of many *Dungeon & Dragon* campaigns over the years, but their interpretation in computer games dates to at least Andrew Greenburg and Robert Woodhead's *Wizardry: Proving Ground of the Mad Overlord* for the Apple II computer in 1980. Before setting off into a dungeon, the player could go to the tavern to hire party members, buy weapons and items, or see the king to gain access to a quest. Over time, this concept would be adapted in both Western and Eastern-developed RPGs and other genres.

Towns in RPGs and adventure games are a very versatile tool for game designers. Thematically, they act as a texture to make the world feel like a real place with people who have their own lives beyond the confines of the player's story. As a game element, they can provide a necessary release of tension, usually after a difficult tribulation such as a dungeon or boss fight. They also provide several game elements crucial to the player's success. While the specifics can change depending on the game, most towns have a common series of game elements: non-playable characters to populate the town and to talk with; stores in which players can purchase new weapons and gear for their journey at the cost of currency earned through combat and/or quests; and a place to restore their health, magic points or similar resources such as an inn or health center.

This is why many RPGs start their adventure in a town, usually the one in which the player character resides in the game's fiction. Aside from the structural parallels to Joseph Campbell's (1949) *The Hero's Journey* where the protagonist begins in an "ordinary world" before the conflict of the story emerges,[3] by their nature, towns allow for a good amount of downtime for new players to learn about the game. After all, RPGs and adventure games can be overwhelming for new players. They can potentially have many complex, interlocking systems including multiple economies, leveling systems, combat mechanics, and a massive list of items. A starting town can help to ease players into these systems at their own pace.

As many 2D adventure games also encourage nonlinear exploration and discovery, a starting town can also provide a crucial tutorial for moving around the world and deciding where to go. This usually involves providing the player with a starting quest to usher them into the adventure. Early role-playing games such as *Final Fantasy* or *Dragon Warrior* for the Nintendo Entertainment System took a more freeform approach, tasking the adventurer with conversing with NPCs and discovering their first quest or

goal on their own. Modern games tend to be a bit more guided, leading them through a tutorial that forces players to go to a shop in order to teach buying and selling items, or following a certain sequence of events designed to teach them game systems prior to establishing the main goal or conflict. For example, the opening to the first generation of *Pokémon* games where players choose their starter Pokémon and engage in a trial battle that has no penalty for failure.

The Hometown setting is a time-honored paradigm for RPGs and adventure games for a reason; it is thematically appropriate for traditional adventure narratives which see the hero setting off from home on a long journey, but it also provides many teaching opportunities for easing in new players. We can use NPCs to introduce dialogue and text and provide helpful starting hints, we can introduce the game economy through shops and towns, and we can slowly lead the player toward the first steps of their adventures.

While certain action games do often begin in hometowns such as *Monster World IV*, for nonlinear platformers and RPGs with real-time combat, this might not be the best approach. With games and other forms of entertainment, there is an expectation that they will be exciting and engaging from the start, and players who are more accustomed to or prefer this type of game may not appreciate the slower and more methodical pacing that hometowns tend to cater toward. Schell calls this opening part of the interest curve the "hook," something that "grabs you and gets you excited about the experience." Though here he is specifically referring to the opening cutscene to a game, this can also apply to our opening level as well. In the next section, we will explore what we will call the *cold opening* for a game and how we can craft an introductory level that is exciting, sets up the initial conflict, and teaches the player how to play the game.

THE INTRODUCTORY LEVEL

In the film world, the opening of *Raiders of the Lost Ark* has been the standard-bearer for action movie openings since its release in 1981. In just 12 minutes and with very little dialogue, the audience is captivated by a series of breathtaking action sequences, culminating in the iconic sequence of the film's hero, Indiana Jones, being chased by a giant boulder. Meanwhile, the audience learns so much about Jones' character, the world in which he inhabits, and the primary antagonist. This introductory sequence helps establish the setting and characters while also teasing the primary conflict, sometimes called a cold open, has been a popular storytelling trope for television and film for many years.

While the cold open has been adapted into video games via non-playable videos and cutscenes, a similar technique can also be used for the introductory level of action games as well. In fact, many popular games and franchises such as *Shantae*, *Metroid*, and *Hollow Knight* are a few popular examples that all begin with a cold open before general gameplay is introduced.

In order to learn more, we will do a deep dive exploring the cold opening level of 1991's *Mega Man X* for the Super Nintendo, followed by the opening for our game *Little Nemo and the Nightmare Fiends* which used this intro sequence as a reference point among others. We specifically chose the opening to *Mega Man X* because it has very clear and demonstrable techniques that it uses in order to teach the player while also differentiating itself from the original series it spun off of, *Mega Man* for the previous generation's Nintendo Entertainment System. This has the added benefit of making *Mega Man X*'s introduction stage a particularly effective cold opening. In his video, *Sequelitis: Mega Man Classic vs. Mega Man X*, animator and video game critic Arin Hanson (2011) says "There weren't a lot of complex concepts in the overall design [of the original series] so it didn't need a lot of time to teach you the basics. *Mega Man X* on the other hand had so much to offer and it teaches you all of it in the first level. No, the first few seconds."[4]

Mega Man X drops the player immediately into the game's introductory level at the start of a new game, a sharp contrast to the previous entries of the *Mega Man* series on the NES, which take players to their stage select screens first. While the opening screen is devoid of hazards or obstacles to give the player a chance to collect their bearings and test out the controller inputs (see the previous section on the runway), the setting is visually interesting and exciting. X, the main character of the adventure, stands on

what appears to be the highway to a futuristic city, with a giant road visible in the background curving off into the distance. The main character sprite has a similar but noticeable visual upgrade to the original Mega Man sprite with more shades of blue and decorated armor. He stands a bit taller with a more pronounced stance and has a readable, serious facial expression compared to the original's simple and cartoon-esque face. All these elements combined allow *Mega Man X* to set itself apart from its parent series with increased visual fidelity and a slightly more serious tone.

This tonal shift continues when the player first sets off to the right, as non-interactable cars drive in the opposite direction of X to indicate they are driving away from some unseen threat. This helps give the impression that X is bravely running toward the conflict that has appeared on this stretch of highway. It does not take long before our first enemy appears on-screen; a thematically appropriate robot wheel that rolls casually toward X before dropping at his feet to force the player to jump if they were not able to successfully shoot the enemy in time. While this first monster is a bit more active than *Super Mario Bros.*'s slow-moving Goomba to match the pace of the action, it is nonetheless simple compared to future enemies that will be encountered later on.

The regular enemies that X encounters throughout this three-to-four-minute stretch of level are similar in design; they have low health and simple patterns that mostly force the player to think about how X moves and jumps. For example, while the first enemy either can be dispatched via X's projectile or jumped over, the second enemy type's hitbox is taller than X's jump and forces the player to learn how to shoot in order to proceed. The third enemy type flies through the air and stops moving when X's hitbox is about two tiles (or 24 pixels) away from the enemy, dropping down and destroying the ground below. This forces Mega Man to both jump and shoot in order to avoid a hit and reinforces the basic verbs available to the player.

Mega Man X uses this thematic backdrop to teach the player X's new abilities that differentiate him from Mega Man. Early on, the player will be locked onto a screen with *Mega Man X*'s first mid-boss; a giant robot bee that drops weaker, standard enemies and slowly approaches X every time the bee-robot is shot. Once this robot reaches a certain point on the screen, it will blow up and cause the ground beneath it to collapse under its weight, taking X along with it to the next vertical screen below. While the area here is devoid of hazards, the player is stuck in this space until they learn a new ability of X that Mega Man did not have. Hanson explains "Bumblebee man fell on the right side of the platform but there's this little gap between him and the wall. Now when you're drawn to the walls because there really isn't anything else to be drawn to, you hop up on the bumblebee, run at the wall, and then you slide down the wall. Now you can easily observe your descent to slow, there's a little smoke trail coming up." By pressing forward while in the air against the wall, X will cling to the side and skid down the wall much slower than his normal fall speed. Pressing the jump button again while in this wall slide state reveals that X will bound off the wall a short distance before the player can begin controlling him in air like his normal jump state. The player can then repeat this action and begin climbing out of the newly formed pit and making their way back to the top level of the highway. This has the added benefit of showcasing screens in *Mega Man X* can scroll both vertically and horizontally, another new feature of the X series.

Furthermore, at the bottom of the previous pit, eagle-eyed players can see a large health restoration pick up on the other side of the right-hand wall that is inaccessible from where they are currently trapped. Once back at top level, the player can then choose to fall back down a different hole in the highway next to where they came from to obtain the health pick up. This is not a completely safe action; however, as there is a bottomless pit next to where the item is, so players can proceed cautiously by sliding down the wall with their newly learned ability rather than falling fast straight down into the death pit and losing a life. This pattern of introducing an ability during a safe but forced sequence, followed up by an optional yet risky challenge, is a great teaching tool for players that is rewarding without also being punishing.

Further down the highway, following more enemies and another encounter with the robot-bee miniboss, players meet another thematic enemy; robots driving gun-attached convertibles with spikes for bumpers. These enemies are the biggest test of a player's dexterity yet; they spawn on screen from both directions at seemingly random intervals and they both shoot at and attempt to collide with the player. Their main weakness is that they cannot fly, and their bullets only travel along the horizontal axis, but

nonetheless are the most demanding in terms of testing the player's reflexes. They also hold a nasty surprise should the player try destroying them with projectiles; after about four or five shots, the top half containing the driver and the gun is destroyed, but the car continues to drive toward them. This attempt to shock the player can also potentially reveal a fun reward; if the player happens to land on top of the speeding car, they will realize they can ride along the top of them in either direction, gaining more leverage on the other cars but also needing to jump off if the car begins to career off a cliff. This kind of fun dynamism is once again unique to the *X* series and is introduced during the height of the introduction level's difficulty.

After one last mid-boss, a flying carrier that is revealed to be the source of the robot cars, the final sequence of the cold open begins. The music changes to a more sinister theme as a helmeted humanoid robot driving a giant mech drops out of the carrier above X and immediately begins attacking. Although a second health meter has not appeared on screen, players can rightly assume this is the boss of the stage. Unlike all the other challenges however, this one is not trivial; the mech rider will very quickly dash and punch at X, then leap backward without pausing to continue assaulting him with projectiles and dashes meant to overwhelm the player. Despite this immediate, sharp turn in difficulty, this battle is not meant to be won; it is yet another surprise meant to differentiate the tone and narrative of *Mega Man X*. After wearing down all but a quarter of X's health, the boss will begin shooting balls of light at X while avoiding making physical contact to prevent the player from dying carelessly. Once a ball of light makes contact with X, he is trapped and control from the player is removed while the first cutscene of Mega Man X begins to play.

While relatively short in terms of dialogue, this cutscene is nonetheless as important as the playable parts of the level. First, we know this game will be more narratively dense than former *Mega Man* games just by the inclusion of text dialogue outside of the game's ending. Second, this moment of threat X appears to be under is soon broken up by the music cutting out and the sound of a weapon being charged up from off screen. Suddenly, a blast is heard followed by a projectile that pushes forward and rips the hand off the boss' mech. Suddenly a new character dashes in from the left side of the screen; a red humanoid robot that is as vaguely reminiscent of X. This blonde-haired robot reveals himself to be Zero as the boss escapes from the scene. In his dialogue, Zero teases that X will someday be more powerful, and that he must continue to fight against the Mavericks (the name for the villainous robot force that serves as the game's primary antagonist) in order to get stronger. This dialogue is more than just textual flavor that is strongly reminiscent of the sentai anime that inspired *Mega Man X*'s look and narrative; it's also a teaser for what's to come as X will gain new suit upgrades and abilities throughout the adventure in future stages. Of how the intro stage establishes the mechanical and narrative themes of the game, Hanson says "Everything in this game has to do with X growing stronger. And all the elements are clear; you don't just have the personal parallel character Zero, who represents how strong you will become, you also have the goal, to beat Vile, who at this point in time you can't even visibly damage … so now you have true motivation to beat Vile."

This introductory level to *Mega Man X* is similar in function to the cold open of *Raiders of the Lost Ark* that we mentioned at the beginning; it establishes the setting and tone of the game and provides several engaging and exciting sequences to hold the player's interest while also easing them into their controls and starting abilities. These were all features we sought to emulate with the opening to our game, *Little Nemo and the Nightmare Fiends*.

Being a slightly more complex game than *Mega Man X*, our game does begin with an introductory cutscene to establish the background conflict. We also wanted a sequence that would be engaging for people unfamiliar with the *Little Nemo* comics while also being something that would excite fans. And so, after Nemo is awoken in his bed and told that he must come to Slumberland, we see the game's first big moment, the iconic Walking Bed. Nemo's bed begins to move before the legs rise up and down, finally settling at medium length and moving toward the window. Shortly thereafter, we see Nemo and our new character, Peony, running down Nemo's Street before suddenly, there's a shot of a mysterious, dark projectile that spooks the bed as if it were a horse that had just heard a loud noise. Nemo is then flung off and must chase after the bed from where he's landed; the rooftops of the houses that make up his home city.

We did not want to open our game with a challenging sequence with a lot of death pits or a race against the bed, however. While a cold open should be exciting and engaging, it still needs to ease players into the game. Thus, the first few screens of the city feature trivial jumps and no enemies to ease players into the game's movement and physics. Soon, the players find themselves whisked above the clouds and into the game's first true level, the Night Sky. Apart from the fact that a walking bed is not something you'd normally see out and about, the Night Sky needed to visually represent the transition from Nemo's ordinary, waking world and the dream world of Slumberland. Therefore, it was important that it be visually exciting and distinct from the city rooftops.

This is also where we see the first few enemies of the game, including our most basic enemy, the Momerath. Like the Goomba from *Super Mario Bros.*, the Momerath lazily walks toward the player and needs to either be attacked or jumped over in order to not take damage. While throughout the game, the player will encounter many different variations of Momerath (ones that turn around at cliffs, ones that jump up and down, etc.) and their normal function is to make certain jumps and challenges trickier, the first few simply walk toward the player to ease them into learning the controls for jumping and attacking.

Mega Man X levels as a whole are linear, only offering the player a choice in direction to find optional items and upgrades should the player possess the ability, such as the bonus large health pick up that functions as a reward for wall slide and wall jump mastery we discussed earlier. *Nightmare Fiends,* by contrast, has nonlinear levels, allowing players to make more choices in where they can go as they gain new abilities and requiring them to do so to make progress. This is something we wanted to tease in the Night Sky; unlike the opening stage of *Mega Man X*, players would be able to come back to this stage later in the game, so it was important that the promise of exploration was introduced early on. The first hint of this is in the first vertical area of the game, a shaft that features three doors, not including the first door the player enters through from the left side of the screen. The first door is visible as soon as the player walks in, slightly above their starting positions and goes off to the right. The second is on the next screen above the first door and goes off-screen to the left, and further up another screen still is a locked door that goes off to the right (Figure 4.2).

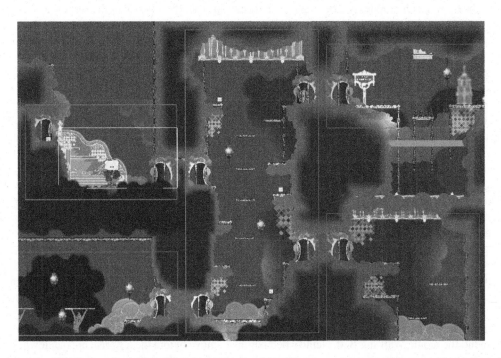

FIGURE 4.2 The first vertical area of the Night Sky level in *Little Nemo and the Nightmare Fiends* introduces the idea of branching paths and non-linear gameplay, but in a brief and controlled space that does not let players stray too far from the main path shown as the vertical central room in the middle of this image. The gameplay elements in this area are reinforced in later areas with more open-ended exploratory structures.

Although the player is presented with seemingly three options for where they want to explore first, this is an illusion. This is most obvious with the top-most path, which is visually blocked off by a large gate that has a noticeable keyhole shape in its center, an icon to let the player know this area is locked off to them. The second door in the middle of the room also features a lock, albeit a different type of one. Though the player can go into that room, they are met with a wall that is too tall for them to jump; a skill gate requiring an ability they have not earned yet. This is a room they will not be able to surpass until later, so it was imperative we made it as memorable as possible for the player's mental map. First, the wall that cannot be jumped over is visually distinct from most other areas of the level; a translucent crystalline structure as opposed to the purple- and brass-colored platforms the player has seen thus far. There's also an NPC in this room, a construction worker who notes that the stairs in the background of the room are broken and the only way up the path now is to climb the wall, with the word "climb" being a distinct color of purple. Later, players will be able to return to this spot as Peony, a character who dresses primarily in purple and is able to climb along walls.

That leaves the first room that players are given the choice to encounter and goes off to the right. This room is also a dead-end; however, it contains an important item; a key below the entrance that can be obtained by completing a simple jumping puzzle. This key unlocks the true path forward, the last room at the top of the structure. This was designed to tease the game's nonlinear nature without overwhelming the player immediately while also introducing the concept of lock and keys that players will encounter throughout the game. It was also designed this way to engage different types of players; expedient and casual players will travel to the first room they see, pick up the key, and use it once they reach the top of the shaft and continue along the game's main path. Players who enjoy exploration and fear missing out on valuable items or stories will tend to explore the entire shaft and the two proceeding doors first before finally checking the door at the bottom of the stairs. In both cases, players will be ushered through the cold open of the game as expected while allowing both types of players to be satisfied with the experience.

Finally, our opening level concludes with an exciting set piece; the game's first boss, the Man in the Moon. We decided to take a different tact than *Mega Man X* for our introductory boss; rather than making a fierce opponent that was unbeatable, we decided to create a boss that seemed intimidating but was easier and more relaxed to fight overall compared to the later boss fights in the game. We did this first by introducing a narrative conflict; the normally benign Man in the Moon character has been taken over by the same mysterious force that spooked Nemo's bed and attacked Nemo and Peony. Despite this, we used relatively simple boss patterns and made the pieces large in size in order to keep the fight easy for new players, allowing the aesthetics of the fight to help create the illusion of difficulty and tension instead.

In the above examples, we looked at linear action sequences in platforming games. However, it is worth noting that certain RPGs, especially ones with an action focus, will often also utilize a cold open for their introductory stage as well; for example, *Secret of Mana* by Square-Enix begins with the hero character falling from a waterfall, obtaining a mysterious sword and fighting through a short corridor of monsters with the goal of returning to his hometown. This cold opening does several things in order to grab the player's interests; it introduces the hero character, a goal is established (find your way home), a mystery is established (why are monsters suddenly appearing?), and basic movement and combat are taught. All of this occurs within the first five minutes before the hometown is reached.

VERTICAL SLICE

Alongside the introductory stage, another pattern often discussed by game designers is the idea of a vertical slice. Sometimes the term is used to mention the introduction of a game, such as the *Mega Man X* example that we mentioned. While this can sometimes be the case, there are certain considerations for the vertical slice that do not always apply to the introductory stage.

In the world of game production, the vertical slice is a portion of the game that is often requested by the publisher as a proof of concept for a game. It is, in effect, a "slice" of your game that demonstrates the main appeal of the game in a short period of time, usually no longer than five to ten minutes. This is like a trial demonstration, or demo, of a game though one meant specifically to gauge who the game appeals to or whether it is a fit for the publisher's library of games.

With some exceptions, the opening of a game usually does not make for a very good vertical slice. By their nature, openings do not tend to demonstrate all of the core mechanics. If we are to presume the player may not have ever touched a video game before, it is important to lead them through basic movement and starting mechanics prior to introducing more complex systems and navigation. This is the technique we have explored thus far in this chapter.

This is not to say the intro stage and the vertical slice can never be the same. For games with simpler mechanics, the vertical slice can very well also be the start of the game. It is worth demonstrating however that they are not the same thing in and of themselves. For example, while the cold open of *Mega Man X* suggests the mechanical and narrative theme of growth, it also does not feature said growth; X does not gain any new equipment or is able to explore new areas in the introductory stage.

A better example of *Mega Man X*'s vertical slice would be the Chill Penguin stage. While multiple levels are selectable after the introductory stage, difficulty-wise it is scaled to be the first level players are intended to finish. In this level, X is forced into an armor upgrade about halfway through the level; boots that give him the ability to dash a short distance. These boots allow him to explore new areas of the level he would not have been able to without them and allow him to find other armor upgrades in other levels as well. In this way, the stage is a proper vertical slice; the primary theme of *Mega Man X* is revealed quickly and demonstrable within the confines of the level itself.

Similarly, while keys are introduced in the opening Night Sky level of *Little Nemo & the Nightmare Fiends*, exploration does not really open until the player obtains the second playable character in the game. Like *Mega Man X*'s boots, this upgrade is forced upon the player during a linear sequence. The second level, the Mushroom Forest, begins with a straight walkway that ushers the player from the beginning into a sequence where they find Peony, fight a short mini-boss, and then must work their way through a small introductory training ground for Peony, a "cold open" of sorts for learning how to switch characters and utilize their abilities. Specifically, Peony can cling to horizontal surfaces and climb along them, a skill that will be recognizable as the necessary ability to overcome most of the obstacles the player witnessed at the level's outset. Indeed, once the player succeeds in escaping the tutorial area for Peony, they are let out near where they started the level, free to explore much more of the area than they could with just Nemo. This represents our vertical slice; the level starts more linear, a friend is made, and more of the level is open to exploration. This small section of the game, about ten minutes of gameplay, exhibits the core appeal of the game.

Case Study: *Link's Awakening*

So far, we have looked at two patterns, the cold open and the starting town. As mentioned with the previous example of *Secret of Mana,* however, many games combine these two techniques together to create an engaging opening while also being able to explain complex game systems and provide players with the feeling of freedom and exploration. To explore this in detail, we will be looking at Mabe Village, the opening area of *The Legend of Zelda: Link's Awakening*, originally released in 1993 for the Nintendo Game Boy. We have chosen this example for several reasons. For one, it slowly introduces spatial navigation and game mechanics in a way that does not specifically guide the player explicitly nor does it overwhelm the player with too many options. The developers also needed to be creative in designing each screen to be as memorable as possible to allow players to form a mental map of the town due to the technical limitations of the Game Boy. Since our example game that we are creating is also limited by these same limitations, it also provides a great model from which to learn how all the techniques we have explored in this chapter can be put together.

Design wise, Mabe Village is multifunctional. It serves as a sort of starting hub for the early part of the adventure; it helps to establish the aesthetic tone the game will have; and it introduces several gameplay features such as shops, hint houses, and minigames. It also features several unique screens and structures that are meant to stick in the player's brain while also providing the player with the first goal and subtly ushers them toward it to properly start the game.

After inputting the character's name, the game opens inside the central most house of the town. Link is seen thrashing in bed before awaking in front of his rescuers, Tarin and Marin, who establish the game's backstory: Link was found washed ashore the beach south of the island with his shield, but his sword that he had with him prior to being shipwrecked was not among his items. This also establishes the player's initial goal, finds the beach and the sword, and provides them with their first key item, the shield, which will be necessary for accomplishing the goal.

Stepping outside to the exterior of the house, we get our first real sense of scale for the game; the Nintendo Game Boy's resolution of 160×144 pixels limits screen real estate while the four-color palette consisting of green and black shades does not allow for fine detail, so the level designers needed to be judicious in their use of tiles and shading to maximize utility. To make Tarin's house look memorable, it is surrounded with fence posts, a big tree in the back, and grass on the inside of the fence. All of these are generic tiles that the player will see in innumerable amounts over the course of the adventure, but they are arranged in a way to make the house memorable and distinct from other houses in the village. Unique arrangements such as these are common throughout Mabe Village; as the town is a relatively small space (About 14 screens overall), giving each unique element and imagery allows individual screens to stand out and help the player understand how they are all connected in order to help them to form a mental map.

Another striking image is the road that starts at the entrance to the house and leads off to the left edge of the screen, giving the player a starting direction in which to set off (though nothing will stop them from traveling to a different screen should they choose). In his analysis of the opening sequence of the game for video game blog and news site *Kotaku*, critic Tim Rogers (2019) notes that "You (the player) can tell it's a road because it's a different shade than anything else, and there are little white dots down the center, almost like the kind that a car would drive on."[5] This again emphasizes the importance of color choice within the Game Boy's limited palette.

Following the path brings the player to another striking image: a cannonball-looking monster with teeth launching in their direction, stopped short by a chain attached to a spoke nearest to Talon's next-door neighbor's house. This monster will look familiar to fans of the *Super Mario Bros.* games as a Chain Chomp, a dog-like, invincible monster that pounces on Mario when in range. The Chomp here does not damage Link, but this cameo (the first of many over the course of Link's Game Boy adventure) helps to establish the dream motif throughout the game with familiar yet foreign imagery for a typical *Zelda* adventure. Exploring this house also introduces us to the Chomp's owner as well as a younger, smaller Chomp that mentions wanting feminine accessories, the first hint of many in the village about future side quests in the game (Figure 4.3).

The path continues to the left, with a screen that features a well in the center surrounded on the left and right side with fence tiles to draw the player's eye, above which is a small cliff. There is also a notable gap in the cliff just above the well, however it is blocked by three bushes. If the player is familiar with the game's Super Nintendo console counterpart, *The Legend of Zelda: A Link to the Past*, they may presume they can pick these bushes up as they could in that game; however, this is impossible in *Link's Awakening*. Similarly, there is now a second path on this screen leading north to an area similarly inaccessible by these bushes. These bushes are some of the first "keys" blocking off the player's progress that they are likely to come across, and they are directly tied to the first goal that was established at the beginning of the sequence; find the sword so we can presumably access these notable areas. Rogers notes "We know if we've played a *Zelda* before … we know that we can use our sword to chop down the bushes and we can then jump down into that well, and that there's probably something in there … and even the casual player might think there's probably something in there." Later, when the player returns with the sword, dropping into this well rewards the player

FIGURE 4.3 A map of Mabe Village at the beginning of *Link's Awakening.*

with the game's first heart container piece, a common *Zelda* trinket that will increase the player's max health when enough are collected, introducing an important, albeit optional, side quest at the very start of the game.

Continuing south toward the beach and ultimately, the sword, is the final screen of Mabe Village in this direction. Here there are two children standing about two tiles apart from one another, throwing a ball back and forth in a timed interval across the road Link is traveling upon. One way in which *Link's Awakening* is unique compared to other action RPGs, including other *Zelda* games, is that because it has a relatively small overworld and few towns and thus, NPCs, villagers can have distinct sprites, animations, and personalities compared to the generic, nameless denizens of other games. In terms of level design, the kids playing ball here is also a unique set piece that helps to create the mental map mentioned when discussing screen layouts earlier. There is also a building on this screen, featuring a library that serves as the game's broader tutorial section, a beginner's house. Here, sets of books give players more advanced techniques and hints at future challenges that cannot be demonstrated easily through trial and error. Among the books that explain some of these more oblique mechanics, Link will also find a book that requires a magnifying lens to read, another quest for the player to keep track of. The path outside continues to the south outside the village where players will come upon the beach. Elements of the beach area, as well as further areas of *Link's Awakening,* were discussed in an earlier chapter concerning game overworlds.

While the path from the starting house will lead players directly to where they need to go to properly start the adventure, they're not limited to staying on the path. More adventurous players may decide to explore other areas to see where they can and cannot go, and Mabe's village has many other unique features that tease future mechanics and diversions, though most of them are not accessible until the player at least has gotten the sword from the beach. For example, the general store to the northeast of Tarin's house, the conveyor belt minigame to the southeast, and the fishing minigame to the northwest all require spending rupees, the *Zelda* series form of currency, in order to access, however, collecting rupees is not possible without the sword. When rupees do become accessible, these shops

and minigames offer a break from the main adventure and contain key items for resolving certain side-quests. Furthermore, the general store also contains health refill items for a very low cost, establishing Mabe Village as a place the player can return to in order to restock and prepare for more dangerous adventures.

One mechanic the player can engage with at the start that is unique to *Link's Awakening* (later borrowed for the modern indie game *Chicory*) is at a house that's just one screen south of the starting point. Here there is a unique house built into a tree with an icon of an old-timey phone above the door. This phone booth house contains a room with a phone in which players can call Ulrira, an old man from the village who lives one screen over but is too shy to talk in person (and oddly, the only person on the entire island with a phone). This unusual set up acts as the game's hint system, where lost players can call and get a hint where to go next with no charge or gate required to access it.

One last notable area is the field one screen east of the starting point; there are no houses, and it contains a pack of bushes in a 6 × 5 grid. As established earlier, a reward for earning the sword is the ability to cut down bushes, making this area a sort of playground as a reward for the player's early achievement. This reward, however, hides another implicit tutorial; among the bushes is a Secret Seashell, likely the first one the player will come across once they return with the sword and begin cutting away at the bushes. Picking up the seashell gives the player a message that finding enough of these will cause "something good is bound to happen." This kind of side-quest, where judicious explorers are tasked with finding many optional items over the course of the game, is a common trope of both *Zelda* games and adventure games in general, and in *Link's Awakening* is introduced early on by a memorable sequence in the starting town like the heart container piece in the well from earlier. As Rogers notes, "The game is being very coy and humorish at this point, and you are now aware of a mystery."

Finally, there are more hints at future events and locks in the village; a rooster statue and compass just north of the starting point (and suspiciously like a key structure from *A Link to the Past*), a small house whose doorway is blocked off by impassable rocks, and the path out of town to the east which is blocked off by both bushes and the impassable rocks. The final NPC residence contains a family, including a mother who is looking for a "Yoshi" doll, another non-*Zelda* cameo appearance that can be found within the town itself, a reward for the conveyor belt minigame. All these work toward teasing future abilities and adventures the player will have and help to establish the off-kilter, dreamlike tone of *Link's Awakening* from previous *Zelda* entries.

While many elements of *Link's Awakening*'s Mabe Village were born either out of the necessity of the Game Boy's technical limitations or the unique aesthetic and narrative tone of the game, we can draw some general conclusions from the game's unique trappings; a starting area for a nonlinear adventure game can help create the foundation for our game's worldbuilding and narrative tone, it can help establish our player's starting goal, it can both lead them toward the said goal while also rewarding exploration, it can teach early mechanics while also teasing future mechanics and events, and finally, it can provide a safe, welcoming "home" space that the player can return to rest or take a break from questing at any point with affordable health refills and minigames to help add variety to the gameplay.

PUTTING IT TOGETHER

Looking at all our examples thus far, we can see multiple patterns that 2D action-adventure games use for their introductions and tutorials. First, the hook; the introductory sequence or establishing background information. This usually takes the form of a cutscene or non-playable sequence. Both *Link's Awakening* and *Mega Man X* leave this information as part of their attract mode, before the player has confirmed

playing a new game. For modern games, including *Little Nemo & the Nightmare Fiends*, this information is conveyed at the start of a new game. The introductory cutscene reveals a mysterious conflict in Slumberland, and Nemo is told he must return to help alleviate it.

When the player is handed the controls, they can be given time to adjust; this can come either in the form of an explicit tutorial, an empty runway, or a starting town. For nonlinear or exploratory games, a goal is established quickly; find the sword, defend the highway, catch the bed. These drive players forward and leave them with few questions about what to do next.

In order to drive them toward accomplishing this goal, the game must next do two things; it must teach the player the basic controls and mechanics and tease future abilities. Teaching can be accomplished using explicit tutorials, either through nondiegetic message boxes or diegetic narrative or gameplay mechanics such as through NPC dialogue. It can also use implicit tutorials using visual conveyance and feedback through its level design to guide players to the goal or use simple enemy patterns to subtly teach gameplay movement and mechanics. We can also use these techniques to tease future abilities and narrative events; *Mega Man X* casually introduces simultaneous vertical and horizontal scrolling through a forced boss fight, or how *Link's Awakening* teases cutting down bushes, lifting large stones, and jumping over gaps by teasing where the player cannot go.

Finally, we close our introduction with an exciting incident to heighten player engagement. This can be a boss fight before we accomplish the goal such as the impossible fight with Vile or the broken bed fight with the Moon. It can also be the accomplishment of the goal itself and the new potential it brings, such as receiving the sword in *Link's Awakening* and having new paths to explore. Regardless, the player should have many new possibilities open to them that drive their curiosity; the promise of becoming stronger than Zero, new areas only accessible with their newfound abilities, or new worlds to explore within Slumberland.

CONCLUSION

In this chapter, we discussed both the necessary elements of an opening level and why they are difficult to create. We discussed how they act as the hook for your game early into the interest curve, providing background for the world, aesthetics, and tone of the game's narrative. We looked at how the first level of a game can teach the player using implicit and explicit tutorials. We introduced the concept of the hometown, a sort of larger runway with narrative background for more complex game types. We looked at the cold opening level to create an introduction that is both exciting and eases players into an adventure. Finally, we put it all together to form a pattern to open a game. Next, we will put this into practice by creating an introductory town for our example game.

NOTES

1. Schelle, J. (2008). *The art of game design*, third ed. CRC Press.
2. Eurogamer (2015). *Miyamoto on World 1-1: How Nintendo made Mario's most iconic level.* 15 Sept. Accessed April 27, 2023. youtu.be/zRGRJRUWafY
3. Campbell, J. (2008). *The hero with a thousand faces.* New World Library.
4. Hanson, A. (2011). *Sequelitis: Mega man classic vs. mega man X.* 31 Oct. Accessed August 1, 2023.
5. Rogers, Tim (2019). *Link's Awakening (Game Boy, 1993) improvised review.* Kotaku. 24 Aug. Accessed June 30, 2023. https://youtu.be/2sjI-KJ4ZVU

REFERENCES

Campbell, J. (1949). *The hero with a thousand faces*. New World Library.

Eurogamer. (2015). *Miyamoto on World 1-1: How Nintendo made Mario's most iconic level.* 15 Sept. Accessed April 27, 2023. https://youtu.be/zRGRJRUWafY

Hanson, A. (2011). *Sequelitis: Mega man classic vs. mega man X.* 31 Oct. Accessed August 1, 2023. https://youtu.be/8FpigqfcvlM

Rogers, Tim (2019). *Link's Awakening (Game Boy, 1993) improvised review.* Kotaku. 24 Aug. Accessed June 30, 2023. https://youtu.be/2sjI-KJ4ZVU

Schelle, J. 2008. *The art of game design*, third ed. CRC Press.

Creating Scenes, Dialogue, NPCs, and Cutscenes

4.2

In the previous chapter, we looked both at video game tutorials and how certain action-adventure games use in-game towns as a place to teach players how to play the game. In this chapter, we will be constructing a town for our demonstration project that we introduced in the last practical chapter, *Molly the Plant Princess*. We will be using what we have learned from the previous practical chapters and learning how to apply those techniques to a full game project.

If you have not already done so, you can begin to create your town utilizing the techniques we explored in the last practical chapter, though we also have provided you with a town background that you can use instead if you wish to just follow along with the steps in this chapter (Figure 4.4). Note that our town map does not feature common amenities such as a shop, as scripting those mechanics would be a project beyond the scope of this book. When creating your own town background, it is important to keep in mind the common mechanics you want players to encounter and how they fit within your world. Once our Town background is ready to go, we can begin creating trigger zones for our player to move between our Town scene and interior houses on the map.

FIGURE 4.4 The town scene background that we have included for *Molly the Plant Princess*.

DOI: 10.1201/9781003441984-10

BUILDING OUR TOWN

1. To begin, we will need a background for our town. You may create your own following the steps outlined in Chapter 3.2, or you can follow along with our sample scene, named "TownTut."
2. Add a new scene as you did in the previous chapter, selecting either the provided town background or one of your own creation. Remember to paint collisions for all walls and solid decorations.
3. With the Title Screen scene selected, scroll down until you see the Change Scene event. It should be set to take players to the Cave scene we created in a previous chapter. Change this scene to our new Town scene.
4. Place the Destination Icon where you would like the character to load on the map. Be aware that we will change this later in the chapter.
5. Create new backgrounds, import them, and use them to create scenes for home interiors, remembering to paint collisions as you create your new scenes.
6. Place triggers in the doorway of houses that you want the player to be able to enter into. Also add triggers to the doorways inside of houses so that players can return back to the Town scene. Remember to not place your triggers overtop of where you want the player to appear when they re-enter the scene (Figure 4.5)!
7. Add "Change Scene" events on all triggers so the player can move between the interior and exterior scenes.

FIGURE 4.5 Our town map with colliders and triggers moving between exterior and interior spaces.

SETTING THE STAGE

Now, we should create a simple object the player can interact with. In older action-adventure games of the style that we are mimicking, signposts were an easy, repeatable way of conveying information. While the act of reading a signpost is voluntary and thus critical information such as play control or mission objectives should be conveyed through other means, signposts can elicit curiosity that draws the player in to see the contents of the sign. Let us create our own now.

1. As before, add a new actor to the scene by pressing the Add (+) button on the toolbar and selecting "Actor."
2. From the Sprite Sheet selection, scroll down and select the Signpost sprite sheet.
3. Ensure that "On Interact" is selected.
4. Add the "Display Dialogue" event and type what you would like for the sign to say.

For this example, we will be placing the signpost outside of the house we can enter. This will be Molly's, our protagonist, home (Figure 4.6). You can also place signs in front of other houses indicating their function, such as shops, save rooms, or other houses. While more complex games could use more bespoke artwork such as unique houses or other design elements and be more diegetically appropriate, easily reproducible elements such as signposts will also save us valuable time and, in the case of GB Studio, space.

Our town is still a bit empty, so let us begin populating it with non-playable characters, or NPCs, for Molly to talk with. For this tutorial, we are going to create an NPC in its most basic form. From a game development perspective, this is just a signpost that also moves around. Therefore, we can repeat the same steps we did to create a signpost to create an NPC with something to say. You will also need to select which direction you want the actor to face; however, this is less important for NPCs that will walk randomly around the map.

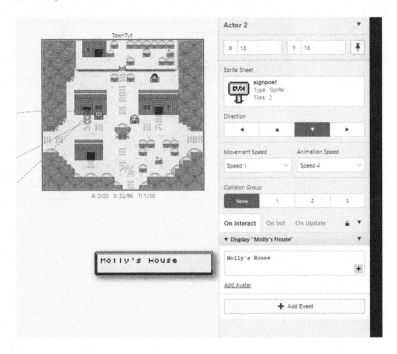

FIGURE 4.6 Creating our signpost actor within GB Studio.

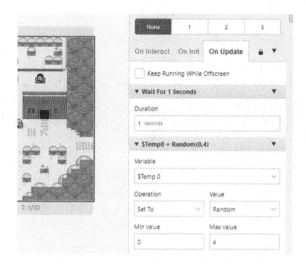

FIGURE 4.7 A standard town NPC alongside random walk behavior.

When selecting a character sprite, be sure to select a sprite sheet that has a walk cycle in each of the four cardinal directions (Up, Down, Left, and Right). This way we can start to make them walk around the map rather than stand in one place. This is the same behavior we applied to our enemies in Chapter 2.2 – "Building Basic Game Mechanisms," and the one applied to the Pet Owner NPC from the GB Studio demo scene (Figure 4.7). You may repeat the steps we went over in that chapter, or you can simply take the Pet Shop owner, then copy and paste her actor into your hometown scene and change the dialogue and sprite to fit your needs. Just be sure to delete any behaviors you do not need, such as checks for side quests that do not apply to the NPC you are building!

EFFECTIVE NPC DIALOGUE

In the previous theory chapter, we discussed how NPCs serve several important functions for the player in terms of guidance and worldbuilding. Now we will expound a bit more on common patterns and purposes of NPC dialogue to consider when populating your town and world. The goal is for this to serve as a starting point for you to write dialogue for your NPCs that is both meaningful and functional.

NPCs are an important part of action-adventure games. Writing for *New York Times Magazine* in 2022,[1] writer Mac Schwerin notes an inherent irony in video game NPCs. Unlike other mediums, such as film, where side characters are ancillary and thus quickly exit the narrative, NPCs are ever present within a game and in fact, often take center stage. The main character and thus the player cater to their needs in different types of quests, creating a fulfilling sense of purpose not only within the game, but within the player's exterior life (Schwerin, 2022).

Broadly, we can divide NPC dialogue into three functional categories that we will explore in further detail:

1. Narrative exposition: any dialogue that expands the player's background knowledge of the world or the characters within.
2. Directional exposition: dialogue that provides the player with a hint toward an objective or goal or provides tutorial information such as explaining controls or systems within the game.
3. Irreverent exposition: dialogue that serves no functional purpose beyond adding a sense of interactivity or levity to the overall game experience.

FIGURE 4.8 Narrative exposition in *Molly the Plant Princess*.

Narrative exposition serves several important functions that are worth considering. From the perspective of an interactive narrative, learning more about the world and how it has affected the interior lives of people living within it creates the illusion of a real place. As a game, it can also function as a reward for a player's curiosity, particularly those who are motivated to explore every corner of the world or are deeply invested in your story (Figure 4.8). In the opening to Square-Enix's time-traveling RPG *Chrono Trigger*, many of the NPCs discuss the history of the kingdom of Guardia and the events that led up to the game's opening setting, the Millennial Fair. Soon after the game's inciting event which transports the player into the past, they get to experience these events for themselves. While players who simply move through the game's introduction quickly will be able to follow the game's plot with no issue, those who took the time to explore are rewarded by seeing the past events play out for themselves.

Directional exposition is perhaps the most functional of the three types. These NPCs will often help guide the player toward objectives in the game. This can either be related to the quest that the player is actively pursuing or to convey a long-term objective. A simple example of both happens at the beginning of the original *Final Fantasy* for NES. At the start of the adventure, the main party is dropped in front of the kingdom of Corneria, split into the starting town and castle. A lot of the dialogue by the town residents inform the player of either the first main quest in the game – rescuing Princess Sara from Garland at the dungeon to the northwest – or the game's overall objective to light the four crystals and bring balance back to nature. Note that directional exposition such as this also often serves as narrative exposition to provide a logical reason for NPCs to give direction, but not all directional exposition need to be narrative exposition. For example, if an NPC mentions hearing strange noises emerging from a nearby well, that can direct the player to inspect the well without necessarily providing additional information about the narrative.

Another form of directional dialogue is providing the player with tutorial information, such as what buttons on the controller can do. This can often come from an NPC when the player unlocks a new ability through conversation. When players first receive the world map in Nintendo's *EarthBound* for the SNES, the librarian that hands the map tells the player character, Ness, that they can open the map with the X button on the controller. However, dialogue like this is also often seen for basic controls and inputs as well, particularly in games on older consoles where memory constraints prevented tutorial pop-up messages and training zones that we discussed earlier in the chapter. The opening to Nintendo's *The Legend of Zelda: A Link to the Past* features several guards blocking access to the full world map. These guards would not only help direct players to the first main objective of the game, but their dialogue would instruct

the player to basic gameplay mechanics such as how to pick up and throw objects. In his analysis of this game for *Kotaku AU*,[2] Tim Rogers observed that by placing this information along the periphery of the map, the designers are assuming players who are likely to wander may also be unfamiliar with action games and are experimenting with the controls and button layout (Rogers, 2018).

Finally, irreverent dialogue does not provide direction or narrative background. Nonetheless, these interactions help to make the world feel alive or add humor to the game. These can be a funny or strange remark from an NPC, or an observation from your character when looking around the game world. *Phantasy Star IV* for the Sega Genesis, for example, included unique dialogue whenever the player inspected an in-game bookshelf. The dialogue would typically be either an incidental joke or a reference to other games from publisher Sega. Apart from adding levity to an otherwise serious narrative, this interaction serves to reward players for their exploration and curiosity. Another famous example occurs in *Pokemon Red and Blue* versions, where a rival trainer blurts out, "I like shorts! They're comfy and easy to wear!" before challenging the player to a battle. Chris's game *Kudzu* likewise embraces this element of dialogue to add flavor to even important NPC interactions like those with the map maker, Truffle – an architecture student with a macabre respect for the kudzu's aggressive streak.

All three dialogue categories need not be independent and can be used in tandem with each other. For example, if an NPC mentions hearing strange noises coming from a nearby well, that can direct the player toward the well without necessarily providing additional narrative information. Nintendo's *EarthBound* often contains irreverent humor alongside its narrative and directional exposition for most of its NPC dialogue.

For *Little Nemo & the Nightmare Fiends*, we used background NPCs that have used narrative and directional exposition to help guide the player to certain objectives. An early example of this can be found in our second level, the Mushroom Forest. Early in the level, players will encounter an NPC on one side of an impassable wall, next to a withered mushroom cap. She tells the player that her son is trapped on the other side and wishes she could climb. This foreshadows a later event in the same level where the player unlocks Peony and gains the ability to climb (Figure 4.9).

A little later, we force the player to encounter her son on the other side of the wall. Alongside reinforcing the fact that the player can now climb over this wall, the child explains how he got into this predicament in the first place: there was a mushroom he could bounce on, but it has since wilted. He wishes the Mushroom Farmer might be able to fix it. This alludes to the next area we want the player to go to as part of the critical path in our game; the Mushroom Farmer lives in a nearby town and gives players the

FIGURE 4.9 An NPC from *Little Nemo & the Nightmare Fiends* foreshadowing the player gaining the ability to climb on vertical pathways in the future.

quest which will eventually cause the bouncy mushrooms around our level to blossom. Finally, we add a sense of payoff to this side story by having the child and mother reunite within our town once the bouncy mushrooms have been restored.

The above example reinforces the effectiveness of NPC dialogue. It helps to teach the player future mechanics, gives guidance as to where they need to go next along our critical path, and forms a background narrative. While we did not make their story an official quest in the game – we do not add a quest tracker specifically asking the player to reunite the mom and the son, nor does the player receive a tangential reward for it at the end – the NPC storylines were given a full narrative arc to reward players and to make the world feel alive.

BUILDING AN INTRO CUTSCENE

To finish off this chapter, we will build a non-interactive story sequence, or cutscene, that will serve as the introduction to our game. This introductory sequence needs to fulfill a couple of goals to be effective. First, it needs to introduce the player to our background conflict that will drive the action forward in our game. In *The Legend of Zelda: Link's Awakening*, this was the storm that stranded our main character Link on the island of Koholint. For *Molly the Plant Princess*, these are the fires that have devastated the land. Then, we need to establish a short-term goal to provide the player direction. For Link, this was finding his missing sword on the beach to the south. For Molly, it will be finding and defeating the first boss, Rocko, in the dungeon to the east which we will build in the next practical chapter.

Building a cutscene in GB Studio is relatively simple using the techniques we have learned in previous chapters. The only new event we will introduce is the "Show Emote Bubble" event. This creates an icon that appears above an NPC's head for a short period of time, resembles an emoji, and serves a similar function. This allows for the player to understand an unstated feeling or emotion from the NPC that is built into GB Studio by default. This allows us to add a bit more narrative clarity and character emotion to our game without bespoke art and thus, save precious memory space as well (Figure 4.10).

In practice, it is just a sequence of events that go in a particular order, whether that is moving characters or displaying dialogue without the player's input. The challenge is making sure the flow of the events makes sense so that dialogue does not appear at the wrong time or that actors do not move into places at

FIGURE 4.10 Emote bubbles can help to convey emotion in your dialogue without additional art or animation to help save memory.

the wrong time. That is why we advise that you take your time when building cutscenes, testing in play mode as you go to ensure everything works as intended. Once you have built this cutscene, you will be able to create future narrative sequences throughout an entire game within GB Studio.

1. Add and place a new NPC actor somewhere off screen from the player's spawn point.
2. For this example, we will be exclusively adding events on the "On Init" tab.
3. We can use the "Actor Move Relative" behavior to direct the NPC to move on screen, and then face our player character to speak with them. You will need to use a new event each time the actor must change from horizontal movement to vertical (Figure 4.11). Be sure to run the game and test movement as you go until the NPC moves to the correct spot and behaves in a way that you are satisfied with.
4. Use "Display Dialogue" to add character exposition to your cutscene. The key points that you should hit are providing background on the current state of the world, the loss of Molly's power, and the location of the dungeon the player must navigate to next. Note that GB Studio only lets you put a small amount of dialogue into your text boxes. Also note that extensive dialogue may, over time, increase the size of your game ROM drastically, so get into the habit of saying what you need to concisely.
5. Between dialogue events, you can optionally use the "Show Emote Bubble" event to provide extra context and character to your dialogue sequence.
6. Finally, you can have your character move off-screen by creating a series of "Actor Move Relative" events in the same way as they entered the screen.
7. Once the actor moves off screen, you can use "Deactivate Actor" event so that they disappear once the scene is done.
8. We are almost done. Be sure to test the event and ensure that it works properly. Note that currently, this cutscene will play out each and every time we exit and re-enter the scene. Let us fix that now.
9. We can now use a variable to check whether the player has watched the opening cutscene. Name something you will remember, such as $InitCutscene.
10. Using an if-else event, we can check to see if our variable is true, and if so, deactivate our actor immediately.

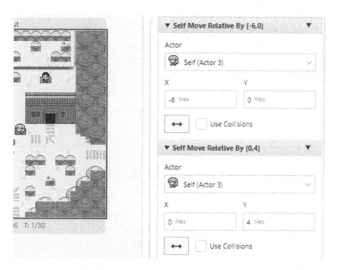

FIGURE 4.11 You will need to change between moving the player along the X and Y axis each time the player needs to switch directions.

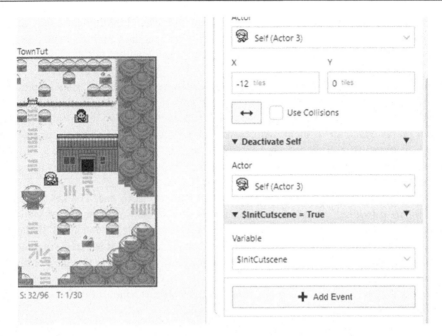

FIGURE 4.12 We set our custom variable, $InitCutscene, to true at the end of the cutscene to verify that the player has watched it and prevent it from playing in the future.

11. Drag our previously created events into the Else condition. Be mindful that you are placing them in the create sequence. Test and ensure our cutscene still runs properly and make adjustments if it does not.

12. Finally, add one last event to the end of our "Else" condition. This will set our $InitCutscene variable to true (Figure 4.12).

13. Test the event once more. Note that the cutscene no longer plays once you leave and re-enter our town scene.

You now have the basic building blocks necessary to create more dynamic cutscenes either for your introduction or throughout the rest of your game. You may want to create unique, event-specific animations for example, such as the way Link thrashes around in bed for the introduction to *Link's Awakening*. You can also make alternative versions of cutscenes play depending on whether certain variables or flags have been activated, opening the door to branching stories or alternate endings. We invite you to see what more you can do with this engine, but once again keep in mind additional animations and variables within GB Studio are limited. You may need to get creative to accomplish your artistic vision, but that should not deter you from experimenting more and seeing what's possible within those limitations.

CONCLUSION

In this chapter, we took our knowledge of GB Studio backgrounds, scenes, and events and used those to construct our own town for *Molly the Plant Princess*. We learned how to create interactive elements such as sign posts and NPCs, as well as gained insight on writing effective NPC dialogue to teach the player and bring our world to life. Finally, we crafted our first cutscene for the game, which gives the player background information to ground them in our world and gives them direction by establishing the first major quest for our game.

Now that we have an established introduction for our game, and a toolkit of mechanisms including enemies and switches, we can flesh out our game with challenges and obstacles to add variety and difficulty to our game. In the next chapter, we will focus on two common mechanisms in action-adventure games; puzzles, which will challenge players' critical thinking, and combat encounters to challenge their dexterity. We will follow this with our final practical chapter, bringing together everything we have learned to construct our own dungeon for *Molly the Plant Princess*.

NOTES

1. Schwerin, M. (2022). "Why I care more about nonplayer characters than about some ex-lovers." *New York Times*, July 31: 14.
2. Rogers, T. (2018). *Kotaku Australia*. June 6. Accessed February 22, 2018.

REFERENCES

Rogers, T. (2018). *Kotaku Australia*. June 6. Accessed February 22, 2018. https://www.kotaku.com.au/2018/06/the-first-ten-minutes-of-link-to-the-past-are-perfect/

Schwerin, M. (2022). "Why I care more about nonplayer characters than about some ex-lovers." *New York Times*, July 31: 14.

Puzzle and Encounter Design

5.1

In his book *Situational Game Design*, Red Storm Entertainment co-founder Brian Upton describes the titular *situational game design* as "a design methodology that takes into account how play unfolds when the player either isn't interacting or isn't trying to win" (2017). This concept is compatible with another useful perspective on design, Anna Anthropy's principle of *scenes*, which describes levels designed with a focus on what players see and experience moment-by-moment (Anthropy & Clark, 2014). In game design writing, there is ever a desire to find "high level" frameworks or "united theories" that help us create and analyze games (Lantz, 2023). Many of the most exciting games, though, are not created with only good "top down" design, but also sequences of interesting gameplay moments or "decisions," to paraphrase *Civilization* designer Sid Meyer (Alexander, 2012). In the industry, there is another term that is used to describe the creation of these individual moments, *encounter design*. Encounter design concerns itself with how players find particular scenes, such as the arrangement of level geometry, puzzles, enemy placement, and other potential challenges that might exist in a space.

Understanding encounter design is vital in level design broadly, but especially in story-driven single-player games where creating a variety of content is an important design goal. While encounters can be built from bespoke code and game assets, creating a full action-adventure's worth of content usually requires some imaginative reuse of common game mechanisms. In these adaptive reuses are opportunities for not only economical design on the part of the developers but also moments of surprise and excitement for players as they see familiar game elements presented in new ways. In this chapter, we will discuss approaches to building encounters in 2D action-adventure levels that will allow you to get the most out of the types of gameplay elements that we have been building throughout the book.

UNDERLYING CONCEPTS

Among the most core principles of level design are translating gameplay mechanics into spatial layouts, and *metrics,* which is basing level layouts on the measurements and movement capabilities of a player character. On the one hand, these form very basic ideas of how we teach or express the purpose of level design: level design is game*play* translated into game*space*, where the "rubber meets the road" (Bleszinski, 2000), and so forth. We can get very far by looking at level design principles from a very "high-up" or "top down" perspective, in the form of patterns and structures for building styles of gameplay. At some point, though, we have to think about what gameplay looks like from the "ground" – from the player's perspective in moment-to-moment interactions.

In a way, this is where ideas like translating game mechanics into space or metrics cycle back around to become advanced-level design principles. Instead of thinking of metrics in broad terms, such as "building a language of specifically-sized objects that enable player character exploration" (Davis, 2019), we can start to think about how those metrics create intense battles or engaging puzzles. In an interview for the 2012 documentary *Indie Game: The Movie*, *Braid* and *The Witness* developer Jonathan Blow spoke about how he was fascinated by how the placement of a ladder one unit in any direction might drastically change the shape of a puzzle (Swirsky & Pajot, 2012). In action games, and in the "action" portions of

DOI: 10.1201/9781003441984-11

action-adventures, the placement of pick-up items, enemies, and level geometry can be used to great effect to create nail-biting challenges. Platformers like *Super Mario Bros. Wonder* lean heavily on this, with levels where players must make precise jumps as ledges appear and disappear.

While mastering the design of such challenging moments seems daunting, there are some techniques we can use to ease the process. First and foremost among them is careful and thorough playtesting, where we have external users' play levels so that we can get a sense of whether the design works as intended. As we design though, there are other underlying concepts foundational to how we think about designing great encounters.

Lego Mechanics and Action Figure Mechanics

In a February 17, 2023 post on the social media website, Twitter, *Mewgenics* game designer Tyler Glaiel posited the question, "are your game mechanics Legos or action figures?" (Glaiel, 2023). His post had an image attachment that better outlined the aspects of "Lego" and "action figure" game mechanics. Glaiel defines Lego mechanics as those for which:

- Pieces are not that interesting on their own.
- Fun comes from how many small pieces combine together.
- Effort and creativity are required to use them to their full extent.
- A few different building blocks can produce countless results.

Meanwhile, he defines action figure mechanics as those which:

- Are fully assembled out of the box and immediately fun.
- Can do a few really cool things really well.
- Are a full, cohesive design on their own.
- Can not do much beyond what their designer intended.

Throughout this book, we have made an effort to speak in terms of Lego mechanics, especially in our explorations of individual mechanisms such as switches, keys, enemies, and so on. These each have different levels of interest individually but can be mixed, matched, and blended in different ways to produce many types of gameplay situations. This *modular* approach to design, where individual parts can be swapped out and replaced, helps create many different design orientations from a *system* of individual parts (Figure 5.1).

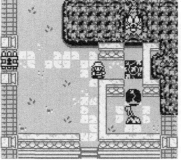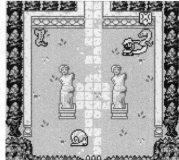

FIGURE 5.1 Three different screens from *Kudzu*, all made from the same modular set of tiles and potential enemies and gameplay mechanisms, providing different gameplay experiences.

The "Lego" or "building block" metaphor is important for thinking about how to get lots of *content* out of a small number of parts. In a video on the *Super Mario 3D World,* game designer Mark Brown talks about how Nintendo designers make the most out of individual gameplay mechanics by presenting them in evolving ways (Brown, 2015). The first time a mechanic is presented, it is shown in a "safe" environment where the player can interact with it without failure. Later, the mechanic appears within more dangerous contexts such as over pits, among different groups of enemies, etc. In another video on the design of *Donkey Kong Country: Tropical Freeze*, Brown argues that the game's designers take Nintendo's approach to *Mario* a step further, by not only building individual mechanics but also using individual mechanics in concert with others to build new types of scenes (2017).

In introducing *Tropical Freeze*, though, Brown cites levels such as one where the player must chase a rolling wheel of cheese while piloting a rocket, and another where they must jump up crumbling platforms as an avalanche is happening. These *set pieces* – individual memorable moments usually involving some bespoke artwork, animation, music, or code – may have some Lego elements, but fall squarely into the "action figure mechanic" end of the spectrum. Action figure mechanics are useful when you want something to stand out in the player's memory and can be an important part of making players excited about your game. The first three *God of War* games were exceptionally good at this: each game began with player character Kratos in a large battle that ended with a boss fight against a legendary monster or god. Among these opening levels are gameplay elements that would never be seen again but would get players excited for the game they were about to play.

Less cinematic, but still effective, is the opening level of *Mega Man X*, which saw player character X battling robots on a damaged highway, including fly shaped attack helicopters and rideable car robots. This level integrated both Lego and action figure style mechanics in such a way that taught the player the basics of *Mega Man X*'s gameplay while also offering stylish moments of excitement. In our game *Little Nemo and the Nightmare Fiends*, we literally referred to the level that we showed at conventions, which formed the beginning of the actual game, as our "*Mega Man X* demo," employing both tutorial and spectacle (Figure 5.2).

Action figure-style mechanics appear in the form of individual set pieces, such as *Tropical Freeze*'s avalanche level, or as elements with highly customized behaviors, such as boss enemies. Learning how to use both together is an important part of not only creating a well-paced game but also creating games with a satisfying amount of content. Learning how to use both is especially important for small teams with limited budgets, as Lego mechanics can create satisfying core gameplay flavors with action-figure moments as seasoning.

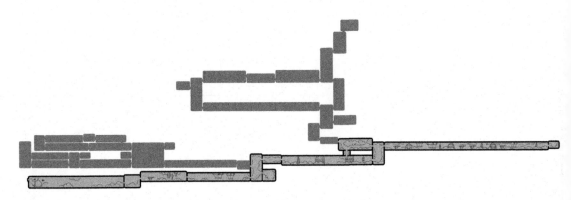

FIGURE 5.2 The map of the Night Sky level in *Little Nemo and the Nightmare Fiends*, with the opening area of the game outlined in black. This area is both a fast-paced action level and a "highway" that contains branching pathways to other, more exploratory, areas of the level.

"Juicing" Mechanics

By crossing into the realm of food and cooking metaphors, we can talk about another game design mind-set useful for working with Lego mechanics – *"juicing" gameplay.* "Juice" is a widespread concept in game design, typically used as a slang term for the *aesthetic* elements of *game feel* – the haptic and semi-intangible sensations experienced during gameplay (Swink, 2008). These elements include things like making the player's view of the screen appear to shake during big gameplay moments ("screen shake"), particle effects, explosions, "big" sound effects, over-the-top animation, and other visceral reactions to player input (Keogh, 2017). Game feel and "juice," as used in that context," are topics for other books. Instead, we are focused on another way that game developers use the term "juice": to describe how to "juice" game mechanics by getting multiple uses out of one Lego-style design idea.

This usage is used informally around the industry, but is explained by *Super Meat Boy* designer Edmund McMillen in *Indie Game: The Movie* in an example of the spinning blade hazards from his game. In one scene, McMillen describes the basic functionality of the blades as hazards that will kill the player character instantly but argues that mechanisms that can be used in only one way are not very interesting. With this in mind, he and development partner Tommy Refenes devised other versions of the blades, such as ones that move on different pathways, providing different experiences with minimal modifications to code and art assets. While this sounds like a rehashing of "Lego mechanics," this presents more of a way to think about using Lego-style mechanics. To borrow terminology from Jesse Schell's *The Art of Game Design: A Book of Lenses*, this becomes the "Lens of Juiced Mechanics": when you have a Lego-style mechanic, have you used it in every way you possibly can? (2019). In Chapter 2.1, we talked about switches in level design, and the many considerations one must take into account when using them instead of other systems for activating other mechanisms or opening doors. A basic version of a switch mechanism is having the player find a switch to open a door, but this offers limited extensibility over the course of a longer adventure that lasts several hours and gets repetitive. You can "juice" a switch mechanic by requiring multiple switches to be flipped, hiding switches behind gates that must be unlocked by solving puzzles or defeating enemies, or making switches activate new or surprising things.

Alternatively, you sometimes run into situations where you cannot juice a game mechanic any further ("run out of juice"), so it can be important to know where to stop or use a mechanic in only limited situations. In *Kudzu*, the rocky dirt mechanic, where players would need the garden hoe item to destroy special "rocky dirt" blocks in the environment, was one such mechanic. In its most basic form, rocky dirt was a means of creating a roadblock that kept the player from progressing until they overcame a specific boss in the game's Garden area, which yielded the garden hoe. It was functionally the same as the titular kudzu blocks, which blocked players from progressing until attacked with a machete, except this required that the garden hoe be equipped to destroy it. Rocky dirt also had a variation where there is fertile soil underneath, which can be used to grow plants and solve puzzles. Even this had limited uses, so beyond a few uses in the Garden area of the game, we chose not to let rocky dirt overstay its welcome in the game's world. In later areas where we needed a roadblock or something to cover other objects, we stuck with kudzu tiles in keeping with the game's overall theme of adventuring among invasive plants.

Structure for Playful Situations

Like all game design, these very structured and programmatic elements such as code, mechanisms, Legos, action figures, etc. are all a means for shaping something much less tangible, *play*. Play is the open-ended experience of a game – the triumphs, narrow escapes, epic battles, moments of planning, quiet breaths, and so on – that we shape through our structures and rules. As we tell our students: play is the actual output of a game designer's craft, the mechanics themselves are just the way that we shape the

experience of play. Brian Upton echoes this in *Situational Game Design*, saying that play is "dynamic" and is "not a static property of a system of rules," rather, "emerging from them as we play" (Upton, 2017). This was commonly misunderstood in the 2010's "serious games" boom, where a large number of organizations utilized games as tools for creating real-world impact through media that learners would find engaging. Serious or transformational games created by designers unfamiliar with the playful aspects of games – seeing them only as systems of rules and rewards – made bad games and flooded that portion of the industry with substandard products.

Despite play's ephemeral nature, Upton describes a structure for playful situations via elements that playful situations in games all share. By thinking of play as something that can be shaped via our design decisions, we can bridge the gap between our intent and how players experience or remember our games. By including these elements in varying degrees, we can create not only a structured sequence of events that our players experience, but opportunities for more open-ended moments that help players form attachment to our games (Upton, 2017):

- *Choice* – the number of possible moves the game offers players in encounters.
- *Variety* – situations or encounters do not repeat.
- *Consequence* – player moves or decisions lead to new situations.
- *Predictability* – new situations can be anticipated.
- *Uncertainty* – new situations are not predetermined.
- *Satisfaction* – desirable outcomes are attainable.

Some of these are self-explanatory, so we will focus on choice, variety, and consequence here. In competitive games, like those in the *Rainbow Six* series that Upton worked on, there are lots of opportunities for moment-to-moment choices as players react to the positioning and tactics of their opponents. On the one hand, this is the crux of encounter design: you are creating interesting combinations of level geometry, puzzle elements, and enemy placement to incite the player into reacting – with proper "juicing" creating variety. On the other hand, the planful world design of action-adventures risks the creation of linear solutions to the game itself where all players follow the same sequences of spaces and levels. In game design terms, this is where building mechanics that invite decision making is useful. In *Kudzu*, we chose to use a "flask"-style health refill system, where the player carries a "potion" that they can drink at any time, rather than the more traditional "health pickup" system, where health refills instantly when the player finds a health item, used by many *Zelda*-style adventures. This subtle difference has the potential to build moments of *risk/reward* gameplay. For example, if a player is low on health, but knows that a boss fight will be happening soon (because the visual design of the environment leads to this kind of predictability), they have to choose whether to use the potion immediately and risk being unprepared for the boss later, or fight carefully now to save the potion for the boss. Each option carries their own potential consequences where the player may find themselves in close battles, exciting victories, or heartbreaking defeats where they rue their choices.

In level design terms, we can refer to Mark Brown's concept of *explorable space* described earlier in this book: the feeling of playfulness can be created by offering certain amounts of open-endedness and *legibility* – the ability to read and understand how to navigate the world. Action-adventure games operate in a delicate balance of structure and explorability: they have a structure to how new areas are unlocked as new abilities are doled out or story events are experienced, but the best ones offer opportunities for open exploration and goal-setting. In previous chapters, we referred to a back-and-forth of having planned sections where the player's progress is linear, but the world includes areas that tease the player with unreachable areas or objects that they cannot bypass. These are offset with those moments of "blooming" where a player earns a new ability that they realize offers the means to tie up those exploratory loose ends in previous areas, inviting opportunities for meaningful backtracking.

These moments help create the "choice" that occurs in action or competitive games: where those games have a lot of open-ended options of moves to make moment to moment based on the game state, action-adventures offer opportunities for different paths or chances to explore. Some games even invite

opportunities for advanced players to pull off complicated moves with the player character's abilities – such as how Samus Aran's Shinespark ability is used by the *Super Metroid* speedrun community. While difficult to plan, frequent playtesting, dialog with potential speedrunners, and open-mindedness during prototyping can help you plan for this kind of choice.

These principles provide us with our own conceptual building blocks ("Legos") with which to discuss some more specific applications of encounter design relevant to action-adventure games. In the next section, we will return to puzzle design to describe how puzzle mechanics are introduced, iterated upon, and blended to create interesting variety.

THE LOGIC OF BUILDING PUZZLES

One of the most common questions we are asked is about how to design good puzzles. The truth is, we do not have one surefire process for good puzzle design. Rather, we have built up a broader perspective on puzzles that helps us come up with satisfying outcomes in the kinds of games we make (mostly action or action-adventure games). To be clear: the puzzles we are talking about here are more of the puzzles found in action, adventure, or action-adventure games (games with other goals beyond the puzzles themselves). They are not the puzzles in *"puzzle games"* like *Tetris* or *Candy Crush Saga,* where a player is manipulating abstract pieces into formations or creating matches. Though some action-adventure games have sequences that feature these kinds of puzzles, their inclusions have a very different purpose than when one plays a game that is explicitly a "puzzle game."

Puzzles, but Not Too Puzzling

The most important thing to remember when creating puzzles in action-adventure games is that these games are not specifically about the puzzles: they are about exploration, progress, and often, narrative and storytelling. Puzzles are one type of encounter that action-adventure designers can put into their games and indeed, their role is not to be so difficult that they actually slow or stop player progress. Some tentpole games of the genre do not feature puzzles at all (or use them lightly). *Hollow Knight*, for example, focuses primarily on exploration and combat to fill out its world, with most "puzzles" being traversal-style puzzles where the content of the puzzle itself is plotting how to move through the level. On the opposite end of the spectrum are games like Mega Cat Studios' *Little Medusa*, which has adventure game theming and elements, but focuses on single-screen puzzle rooms rather than contiguous environments, making it much more of a puzzle/action game. In action-adventure games, puzzles exist to control progress and provide interesting things to do during exploration.

As covered in Chapter 2.1, puzzles in action-adventures can be as simple as whether you have the right item to give to a non-player character or the right tool to open a door. In the original *Legend of Zelda*, puzzles consisted only of pushing a block in the environment to make a staircase appear. While we do not advise modern game designers to create something so opaque as the puzzles in that game, we do think that new designers tend to overthink puzzles by focusing on complexity. If you find that you have created a space that works elegantly within the systems of the game (i.e., moving through the room, enemy placement, and overall feel are good), but which you do not feel is your best work in terms of cleverness or complexity, it is okay to still include it in your design. These sorts of spaces are often the type of spaces that add content but can be moved through quickly. If a player can traverse a room in a short amount of time, they will not have time to be critical about whether a puzzle was too simple or whether pieces moved into place in the most interesting way possible, but the room is still there to add a few seconds to play time.

Small Number of Systems, Many Contexts

In action-adventure games, puzzles are a means of creating variety in your environments by filling your environments with different types of activities that keep players thinking in different ways and having small moments of achievement. As in our discussion of "juicing," puzzles can be built out of a relatively small number of mechanisms that are mixed and matched in different ways. Many different types of Sokoban (block-pushing) puzzles, for example, can be built from a small number of pieces – often just the most basic pushable objects themselves. As we have seen, other common mechanisms like locks, keys, switches, destructible objects, projectiles, etc. can also be added to create even more possibilities. A block-pushing puzzle room could also include enemies to fight, destructible objects that have to be cleared out of the blocks' paths, or platforms to jump, making a more interesting encounter. Puzzles are flexible such that one puzzle can itself incorporate many different types of puzzle gameplay: traversal, inventory-object, reflexes, combat, etc.

When designing with this mindset, it is important to not throw everything at the player at once: action-adventures are games about developing ideas over a long time rather than overwhelming players in individual action scenarios. When introducing any new gameplay mechanism or idea in your game, it is best to feature that idea in isolation or non-dangerous contexts so that players can be familiar with its function. The first time the player sees a switch that opens doors should be in a space where the player can easily observe the door opening when they pull the switch, making their cause–effect relationship clear. A classic strategy (possibly to the point of being a trope) is to similarly require that players use the new tool or ability they find in item rooms to leave the room. In *The Legend of Zelda: Ocarina of Time*, the player must fall into the room where they gain the slingshot, and use the slingshot itself to make the ladder they will use to climb out of the room into place. Other games are less subtle, closing the door that the player used to enter the room in some way, requiring that the player use a different new-tool-requiring route, or having enemies that must be defeated with a new weapon swarm the room. Once the use of any new mechanic, tool, ability, or mechanism is clear, then they can be put into new or more opaque contexts, or combined with previously used ones to create whole new puzzle types.

Something that Resembles a Methodology

So far, this section has dealt in design concepts and pieces of advice. In terms of practical design methods, we want to offer these building blocks for puzzle design:

- The puzzle's "core mechanic" – decide on what the main gameplay focus of the puzzle is – an ability, tool, level mechanism, etc. – and make it the primary element of the puzzle and the thing that must be "solved." This will likely determine the "type" of puzzle it is.
 - New elements – not a building block on its own, but an addendum to the first step – if you are introducing a new mechanic for the first time, it should be in isolation and the puzzle should be super-simple and only about the new thing.
- The difficulty of the puzzle – whether a puzzle is early or late in a game, environment, or region of the world can have a lot of impact on how difficult the puzzle should be. Earlier puzzles should be simpler than later puzzles where ideas are more established.
 - How many possible solutions do you want there to be? It is optimal if you can have more than one, but sometimes puzzles come out having only one solution and that can be okay too.
- Nearby game mechanics – Your puzzle should logically fit into the area where you are building it. You do not want to start using mechanisms built for and themed around a jungle-themed dungeon when you are building puzzles for the ice dungeon (unless you are building an ice jungle). Sticking to a concise set of mechanisms allows you to focus your design and builds logical consistency with the rest of the puzzles in the environment. It also gives you a toolbox for the next bullet point.

- Supplemental puzzle types – refer to the "Puzzle Types" section in Chapter 2.1 for a list of puzzle types, but while your puzzle's core mechanic will probably determine the main puzzle type, you can also supplement it with elements of other types. A block-pushing puzzle becomes a block-pushing and reflex puzzle if you have the player push a block through an area where wall-mounted cannons are firing lasers, or block-pushing and combat if there are enemies, etc. Again, practice logical consistency within your individual regions or zones, but layering puzzle types will help you "juice" your puzzles to get the most out of them.
- Puzzle frequency – have you used this type of puzzle in a while? Are you using too many of them? Think about this when you are building sequences of puzzles so that you are not making repetitive levels. Sometimes you want to break up consecutive rooms of puzzle solving with rooms of combat or simple traversal.
 - Along these lines – how difficult are puzzles or encounters you have put together? We like to take a page from *Mega Man 2* director Akira Kitamura's book and design in waves of 2-3-1 in terms of difficulty, where the first encounter in a sequence of encounters is challenging but manageable. The next is more difficult or complex than the first, and the third in the sequence is the easiest to give the player the impression that they have become more powerful (Ariga, 2011). While Kitamura was discussing enemy placement, we feel this works well with puzzles as well.
- Playtest playtest playtest – when it comes to complex gameplay constructs like puzzles, it is best to test frequently for both technical functionality and to maintain a reasonable level of difficulty. Game designers do not have to be geniuses with all the answers – we can look to team members, friends, family, and members of our audiences to "sanity check" our ideas.

Puzzle design may seem daunting, but is far easier than most designers think in action-adventure games, simply because they are games that have puzzles, but not puzzle games. In many ways, puzzle design in these contexts is a lot like game design: they have core mechanics or interactions, and then complexity can be built by carefully adding complementary ideas or mechanics to supplement the core. If puzzle design is less complex than designers assume, though, enemy encounter design is more complex. In the following section, we will look at some considerations to think about when implementing enemies in your levels.

BUILDING ENEMY ENCOUNTERS

The previous section cites a 2011 interview with *Mega Man* and *Mega Man 2* director Akira Kitamura, in which he describes a pattern for enemy placement in his games. In his games, he would place a challenging encounter first, an even more challenging encounter second, and the least challenging encounter third. This would build difficulty but reward the player at the end of each sequence by making them feel like they had become stronger and more skilled. This is a far cry from how many designers treat enemy placement, as an activity to do once the level geometry has been carefully shaped. Rather than content to stick into a level space, enemies have a close connection with the level geometry within which players find them, and designers who understand this relationship can create some truly memorable moments. In this section, as with puzzle design in the previous section, we will explore how enemy encounters can impact the overall experience of your level.

Small Number of "Pieces," Many Contexts

As with puzzle encounter design before it, enemy encounter design is best thought of as a way to build a wealth of content in your game with a small number of "Lego" style pieces. While in puzzle design, the

pieces were switches, keys, destructible blocks, etc., in enemy encounters, our pieces are level geometry, obstacles, and the enemies themselves. We previously described enemies as being designed for battle ("battle monsters") or as puzzles in their own right ("puzzle monsters"). Mixing and matching level spaces, obstacles, and enemies in different ways can yield a variety of interesting and memorable results.

Few games understand this principle as the 2016 iteration of *DOOM*, created by Id Software. In the game, the first encounter with a new monster is treated like an event, often with a cutscene marking the arrival of a new enemy in a stage. The horned "Baron of Hell" enemies stick out in this regard, as one of the player's early encounters with them occurs in a large arena against just one Baron. Once the player has played through this encounter, a pair of them enter the arena along with a smattering of smaller monsters. This requires the players to adjust their strategies for this new, more complex, context. Later, the monsters are found as part of much more regular "kill arena" style encounters, where the player must defeat waves of enemies before they can progress to the next area. Some of the spaces where the arena encounters occur are large and open, but others contain more cramped passageways, requiring constant tactical adjustments amid moments of surprise and panic. Encounters like these are also set against updates in the player's weaponry and abilities as a way to demonstrate progression: the Baron of Hell is among the first enemies that the player sees when the get the game's strongest weapon, the BFG 9000, which can kill them in one shot. From these examples of how encounters with one type of enemy can change drastically depending on the size of the space, the number of enemies, or the available tools, we can see how versatile enemies are as tools for building gameplay experiences.

Similar to how we created building blocks for puzzle encounter design, we might do the same here to build a framework for enemy encounter design:

- The encounter's core "mechanic" – What is the encounter "about"? Are we introducing a new enemy? A new weapon or tool? Is this a simple fight with a group of enemies? If so, what is the "main" enemy in the space?
- Advantage – who has the "advantage" in the encounter – the player or the enemy (or enemies)? Is it equal? Deciding on the power dynamics between the combatants can help define how you want the encounter to "feel" for the player (power fantasy, climactic duel, trial to survive).
- Difficulty – when does this battle occur in the game, environment, or level? If it is early, it should have a low ceiling of difficulty, but later encounters can be harder. Early encounters should especially focus on simple enemies that can be defeated easily.
 - Along these lines – some enemy encounters are not about combat, but are something to do while traveling through a "commuting" space in the level. In these cases, you may want to use simple enemies that can be dispatched quickly to keep the player moving.
- Number and types of enemies – your choice of enemies to include and when can greatly change the feel of an encounter. Kitamura's style was to encounter enemy types one at a time rather than in a group. Other designers will have enemies in pairs. Yet others will throw everything at the player in controlled groupings (as in *DOOM*'s arenas). Finding interesting pairings can make for interesting encounters, so experiment to get the feel you want.
 - Also keep in mind that the number and types of enemies you use at one time may also be limited by console memory, as in our GB Studio exercises.
- How the space enhances the intended experience: as with designing for player abilities, you should also design for enemy abilities. Is it easy or difficult to find an enemy's weak point (if they have one) within the available level geometry and with how the enemy is placed? Is there high ground, and who controls it (player or enemy)? Does the enemy have space to attack (and does the player have space to avoid the attack?)
 - Related to this: is any of the environment destructible or moveable such that players can give themselves better odds in the encounter if they do not attack right away?
- Space to observe – players should have some amount of space to take stock of the situation they are in during enemy encounters and plan next moves. The amount of space or time allowed depends on the intended difficulty of the encounter or style of game. Many games let players

enter spaces from a high vantage point such as a ledge or staircase or from behind a barrier in a 2D game such that they can watch enemies before entering the encounter space itself. Others have junctions or corners in pathways that let players stop and take in the state of the scene quickly before moving on.

- Context and frequency – Similar to difficulty, but more based on the nature of the encounters before and after the current one you are designing. As with puzzles, having too many difficult encounters in a row can be tiring for players. If there were a number of strong enemies beforehand, throw in an easier encounter (and vice versa). Likewise, if there are a lot of enemy encounters in a row, consider throwing in a puzzle or a space for uninterrupted exploration to create some variety.
- Playtest, playtest, playtest – as with puzzles, playtesting frequently with team members, other designers, friends, family, and members of your audience can be helpful. This is useful for understanding not only whether specific encounters work well, but also whether sequences of encounters flow well.

What Not To Do

Moreso than puzzle design, enemy encounters are also subject to pitfalls that can severely damage the experience of your game. Some of these are more related to the design of enemies, but others come from the combination of enemy and spatial design.

The first, and perhaps most severe, issue comes from how enemies are implemented in levels themselves. In our building blocks of enemy encounters, we alluded to how many types of enemies the player encounters at one time. If the player encounters too many enemies or types of enemies at one time, it can easily overwhelm the player and feel unfair. At the same time, this can also be a matter of style: the newer *DOOM* games use lots of enemies at once, but often unleash them in carefully moderated waves rather than all at one time (though, it can sometimes feel that way). In this way, those games walk a line between business and unfairness such that the player feels consistently challenged. On the opposite end of the spectrum are games that feature only one or two types of enemies at one time. In more exploratory games, this can be desirable since you can change out selections of enemies between regions such that the player feels like they are always seeing new things. Along these lines is also whether enemies are encountered in spaces that support players' encounters with them. While it can be interesting to fight enemies in tight quarters or open areas where the player is open to attack, these spaces can work against the player if they diminish the player's ability to fight back. Some Metroidvania-style games feature overly huge open areas with flying enemies that home in on the player's location or fire projectiles from off screen (if the enemy is not scripted to start firing projectiles only when visible), leading to cheap hits. If the job of level design is to control how players encounter enemies, these sorts of encounters are wholly *uncontrolled* and can make the player feel overwhelmed.

Related, but more based on the design of enemies themselves, is whether the enemies encountered take too much damage (a "damage sponge") or are too skilled for the point of the game where they are encountered. Unless the game is specifically combat-focused or has a "Soulslike" tone as in *Blasphemous* or *Hyper Light Drifter*, early enemies should offer little resistance and enemy difficulty should scale with the player's progress through the game. If a small, floating head enemy in a "vanilla" action-adventure game is taking multiple five or six shots to kill in the first level and taking away 20% of the player's health per hit, the encounter is unbalanced. Likewise, enemies should not be too skilled in their attacks and should have a reasonable amount of simplicity in their design. Enemies that throw projectiles in an arc, for example, should use only one or two different arcs (three maximum) that are easily legible to players. In this way, a player can wait for an enemy to throw their projectile, then slip in under the projectile's typical path to attack. There are games where such an enemy would adjust their arc so that it precisely targets the player's location, even when traveling in an arc, overcomplicating the encounter.

While some of these are for sure a matter of taste, aligning the tone of your game with the difficulty or severity of enemy encounter design can help players understand the intended experience of your game and create a more satisfying experience.

In the last section of this chapter, we will look at an encounter type where puzzle and enemy encounters collide: boss design. While the previous encounter types could be constructed as collections of "Lego-style" mechanics; however, boss designs are the epitome of "action figure" design. As such, they present their own complicated design considerations.

BOSS DESIGN

Boss design is a complicated aspect of the game development process. On the one hand, it is one of the most attention-grabbing and accessible tools for building player excitement for your game. On the other hand, most bosses are built of artwork, animation, and code that cannot be used anywhere else in your game – the perfect "action figure" game element. Boss design can be a lot of fun because you are creating exciting action sequences with interesting variations of your gameplay, but can also be difficult to get balanced or even functional, if your boss designs feature a lot of specifically scripted sequences.

Designers who have not created many video game bosses may think – as many fans do about games themselves – that boss design is just a matter of having ideas about how a boss might work and implementing them. As with game and level design themselves though, having a framework of design principles for understanding boss design can help build more consistently engaging bosses in games. While bosses can vary by genre and game style, since this is a book about action-adventure games, this section will focus on building a framework for boss design in those types of games.

Combat-forward Bosses

In a discussion of game boss design, Retronauts host and games journalist Stuart Gipp described a scale of boss design ranging from *combat-forward* to *puzzle-forward* bosses. He particularly expressed a preference for bosses who "cycle through a series of attacks" that the player has to respond to (Retronauts, 2023). He specifically cites the Doctor Eggman/Robotnik encounters from the early *Sonic the Hedgehog* games, which would each have a few attacks that they would rotate through. These specific bosses were large and took up a significant portion of the spaces they were encountered in, making the player react to their attacks. Many of these bosses also had no specific *period of vulnerability* where the player could attack but could technically take damage at any time as long as the player could reach their vulnerable points (either the whole boss or a specific portion of the boss).

Bosses in the larger *Mega Man* series, including not only the classic action-oriented games but also later action-adventure style series such as *Mega Man Zero*, were also combat-oriented bosses that would cycle through a small number of attacks. Unlike the different versions of Doctor Robotnik, these bosses are typically at the same scale as the player character, providing battles that feel like duels even when the boss uses simple patterns. Like Robotnik, they are usually able to be damaged at any time, though according to the core mechanics of the *Mega Man* games, they are more vulnerable to some weapons than others. At the same time, the bosses in these games each have different movement abilities and attack reaches. In more "classic" *Mega Man* games, where players can choose the order in which they fight bosses, this leads to recommended "boss orders" that reflect a difficulty curve from least to most complex. In *Mega Man Zero,* bosses instead employ increasingly complex attacks that require more complex movements to dodge. In all of these encounters, players must choose when it is most advantageous to dodge and when to attack, creating different tactical possibilities in how aggressive or defensive players feel they should be.

In these descriptions, we see several design elements that might be mixed and matched to create boss combat-forward boss design. As with enemy encounters, we should focus first on the core mechanics of the fight. In puzzle-focused bosses, this may include the use of specific items or tools, but in combat-forward bosses, the goal is usually to leave the boss attackable with the design focused on its attacks or the abilities players use to dodge them. Boss difficulty or complexity can be created by varying the size of the boss itself, the reach of its attacks, and the number of its moves. Bosses in games like *Hyper Light Drifter* and *Hollow Knight* have typically three to five attacks, though many earlier bosses in games have between one and three. These attacks can cover everything from small areas around them, to entire vertical or horizontal strips of screen-space, to even most of the screen except for a small area (Figure 5.3). Depending on the intended difficulty of the boss or the game itself, these attacks also have different amounts of "wind-up" animations that show players what attack is about to come. These were the strategies we employed in the boss designs of *Little Nemo and the Nightmare Fiends*, focusing most of our bosses on always-vulnerable combat-forward boss designs. Since one of that game's core mechanics was the ability to swap between four potential playable characters at any time, each boss had patterns that could be more easily overcome with a specific character's abilities.

As with attacks, the size of the boss and how they move around the environment likewise affects difficulty. A boss like Metal Man in *Mega Man 2*, who stays still unless the player shoots at him, is a typical early game boss since it has a simple, predictable, and exploitable pattern with limited movement. A boss like *Hollow Knight's* Radiance attacks with faster and more screen-filling attacks that make them a more significant challenge. *Mega Man X's* first fight against maverick robot leader Sigma features a boss character that is not much bigger than the player character, but who moves in a lot of challenging screen-crossing patterns. Battles like this demonstrate that boss size is not necessarily a determining factor of challenge, but rather attack reach and how far or quickly they can move in battle.

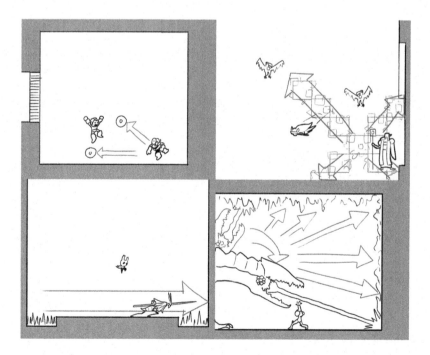

FIGURE 5.3 Different types of boss attack in combat-forward bosses, covering different amounts of screen space and distances around the boss. You can create varying amounts of challenge or complexity by focusing on attacks that cover small areas of the screen for simpler bosses or large areas of the screen for more challenging bosses.

FIGURE 5.4 *Kudzu* includes the Pokeweed mini-boss monsters which have a consistent combat-forward attack style of creating a shield around themselves with a flail, but then opening themselves up to attack by throwing it at the player. This boss is part of a side-quest to hunt them down and gather their leaves, so several are in the game. Variations are created by varying the amount of space the player has to move around in the Pokeweed rooms to create more or less dangerous encounters.

The spaces built for these bosses should support or provide interesting spaces within which the boss attacks can occur. In one way, combat-forward bosses can be more the more "Lego"-like boss style. Variations can be made by duplicating the boss encounter in another part of a game but changing some aspect of it such as the size of a ledge or the distance between the player and the boss (Figure 5.4).

Simple boss characters that act more like giant regular enemies are the most reusable, and can occasionally be reused entirely as advanced regular enemies. This occurs in the original *Legend of Zelda*, where bosses of easier dungeons would be found as regular enemies in more difficult ones. In some of these cases, the number of boss monsters encountered is changed to create an increased challenge. *Hollow Knight* uses this method to create advanced, optional versions of bosses that can be defeated for upgrades. Since combat-forward bosses are more pattern-based, iterating on them is easier via small variations in level space, increasing their number (when able), or by changing the variables for attack speed, time between attacks, etc.

Puzzle-forward Bosses

Puzzle-forward bosses, on the other hand, are the most bespoke, action-figure-like, and least reusable. These types of bosses can feature several attacks that they cycle through, but they are typically not always vulnerable and must have a weak point of some sort exposed. How this weak point is exposed is where the "puzzle" aspect comes into play: to expose the boss's vulnerability in these situations typically involves a logic puzzle of some kind. Some of the earliest "bosses" in video game history function in this way: the Qotile in *Yar's Revenge* hides behind a shield that the player must tear down before attacking the Qotile itself. In many of his incarnations, but especially in his first few on the Nintendo Entertainment System,

Bowser from the *Super Mario* series cannot usually be attacked directly. Instead, the player must either slip past him to destroy the platform he stands on or goad him into breaking a hole in the floor beneath him and falling into a bottomless pit.

Zelda games starting with 1991's *Link to the Past* increasingly employed puzzle-forward boss designs, with a common structure being that the tool acquired in the dungeon where the player encounters the boss being the key to defeating the boss. The Swamp Palace's Arrghus boss – a floating mass of jellyfish that are difficult to attack when together. To expose the boss's main weak point, the player must use the hookshot tool to reel in individual jellyfish and kill them, eventually leaving the main jellyfish vulnerable. The transition from 2D to 3D in games increased the complexity and drama of puzzle-forward bosses in games. In the original version of *Resident Evil 4,* many of the bosses require players to attack bosses in specific ways to expose the parasite controlling the bosses' actions, which can then be killed. *Metroid Prime*'s Flaahgra boss fight requires a specific sequence of actions on the player's part. These include shooting the mirror-like mechanisms that provide the plant-like boss with sunlight, then rolling down tunnels to the plant's roots in Samus's Morph Ball form to plant bombs next to the boss's roots. Among the most cinematic, and some would say convoluted, was the Gohma boss from *The Legend of Zelda: The Wind Waker*, which in the game's story is irritating a dragon's tail from within a volcano. Players must use a grappling hook to swing on the dragon's tail, triggering several cutscenes of the surprised dragon and part of the rock it is sitting on falling and cracking the Gohma's shell, rendering it vulnerable.

Today, most 2D games employ strategies like those in earlier *Zelda* games, where the means of exposing a boss's weaknesses are still puzzle-like, but largely straightforward. As mentioned in the last section, our bosses in *Little Nemo* were largely combat-forward, but identifying which of the four playable characters could best deal with each boss's patterns added some light problem-solving to each battle. *Kudzu*'s major bosses are all puzzle-forward bosses. The first boss is a giant bug with a hard shell that the player's machete cannot penetrate. To expose its weak underbelly, the player must goad it into charging and hitting the bottom wall of the room, which knocks down a character that will fire a kudzu seed if defeated. This seed knocks the boss onto its back so that the player can attack it. Another boss is a ghost that can be attacked directly, but rather than killing it, the player's machete chops off pieces of the boss's spirit body. These pieces must be pushed into a nearby fireplace while ghosts fire ectoplasmic energy at the player. These encounters are each combination of logic, combat, and reflex puzzles.

With all of these moving parts, puzzle-forward bosses tend to have simpler and slower attacks. While they are often big and attack with claws, tentacles, or other large appendages, they also do so with lots of wind-up, and their attacks rarely fill the boss fight space in the way that some combat-forward boss attacks do. This is so that players can balance their focus between dodging attacks, decoding the elements of the boss's puzzle design, and actually executing the solutions to the puzzle. Due to these factors, puzzle-forward bosses tend to be less flexible and reusable and often contain the most non-reusable code and assets. Still, due to their impressive scope, they can be worth creating for early game encounters where you want to hook players. In pure level design terms, spaces for these battles should reflect the elements of puzzles themselves but also allow for the puzzle elements to be legible for the player. In the *Wind Waker* Gohma fight, the dragon's tail shows dark against orange mists of the cave and waves back and forth, calling attention to itself. Other background elements tend to be simple, allowing the most visual interest to be on the boss or puzzle elements themselves. 2D games should likewise keep the action to a single screen if possible in these types of fights or employ very little scrolling, so that the player can easily see all elements of the encounter at one time and notice anything interactive in the environment. By maintaining legibility via color and detail choices, as well as arranging space to let the players see all elements of the puzzle easily, it is possible to build exciting puzzle-forward boss designs.

Other Variations

Worth a quick mention are other boss designs that do not neatly fit into either of these categories. The bosses in Mercury Steam's *Metroid* series games: *Samus Returns* and *Metroid Dread* are largely

combat-forward designs with later bosses featuring complicated, screen-filling attacks. At the same time, they are combat and reflex puzzles that require players to expose weak points via concentrated attacks to break through armor plating or identify opportunities to use one of Samus's parry moves. The titular Hollow Knight boss in *Hollow Knight* is likewise combat-forward, but if the player has completed certain tasks, they can attack with their dream nail weapon at a specific time to initiate an alternate ending. The short window to do this in – shown as the non-player character Hornet stunning the Hollow Knight with her own weapon – is both a logic and reflex puzzle that requires some familiarity with the game's lore (or reading an online guide) to identify.

Last are bosses that are also environmental set-pieces. Most examples of this boss style include some form of opening sequence to the boss encounter, or the entire encounter itself, where the boss itself is not vulnerable and must be avoided. Many games build these sorts of encounters as chase sequences as in *Guacamelee*'s Alebrije boss fight. The giant monster cannot be attacked but chases the player through the environment while destroying level geometry. The gaps in geometry made by the boss become spaces through which the player can escape the boss. The Alibrije "fight" ends when the monster stands on a thin bridge and falls through into a lava lake below, but some similar sequences have a more typical boss fight afterward. An interesting reversal of this dynamic can be found in *Cave Story* during the fight with the Heavy Press boss, a giant version of an enemy that can instant-kill the player character by falling on them. When this boss is defeated, it also falls, both opening a passage deeper into the cave leading to the game's true final boss and becoming a huge instant-kill hazard. This latter design is more divisive, as it can feel like an unfair "gotcha" moment within a grueling sequence of enemy and boss encounters, but the region of the game is itself called "Hell," so the frustration feels intentional, aggravating as it may be.

As among the most memorable moments of games, one would assume that boss design is a well-trod area of game design theory, yet it is one with perhaps the least amount of ink spilled on its behalf. Whether that is due to the complexity of the topic or the bespoke nature of each boss encounter, our goal here is to give an attempt at organizing aspects of action-adventure boss design into something usable and repeatable by scholars and designers. We hope that as more game design writers take on this topic, we will start to see explorations of bosses in other forms and within other genres.

CONCLUSION

Encounter design is an intriguing element of level design in that it takes basic tenants of level design, creating spatial constructs that maximize the effectiveness of gameplay mechanics, and flips them into complex user-centric principles for the most specific gameplay moments. This is where old arguments about level design being impossible to write about seem to come true: these encounters are too specific, too context-sensitive, too based on the factors of individual games or scenes to be described in useful ways. Yet, by leaning into the genre we are building in, action-adventures, we can build a framework of principles through which we can describe best practices for encounters in these games. As a mish-mash of genres itself, the action-adventure genre rarely features combat or puzzle sequences in such purity that they must be absolutely perfect. Puzzles can be challenging, but should not stump the player or stop their exploration in a space. Combat is more important and in some sub-genres, such as Soulslike action-adventures, is indeed a focus, but can be described in ways that designers can create consistently engaging encounters. Learning how to tune encounters to the appropriate level of complexity and to work within action-adventures long sequences of encounters is a skill in and of itself, but one that can be mastered with practice

In the next and final chapter, we will bring together principles from throughout the book as well as the encounter design principles in this chapter to build a small dungeon. Through this exercise, we will see how individual puzzle elements and enemy actors can be mixed and matched to create interesting situations. We will also see how pacing can be controlled by alternating a variety of room and encounter types.

REFERENCES

Alexander, L. (2012). *Game developer: Sid Meier on how to see games as assets of interesting decisions.* March 6. Accessed December 28, 2023. https://www.gamedeveloper.com/design/gdc-2012-sid-meier-on-how-to-see-games-as-sets-of-interesting-decisions

Anthropy, A., & Clark, N. (2014). *A game design vocabulary.* Addison-Wesley.

Ariga, H. (2011). *Shmuplations – The birth of mega man – 2011 developer interview.* Accessed December 28, 2023. https://shmuplations.com/megaman/

Bleszinski, C. (2000). "The art and science of level design." *Game developers conference proceedings.* San Jose.

Brown, M. (2015). *Super Mario 3D world's 4 step level design.* March 16. Accessed February 6, 2022. https://www.youtube.com/watch?v=dBmIkEvEBtA

Brown, M. (2017). *Donkey Kong Country: Tropical Freeze – Mario's level design, evolved.* June 16. Accessed December 28, 2023. https://www.youtube.com/watch?v=JqHcE6B4OP4.

Davis, R. (2019). "Level design workshop: The level design of God of war." *Game developers conference.* San Francisco.

Glaiel, T. (2023). *Twitter.* February 17. Accessed December 28, 2023. https://twitter.com/TylerGlaiel/status/1626496746074570755?t=B5RUSzjP_tR7HzDGLMFXEA&s=19

Keogh, B. (2017). *An incomplete game feel reader.* March 31. Accessed December 28, 2013. https://brkeogh.com/2017/03/31/an-incomplete-game-feel-reader/

Lantz, F. (2023). *The beauty of games.* MIT Press.

Retronauts. (2023). *Sonic 3 & Knuckles, Part 1.* April 3. Accessed December 28, 2023. https://retronauts.com/article/2043/retronauts-episode-524-sonic-3-knuckles

Schell, J. (2019). *The art of game design.* CRC Press.

Swink, S. (2008). *Game feel: A game Designer's guide to virtual sensation.* CRC Press.

Swirsky, J., & Pajot, L. (2012). *Indie game: The movie.* BlinkWorks Media.

Upton, B. (2017). *Situational design.* CRC Press.

Let's Build a Dungeon

5.2

In the previous chapter, we looked both at common scenarios players encounter in action-adventure games, including different puzzle types and enemy encounters, along with strategies for making them more engaging. In this chapter, we will put together our first dungeon for our sample game, *Molly the Plant Princess*. Functionally, dungeons are much like the individual levels of linear games; they contain both dexterity and puzzle style of challenges that test the player's ability up to that point in the game, usually ending with a major challenge such as a boss monster. But in most non-linear action-adventure games, they have several unique properties. They exist as a bespoke space that exists within the game world, further enhancing the feeling of verisimilitude that permeates the genre. As we explored in the previous chapter, they also offer the opportunity for navigational challenges and puzzles that can be explored with various game mechanics. We can begin to explore this concept for the dungeon we will build with the mechanics we built in the previous tutorials, such as switches, locked doors, and enemies.

If you have not already done so, you can plan your own custom dungeon utilizing the techniques from other chapters, though we also have provided you with a blueprint and sample dungeon design you can use instead if you wish to just follow along with the steps in this chapter (Figure 5.5).

Before we can begin, we need to build one more system: a basic health system for Molly. For the sake of simplicity, we are going to create a simple hit-point system where Molly will take one point of damage per collision with either an enemy or hazard. However, it should provide a basis for you to experiment with your own health system should you choose to modify it.

BUILDING A HIT-POINT SYSTEM

1. With the starting scene selected, you can adjust the player character's behaviors from the rightmost sidebar menu. Create a new Variable > Set Variable event under On Init.
2. Set the variable to a new global variable. Rename the variable something you will remember such as $PlayerHealth. Set the number to your desired number of hit points for Molly, such as 5.
3. Move this event to the very top of the Player's On Init event list. It should be above the player being set to deactivate.
4. We are going to create a new script that we can apply to all of our enemies. Name it something like Enemy Damage or another name you will remember.
5. Create a new If statement event for the script as you have done before. Set it to check our new $PlayerHealth variable and if it is greater than zero.
6. If our condition is true, then set a new event to decrement the $PlayerHealth variable by 1.
7. Under the "Else" block of our event, create a Display Dialogue event. Change the dialogue to say, "All health gone!" or something to that effect.
8. You can also add a display dialogue for each time the player is hit if you would like to test the health decrementing. Create a dialogue box event and change the dialogue to "Player Health is $PlayerHealth" without the ". This should display the amount of health left in the variable when you run the game.

DOI: 10.1201/9781003441984-12

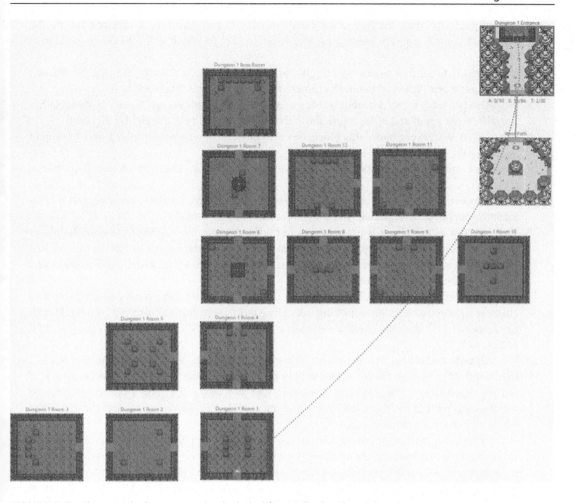

FIGURE 5.5 The sample dungeon we've included for *Molly the Plant Princess.*

9. Copy an enemy from our earlier sample scene and paste it near where our player starts currently to test our health system.
10. Create an event on your pasted enemy's On Hit function, under the Player tab.

You should now see a dialogue appear announcing you are out of health after running into the enemy several times. This means that it is working, but we will want to make it better. For one thing, there is no way to tell currently that we are being hit. Good visual and audio feedback is tantamount to our game feeling both good to play as well as fair to the player. There are several ways you could go about this, but here is one example for you to try.

Creating Feedback for Taking Damage

1. First, we need to tell GB Studio to check and see if the player has collided with the enemy within a short period of time. To do this, start by creating a new If Variable Is True event from the Control Flow menu inside of our Enemy Damage script.
2. Drag it into the If statement you created previously, at the top of the True block, just after where we decrement the player's health.

3. We are going to create another new Global Variable to use with this If statement as we did before. This time, name it something like $JustHit. Set to check if the $JustHit variable is "false."

4. If $JustHit is false, this means we have not just been hit and should take damage. So we will want to move our "$PlayerHealth Decrement By 1" event under this block.

5. We will also want to set $JustHit to true as soon as we take damage. Create a Variable Set Variable event again and place it just above the "$PlayerHealth Decrement By 1" event.

6. Next, add a Wait event under this block. Set it to however long you want the player to remain invulnerable.

7. Now add another Variable Set Variable event to this block. Use it to change $JustHit to true.

8. As we do not want anything to happen if $JustHit is true, leave it empty. You may add a comment to yourself as a reminder, if desired. Test and see if it works.

9. This is better as the player is prevented from taking damage too quickly. However, the player still cannot see if they are taking damage when they touch the enemy or not. Let us fix that now. First, we are going to create an Event Group. This can be found under the Miscellaneous heading of the Add Event button.

10. Groups allow us to place multiple events in a block which we can give a custom name and collapse to keep our event bar looking tidy. Drag our new group between the "$PlayerHealth Decrement by 1" and the Wait event block. Name it "Blink Group" or something to that effect.

11. We will now make it so that the player will blink a few times while they are in this state of invulnerability. We can do this rather simply by creating a Hide Actor event and setting it to our player, creating a Wait event for .1 seconds, and then creating a Show Actor event to reveal the player again. Repeat this a few times, making sure that the player is visible at the end of the string of commands (Figure 5.6).

12. As this blinking will occur while $JustHit is set to true, the player will remain invulnerable throughout the blinking and the Wait event we placed earlier, so you may want to adjust the initial wait event. As a rule of thumb, it is worthwhile to still have a slight period of invulnerability even after your player stops blinking. This ensures the player will have had time to pick up that the blinking has stopped while still maintaining a small, invisible safety buffer. The player will appreciate this regardless of the fact they would not know it exists!

Feel free to make any adjustments that you feel are necessary for your game. The important thing is that the player understands the current state of the game and is given time to react to it; how best to accomplish this will be different for different games, so use this framework as a system that you can build upon.

Challenge: Health UI and Game Over Sequence

Now that our player can take damage, use your knowledge from our previous practical chapters to build out a user interface for displaying the current damage to the player, and a game over sequence once all their health is depleted. There are several options for creating a health display for the player. You could simply display the number directly on every scene or on a pause scene, or you could represent it visually in some way using an actor that persists from scene to scene. This could be a bar meter or using appropriate icons such as hearts akin to *The Legend of Zelda*. The best option will depend heavily on the game that you are making, both visually and functionally; however, it is also important to keep in mind the limited screen real estate on the Game Boy as well.

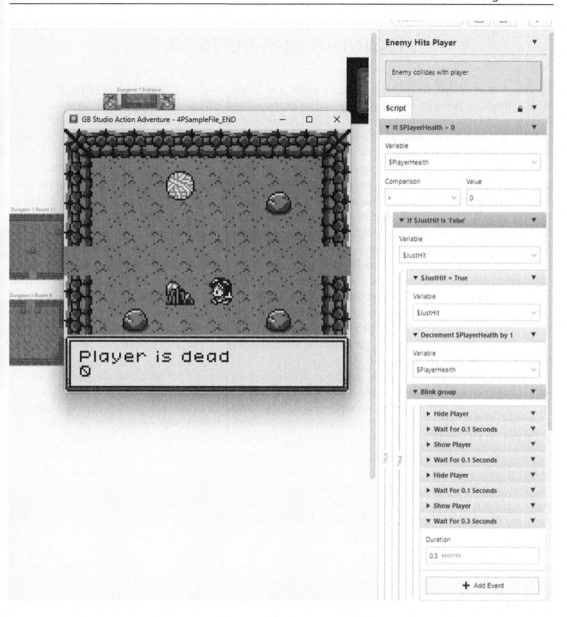

FIGURE 5.6 Using an Event Group to store our series of Events for the character blinking. Feel free to collapse when you are done making the script more readable!

For the game over sequence, you will need to build this screen yourself outside of GB Studio, using a tool such as Aseprite for the design and aesthetics. Then, once you have built a scene for the game over screen in the engine, you will need to have the game move to the scene any time the player loses all their health. In addition, you may want to consider additional feedback for when the player loses before it moves to the game over screen, such as a death animation or music. Finally, you will want to make sure you have a way for the player to reload the previous save, go back to the title screen, or in some way continue playing the game once they have died and moved to this new scene.

PLANNING OUR DUNGEON

In 1989 in an interview with *Dragon Quest* creator Yuji Horii, Shigeru Miyamoto said of the *Legend of Zelda*. "When we're doing an action game, we make the second level first. We begin making level 1 once everything else is completed" (GlitterBerri, 2024). Often when making a game, the initial flow and pacing will change as playtesting occurs or you design new and better areas. Therefore, it is hard to effectively teach the player how to play the game when what you are making has not been fully realized yet. It is in that spirit that the tutorial below is meant to provide you with a base upon which you can then remix into new, original, and even better creations. At the same time, this first dungeon we use in our sample will utilize elements not just of the mechanics we built in previous practical chapters, but many of the theoretical ideas as well. This will help give you a better eye on how to use these concepts in a very real sense and apply them to your own dungeons. With that goal in mind, we will consider this dungeon as if we were making the first encounter in the game.

We will want our players to sample the core elements that make our game engaging, such as combat and puzzles, but also make sure they are not too difficult or ease players into the game properly. At the same time, we will also want our players to have a choice on what direction to go without feeling frustrated or lost. While future dungeons can have a heavier emphasis on linear action challenges or complex multi-room puzzles, here we want our player to have a small taste of everything future dungeons will have to offer. This is akin to the idea of a vertical slice we explored in the previous chapter, but for the dungeon experience rather than the full game.

Way back in Chapter 1.2 we covered various tools and strategies for planning our game. Now we are going to put those tools to work in a practical way. First, we need to make sure we work within the confines of our rules we create as a designer; for instance, since we are developing a simple game as a sample, we can limit all doors in the game to one per wall, and ensure they are only in the middle of said wall. Simply put, doors will only appear on the north, south, east, and west wall, with one door per wall. With that in mind, we can sketch our rooms more easily on graph paper or using an image editor with a graphing option. Flowchart software is also a great option, as we can more easily move our rooms-as-boxes around and create connections between them to better see the flow of the dungeon (Figure 5.7). We can also create a legend along the margins to indicate where game elements like locked doors, switches and what they activate, treasure boxes, and more are located on our map.

When considering the flow of your dungeon, it is worth considering things such as how many open doors can the player explore vs. locked doors, how many keys can the player collect before they need to open a locked door, or what does a locked or blocked off door give access to. This is where Mark Brown's Boss Key diagrams can be very useful to better see the connection between your locks and keys, as well as what parts of your current design are linear vs. non-linear. For the example outlined above, we created this boss keys diagram (Figure 5.8).

While the simplicity of our sample dungeon becomes more obvious from this chart, it also can tell us a lot about the current pacing. On the first row at the top, there is only one locked door blocking future progress of the dungeon but there are also two available keys the player can get without having to go through the door. This tells us the player has a couple of places they can explore without having to make progress. By contrast, once that first door is unlocked, the path becomes more restricted; the player must go down the path to hit the switch (represented by the diamond) before the path to the boss and end of the dungeon is unlocked.

As explained in Chapter 1.2 (and in Mark Brown's Boss Key series), dungeon diagrams with longer horizontal rows indicate a more exploration-heavy dungeon with more keys, barriers, or multi-room puzzles. A dungeon diagram that has shorter rows indicates that the player's path through the dungeon is more constricted and may feature more single-room puzzles or combat challenges. Neither is better than the other, and by creating a boss key diagram for your mock dungeon, you can get a better sense if the flow

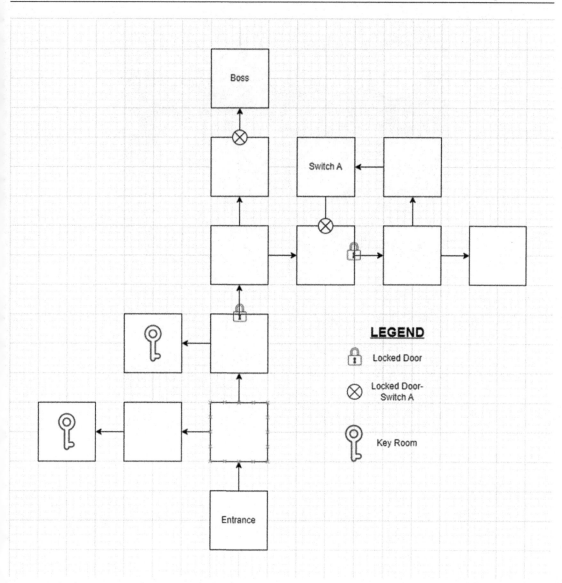

FIGURE 5.7 An example flowchart of our future dungeon.

of your own dungeon matches your own expectations before creating the final version within GB Studio. Our sample dungeon, for example, starts with a more open design that becomes more linear the further the player progresses, something we can see easily by charting out the dungeon.

BUILDING OUR DUNGEON

With our map drawn out and a plan for the content within each room, we can begin creating our dungeon in GB Studio. Thankfully this process is fairly simple; for each practical chapter in this book, we have been building all of the tools we are going to need to make our dungeon. From creating new scenes, to

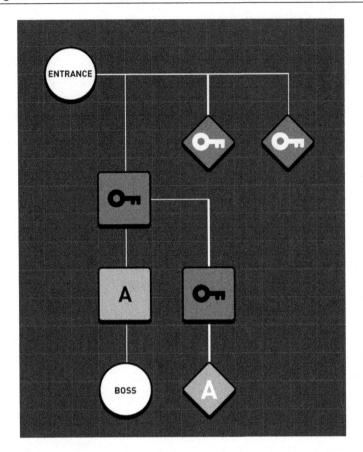

FIGURE 5.8 A boss keys diagram of our sample dungeon.

locked doors, switches, puzzles, and enemies – even using GB Studio's flag system to give objects in the game world permanence – we have many of the tools we will need to put our dungeon together relatively quickly.

1. If you have not done so already, create the tiles you will need for the walls, floors, and objects for your dungeon. As always, we have included sample sprites, backgrounds, and Tiled files you can use as a base. Feel free to create new sprites or tiles to add on top of these pre-existing files as well!
2. For our sample dungeon, each room of the dungeon will be a separate scene that will all be one screen in width and height (160 × 144), with doors to different rooms placed only on the cardinal directions at the edge of the screen. This has been done for simplicity. You may create rooms that are larger than one screen, or with doors placed in other locations as well (Figure 5.9).
3. Place your walls, floors, and other objects and decorations for each room within Tiled and export each one as an individual PNG as you have done before.
4. Once we have our rooms as PNG files, we can now create new scenes within GB Studio for each room. Remember that you can click and drag each scene inside of the GB Studio main editor, so it may be a good idea to arrange your dungeon in the same layout you intend for it to be in the game!
5. As before, paint collision boundaries and trigger zones for each room of the dungeon.

FIGURE 5.9 Creating a dungeon room within Tiled.

6. Place objects and decorative sprites in each room. If you are using a limited tile set and sprites as we are, a good rule of thumb is to remember to create unique or stand out patterns with the objects that you have. For example, we never repeat the same placement of rocks within each room of our sample dungeon. This helps the player to be able to create a mental map of the dungeon without having to go to a separate map screen (though we will be creating that map screen shortly!).

7. Place locked doors, switches, keys, and puzzles around each room. You may copy and paste the mechanics we created in previous chapters for this, create new ones, or implement any prefabs you have made. When copying and pasting our previous mechanics such as locked doors or using prefabs, remember to create new variables and set new flags as you go to make sure your doors, keys, and switches all map correctly and work as you expect them to.

8. Similarly, you can start placing enemies into rooms as well. As before, you can copy and paste the enemies we created previously or make new ones as well.

9. Finally, be sure to test your dungeon as you place new mechanics. If you create a puzzle or place a door locked by a switch in another room, ensure that they work in the game as you expect them to.

And that's it! You now have a dungeon for your game. We have a couple of other elements we need to create before we wrap things up. For one thing, we need a way for players to keep track of where they are within the dungeon. This is important for any non-linear level, but especially for a Game Boy game where we are limited in the number of sprites, tiles, and colors we have. Let us create a map screen for our game.

Art for a Map Screen

First, we are going to need two new scenes for our project; a screen for when we do not currently have a map, and one for the map of the dungeon itself. In a full game, you will need a separate scene for each screen that has its own map. Let us jump back into Aseprite and get started.

1. Open your pixel art software of choice. We will continue to use Aseprite for our example. Create a new project that is the width and size of one screen (160 height × 144 width).
2. Set your palette to be a four-color palette that works with Game Boy. As before, you can select a pre-made Game Boy palette within Aseprite.
3. Fill the background of your screen with the darkest color of the palette other than black.
4. We are going to create a header for the screen. This will require creating readable characters at a resolution readable on a Game Boy screen. If you are using Aseprite, you can do this easily using the Insert Font tool in the Edit menu. Select Insert Font and select a free font you have permission to use such as Arial.
5. Create a header that says, "Map Screen" using a light or midtone color that stands out on our darker background. Place it toward the top center of the image.
6. Repeat the above steps, inserting a font that says something like "You do not currently have a map of this area." And place the text in the center of the screen.
7. Export the project to PNG and place it in your project's background folder.
8. We will now begin creating the map screen. Copy the same project, then remove the text you just made.
9. On a separate layer and using the same color tone we used for our text, create an 8 × 8 square. Move that square somewhere on the bottom center of the screen.
10. Each square will represent a "room" of the dungeon, so you will need a copy for each room of our dungeon. You may do so easily by duplicating the layer you were working on to create a new 8 × 8 square.
11. We can move the squares and lay them out in the same position as our dungeon. For our map to work correctly, however, we need to establish a couple of guidelines. First, each of our squares must align with the Game Boy system's grid. You can work on the grid in Aseprite by selecting View > Grid > Grid Settings and setting the width and height of the grid to 8. Once enabled, ensure each square fits perfectly within the lines of the grid.
12. Secondly, each square needs to be placed one 8 × 8 tile apart from the other tile. If each square is placed directly next to the other, it will look as if it is a single room.
13. Once each of your squares is aligned correctly and arranged in the same manner as our dungeon, we can now draw connecting lines on a separate layer. These lines will represent where our doors are within each room (Figure 5.10).

Creating the Map Scene

Our Aseprite scenes are finished. Export this image as a PNG and place it in the backgrounds folder of your GB Studio project. Remember to save the Aseprite project file in case you need to make changes.

1. Create two new scenes, one for our no map available screen, and one for our map.
2. We are going to assign our map screen to come up when we press select, currently what our demo project uses for a sample menu scene we will no longer use. To change this, we need to edit the Top Down Scene Set Up script which is loaded in the initialization tab for each of our game scenes. Select it from the Scripts section of the left most menu.

FIGURE 5.10 The finished map of our sample dungeon within Aseprite.

3. For now, just change the "Change Scene" event to move from Menu Page 2 to our No Map screen.
4. Test in play mode to see if it works. If pressing select does nothing, you may need to attach the Top Down Scene Set Up script to the scene. You can do this in the editor by selecting a scene (such as the tutorial town or an individual dungeon room) and under its initialization tab on the right most menu, add the event Call Script > Top Down Scene Set Up. Be sure to place this event at the very top if there are other events within the tab! (Figure 5.11).
5. Now pressing select should just bring up the map. To have our map appear when we are in the dungeon, we will need to set a new global variable. Rename an unused variable with a name like "InDungeon."
6. Go back to our Top Down Scene Setup Script. Create a new If Variable is True event under Control Flow. Set it to check if $InDungeon is set to true. If it is, create an event to Change Scene to our dungeon map scene. We can then move the Change Scene > NoMapScreen event under the False condition of this Boolean event.
7. In our first scene when the game starts, add an event that sets our $InDungeon variable to false.
8. Now when our first room of the dungeon initializes, we should create an event that sets our $InDungeon variable to true. Similarly, when we leave the dungeon and go back to the scene just outside of it, the $InDungeon variable needs to be set back to false.
9. Test pressing the select button in play mode both outside of a dungeon, and within the dungeon and ensure proper behavior. You will want to do this with each individual scene to ensure our $InDungeon variable is being set properly in each location and that Top Down Scene Set Up script is being called as well.

FIGURE 5.11 Ensure the top scene set up script initializes at the top of every top-down scene.

Tracking the Player's Position

With the map screen in place, the player has a handy reference guide for the current area; however, our map is not complete. While ideally, we can design each screen to be memorable enough for the player to create a mental map, we want to minimize the feeling of being lost as much as possible. So next, we will create an icon where our player's current position is shown on the map. Let us do this now.

1. First you will need an icon to appear on top of each room the player is currently in. You can create your own within Aseprite or use the icon we have included with our sample project.
2. This icon will be an actor that appears on our map screen. Create that actor now and for the moment, create an event to set the actor to deactivate on initialization of the map scene. We will call this actor our "map point."
3. Set the name of an unused global variable to something like "DungeonRoom." We will use this to keep track of the current room the player is within.

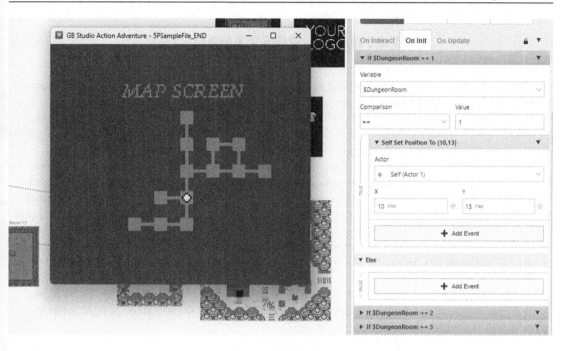

FIGURE 5.12 Our final map screen, with an icon showing the player character's current location.

4. For each Dungeon Room scene, create a Set Variable to Value event on the scene's initialization and set our $DungeonRoom variable to a number that corresponds with the room number. For ease, be sure to name each room scene something like "Dungeon Room 1" and use the same number you named the room as the corresponding value you use for our global variable.

5. Next, go back to our map point actor and within initialization, we are going to make a Boolean event checking the value of a variable. Set this event to check if our $DungeonRoom variable is equal to (==) the value of 1.

6. In the "True" condition of the event, add a new event to Set Position of our map point actor. We then need to set the X and Y position of our sprite so that the map point appears in the direct center of the square which represents the corresponding room 1 of our map which you can see on the GB Studio editor without having to test in play mode. If you are unable to get the map point sprite to align with the center of the square on your map screen, then the map is not properly aligned with the GB screen's grid. If this is the case, adjust your map point sprite in Aseprite.

7. Repeat the above steps for each room, checking the value of $DungeonRoom with the corresponding room, and setting the position of the map point sprite accordingly. Once this has been done with all the rooms, our map screen is now complete (Figure 5.12).

Challenge: Making the Map Screen Better

There are several improvements you could make to the map screen if you wish. For example, you can make the map point icon blink to give the map a slight bit of visual flair. You can also create icons to indicate locked doors or other obstacles on screen (as a bonus challenge, try making it so locked doors only appear on the map when the player has entered a room with a locked door!). You could also make the map screen, or the map point a lockable feature. For example, you could create a map item that the player must find within the dungeon before they can see the map screen or have the map point be an item that must be purchased at a shop.

CREATING A BOSS MONSTER

Now that we can find our way around the dungeon, we need to add one last challenge: a boss monster at the end of the map. As we discussed in the previous theory chapter, bosses are special combat challenges that can perform several useful functions. They can serve as a sort of "final exam" for gameplay elements and mechanics the player has been using throughout their specific level, or they can be a fun reward that gives a sense of finality to the current mission.

From our perspective as developers, creating bosses can be just as challenging as it is for the player to defeat them. From both a design and functionality standpoint, developing an effective boss is like planning out a full level. They have much more complex patterns and game states than normal enemies and need to be tested thoroughly to ensure they are both challenging yet fair. For this tutorial, will be creating a simple boss to serve as the first real challenge of *Molly the Plant Princess*. Rocko, a golem-esque living boulder (Figure 5.13), will move back and forth shooting players at the player. Like our dungeon from this chapter, this tutorial can serve as a base upon which you can experiment with for your own bosses for future titles.

1. Open your pixel art software of choice. We will continue to use Aseprite for our example. Create a new project for your boss monster. For this example, Rocko will be 32 × 32, twice the size of our other actors.
2. Create each frame of animation for your boss. In this example, our boss only needs to move back and forth, and will always be facing down, though feel free to be creative if making your own assets.
3. Once complete, save the sprite sheet into your GB Studio project's Sprites folder.
4. In GB Studio, go to the Sprites view and select the boss' sprite sheet.
5. Set up animation states as you did before, as well as the appropriate collision boundaries.
6. In the Game World View, place the boss actor where you would like them to spawn in your dungeon, ideally near the center of the scene, at least on the X axis.

FIGURE 5.13 Rocko, our boss monster, in Aseprite.

Getting Our Boss Moving

With the boss now an actor within our dungeon, we can start to get them to move before setting up the attack.

1. Because the boss is a type of enemy, the first thing we will do is go to the actor's On Hit tab. On the Player sub-tab, add a Call Script event. Add our Enemy Hits Player script from earlier. This will allow touching the boss to damage the player.
2. Next, let us set up their Init tab. We are going to use local variables as we will be setting parameters specific to the boss. We need a value that will control how many steps the boss will take before changing direction. Set Local 1 to a value of 5 and rename it something like $BossMove. You may need to adjust this value, but 5 is a good start.
3. Because the boss begins moving in the center of the screen, our $BossMove value will need to be a higher number than our starting value as they will be moving a further distance from the left to the right and back again then when the room starts. For this, we will use one of our two temporary variables. Set it to "True."
4. Once you create the Set Temp = True event, move the event in the On Init tab to be **above** where we set $BossMove. This will be important when we begin working in the update tab (Figure 5.14).
5. Let us move to the boss' Update tab. This tab will eventually have a lot of events, so we are going to work in groups. Create a new event group. Name it something such as "Movement Group."
6. First, create an If Variable Set to True event. Check to see if the temp variable we set in step 5 is set to true.

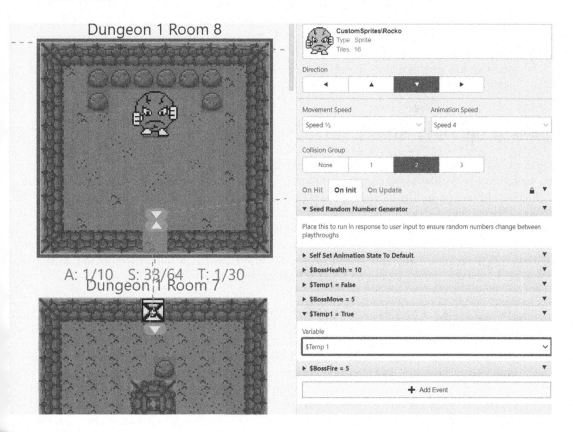

FIGURE 5.14 Our boss' Init tab in GB Studio.

7. If our temp variable is true, create two events. First, Move Actor Relative, with X set to -1 and Y set to 0. Second, Decrement Value by 1 event. Set it to our $BossMove. This will cause the boss to move to the right, and each step they take will reduce $BossMove by one.

8. Create another event inside of our current If True block, checking If $BossMove <= 0. This lets us execute new events once the boss has moved 5 steps to the right.

9. Inside of our new If statement event check from the previous step, create a Set Variable to Value event. Change $BossMove to be 10. Like our starting movement, you may want to adjust this later.

10. Create a new Set a Variable to True event after our last event. We will use a new Local variable. Rename it to $BossMoveLeft.

11. Create a Set a Variable to False event and use the temp variable.

12. Next, we can repeat steps 7 through 12 with some slight changes. Rather than checking to see if our temp variable was true, we will check if $BossMoveLeft is true, and if so, Actor Move Relative will be positive X. We still want to check if $BossMove <= 0, and then we will use another Local variable, renamed $BossMoveRight, and setting $BossMoveLeft to false. You may also copy the "If Variable Set to True" event from Step 7 and then paste it after the event and make those adjustments.

13. Optionally, you may want to test to see that our boss is behaving properly. At this point, they should at the load of the scene move five steps to the left, change direction to the right, and continue until they walk off the screen. If they only take one step to the right and then turn immediately, double check the Init tab to see if the Set Variable to True event for the temporary variable comes before setting $BossMove to five. The temp variable will be loaded into the Game Boy's memory too late otherwise, and the boss will switch to its $BossMoveLeft state, causing the error. Check your values and event order if you see any other unexpected behavior.

14. Repeat steps 7–12 one more time, ensuring $BossMoveRight becomes true again after the boss makes an equal number of steps to the left as they did to the right. We already have a lot of events in our update tab. Please feel free to consult our included sample project for reference to double check your work. Test again to see if the boss is moving left and right as expected. You may need to tweak the values to your liking depending on the set up of your scene's background and your boss' design.

Making the Boss Attack

The boss is moving left and right, but they are not really a threat to the player. Let's change that now, having them throw projectiles at the player in a faster, less predictable way than our spider. We will accomplish this by having projectiles move at angles when they are launched from enemies. GB Studio uses the layout and coordinate system of the Game Boy screen resolution for its vector math, so we need to do a bit of math to determine the values we need to enter within GB Studio to determine the angles at which our projectile will launch. Thankfully, this math has been done for us by developer and GB Studio enthusiast DF Project in their article *GB Studio and Its Angles* (DF Project, 2023). A full breakdown of the math and a diagram for the specific angles can be found at their site.

1. First, we need to create a projectile graphic and actor as we did before for standard enemies. You could also use a pre-existing actor if desired.

2. Once we have a projectile ready, we can go back to our boss actor. In the boss' Init tab, create a new event called "Seed Random Number Generator." We will be randomly choosing an angle to shoot each projectile, and this event is necessary for it to be random at the beginning of every new game. Place this event at the top of the Init event order.

3. Create a new Set Variable to Value event. This will use another of our boss actor's local variables. Rename it to "$BossFire" and set a low value like 3. This will determine how long the boss waits until firing another projectile.

4. In the Boss' Update tab, we will create a new event group called "Boss Attack."

5. First create an If Variable Compared to Value event in this group. Check If $BossFire > 0.

6. Inside of this If event, create an event Variable Decrement by 1. Set it to $BossFire. This will be the only event inside of this If Variable event.

7. Create a new If Variable Compared to Value event at the end of our Boss Attack group. Set it up to check if $BossFire <= 0. We will create three events inside of the "true" condition.

8. First, we need a random value that will serve as our angle which will be the direction of our projectile. Create a new event Math Functions.

9. For this new event, we will define several parameters. First, the variable, which we will use the other temp variable we have not used yet. Next, select "Set to" to tell GB Studio that we are changing the value rather than subtracting from or adding to. We are using the "Random" expression to a number between two ranges. For the minimum and maximum values, we are using 110 to 145. Feel free to adjust to your liking, using DF Project's article.

10. The second event we will use is Launch Projectile. Set this up as we did before in the previous chapter. This time, however, rather than using Fixed Direction, we will use Angle option. Set the Angle to our Temp variable from the previous step.

11. The third event for the If event check will be Set Variable to Value. Set $BossFire back to the value we set in the Init tab. You could also use a random value like we did in the previous steps, it will just be an additional step or two!

12. Test and ensure the boss is firing projectiles as expected. If the projectiles are not doing damage, check the scene that contains your boss has the Call Script "Enemy Hits Player" event under its On Hit tab in the proper collision group.

Defeating the Boss

We are almost done with the boss itself. It can move, it can attack us, now we need to be able to defeat it! This part is similar to how we set up our Player's health and damage system.

1. We have two more local variables left for our boss actor. We are going to use both for this system in our boss' Init tab. First, use the Set Variable to a Value event, and set a Local Variable to a higher number such as 10. Rename it $BossHealth.

2. Next create a Set Variable to False event. Use our actor's last local variable. Rename it something like "$BossJustHit."

3. Now let us move to our boss actor's On Hit tab. We are going to make it so the player's sword attack does damage, and the sword is a part of Collision Group 1. Select the Group 1 sub tab.

4. First, we are going to use an If Variable True event to see if $BossHealth > 0.

5. Inside of this check event, we will need an If Variable is False event, checking our $BossJustHit local variable. Similar to the player, this will help us to prevent constantly doing damage to the boss too quickly and let the player know their attacks are connected.

6. Inside of the check event, we will need two events. First Decrement Value by 1, set this to $BossHealth. Then, Set Variable to True, which sets $BossJustHit. Now the player should be able to do one hit of damage but would not do any more until $BossJustHit is set to false again.

7. Before we move out of the On Hit Tab, let's add one more If Variable Set to True event below all our other events. This will check if $BossHealth <= 0.

8. Inside of this check, create a Deactivate Actor event. This will deactivate the boss once their health is zero. This we will be useful later when it is possible to do more than one damage to the boss! Let us fix that next.

9. Back in the boss actor's Update tab, we will create our third and final Event Group. Name it something like Boss Just Hit.

10. Inside of our new event group, create a new If Variable Set to True event. Set it to check our $BossJustHit variable.

11. Create an Actor Move Cancel event to stop our enemy from moving when $JustHit is true.

12. Next, we want our boss to blink while they are stopped movie to indicate to the player both that they are briefly invulnerable and that their attack is connected. This is the same as the player, which is useful because it gives our game a consistent language; if anything in our game is blinking, it means they are invulnerable. It is also useful because we can go back to our Enemy Hits Player script from earlier in the chapter, copy our event group for the player blinking we created, and paste it into our boss' event below the previous step. We do not need to make an adjustment; GB Studio will automatically change the Hide and Show actor event to our boss actor!

13. Underneath the pasted group, use a Set Variable to False event to set $BossJustHit back to false.

14. Test and ensure it works. You should be able to hit the boss the pre-requisite number of times until it dies! If you're having trouble beating the boss to test it, you can increase your player's health or deactivate collisions to thoroughly test the behavior.

Final Steps

Congratulations, you have just coded your games' first boss! Before we wrap this tutorial, however, we have a couple more steps that will make the boss a proper part of your full game.

1. When a boss is defeated in your game, you may want an item to appear, or something to change in the game world, so we need to tell the game the boss is defeated. For this, we will need a global variable. In our boss actors' Init tab, create a Set Variable to False event. Set it to a new global variable. Rename it something like "$BossDefeated."

2. When our boss is defeated, we need to set this variable to true, so do this in the boss actor's On Hit tab. Add a "Set Variable To True" event to our If $BossHealth <= 0 event block, before the Deactivate Actor event.

3. We can use this event now by locking the player inside of the room when they are fighting the boss. Place a new door or other obstacle as an Actor in our boss room to block the entrance once the player moves into the scene.

4. On this door, we will only be using its Update tab. Here, create an If Variable is True event.

5. Inside of this If check event, create two events. Disable Collisions on Self, and the Hide Actor event set to Self (Figure 5.15).

6. Click the "Keep Running While Offscreen" option at the top of the screen.

7. Test and ensure that the door appears when the player comes into the room, disappears when the boss is defeated, and does not appear again when they re-enter the room.

Challenge: Create Additional Attack States and Ending Sequence

With this tutorial, you now have a base which you can expand upon or create new bosses with unique features and challenges. To experiment further, test out having the boss throw projectiles at different angles, or the amount of damage their attacks cause. Additionally, you could create whole new attacks that happen after every few volleys of projectile attacks. You may also consider an ending sequence when the boss is defeated. Do they shake a little before erupting into a pile of stones? Do they jump off screen and retreat from battle? Do they leave an item or upgrade behind? Thinking through the experience you want your players to have and then mapping out that sequence in steps such as the tutorial above will allow you to explore all sorts of possibilities.

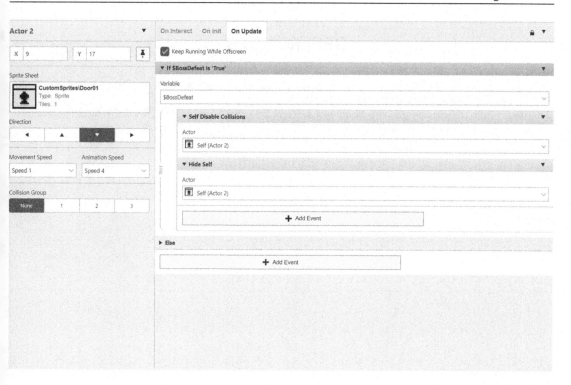

FIGURE 5.15 The Update tab of our door actor.

CONCLUSION

In this chapter, we briefly discussed the unique properties of dungeons in nonlinear action-adventure games versus levels in linear games. We then built out a health system for our player to take damage and explored options to expand this system. We then reviewed how to use our planning tools to prepare an outline before building our dungeon using mechanics we made in previous chapters. Then for our player to not get lost exploring the dungeon, we created a separate map screen along with a tracking sprite to indicate where in the dungeon the player character currently was. Finally, we created a template for thrilling boss battles we can use to expand upon or create other bosses for future dungeons.

If you have followed along with all the tutorials up to this point, then you have successfully put together the vertical slice for a full, 2D nonlinear action-adventure game. As discussed in Chapter 4.1, a vertical slice is a demo that includes the full "loop" of a game that the player will experience for themselves. For the tutorial we have created here, we have an introductory cutscene, a town in which the player can explore and talk with people, areas with enemies and combat, and a dungeon with puzzles and challenges such as a boss monster. This is a complete toolset you can use to further build out the rest of the game or to create your own adventure.

With both the Design and Practical chapters of this book, our goal was to provide an accessible resource for creating action-adventure games for interested people of different backgrounds. We did this through exploring the history of the genre and how it has evolved through the years; breaking down individual concepts such as world structure, quest archetypes, and common game mechanics; and an illustrated guide using these concepts within the GB Studio engine. We hope you have enjoyed this book, and to play the games that you will make in the future.

REFERENCES

DF Project (2023). *GB Studio and its angles.* Sept. 24. Accessed May 3, 2024. https://projectsrya.itch.io/df/devlog/611161/gb-studio-and-its-angles

GlitterBerri (2011). *Discussion between Miyamoto & Horii.* Dec. 20. Accessed April 23, 2024. https://glitterberri.com/miyamoto-horii-discussion/

Index

Note: Page numbers in *italics* refer to figures.

Printed in the United States
by Baker & Taylor Publisher Services